Chimayó Weaving

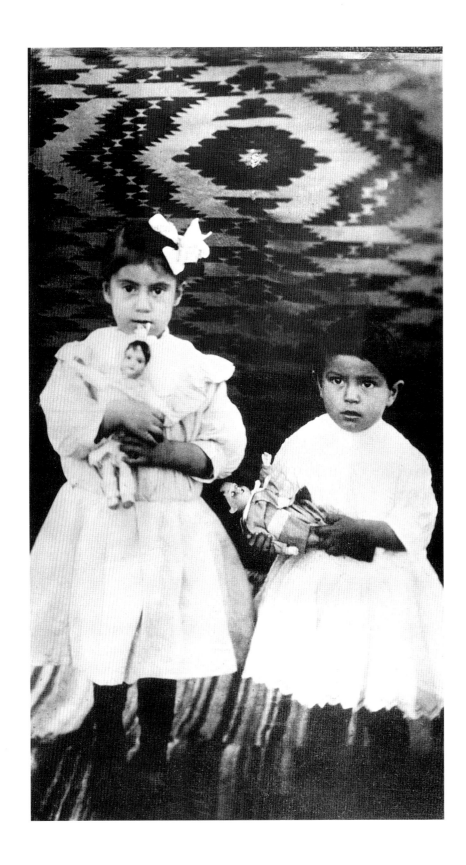

Chimayó Weaving

THE TRANSFORMATION OF A TRADITION

Helen R. Lucero ✦ Suzanne Baizerman

UNIVERSITY OF NEW MEXICO PRESS
ALBUQUERQUE

Frontispiece
Leonarda Jaramillo and her brother,
Guillermo (Willie) Jaramillo, pose in front of a
transitional Chimayó blanket. Hermengildo and Trinidad
Jaramillo, the original owners of the house where
El Rancho de Chimayó Restaurant is located,
were the children's parents. Hermengildo may have
woven the Chimayó blanket in the background.
Courtesy of Laura Jaramillo.

The authors gratefully acknowledge
a grant from the Center for Regional Studies,
University of New Mexico,
which helped make this publication possible.

To our children

Nicky Lucero Ovitt

Arek Baizerman

Tasha Baizerman

Contents

Preface

A drive along the High Road to Taos, one of northern New Mexico's popular tourist attractions, provides visitors with an opportunity to encounter part of New Mexico's Hispanic community. Most tourists will stop at one or more of the weaving shops along the route to purchase Chimayó weavings, woven rectangles with angular patterns, readily recognizable symbols of the American Southwest. Here, visitors can speak directly to weavers, men and women who link their ancestry to the Spanish *conquistadores*, the seventeenth-century settlers of the area. Visitors seldom realize that the shops are but the most visible aspect of an extensive rural cottage industry spread throughout the Río Arriba, the upper reaches of the Río Grande, whose waters bisect the state of New Mexico from north to south. It is an industry that extends into southern Colorado's San Luis Valley and that originated far to the south in central Mexico.

Shopping in these northern New Mexican weaving establishments, visitors participate in one of the oldest forms of cultural contact: trade in handcrafted items. The contact between outsiders and artisans has gone on for hundreds of years; it is a contact that is, indeed, part of the craft tradition itself. As an item of trade, Río Grande Hispanic weaving has been shaped not only by its weavers but also by contact with outsiders: customers, arts organizations, galleries, and museums. These individuals and institutions have admired, traded, influenced, purchased, and displayed Río Grande Hispanic weaving.

In the past, the story of these weavers has been distorted in popular and scholarly literature in two ways: first, by perpetuating the romantic lore that has surrounded the craft, and second, by labeling products for the tourist and curio markets as unauthentic and inferior. This book examines the Río Grande Hispanic weaving tradition between 1870 and 1995. It emphasizes the social context of the tradition and is based on the premise that the weaving tradition is not something that originated in the dim past, something fixed and immutable. Rather, the weaving tradition is an open-ended phenomenon, a renewable resource, a reflection of its changing social context; such "translated tradition" can revitalize a people, shore up ethnic boundaries, and promote cultural survival. From this point of view, artisans are active doers, embracing changes not as "add-ons," but as integrated developments.[1] They may "invent tradition."[2] The translation of tradition extends the concept of invented tradition, emphasizing the unfolding of tradition through the interaction of artisans, consumers, and others within social context and across time.

The Río Grande Hispanic weaving tradition was born in the interaction between weavers and consumers, which changed as the economic and political contexts for these interactions shifted. Traditions have been translated to fit new contexts. This book explores this trade in context: how the context for weaving has changed over time; how changes have affected Hispanic villagers; and how changes have affected their craft. There are several vantage points from which these changes are viewed. First, the historic record of trade in woven goods is examined. Of particular interest is the important role played by various mediators who linked weavers with consumers, such as traders, curio dealers, and art dealers during the late nineteenth and twentieth centuries. A second perspective is that of the weavers themselves, a view of the role weaving has played and continues to play in Hispanic life: personal, familial, and communal. A third source of information is the textiles themselves, how changes in the cloth reflect changes in trade. Taken together, these perspectives on Río Grande Hispanic weaving form a case study of the adaptability of a craft tradition to the modern world.

Chapter 1 briefly describes the setting: the unique cultural and physical geography of northern New Mexico within which the craft developed. Chapter 2 presents a brief account of the classic period, which dates from 1598, with the arrival of the first Spanish settlers, until 1870.[3] The settlers brought with them European traditions, which became synthesized with New World indigenous ways and were further adapted to the rugged life of a remote, northern outpost. It was a time of Spanish domination. Until the late nineteenth century, Hispanic weaving consisted primarily of blankets woven for personal use and for trade. Even in remote rural villages, settlers participated with local Pueblo, and later Navajo, weavers in lucrative blanket trade caravans. These caravans transported goods south into northern Mexico.

The Hispanic blankets, or *frazadas*, were a regional variation of the blankets of New Spain and of greater Mexico and were strongly influenced by developments in Mexican weaving. These blankets are well-represented in museum collections, where they are often referred to as Río Grande blankets.

The focus of this book, however, is not on the early days of the weaving trade, which existed from the seventeenth through the nineteenth centuries. That topic was thoroughly addressed in an earlier volume on Hispanic weaving.[4] This book is designed to fill an obvious gap in accounts of Río Grande Hispanic weaving during the late nineteenth and twentieth centuries, from the transitional period (1870-1920) through the modern period (1920-95). During these two periods, Río Grande Hispanic weaving underwent tremendous changes in response to a changing social milieu, translating the woven product to fit a non-Hispanic market. Changes have also led to a proliferation of romantic trade lore about Hispanic weaving.[5] Despite these changes, research reveals the continuity in the designs and techniques of Hispanic weaving from the classic period through the modern period.

In chapter 3 the discussion of the transitional period is divided into two parts, early and late. In the early transitional period (1870-1900), the effects of American annexation of New Mexico, set in motion by the 1848 Treaty of Guadalupe Hidalgo, had a great impact on the lives of Hispanic people of the region. From political institutions to the goods of everyday life, aspects of Hispanic life were fundamentally changed. For example, relatively inexpensive, commercially woven blankets gradually replaced the market for hand-woven blankets. Personal and community lands that had provided sustenance and joined Hispanos in common purpose disappeared as Anglo agricultural, mining, and ranching needs displaced them. Reduction of Hispanic land resources created the

need for cash to use in exchange for goods. The development of a cash-based economy led to an exodus of many Hispanic males to seasonal migrant jobs in Colorado and elsewhere. Anglo prejudice toward Mexicanos was evident. As Anglos became the dominant political force in the late nineteenth century, the issue of ethnic survival became increasingly important. The Catholic, Spanish-speaking Hispanic world of Old Mexico began to give way to the English-language world of the Anglo, and ethnic markers such as language and craft became more critical to cultural survival.

During the late transitional period (1900-1920), a new source of cash income in rural Hispanic villages became available as a result of the nineteenth-century rise of tourism in the Southwest and the worldwide interest in curios. Anglos sought objects for display in their homes. Santa Fe curio dealers, such as Jake Gold and Jesús "Sito" Candelario, capitalized on the skills of Hispanic weavers, shaping a woven product to meet the demands of a new market catering to tourists and mail-order customers. Weaving for this market provided much-needed cash for Hispanos. Their new product came to be known as Chimayó weaving, named for the village that became the center of weaving activity. Chimayó weaving made use of new commercial yarns from the eastern United States, supplied by the curio dealers within a cottage industry framework. It catered to Anglos' hunger for images of the Southwest, particularly Native American. In marketing Hispanic weavings, resourceful curio dealers even resorted to referring to them as "Chimallo Indian Weaving." Hispanic weaver-entrepreneurs quickly adopted Anglo business techniques, which they combined with their knowledge of community networks and customs.

By the end of the first decade of the twentieth century, blanket dealers were heavily involved with the tourist market. During the transitional period, the Hispanic weaving tradition was modified to satisfy the demands of the curio market. The Hispanic tradition was transformed: trade in utilitarian blankets within the villages gave way to trade with a new, non-Hispanic market, one where mediators played an essential role in helping to shape new products that bore graphic images based on Anglo ideas about Native Americans. Because tourist art and curios were often held in low esteem, little attention has been paid to the art of this period and to the impact of curio dealers on the craft. A detailed examination of the curio dealers' world is a major contribution of this book, giving serious attention in an effort to achieve a holistic understanding of the craft.

The 1920s ushered in the modern period (1920-95), presented in chapter 4, when the Hispanic weaving tradition was again translated to a diversity of forms, the latest oriented to a fine art market. This translation was directed by Anglos who sought an item for display that was visually different from weaving produced for the tourist-curio market, which was considered to be a debased form. The early modern period (1920-40) was shaped by a new breed of Anglo settlers who, like the curio dealers, were interested in the development of tourism in the Southwest, albeit in a different form. These settlers were educated, sophisticated artists and intellectuals who were influenced by the resurgence of interest in crafts throughout Europe and America. The newcomers embraced local Hispanic and Native American people as peasant-survivors who led simple, uncomplicated lives. Under the banner of craft revival, these well-intentioned Anglo aficionados eschewed tourist-oriented weaving and sought to revive Spanish colonial style weaving, which they viewed as authentic and traditional. They stressed the revival of old hand-methods of spinning and dyeing, and dictated aesthetic values based on their own "good taste." And they formed arts societies to advance their ideals.

The weavers' Spanish (European) roots were

emphasized through the use of the term "Spanish-American," thereby minimizing the effect of hundreds of years of contact between Hispanics and the indigenous peoples of Mexico and the Southwest. To avoid ethnic discrimination, Hispanics from northern New Mexico sought at this time to separate themselves from newer, and less educated, immigrants from Mexico; they adopted the designation "Spanish-American." Likewise, weaving was labeled "Spanish-American." As a consequence, the significant influence of the craft customs of Old Mexico upon Hispanic weaving in the transitional and modern periods became obscured.

During the 1930s the paternalistic efforts of the craft revivalists became linked to federal New Deal programs, becoming the first, but not the last, government effort in New Mexico to promote craft as a form of economic development. Unfortunately, the revivalists had not considered the effect of marginalization resulting from labor-intensive, poorly remunerated work like weaving. These craft programs ill-prepared people for a twentieth-century economy. However, the Anglos' interest invigorated the craft and assured its place as a source of pride for local Hispanics. In addition, weaving enabled people to stay on their "beloved land," connected to their family and faith, and it served to sustain rural life in a form that was culturally desirable.

The late modern period (1940-95) was profoundly affected by changes brought about by World War II: jobs in the military and in other government work; mobility resulting from geographically distant employment opportunities; and new Anglo immigrants drawn to the state by expanding opportunities. New Mexico experienced a tremendous population growth, increasing Hispanic intermarriage and ethnic assimilation. Weaving declined as a profession for males, but women entered the craft in growing numbers. However, tourism also declined drastically during the war. Therefore, the effects of women's involvement in

weaving were not felt until the post-World War II era. During this period tourism burgeoned, and weaving activity for this market again increased. The blanket dealers continued to play an important role in the lives of the majority of weavers. However, social activism and heightened interest in handcrafts, characteristic of the 1960s and 1970s, brought new vigor to Anglo support efforts. Government programs, art fairs, and gallery and museum exhibitions intensified the development of Hispanic weaving. Diversification of weaving increased as a number of weavers began to identify themselves as fine artists. They were influenced by the growing respectability of the fiber arts as a fine art form and began to produce one-of-a-kind works. As more Hispanic weavers have studied their weaving traditions, they have gained new perspectives on their heritage and have taken more proactive roles in the translation of tradition. A greater awareness of the Mexican and Native American contributions to New Mexican Hispanic history and experience, separate from a European-Spanish ancestry, has grown among contemporary New Mexican Hispanos.

Chapter 5, "*Tres Familias*: Profiles of Three Contemporary Hispanic Weaving Families," provides an opportunity to view the weaving tradition from a more intimate perspective. These portraits reveal the common threads that link families, such as history, technical skills, language, and religion. At the same time, they reveal the various ways in which these threads of tradition have been translated by different weavers responding to different opportunities. The family profiles of the Ortegas of Chimayó, the Trujillos of Chimayó, and the Martínezes of Medanales show the ways that weaving mirrors the times. Weavers adapt to the vagaries of the market and continue to weave regardless of the exigencies of their daily lives, lives that include such concerns as family, faith, agriculture, finances, education, business, and politics. The profiles also provide an opportunity to examine

some long-held assumptions about topics such as the role of gender in Hispanic weaving. Photographs of the three families provide a lasting visual record and augment the written profiles.

Chapter 6, "The Technology of the Art Form," presents the technical aspects of Hispanic weaving as practiced in northern New Mexico, gathered while collecting data on historical aspects of Hispanic weaving and while interviewing contemporary weavers. Craft technology is a necessary ingredient in the understanding of a craft tradition. Weavers make decisions about tools and materials, weaving patterns, the marketing of weaving, the way labor is divided, and how, when, where, and by whom the craft is learned. There is potential for change as different possibilities, such as new materials or design styles, present themselves.

In chapter 7 the relationship of the various sources of information presented in this book—history, technology, and family studies—are drawn together to show how this craft tradition has been transformed by different waves of Anglos and others who interacted with Hispanic weavers during a succession of social, political, and economic contexts.

This volume, then, meets a demand for longitudinal studies of craft traditions coping with the expansion of external markets. It also may help sensitize those who seek to sustain crafts about the way in which craft traditions adjust to differing circumstances.

※

Primary data for the research on Hispanic weavers were obtained from two separate research projects conducted during the early 1980s; these have been periodically updated in the intervening years. Both research projects involved extensive, in-depth oral history interviews (in English and Spanish) and participant observation encompassing a wide range of contemporary Hispanic weavers, dealers, curators, gallery owners, and collectors. Persons

interviewed ranged in age from fifteen to ninety-five. Published and unpublished sources furnished additional comparative data, as did archival documents pertaining to earlier periods and the files of turn-of-the-century curio dealers. Historic photographs were gathered to provide contextual depth to this research and illustrate the evolution of this art form. Finally, examples of late nineteenth- and early twentieth-century Hispanic weavings in museums and private collections were extensively studied and documented. Because Hispanic textiles were collected by tourists from all parts of the country, they can be found in collections from coast to coast. Many illustrations of these textiles are reproduced in this book for the first time.

The collaboration that formed the basis for this book may itself be viewed as an example of cultural contact. As a native Spanish-speaker from northern New Mexico, Helen Lucero is an "insider" to Hispanic culture. She is herself an Hispanic weaver, the granddaughter of a weaver, and related to dozens of other weavers. She was raised in Vadito, New Mexico, in an era when the road into town was not paved and electricity had not reached her home. For her doctoral research during 1981-83, Lucero studied her own people; in fact, often her own relatives. She conducted in-depth interviews with contemporary weavers, learning the role of weaving in each weaver's life and documenting the ways that weaving skills are learned and transmitted from generation to generation. She also compiled detailed genealogical charts of twenty families of weavers, oftentimes finding links from one extended family to another. Her task as a researcher was to balance her intimate knowledge of her culture with the scholarly goal of objectivity. She has continued to follow the progress of several Hispanic weavers, updating her research to the present.

Suzanne Baizerman, an "outsider" to Hispanic culture, began to explore the idea of researching Hispanic weaving as a doctoral student. A special-

ist in Latin American textiles with a background in anthropology, she was interested in the effect of tourism on hand-produced textiles; in Hispanic weaving she sensed a rich example.

Initially, Lucero was apprehensive about a non-Hispanic studying this Hispanic craft. However, it soon became apparent that the role of Anglos in the history of Hispanic weaving was an important area that had not been explored. Further, the value of an outsider's perspective could balance her insider's point of view. Through Lucero's mentoring, Baizerman learned from her, from her extended family, and from weavers in Lucero's study about the craft of weaving from an insider's perspective. An accomplished weaver herself,

Baizerman studied with an Hispanic weaver to sensitize herself to the craft's finer points. She scrutinized documentary evidence from the business and personal files of Santa Fe curio dealer Jesús "Sito" Candelario to better understand weaving during the transitional period and its effects in later decades. Baizerman conducted interviews with various Anglos who played a part in the development of Hispanic weaving, including members of art societies, museum professionals, and gallery owners.

The contrasting but complementary nature of the authors' backgrounds and interests provides for an unusual volume on the most recent century of Hispanic weaving in northern New Mexico.

Acknowledgments

The authors' research has been supported in part by grants from various sources. The Rockefeller Foundation (administered by the Southwest Hispanic Research Institute at the University of New Mexico), the Center for Regional Studies, and the International Folk Art Foundation of the Museum of International Folk Art contributed to Lucero's support. Baizerman received funding from the Department of Design, Housing, and Apparel, the College of Human Ecology, and the Graduate School, University of Minnesota; the American Home Economics Association; and the National Endowment for the Humanities (Travel to Collections Grant).

The authors are indebted to the many Hispanic weavers who helped us to understand their craft. Those who spent the most time with us were members of *Las Tres Familias* (chapter 5): the Martínezes (Agueda Martínez, Eppie Archuleta, Cordelia Coronado, Georgia Serrano, Louisa García, and Norma Medina); the Ortegas (David, Andrew, and Robert) and the Trujillos (Jacobo, Irvin, and Lisa). However, many other weavers contributed to our efforts. Three weavers have studied their craft in depth and have had much to offer: Teresa Archuleta Sagel, Juanita Jaramillo Lavadie, and María Vergara Wilson. In addition to these three, many other weavers have made important contributions to our research. They are referred to throughout this book.

Encouragement from colleagues was vital to our work. In the almost fifteen years that we have worked on this research we received guidance, information, feedback, and moral support from Richard Ahlborn, Jonathan Batkin, Louis B. Casagrande, Charlene Cerny, Andrew Connors, Tobías Durán, Nora Fisher, Ann Lane Hedlund, Kate Peck Kent, Lyle McNeal, Ward Alan Minge, José A. Rivera, Margot Schevill, Marianne Stoller, and Joe Ben Wheat. We also acknowledge our dissertation committees: James Srubek, Anne Taylor, David Maciel, Guillermina Engelbrecht, and Marta Weigle for Lucero; Joanne Eicher, Riv-Ellen Prell, Marilyn DeLong, Margaret Grindereng, and Stephen Gudeman for Baizerman.

For access to collections we are grateful for help from Orlando Romero, History Library, Museum of New Mexico; Dick Rudisill and Arthur Olivas, Museum of New Mexico Photo Archives; Esther L. McIntire, Menaul Archives; Guadalupe Tafoya and Vicente Martínez, Millicent Rogers Museum of Northern New Mexico; Marian Rodee, Maxwell Museum of Anthropology, University of New Mexico; Marilee Schmit Nason, Albuquerque Museum; Kathy Wright, the Taylor Museum of the Colorado Springs Fine Arts Center; Katie

Chimayó Weaving

Davis, Colorado State Historical Society; Leslie Freund, Phoebe Hearst Museum, University of California, Berkeley; Joyce Herrold, Denver Museum of Natural History; Margaret Hardin and Chris Coleman, Los Angeles County Museum of Natural History; Cheri Doyle, Southwest Museum, Los Angeles; Andrew Nagen, Los Colores Museum, Corrales, New Mexico; Andrew Connors, National Museum of American Art, Smithsonian Institution; Marcia Anderson and Linda McShannock, Minnesota Historical Society; Lisa Whittall, American Museum of Natural History; Eulie Wierdsma, Museum of the American Indian; and Lynn Teague, School of American Research.

Special thanks are reserved for photographer Miguel Gandert, editor Dana Asbury, and for our families and friends who have never stopped believing we would complete this project.

Chronology

1519 — Hernán Cortés landed in Vera Cruz, Mexico. Two years later, he conquered the Aztec empire and the capitol at Tenochtitlán. Mexico (New Spain) was officially claimed as a colony of Spain.

1540 — Francisco Vásquez de Coronado led the first large expedition into New Mexico from New Spain. He opened up the region to further exploration and settlement, claiming the area as part of the Spanish colonies.

1598 — First Spanish colony established in New Mexico under Don Juan de Oñate at San Juan de los Caballeros (near present-day San Juan Pueblo). The colony was abandoned by 1610.

1610 — Santa Fe established as the first capital of New Mexico under Don Pedro de Peralta. Santa Fe remains the oldest, continuously occupied capital city in the United States. Saint Augustine, Florida, the oldest continuously occupied European community, was settled by the Spanish in 1565. Santa Fe and Jamestown were both settled in 1607 but Jamestown was abandoned by 1700.

1631 — Official contract established with Mexico for the mission supply caravans that had been operating since 1609. Scheduled to arrive every three years, the caravans brought woodworking tools, cloth, clothing, Majolica pottery, church furnishings, and holy images. These images became the prototypes for later New Mexican santos.

1638 — Trade invoice from weaving workshop of Gov. Luis de Rosas indicated use of treadle loom in Santa Fe. Textiles exported to Mexico.

1680 — Pueblo Indians revolted and expelled the Spaniards. Under the leadership of Governor Otermín, the Spaniards were driven south from New Mexico into El Paso del Norte, present-day Juárez, Mexico. The colonists' homes, churches, and belongings were destroyed.

1692–93 — Gen. Don Diego de Vargas led the reconquest, or entrada, into New Mexico. Vargas reoccupied the capital, expelled the Tano Indians from Santa Fe, and reestablished Spanish rule.

1695 — Vargas expanded the province and made the first recorded settlement grant for the new *Villa de Santa Cruz de la Cañada* which then became the administrative center for the area north of Santa Fe throughout the Spanish (1540-1820) and early Mexican periods (1821-46).

1704 — De Vargas's will details variety of textiles available in Santa Fe.

1729 — Nicolás Gabriel Ortega born. The first recorded weaver in the Ortega family of Chimayó began an unbroken patrilineal lineage of weavers that now numbers eight generations.

1790 — Census illustrated the importance of weaving in New Mexico. Close to a hundred people, half in Albuquerque, listed their occupation as weaver.

1807–9 — The Bazán brothers, master weavers from Mexico, worked at improving the technical skills of New Mexican weavers in Santa Fe.

1821 — Mexico achieved independence from Spain and claimed New Mexico as its province. New Mexicans became Mexican citizens for twenty-five years (1821-46). Although 1821 marked the end of the Spanish colonial period, colonial art forms and Spanish traditions persisted in New Mexico well into the twentieth century.

1821 — The Santa Fe Trail, originating in Franklin, Missouri, and ending in Santa Fe, New Mexico, was officially opened for the transport of goods from the eastern United States. Spanish government restrictions on foreign commerce were officially lifted.

1823 — José Concepción Trujillo was born. He was the first identified weaver in the Trujillo family of Chimayó.

1840 — According to trade documents, more than twenty thousand blankets were exported from New Mexico to Mexico, indicating sizable trade in handwoven textiles.

1846 — Mexican-American War began and continued for two years. Brig. Gen. Stephen Watts Kearney occupied Santa Fe and set up a provisional territorial government. Mexican Governor Manuel Armijo left New Mexico, thereby ending some 250 years of Spanish and Mexican rule.

1848 — Treaty of Guadalupe Hidalgo officially ended the Mexican-American War. The boundaries between Mexico and the Southwest shifted dramatically. New Mexicans could choose to become citizens of the United States or retain their Mexican citizenship. In either case, their property and civil rights were to be protected. Many property disputes date from this period because the U.S. government did not recognize all the Mexican land grants.

1850 — A formal territorial government was created for New Mexico. Texas-New Mexico border was established at this time. New Mexico was a U.S. Territory for sixty-six years (1846-1912).

1856 — The first coal tar (aniline) synthetic dyes were discovered in England by William Henry Perkin. This discovery had a profound effect on the coloration of New Mexican handwoven blankets, which had previously been restricted to a natural dye palette.

1859 — The first Merino sheep were introduced into northeastern New Mexico. They eventually replaced the hardy churro sheep brought by the Spanish colonists, which, following near-extinction, have been bred back into existence in the late twentieth century.

1860s — Commercial Germantown, Saxony yarns introduced into New Mexico.

1878 — The Atchison, Topeka and Santa Fe railroad crossed the Raton Pass into New Mexico, reaching Las Vegas in 1879. The railroad increased the availability of mass-produced products and religious images. It also had a profound impact on

tourism and the sale of Hispanic and Native American arts and crafts.

1898—Agueda Salazar Martínez born. Considered to be the matriarch of Hispanic weaving, Doña Agueda was still weaving in 1995 and had a family numbering 204, with 64 weavers spanning five generations.

1900—Fred Harvey Company began curio business catering to tourists; it became a prominent firm in the Southwest.

1903—J. S. Candelario assumed control from Jake Gold of the Old Curio Shop in Santa Fe. Candelario and other Spanish entrepreneurs actively participated in the promotion and sale of Spanish crafts.

1910—Mexican Revolution began. Civil war raged throughout Mexico. Led to increased migration into New Mexico by political refugees and migratory labor. Pancho Villa raided Columbus, New Mexico, which led to General Pershing's massive punitive expedition in 1916.

1912—New Mexico became the forty-seventh state of the Union following some three hundred years of Spanish and Mexican presence in the area.

1914–17—World War I. Many Hispanic men left the area for the first time and returned with a new awareness of the outside world.

1915—Professional artists from the eastern United States began migrating to New Mexico.

1916—Julius Gans opened Southwestern Arts and Crafts Shop on the Plaza in Santa Fe.

1918—Nicasio Ortega established a general store in Chimayó, which later became Ortega's Weaving Shop. This shop established the dominance of Chimayó as New Mexico's major weaving center, specializing in Chimayó blankets.

1925—Spanish Colonial Arts Society (SCAS) founded in Santa Fe by Mary Austin and Frank Applegate to help preserve and foster traditional Spanish colonial arts in New Mexico.

1926—First exhibit of Spanish crafts in connection with art exhibit at the Fine Arts Museum held during Santa Fe's annual fiesta.

1928—First Spanish Market held under the portal of the Palace of the Governors.

1929—Beginning of the Great Depression in the United States.

1932—Brice Sewell appointed supervisor of trade and vocational relations for the State Department of Education; he instituted state vocational programs including the production of weaving, furniture, tinwork, and other Spanish crafts.

1932—Jacobo O. Trujillo taught dyeing and weaving at the University of New Mexico's San José Training School in Albuquerque. Inspired by Mexico's postrevolutionary educational program to establish rural schools in isolated areas, the founders of the San José Project developed an innovative pilot program to improve the education of rural Hispanic children.

1934—End of SCAS's Spanish crafts exhibit at Santa Fe Fiesta.

1934—Mary Austin died; SCAS activities entered a period of decline.

1935—Works Progress Administration (WPA) programs began.

Chimayó Weaving

1935 — Tewa Basin Study published, documenting continued activity in Hispanic crafts in villages throughout northern New Mexico.

1937 — Parian Analco opened. This market and others, such as the Native Market, attempted to revive interest and sales in Hispanic crafts.

1938 — Leonora Curtin attempted to revive the Spanish Colonial Arts Society.

1939 — Federal directives changed vocational programs to support the war effort.

1939-45 — World War II. An inordinate number of New Mexican Hispanos lost their lives in this war.

1942 — WPA ended as a result of the war. Other art and social programs were terminated, including the Native Market.

1952 — E. Boyd, curator of Spanish colonial arts at the Museum of New Mexico in Santa Fe, led the revival of the Spanish Colonial Arts Society.

1953 — Museum of International Folk Art, a unit of the Museum of New Mexico, inaugurated in Santa Fe. This museum currently houses an immense Spanish colonial art collection, one of the country's largest.

1956 — Millicent Rogers Museum, dedicated to Hispanic and Native American art, opened in Taos. This museum is known for its high-quality collection of Hispanic materials, especially twentieth-century artifacts.

1962 — HELP (Home Education and Livelihood Program) launched. Many Hispanic women learned to weave as a result of this program.

1965 — Spanish Market, sponsored by the Spanish Colonial Arts Society, reactivated. Since 1965 it has been held annually every summer (on the last weekend of July) in Santa Fe's plaza.

1971 — Old Cienega Village Museum opened at El Rancho de las Golondrinas. It is the only working Spanish colonial museum in the United States.

1974 — E. Boyd's *Popular Arts of Spanish New Mexico,* the first major book on the topic, published. This publication encompassed her life's work and continues to be an important reference work on Spanish colonial artifacts.

1975 — Gov. Jerry Apodaca instituted the New Mexico Governor's Award for Excellence in the Arts. Agueda Martínez was named as a recipient in 1975. Several Hispanic New Mexicans have since been honored with this award.

1976 — First of two Río Grande dyeing and weaving workshops sponsored by the Museum of International Folk Art held in Santa Fe. The second workshop was held in 1979 in conjunction with the first major exhibit and catalog of Río Grande weavings, *Spanish Textile Tradition of New Mexico and Colorado.*

1977 — The Taylor Museum of the Colorado Springs Fine Arts Center, a museum with an impressive collection of Spanish colonial materials, mounted a traveling exhibit, *Hispanic Crafts of the Southwest,* and produced an accompanying catalog.

1979 — *One Space/Three Visions* exhibition mounted by the Albuquerque Museum. It included the work of fifty traditional Hispanic artists (many who showed their work for the first time in a museum) as well as numerous Native American and Anglo artists.

1980 — Feria Artesana, celebrating Hispanic arts and culture, first held at Tiguex Park in Albuquer-

que. This feria was later moved to the Albuquerque Convention Center and died out in the mid-1980s. It was later revived as the Fiesta Artística and continues in a much-abbreviated form today.

1980—Census records listed New Mexico's total population at 1,302,894 of which 477,238 (36.6 percent) claimed to be of Hispanic origin.

1982—Jacobo O. Trujillo and his family opened Centinela Traditional Arts shop in Chimayó, New Mexico. Specializing in innovative adaptations of Spanish colonial designs, Irvin and Lisa Trujillo continue to weave and market their work at this shop.

1983—Founding of the Hispanic Culture Foundation, the only New Mexican Hispanic organization dedicated to the support of Hispanic arts and humanities. The stated purpose of this Albuquerque organization is to identify, preserve, enhance, and continue New Mexico's Hispanic legacy, thereby increasing cultural awareness and pride.

1983—The exhibition *Four Centuries: A History of Albuquerque* opened at the Albuquerque Museum. This exhibition continues to tell the story of New Mexican Hispanics during the Spanish colonial period.

1983—Ganados del Valle/Tierra Wools established as a sheep and weaving cooperative in Los Ojos, New Mexico. A connection between land, sheep, and weaving was reestablished as churro sheep were bred back into existence and wool was processed from sheep to finished product.

1985—New Mexico's Hispanic fine artists started a contemporary Hispanic market to exhibit and sell their work. Scheduled to coincide with the traditional Spanish Market in Santa Fe, the first market was held in the patio of the Palace of the Governors. The market was moved to Lincoln Avenue in 1990 and, by 1995, had grown to include seventy-three of New Mexico's best Hispanic and Chicano artists and craftspeople.

1985—New Mexican-born Hispanic weaver Eppie Archuleta from Alamosa, Colorado, was selected as a recipient of a 1985 National Heritage Fellowship awarded by the National Endowment for the Arts.

1986–89—SCAS added a youth market component to Spanish Market in 1986, artist demonstrations and Spanish Market Magazine in 1988, and a Winter Spanish Market in 1989.

1989—*Familia y Fe* exhibition opened at the Museum of International Folk Art. This exhibition is housed in the first space permanently dedicated to showcasing Hispanic art in New Mexico.

1990—Census figures for 1990 listed New Mexico's total population at 1,515,069 of which 579,224 (38.2 percent) claimed to be of Hispanic origin.

1992—New Mexico was the featured state at the Smithsonian's Festival of American Folklife in Washington, D.C. Over fifty Hispanic artists, including five Hispanic weavers, demonstrated or performed before an international audience. Other New Mexican cultural groups, especially Native Americans, were also well represented.

1992—Chimayó and Santa Clara Pueblo featured in *American Encounters*, a long-term exhibition about New Mexico, at the National Museum of American History, Smithsonian Institution.

1993—The New Mexico Folklife Festival, an offshoot of the Washington festival, was brought home to Las Cruces, New Mexico. Many of the same artists and performers participated.

1993—A legislative bill was introduced and passed to build a Hispanic Cultural Center in Albuquerque. It will be the first center dedicated solely to Hispanic arts and culture in the state of New Mexico.

1994—*Colcha* embroiderer Frances Varos Graves of Ranchos de Taos, New Mexico, selected as a recipient of a 1994 National Heritage Fellowship awarded by the National Endowment for the Arts.

1995—The forty-fourth Spanish Market in the summer of 1995 involved over 480 visual and performing artists, a tremendous growth from 125 artists ten years before.

Chimayó Weaving

Chimayó Weaving

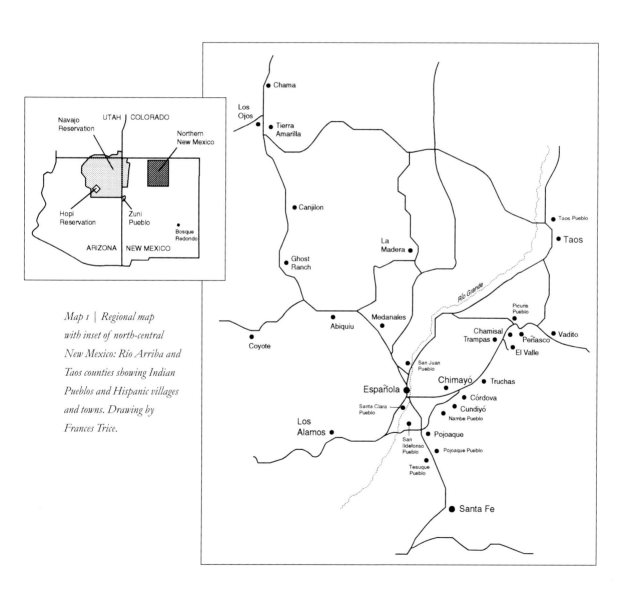

*Map 1 | Regional map
with inset of north-central
New Mexico: Río Arriba and
Taos counties showing Indian
Pueblos and Hispanic villages
and towns. Drawing by
Frances Trice.*

I

Setting

Heading north from Albuquerque on Interstate 25, the old *Camino Real,* a traveler drives parallel to the Río Grande, the river that bisects the state of New Mexico from north to south (map 1). At La Bajada Hill, fifteen miles south of Santa Fe, the traveler passes into the Río Arriba area of the state, which extends to the Colorado border. The area contrasts with the Río Abajo, the southern region with Albuquerque as its hub. Physically, the Río Arriba is a "mountainous upland, almost all of it above 6,000 feet, that tilts from north to south."[1] Its plant life is nourished by the many tributaries of the Río Grande and the Río Chama, whose confluence north of Española is considered "the birthplace of all *manitos.*"[2] (map 1 and fig. 1.1.)

The Río Arriba is a strongly Hispanic region of the state, rich in colonial history. If based on cultural rather than political boundaries, the Río Arriba would reach beyond New Mexico into Colorado's San Luis Valley; New Mexican Hispanos settled in this area in the late nineteenth century.

Historically, the contrast between the Hispanic Río Arriba and the Río Abajo has been based on "differing ecological adjustments." The Río Arriba was "characterized by community land grants, small economic enterprises, a high degree of *campanilismo* (best defined in this context as community spirit), and relative social equality; the Rio Abajo

[was associated] with individual land grants, large *ranchos,* enormous herds of sheep, [and] a distinction between patrón and péon."[3] (See figs. 1.2, 1.3, and 1.4.)

It is fitting that the entire region derives its name from the river; the banks of the Río Grande del Norte and those of its tributaries strongly determined original settlement patterns. Pueblo Indians and their ancestors lived in the region before the arrival of the Spaniards. Then Spanish villages, small farms, ranches, and towns were built near the river banks. The Río Grande has been aptly called "the life line" of the Hispanic people in New Mexico.[4]

While the Río Grande is the major geographic feature in this region, it shares significance with the river valleys, the alluvial basins that formed between the high mountain ranges. The San Juan and Jémez Mountains to the west and the Sangre de Cristos to the east form part of the Rocky Mountain system. Melted snow in these mountains supplies water downstream for irrigation. Although during the summer season there are often heavy thunderstorms, which develop as moist air from the Gulf of Mexico becomes unstable over the hot New Mexico land, the rain evaporates quickly and contributes less than snow melt to the water supply. Drought is a frequent problem. Water from

Chimayó Weaving

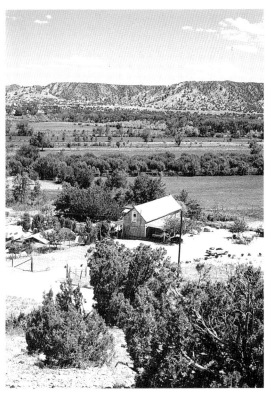

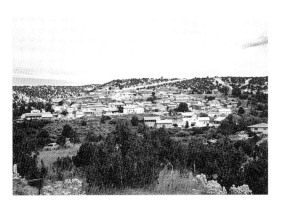

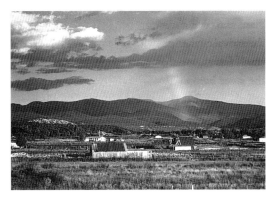

Figure 1.1 | River near Peñasco, NM, which feeds into the Río Grande. Photo by Miguel Gandert, 1986 (upper left).

Figure 1.2 | Village of Córdova, NM. Photo by Miguel Gandert, 1986 (middle left).

Figure 1.3 | Peñasco, NM. Photo by Miguel Gandert, 1985 (lower left).

Figure 1.4 | Agueda Martínez's home in Medanales, NM. Photo by Helen Lucero, 1995 (upper right).

streams and rivers is channeled to crops via *acequias;* many of these irrigation ditches date back to the time of original Hispanic settlement in the early seventeenth century (fig. 1.5).

The Río Arriba is not a heavily populated area. The high percentage of federally owned land in the northern region has contributed to low population figures; much of the mountainous terrain of the Río Arriba is included within the boundaries of the Carson National Forest, and there are other federally owned lands in the region.[5]

Before modern transportation was introduced to the region, the Río Arriba was relatively isolated and poverty was widespread. The rail link between Española and Santa Fe was established in 1880 and was known locally as the Chili Line. In the 1920s paved roads were built between Santa Fe and Taos, and roads to smaller villages were improved during the 1950s. These linkages ended Hispanic isolation as Anglos (those who are neither Hispanic nor Indian) entered the area in growing numbers.

However, despite contact with the Anglo world, poverty continues to be a widespread problem in the region.[6] Because of limited employment opportunities, many people have migrated out of the region for full-time employment or seasonal labor in California, Colorado, and other points west. Many families have ties to cities across the country, and visits between New Mexico and elsewhere are frequent. Absent family members may make significant contributions to family support.

The Río Arriba is often called a "tri-ethnic region." According to the 1990 census, 73 percent of those living in Río Arriba County and 65 percent in Taos County were of Hispanic descent.[7] In addition to New Mexican–born Hispanics, later migrations of people from Mexico, beginning in 1910, have added to the ethnic mix of the area. The Mexicans were, for the most part, unskilled people who sought work as farm laborers and were not readily accepted by the resident Hispanic population.[8]

American Indians comprise the next largest ethnic group in the region. Many are Pueblo Indians, descendants of the ancient Anasazi. Home to New Mexico's northern Pueblo people, eight actively thriving Pueblo villages remain today in the Río Arriba: Nambé, Picuris, Pojoaque, Santa Clara, San Ildefonso, San Juan, Taos, and Tesuque. Some of these Pueblo villages are a mere stone's throw from neighboring Hispanic villages. For example, the Hispanic village of Vadito and the town of Peñasco are near Picuris Pueblo (see map 1).

Anglos are the other major inhabitants of the region. They entered the area in several migrations. The earliest substantial influx followed Mexican independence in 1821. Many of the early Anglo settlers were in pursuit of land for farming and for cattle and sheep enterprises. Later immigrants, especially those suffering from respiratory ailments such as asthma or tuberculosis, sought the health benefits provided by the arid climate.

By the 1920s Santa Fe and Taos, the largest Anglo settlements in the Río Arriba, were attracting increasing numbers of individuals interested

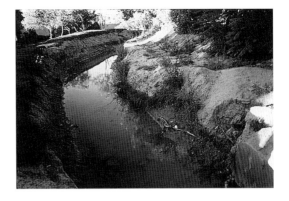

Figure 1.5 | Acequia (irrigation ditch) near San Juan Pueblo. Photo by Miguel Gandert, 1986.

in art and culture. Today these towns are well known by Anglo artists, gallery owners, and art collectors. It has been said that "more art is hung in more galleries here [in Santa Fe] than in any other city of its size in the nation."[9] Santa Fe and Taos are also havens for tourists and have many shops that carry tourist-oriented goods. During World War II the town of Los Alamos grew around the federal site where the atomic bomb was developed; today it is a largely Anglo community serviced by people from surrounding Pueblos and villages. Española, located between Santa Fe and Taos, is a predominantly Hispanic town, a service center for outlying villages, and is famous for its customized "low-rider" cars.

Most people in Río Arriba and Taos Counties practice the Catholic faith brought by settlers and missionaries; 93 percent of the populations of these counties are Roman Catholics. Early Spanish missionaries were quite successful in converting New Mexico's Indians. However, during the colonial period, there was a shortage of clergy for Hispanic settlers, so they came to rely on lay religious organizations, such as *La Hermandad de Nuestro Padre Jesús Nazareno (los Penitentes),* which supported religious ritual and strengthened community bonds.[10] Each village had a patron saint and distinct places of worship: a church, a chapel, and a *morada* (fig. 1.6). Today the saints' feast days, which mark the

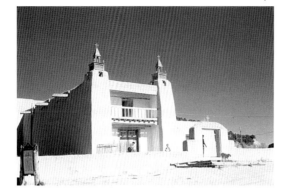

Chimayó Weaving

Figure 1.6 | San José de Gracia Catholic Church, Las Trampas, NM. Photo by Hank Saxe, 1993 (above).

Figure 1.7 | Ristras at El Rancho de Chimayó, a well-known restaurant in Chimayó, NM. Photo by Helen Lucero, 1992 (below).

Figure 1.8 | Santuario de Chimayó. Photo by Miguel Gandert, 1987 (opposite).

religious calendar, continue to be celebrated at the Pueblos and in the Hispanic villages, and festivities are enjoyed by all ethnic groups. As in the past, life continues to revolve around yearly celebrations, such as saints' feast days and events associated with the life cycle: baptisms, first communions, marriages, and funerals.[11] These are times when people can participate in their faith and fulfill their religious obligations. While weaving is mainly a secular craft, it may sometimes be found in religious contexts, used as wall hangings or rugs.

Chimayó, seven miles east of Española, is the best known of the Hispanic villages. It was one of the earliest settlements following Don Diego de Vargas's 1693 reentry into New Mexico. The town is best known for the Santuario de Chimayó, a pilgrimage site completed in 1816, where the faithful visit to pray and to gather holy earth to use in healing (fig. 1.8). The Santuario is dedicated to Our Lord of Esquipulas and is believed to have a connection to the pilgrimage site in Esquipulas, Guatemala.[12] The Santo Niño de Atocha is another image revered by the faithful at the Santuario. Chimayó's Presbyterian mission, established in 1900, also serves a sizable congregation.

In addition to its fame as a religious site, Chimayó is well known for its fertile soil and for the fine quality of its fruit and chiles. Any description of Chimayó—even one written today—is bound to mention the bright strands of chiles, called *ristras,* hanging from the adobe walls (fig. 1.7).

During the past hundred years, Chimayó has also gained international renown as the center of Hispanic weaving. It may be that Chimayó's distinction as a weaving village was somewhat fortuitous: it was the village closest to the Denver and Río Grande Western Railroad, twenty-three miles north of Santa Fe. A positive attribute frequently mentioned in the early twentieth-century literature regarding Chimayó residents is their industriousness. "Here is no lazy, indifferent, drinking gambling Mexican settlement, but the home of self-re-

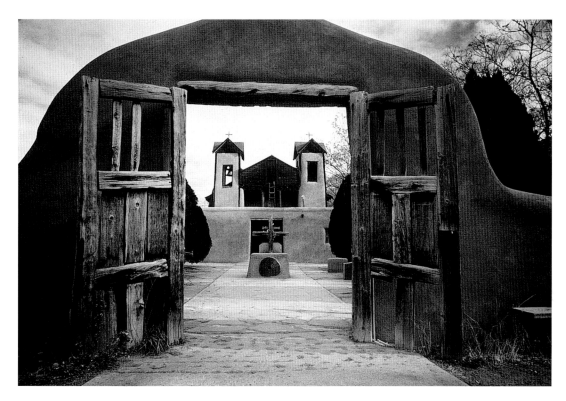

specting, hardworking, thriving, law-abiding men and women, who could well set an example to many far more pretentious towns and villages in our eastern states."[13] The Chimayósos' industriousness may also explain why this village became the most significant weaving site in New Mexico.

While Chimayó is the center of Hispanic weaving, weavers live in small communities throughout the Río Arriba. On or near the High Road to Taos lie the villages of Córdova, Truchas, Las Trampas, and El Valle. In the Chama Valley to the west, north of Española, are the villages of Medanales, Cañones, Canjilon, Los Ojos, La Madera, and Coyote. All are home to Hispanic weavers.

The importance of farming, livestock, and the land to any discussion of the Hispanic Río Arriba cannot be overstated. "The society has maintained its geographic and spiritual sense of place in northern New Mexico."[14] "Going up north" is the way transplanted rural Hispanos who live in the city speak of the transition between cities and rural villages. To a tourist passing through, the trip from Santa Fe to Taos along the High Road, stopping at shops and homes of craftspeople, is a half-day outing. To the urban Hispano it is experienced subjectively as a long journey to a distant, yet beloved, place.

2

The Classic Period

Before 1870

Hispanic weaving in northern New Mexico can trace its roots to Spain and to Moorish weaving influences introduced during the Moors' eight-hundred-year occupation of Spain. Added to these Old World traditions are influences of indigenous Indian cultures of the New World and of trade goods imported from the Far East.

In 1519 Hernán Cortés claimed for the Spanish Crown the land that came to be called New Spain. Within little more than fifty years, the Spanish had extended control into the more remote corners of this land (map 2). Immigrants from Spain, eager to acquire land and other riches in the New World, and Catholic missionaries in search of converts were the vehicles by which Spain extended her dominion over the vast new territory.

The Settlement of New Mexico

Into the northern reaches of New Spain, early sixteenth-century explorers set out in search of gold and other forms of mineral wealth. The first settlers arrived in the present-day American Southwest in 1598, led by Don Juan de Oñate. These settlers were lured by the promise of land and of Indian labor provided by the *encomienda* system. Indian labor was to come from local Indian settlements, termed *pueblos* by the Spaniards, using the

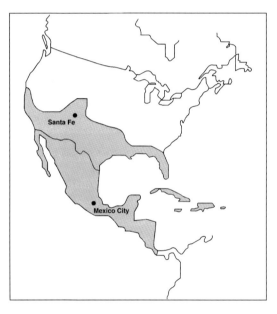

Map 2 | *New Spain, mid-17th century (after Gibson, 1966, 96). Drawing by Frances Trice.*

Spanish word for "town." The Pueblo Indians were not the only indigenous people in the area; there were also nomadic Indian tribes, who periodically raided the settlers, Indian and Spaniard alike. The new Spanish settlement was an extremely remote one by the standards of the day; supplies and government and military authorities in Central Mexico were several months away.

Land was acquired by the Spaniards largely

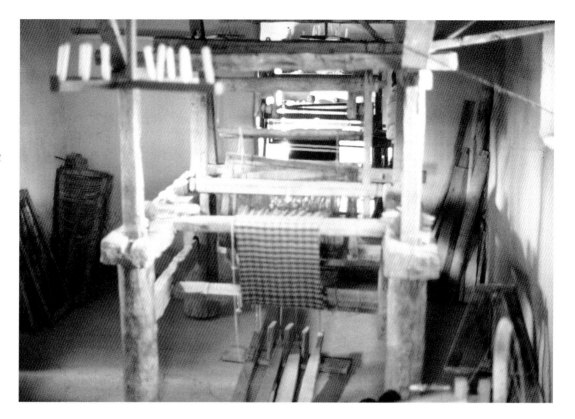

Figure 2.1 | Classic period loom, El Rancho de Las Golondrinas, La Ciénega, New Mexico. Photo by María Vergara Wilson.

through the land grant system. Village land was issued for home sites. Irrigable land for agriculture, located nearby, produced such crops as corn, wheat, squash, beans, and fruit. Villagers shared common grazing land for sheep and goats. (Oñate's party had brought four thousand sheep to the area.[1]) "Land not only provided the means of livelihood, it also established the social order of the 'kingdom of man.'"[2] The overwhelming importance of land to Spanish descendants is a feature of New Mexican life to the present day, as litigation surrounding historic land grants continues.

Textiles as Tribute Payment

In most regions of colonial New Spain, the Spaniards and the Indian population were linked in the *repartimiento* system: the Indian population was expected to pay tribute to the Spanish landhold-ers. For the settled Pueblo Indians of the Río Grande Valley, one form of tribute paid to the local Spaniards was a textile known as *manta,* a white, cotton rectangle used by the Pueblo people as a shoulder robe or wraparound dress. Manta was the product of a textile technology predating Spanish contact, woven by men on upright, fixed-tension looms. Although Oñate's early settlers brought textiles with them to the region, Spaniards soon faced extreme shortages of cloth, and mantas became a valued form of tribute.

In addition to weaving on their own looms, Indians were recruited to weave in the Spaniards' workshops on newly introduced treadle looms, a European technology brought to the Americas from Spain. While these bulky looms were not physically transported to New Mexico with the colonists, the settlers brought the knowledge of how to construct and operate them (fig. 2.1). Simple,

utilitarian textiles were produced for the domestic textile needs of the Spanish settlers. However, from records of trade goods and wills, it is clear that imported fabrics from Europe and the Far East were distributed in northern New Mexico even during the earliest days of occupation.[3]

In 1680 there was an organized Pueblo Indian insurrection, known as the Pueblo Revolt. This uprising resulted in large part from resentments stemming from the repartimiento system. Spanish settlers were driven out of New Mexico. Most of the colonists who resettled the northern area between 1691 and 1696, led by Don Diego de Vargas, were Mexican-born "Españoles Mexicanos," descended from Spanish-Indian parentage.[4] Following resettlement, the colonists were forced to abandon the repartimiento and encomienda systems. Instead, labor for activities such as weaving was often supplied by orphaned or captive Indian children who were adopted or traded into Hispanic families and used as servants. Trade in captives took place at fairs, held regularly at Abiquiu and Taos where Indians and Spaniards had direct contact. Indian children thus acquired were Christianized, then became *criados* (servants).[5] Criados "made a significant genetic contribution" to Hispanic families.[6]

In the 1700s, following the recolonization, land grants were given to the new settlers. Such grants encouraged the formation of large sheep ranches in the Río Abajo, as the land south of La Bajada Hill, just south of Santa Fe in northern New Mexico, is known.[7] The limited Spanish trade in the 1700s, in sheep wool and wool fabrics, was centered in the Río Abajo as well.

Settlers in the Río Arriba faced intermittent tensions as the Spaniards tried to extend their settlements northward and the nomadic Indians —Ute, Apache, Navajo, and occasionally Comanche—raided the Spanish settlers and their Pueblo neighbors.[8] Settlers lived in dispersed settlements that "reinforced the internal patterns of community authority among the residents of each plaza, who were largely related by blood and marriage." While a dispersed settlement pattern left people vulnerable to Indian raiding, it also served to "maximize individual friendships with Indians." In addition, trade (in legal and illegal goods) served to smooth interethnic relations; protection was enjoyed between trading partners, even over generations.[9] With the loss of the repartimiento labor system after reoccupation at the end of the seventeenth century, the commercial aspects of Hispanic weaving declined in northern New Mexico.

Hispanic Textiles
During the Early Classic Period

The best-known textiles of the early classic period were utilitarian blankets designed for hard wear. They were woven almost exclusively of handspun yarn, spun from the long, silky fibers of the *churro* sheep, the hardy breed imported to the Southwest by the Spaniards.[10] Most blankets retained the natural colors of the sheep: off-white, tan, or dark brown. Blankets were plain or decorated with stripes arranged in bands (plate 1). When additional colors were used, they were derived from natural dyes. Plant dyes from local flora produced reddish brown, yellow, and green hues. A processed form of indigo received in trade from central New Spain was most commonly used. Occasionally, unraveled yarns dyed with lac, an insect dye, appeared in blankets.[11] The best-known striped blankets are known as "brazilwood" blankets, due to the predominance of a reddish brown color, attributed to brazilwood, a hardwood dye.[12] (See plate 2.)

Typical Spanish looms were narrow, producing a woven strip approximately two feet wide. Most often, two identical panels were woven; they were carefully seamed together, matching the stripes in the panels. A wider blanket could also be woven in two layers. During the weaving process, the weft

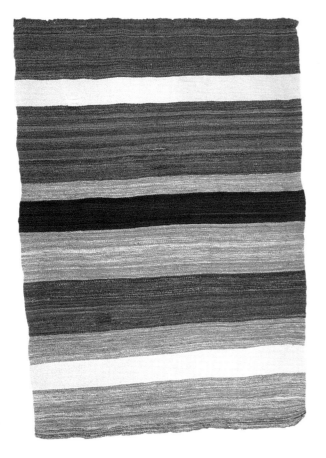

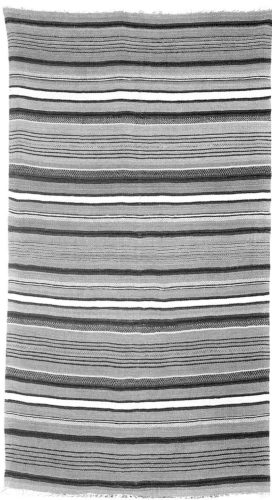

Plate 1 | Río Grande striped utilitarian blanket, single width, woven after 1880. Handspun weft, commercial cotton warp, 76 x 56 in. Millicent Rogers Museum of Northern New Mexico, Taos, New Mexico, 1956-1-63 (left).

Plate 2 | "Brazilwood" blanket, woven double width. Handspun wool warp and weft, 94 x 53 in. Spanish Colonial Arts Society, Inc. Collection on loan to the Museum of New Mexico, Museum of International Folk Art, Santa Fe, New Mexico. L.5.62-70. Photo by Miguel Gandert, 1992 (right).

would connect the layers along one edge, creating a double-width, or *doble-ancho,* blanket. These double-width blankets can be recognized by the presence of extra warps at the blanket center, which may leave vertical ridges or may be nearly undetectable. Many brazilwood blankets are double-width (see plate 2). In general, blankets were rather loosely woven with warp counts of five to seven ends per inch and twenty-five to thirty weft passes per inch.[13] Blanket fringes were finished most often with half hitches (see fig. 6.20).

These blankets were called *sarapes* (for wearing) or *frazadas* (for bedding). Sometimes referred to in English as "camp blankets," they were designed to

meet the needs of "the presidio soldier, laborer, farmer, [and] Indian."[14] To fulfill household needs, Spanish looms were used to produce yardage. *Sabanilla* was a plain-weave fabric of undyed, off-white wool used for clothing and sheeting and as a ground cloth for *colcha* embroidery (plate 3). A twill-weave fabric called *jerga* was woven for floor coverings and utility sacks (plate 4). Another coarse utility fabric was known as *sayal*. *Bayeta* and *bayetón* were fulled cloth used for work clothes. The more privileged classes wore clothing made from fabrics imported from Europe and the Far East.

Scattered population settlement patterns, together with the duties and taxes imposed by the central government of New Spain, discouraged the organized development of a weaving industry based on the European model. *Gremios* (guilds) were not established in New Mexico as they had been in central New Spain. Instead, the Spanish weaving industry was rancho- or hacienda-based and informally organized. "Servant" Indian labor was extensive, especially in the carding and spinning of wool. The custom of debt peonage was not unusual either: while "the *don* had the powers of his southern counterpart [plantation owner], he moved in a much more primitive, self-sufficient economic system which was more subsistence than commercial."[15]

The Emergence of Commercial Navajo Weaving

During the 1700s Navajo textiles began to play an important role in the commercial weaving market. These textiles became highly prized for their tight weave and resultant waterproof qualities. Navajo women had adopted Pueblo men's weaving practices from the mid-seventeenth century.[16] They worked in isolated, family-based settlements, and like their Pueblo teachers, the Navajo wove on upright, fixed-tension looms (fig. 2.2). Because they also used wool fibers, which the Pueblo had

The Classic Period

Plate 3 | Sabanilla, *reproduction cloth, yarn spun and woven by Juanita Jaramillo Lavadie. Photo by María Vergara Wilson.*

Plate 4 | Jerga, *woven by co-author Helen Lucero's great grandmother, Martina Trujillo Romero. Collection of Helen Lucero. Photo by Miguel Gandert, 1992.*

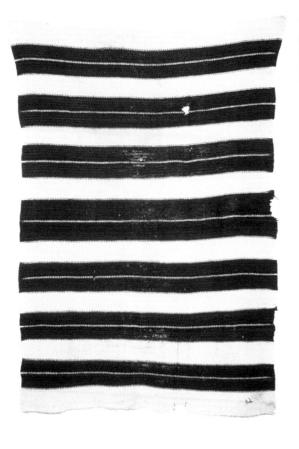

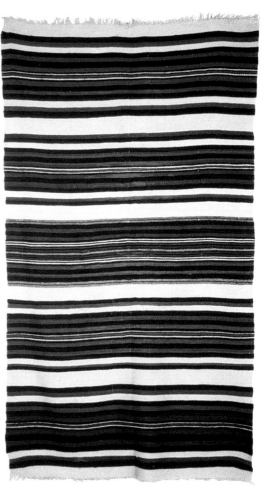

adopted early in Spanish colonization, the need for sheep to supply a growing weaving industry stimulated Navajo raids on Spanish sheep.

While the Indians never adopted the horizontal treadle loom, except while working as servants in Spanish homes, they did adopt new dyestuffs, such as the superior lump indigo, to complement their own plant-material dyes. In addition, by 1700 Spanish preference for blankets that were long and narrow, rather than short and wide, influenced the Pueblo and Navajo to change the proportion of their textiles for trade with the Spaniards.[17]

During the eighteenth century, Spanish, Navajo, and Pueblo loom products were all available at trade fairs, although the Pueblo products were not serious competition to the more numerous Spanish and Navajo ones. Visually the blankets of all three groups were quite similar in appearance, and they were used interchangeably for local trade, for trade with Mexico, and to meet domestic needs.[18] (See plates 5, 6, and 7.)

The Bazán Brothers

In the early 1800s the local government of the New Mexico frontier made efforts to stimulate the expansion of the weaving industry, since wool was one of the more promising resources to develop in the Río Arriba. Officials appealed to the central government to provide special instruction from skilled Mexican weavers. The services of Juan and Ignacio Bazán were secured. These brothers trav-

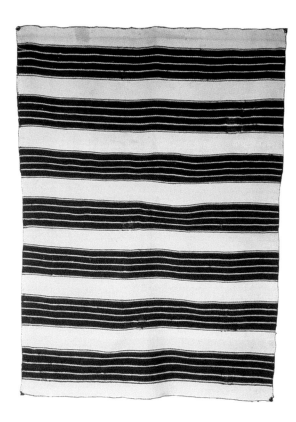

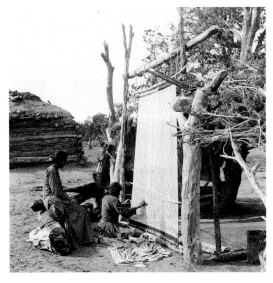

The Classic Period

Figure 2.2 | *"Navajo Blanket Weavers, Arizona," ca. 1890. Museum of New Mexico, negative #48998. Photo by Ben Wittick.*

eled to northern New Mexico in 1807 for an agreed-upon six-year stay to train youth in weaving. However, after only two years, they asserted that they had accomplished their goal and asked to be released from their contracts.

Little is known about what the brothers taught, and who their students were is a matter of speculation. It has been assumed that they introduced new weaving techniques. No doubt they provided at least a general upgrading and professionalization of skills. The Bazáns have been credited with the introduction of more complex tapestry weave-patterning techniques and with encouraging the use of cotton fiber in blankets.[19] They have also been credited with the introduction of techniques for patterning warp with resist-dyeing (known as *ikat*).[20]

Plate 5 | *Hispanic banded blanket, woven double width, 1850–70. Handspun wool warp and weft, 95 x 52 in. University of New Mexico, Maxwell Museum of Anthropology, Albuquerque, New Mexico. 63.34.77 (opposite, right).*

Plate 6 | *Pueblo banded blanket, probably Zuni, 1860–1900. Handspun wool warp and weft, 75 x 50 in. University of New Mexico, Maxwell Museum of Anthropology, Albuquerque, New Mexico. 82.30.1 (opposite, left).*

Plate 7 | *Navajo banded blanket, 1860–80. Handspun wool warp and weft, 69 x 51 in. University of New Mexico, Maxwell Museum of Anthropology, Albuquerque, New Mexico, 63.34.104. Photo by Damian Andrus (left).*

In addition to technical skills, the Bazán brothers probably introduced new forms or refinements of production organization. Home-based modes of production were replacing *obrajes* (factories) in the central Mexican weaving industry at the time the brothers were dispatched north.[21] Early in the settlement of central New Spain, Spaniards had established obrajes where large numbers of workers, many of them slaves, prisoners, or debtors, produced cloth in abysmal working conditions. By the eighteenth century "a shift in emphasis toward smaller workshops" headed by males who were assisted by family members "was taking place."[22] Wool was "put-out" by shop owners into the homes of Indians in smaller communities. It is not hard to imagine that one of the Bazán brothers' contributions might have been to organize production using the principles of this new, small workshop or cottage industry mode. Such production continues to the present day.

Mexican Independence and the Expansion of Trade

The securing of Mexican independence in 1821 was a great stimulus to trade in the far northern frontier. Barriers to trade across the U.S. border, imposed by the Spanish government, were lifted with the declaration of independence. Trade to the eastern United States along the Santa Fe Trail flourished, as did trade to the west on the Old Spanish Trail. *Sarapes* and *frazadas* maintained their position as chief trade items. The Mexican period from 1821 to 1848 was a very prosperous time in northern New Mexico; in 1840 alone, over twenty thousand textiles from the Southwest were exported to Mexico.[23] By 1840 production from Spanish looms had usurped the dominant position the Navajos had held in the early 1800s in the commercial weaving industry, and commercial Pueblo weaving had declined drastically.[24] The sheep industry also expanded at this time, in part due to the higher demand for weaving. Little is known about the organization of trade in weaving during this period of time or about those who served as mediators between weavers and consumers, though there were undoubtedly many who facilitated this connection.

The Annexation of New Mexico

In 1848, following the Mexican-American War, the United States acquired an immense area of the Southwest—nearly half the land of Mexico—in the Treaty of Guadalupe Hidalgo. This annexation included the territory of New Mexico. The transition between Mexican and U.S. rule was a gradual one due to conditions unique to New Mexico. First, unlike populations in Texas and California, in New Mexico, Hispanos outnumbered Anglos.[25] In 1850, 86 percent of the population was Hispano, 2 percent Anglo, and 12 percent Native American. In addition, Hispano settlements were widely dispersed and contact between them limited. Furthermore, Anglos were forced to rely upon Hispanos to deal with raids upon settlers by nomadic Indians. Later, Hispanos were important in the Union Army's efforts to control the Confederacy.[26]

Trade contact between New Mexican Hispanos and Anglos from the United States had been ongoing since the beginning of the Mexican period. Anglos' military success in New Mexico was in part aided by the merchant class of Hispanos who collaborated with the Americans.[27] The shift to an American social and economic system was not an abrupt one; it was spread out over decades as new technologies and the Anglo ethic of acquisitiveness gradually came to dominate frontier life.

Village Life after Annexation

Hispanic life after annexation was colored by Anglos' prejudices. In general, there was a disdain for the indigenous Mexican culture and racist atti-

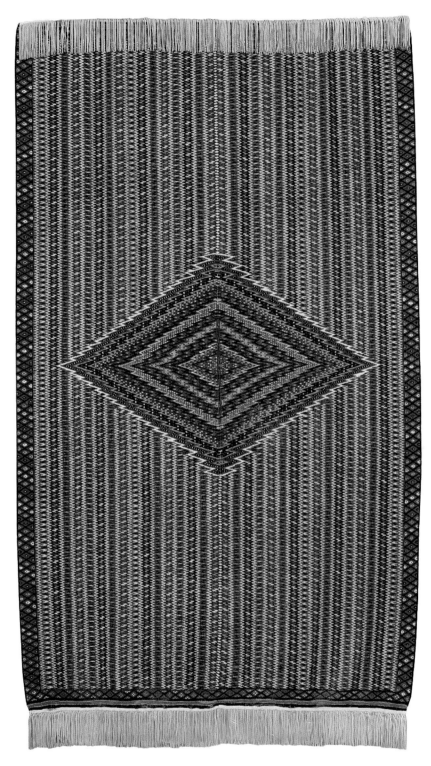

Plate 8 | *Saltillo* sarape, *ca. 1775. Albuquerque Museum, Albuquerque, New Mexico.*
1981.0085.0001. Photo by Damian Andrus.

tudes toward New Mexican "Mexicanos."[28] Such feelings were related to the "hispanophobia" experienced historically by the English and passed on to its colonies. In part, it was an anti-Catholic bias.[29]

Hispanic settlements of the period after annexation had been shaped during the colonial and Mexican periods. They were located along tributaries of the Río Grande. "By 1850 virtually every tributary stream within approximately a hundred-mile radius of the Santa Fe heartland that could support people and sheep had been settled. . . . The nomadic Indians . . . barred further settlement."[30] Villagers were a close-knit group, and Hispanic traders were even more autonomous than others. "Control over their own institutions and independence from outside interference were vital to people whose chief path to affluence was contraband trade with the Indians. . . . The Hispanic life outlook which emerged as a result of the risks and vicissitudes of frontier existence stressed personal responsibility, business initiative, and courage."[31]

In Cañones, a northern New Mexico village, "during the nineteenth century, the ways of survival were communal, involving a mixed village economy: irrigation farming, stock raising, hunting, gathering and trading were pursued cooperatively Everyone was a generalist rancher, farmer, trader, fighter, builder, blacksmith, and whatever else it was necessary to be changing as the needs of survival changed."[32] Within a given village there was little class distinction. However, the "least landed" people, the people most in debt, and those with "most recent Indian ancestry" could be identified as a lower status group.[33]

Relationships between Hispanos and nomadic Indians were smoothed by networks of trade relationships, including trade in contraband goods. Hispano-Indian trade in captives was a major enterprise. It reached its height between the 1830s and the 1860s. By midcentury such trade was "becoming somewhat more rampant and vicious."[34] The rising demand for blankets probably contrib-

uted greatly to the demand for more captive labor: boys became sheepherders; girls, wool-carders and spinners.

Changes in Hispanic Weaving
During the Late Classic Period

During the middle decades of the nineteenth century, the design configurations of Navajo and Spanish blankets underwent dramatic changes, influenced from 1830 on by the Saltillo sarape.[35] While the name Saltillo sarape gives the impression that this textile was made in the Mexican town of Saltillo, sarapes of this style were actually produced in a number of towns in northern and central Mexico, such as San Miguel de Allende, San Luis Potosí, and Aguascalientes.[36] The sarape was typically an exceedingly fine, intricately detailed weft-faced tapestry (plate 8), evidence of a labor-intensive weaving industry.

In Mexico the Saltillo sarape had value over and above its functional one. It suggested the prestige, wealth, and dignity of its wearer.[37] Woven with a slit in the center, it could be slipped over the head, poncho fashion; woven without a slit, it could be folded over the shoulder or wrapped around the body (plate 9). Due to intricate patterning, the most prized examples required an investment of hundreds of hours of weaving labor. For the wearer, its value as a form of "conspicuous consumption" cannot be overlooked.

During the Mexican period, the Saltillo sarape became emblematic of Mexican nationalism, aptly so, since its design format appears to represent a synthesis of three sources: the Spanish-Moorish designs brought to the New World; designs that came to the New World through Spanish trade with Asia, for example via the Manila Galleons; and pre-Columbian designs indigenous to the New World.[38]

New Mexican Hispanic weavers adopted elements of the Saltillo design system, but their version reflected the different social and cultural mi-

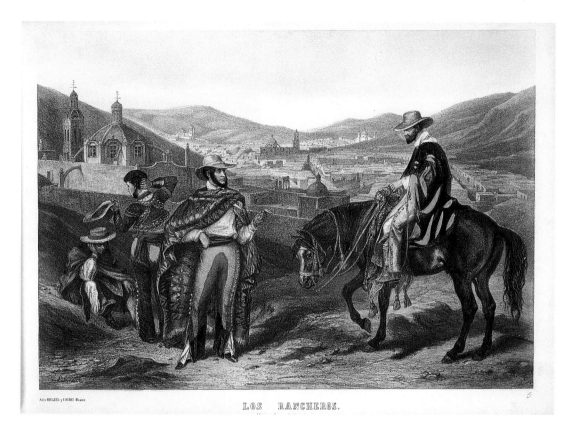

Plate 9 | Lithograph by Pierre Frederic Lehnert entitled Los Rancheros, *from* Album Pintoresco de la Republica Mexicana *(Plate 8), published by Julio Michaud y Thomas, Mexico City, Mexico, 1850. Bancroft Library, University of California, Berkeley, xff F1213 A43.*

lieu of weavers in New Mexico. The patterns were enlarged, less refined, and made for a less-affluent clientele. Some blankets merely included some Saltillo motifs in bands of striping (plate 10). It is likely that the more elaborate New Mexican sarapes with Saltillo-derived design elements were woven by a group of weavers with superior skills, perhaps professional weavers (plate 12). These weavers must have commanded a large pool of yarn producers, likely captives and other laborers, supplemented by family members.

The adaptation of the Saltillo design system is not unique to northern New Mexico Hispanos. The Navajo, during what is known as their classic period (1650 to 1865), produced the famed "Chief's Blankets" and Saltillo-influenced wearing blankets (plate 11). In northwestern Mexico, "the other Southwest," two Indian tribes, the Mayo and the Tarahumara, are known for wool blankets with isolated Saltillo elements and simplified designs (plate 13).[39] Today, these blankets are produced on treadle looms by male weavers and on staked-out ground looms with circular warps by female weavers.[40] The latter type of loom is more closely related to the Navajo's and Pueblo's vertical loom with fixed tension than to the Spanish treadle loom. Other nineteenth-century Saltillo-style sarapes were produced as far south as Guatemala, where examples from the town of Totonicapán can be cited (plate 14).[41]

In addition to new designs, new materials such as raveled *bayeta* were used by the Navajo, and very occasionally by Hispanic weavers, to supplement handspun yarn.[42] Limited quantities of Saxony three-ply, naturally dyed commercial yarns became available to the Spanish and Navajo weaver

Chimayó Weaving

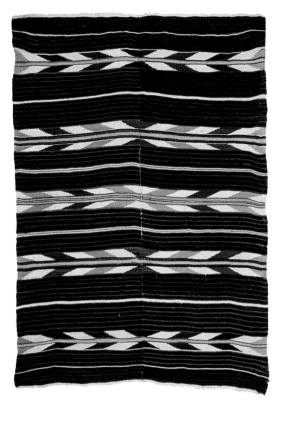

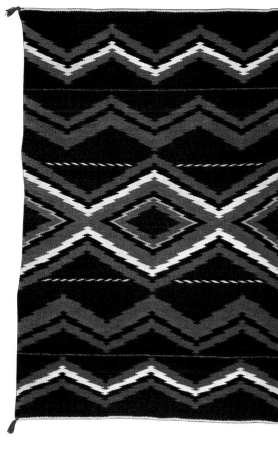

Plate 10 | Classic period Hispanic weaving showing Saltillo design elements arranged in bands, woven before 1860. Handspun wool warp and weft, 85 x 61 in. Millicent Rogers Museum of Northern New Mexico, Taos, New Mexico, 1956-1-26 (left).

Plate 11 | Navajo blanket with serrate diamonds showing Saltillo influence, ca. 1870–75. Handspun wool warp and weft, with some recarded American flannel, 73 x 49 in. William Randolph Hearst Collection, Natural History Museum of Los Angeles County, Los Angeles, California, A.5141.42-54 (right).

alike in the 1830s, as a result of trade over the Santa Fe Trail. These yarns were imported from England, France, and Germany, and they were later manufactured in the United States.

To underscore the climate of borrowing and adaptation during this period, it should also be noted that Hispanic weavers drew upon Navajo terraced designs. Motifs were characterized by stepped (right angled) edges. At times, Saltillo-style motifs were woven using this stepped or terraced edge.

The Expansion of Markets

Coupled with the demand for blankets on the Old Spanish and Santa Fe Trails, new markets for Hispanic weaving developed. In this new marketing

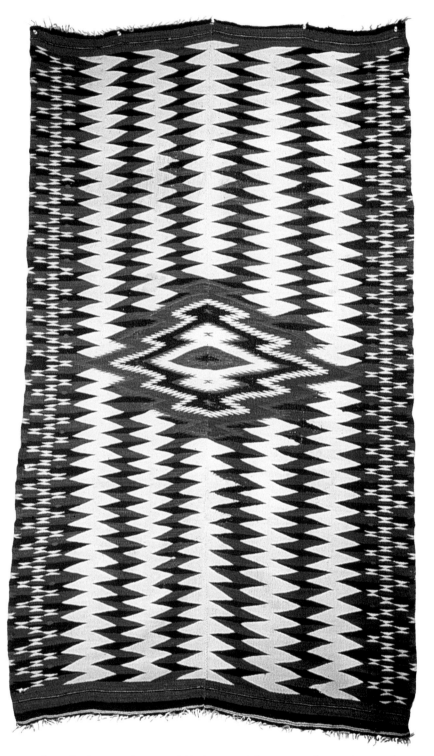

Plate 12 | *Classic period Río Grande blanket, woven before 1860. Handspun wool warp and weft; red yarn is commercial cochineal-dyed, 78 x 44 in. International Folk Art Foundation Collections at the Museum of International Folk Art, Santa Fe, New Mexico, FA.67.16.1.*

Chimayó Weaving

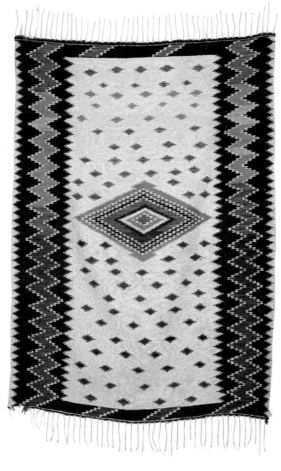

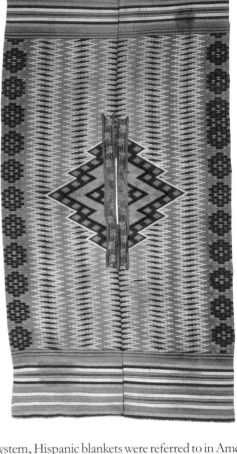

Plate 13 | *Mayo blanket showing Saltillo influence. International Folk Art Foundation Collections at the Museum of International Folk Art, Santa Fe, New Mexico, FA.1995.23-6 (left).*

Plate 14 | *Blanket showing Saltillo influence, collected by Gustavus A. Eisen in Totonicapán, Guatemala, 1902, 90 x 47 in. Phoebe Apperson Hearst Museum, University of California, Berkeley, California, 3-3 (right).*

system, Hispanic blankets were referred to in American documents of the time as "Mexican blankets," because the residents of northern New Mexico were then known as "Mexicanos," undistinguished from the Mexicans south of the border.[43]

One of the new markets for Mexican and Navajo blankets during the territorial period was as trade with the Plains Indians. Such trade stimulated what some consider the apogee of Navajo weaving. Fine chief blankets, so named because of the value placed upon them by Plains Indian chiefs, were prized and worn by male and female Plains Indians alike. Other Mexican and Indian blankets were traded at the sutlers' stores at army posts.[44] Later, Mexican blankets were distributed as part of the U.S. government's "policy of gratification"

in which Plains Indians were rewarded if they remained at peace. While this approach to maintaining peace with the Indian population had begun under Spanish rule, not until the Mexican period was it used extensively. By the late 1840s and the American takeover, the policy of gratification had become institutionalized. Contracts went out for bid, and agents for successful contractors scoured the countryside for blankets. Some of these contractors owned mercantile businesses in Santa Fe (Stabb, Spiegelberg) or in rural areas (Elfodt at San Juan Pueblo).[45]

By 1858 the U.S. government had established a more tightly organized annuity system to distribute goods to the Plains Indians. The Indian Service bought blankets outright. Records show that many Hispanic traders dealt in Navajo blankets. Several letters of the day describe the kinds of blankets being sold as plain and utilitarian.[46] Blankets issued by the government were so central to the annuity payment that a depiction of a blanket was used to symbolize the whole government issue. Figure 2.3 shows "Mexican blankets" as they appeared in Cloud Shield's Winter Count, 1858-59, illustrated in Mallery's 1886 article for the Bureau of American Ethnology. Mallery's drawings were derived from those made by an army officer who had copied Dakota Indian charts. These charts were first drawn by the Dakota in 1800 and conveyed, in pictures, "the orderly arrangement of divisions of time." The drawings illustrated tell of blankets bought by the Dakotas from John Richards "who bought many wagon-loads of the Mexicans." (The "Mexicans" in this instance refers to Mexican blankets).[47]

In the 1860s the U.S. government became determined to end the raids on Anglos and Hispanos by the nomadic Indians, in particular by the Navajo. In 1863 Col. Kit Carson led a massive retaliation by the U.S. Army against the Navajo. The wholesale slaughter of sheep was one tactic Carson used to subjugate the Navajo people. Once gathered to-

(a)

(b)

The Classic Period

Figure 2.3 | Depiction of blankets by Plains Indians: (a) blanket used as symbol of annuity payment; (b) blanket from Cloud Shield's Winter Count. After Mallery, 1893. Drawing by Frances Trice.

gether, the Navajo were marched during 1863-64 to the eastern New Mexico site known as the Bosque Redondo, near Fort Sumner, where they remained until 1868.[48] The Hispano servant-labor pool was significantly augmented during the time of this roundup by Navajos who sought refuge in Hispanic households to avoid the march to Bosque Redondo. To these Navajo, servitude was preferable to internment.[49]

At Bosque Redondo, Navajo weaving was encouraged. Soldiers would supply the women with three-ply Germantown yarn for weaving.[50] In all likelihood, it was during this time that Navajo weavers were exposed to the Saltillo design system from Mexico. Efforts to steer the nomadic Navajo toward a sedentary agricultural life met with failure. However, after their return to the reservation area, the defeated Navajos largely refrained from raids on Anglos and Hispanos.

During the Navajo internment at Bosque Redondo, the U.S. Army ordered many blankets for the Navajo from Hispanic sources, probably num-

Figure 2.4 | Navajo Indians at Fort Sumner, New Mexico, Bosque Redondo era, ca. 1864–68. Museum of New Mexico, negative no. 89194.

bering in the thousands.[51] Figure 2.4 shows Indians at the Bosque in plain white blankets or blankets with simple striping, likely government-issue Hispanic blankets.

The increase in trade between 1848 and the 1880s resulted in a time of newfound prosperity for Hispanos.[52] Though the United States had taken political control of New Mexico, Hispanic culture thrived as Hispanos in remote villages were left virtually on their own. Hispanos continued to overwhelmingly outnumber their Anglo conquerors. It was during this period that Hispano and Anglo expansion into southern Colorado began.

The Organization of the Craft of Weaving in the Classic Period

Judging from the volume of weaving traded between 1848 and 1880, the Hispanic weaving system was well organized. It is likely that weavers pursued their craft seasonally, in family units, in remote sites, and that there was a class of merchant-traders whose job it was to round up the products and convey them to more central locations. The following account suggests how the Hispanic weaving industry at mid-nineteenth century might have appeared.

The few articles that are made are of coarse texture, and are manufactured in families. The leading fabric is a coarse woolen blanket called *serape,* which is made to some extent for domestic use and sale. . . . It forms an important article of clothing among the peasantry, and many of the better classes use it instead of cloaks and overcoats. A few of a finer texture, in imitation of the *serape saltillero,* are also manufactured, some of which sell for forty and fifty dollars each. They are woven in bright and handsome colors, and are quite beautiful.[53]

In a more romantic vein, "The custom of working together was the thing that made them enjoy their work. In the evenings, servants of the haci-

enda gathered in a big hall where the overseer supervised all their work. . . . There was carding of wool and weaving of blankets, the making of material for clothing. This wool was from the flocks of the *patron*."[54]

Women processed wool and men wove *sarapes, sabanillas,* and *tápalos* "usually for those who could afford to pay. . . . Women wove for the use of their own families."[55]

Other Changes Related to Annexation

New technology was introduced by the Americans, and it had a profound impact in several areas. First, with the introduction of milled lumber brought over the Santa Fe Trail and the establishment of sawmills in New Mexico in the 1850s to 1860s, looms could be made with smaller frames, making them more suitable for women.[56]

Metal weaving equipment, imported over the Santa Fe Trail, included metal reeds for looms. Metal reeds were more stable, finer, and wider than the hand-carved wooden reeds they replaced. As a result, wider woven goods could be more easily produced. Other changes, in dyes and yarns, had such a dramatic impact upon the craft that they signal the onset of the transitional period.

The broad features of the craft of Hispanic weaving unique to northern New Mexico were established during the classic period. Trade continued to be the cornerstone of the craft: from trade caravans to local fairs where Indians, Anglos, and Hispanos gathered to exchange goods. This trading tradition was a legacy of European influence and of indigenous populations of the New World who had well-established trade routes when the Spaniards arrived. The production of woven goods became family-based, rather than guild-based as in Europe. And while early Hispanic settlers brought to the region materials and technology that were closely related to the European horizontal loom, they remained open to innovation based on patterns of interaction with local native populations, with developments in central New Spain, and with technology of Anglo origin.

3
The Transitional Period
1870–1920

The transition from the relative self-sufficiency of nineteenth-century Hispanic village life to one marked by dependence on the more complex cash economy of the United States characterizes this period. The discussion that follows outlines the impact of change on the craft of weaving both early and late in the transitional period. During the early transitional period, new material goods poured into the area and needs for these goods became established. Weaving declined as new, imported goods replaced handwoven ones. In the late transitional period, new ways to access cash were institutionalized through trade relationships. Trade in weaving was one excellent example of this new form of trade. Changes introduced in the transitional period affected the expansion of businesses throughout the modern period that followed.

The Early Transitional Period
(1870–1900)

Weavings produced in this era share many characteristics with those from the classic period. At first glance, they may be indistinguishable. Most are still woven of handspun yarn; warp and weft counts are the same; design layouts in bands and tapestry patterns continue. However, small quantities of commercially prepared yarns and chemically manufactured dyes become increasingly evident during the early transitional period.

In 1856 the first chemical substitute for natural dye was synthesized in England. By the 1870s the results of this new chemical dye technology were apparent in the Southwest, and by 1880 synthetic dyes were in common use by Southwest weavers. Navajo weavers had access to Diamond Dyes sold by Wells and Richardson of Burlington, Vermont. These dyes combined dyestuff and mordant in one package.[1] Such dyestuffs were no doubt welcomed by production dyers accustomed to many hours of gathering vegetal dyestuffs, preparing mordants, and brewing dyebaths.

Imported commercial yarns, too, were available to Hispanic and Navajo weavers; Germantown yarns from Germantown, Pennsylvania, were brought into the Southwest. These aniline-dyed yarns gradually replaced the earlier Saxony (natural-dyed) commercial yarns. In the 1880s cotton "string" warp also came to be adopted by Hispanic and Navajo artisans. The cotton warp was very strong and smooth and slightly lustrous. Initially, these new products did not replace handspun yarns but augmented available materials.

The new yarn products led to dazzling Hispanic blankets later in the century, typified by the

"Vallero" blankets, which originated in the mountainous valleys south of Taos, particularly in the communities of Las Trampas and El Valle (plate 15). Trampas/Vallero blankets were distinctive, featuring an eight-pointed star or stars. Some trace the inspiration for this new design to patchwork quilt patterns, although the use of this motif can be found on Mexican textiles as well as many other textiles worldwide.[2] The new yarns and dyes also stimulated the famed eyedazzlers of the Navajo. Navajo eyedazzlers show the design influence of the Saltillo sarape, probably transmitted to the Navajo both directly and via the Hispano blankets derived from the Saltillo system.

However, design influence went in both directions. Wheat suggests that Navajo influence on Hispano designs during this period was evident in "triangular fillers in the corners" of sarapes and in terraced figures (plate 16). Kent concurs: "Because the same new commercial aniline dyes and Germantown yarns were available to all three peoples [Pueblo, Navajo, and Hispano], many of their blankets continued to be very similar in appearance until the end of the century."[3]

Home weaving declined when prices of domestic goods dropped. Items such as commercially manufactured fabrics became more accessible to rural families. The need for women to weave yard goods for family needs decreased. An acceptable cotton twill fabric for *colcha* embroidery became available, as did various types of fabric for clothing. Women, who had assisted with yarn preparation or weaving in family weaving enterprises, had more free time with the availability of these new fabrics.

In addition, commercially manufactured blankets with acceptable tactile and wearing qualities competed with home-produced blankets to satisfy the blanket needs of the Native American and Hispano. By the 1880s companies such as Pendleton in Oregon were producing commercial blankets with designs that would have special appeal to the Native American market.[4] Although the Navajo weavers did not produce handwoven clothing for their own consumption, they did continue to weave trade goods.

Another consequence of new products entering the area was the emergence of the rag rug from Hispano looms in the latter part of the nineteenth century. Hispanic rag rugs were woven in simple striped patterns. Occasionally, rags were combined with yarns in blankets.[5] Rag rugs are typically made from torn strips of commercially woven cloth, most often clothing that has been recycled. Their manufacture is predicated on the availability of suitable cloth, the presence of which increased in rural northern New Mexico after the railroad was completed in 1880. The method of cutting strips to be used as wefts may have been an idea borrowed from Anglo settlers since rag rugs were being woven throughout the United States at this time. However, Hispanic preparation of rags was atypical in one respect: they were twisted on a spindle, in the same way yarn is spun, producing a firmer rug with a smoother surface.[6]

Village Life

Significant changes occurred in the transitional period. The completion of railroad connections had far-reaching consequences for Hispanic life in New Mexico. The development of certain Anglo industries—lumber, mining, agriculture, and livestock—burgeoned once rail links were in place. Changes in systems of government, from municipal systems to a county commission system, also had an impact on Hispanic life. Justice of the peace courts were replaced by district courts, which enforced laws unfamiliar to Hispanos. Hispanos were also exposed to Anglo racist attitudes. The word "Mexican" became a pejorative term, and Hispanos began to stress the Spanish (European) rather than Indian, Mexican, or Mestizo parts of their heritage; a "new ethnic consciousness began to be formed".[7]

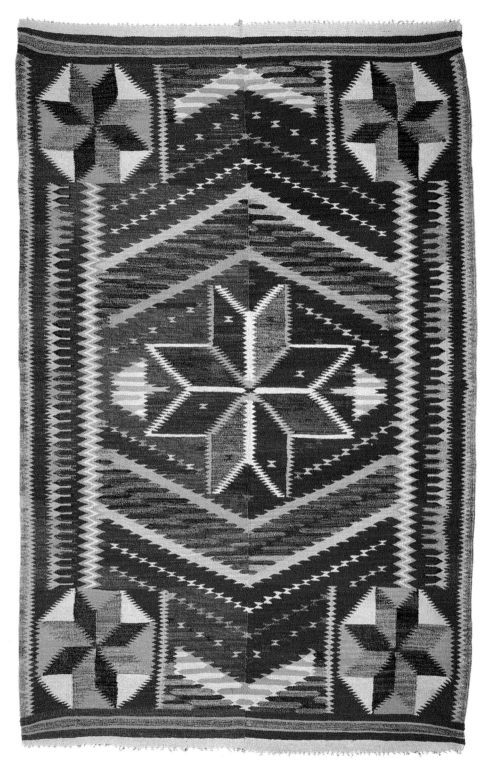

Plate 15 | Vallero-style blanket, ca. 1890, handspun wool weft, cotton warp, synthetic dyes.
Courtesy of Andrew Nagen, Los Colores, Corrales, New Mexico.

Chimayó Weaving

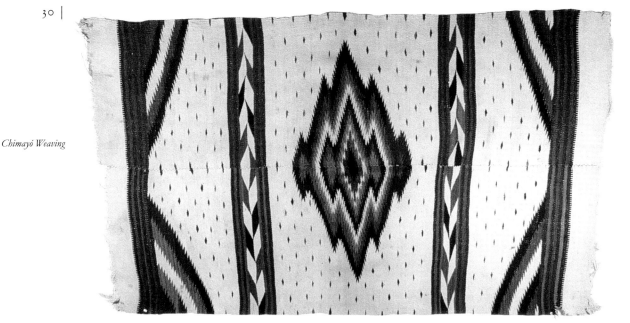

Plate 16 | Río Grande blanket with Navajo-style serrated corners, ca. 1850. Department of Library Services, American Museum of Natural History, catalog number 50.2/6769, neg./trans no. K 14488.

Hispanos were ill-equipped to deal with these new institutions and attitudes, and as a consequence, Hispanic land was lost through "litigation and fraud, government seizure and tax delinquencies."[8] Many "shady land deals" were forged during the late nineteenth and early twentieth centuries. The federal government seized grazing lands through legal and illegal means, capitalizing on the fact that colonial communal land grants did not clearly define boundaries. Although original Spanish grants were protected under the 1848 Treaty of Guadalupe Hidalgo, few of the ancient records were well preserved. In 1854 "Congress provided for a surveyor general to pass on the validity of the land titles in question, and Congress made the final disposition." However, "by 1886, of the original 205 land claims filed, 13 were rejected, 141 were approved, and the remaining 51 had not been acted upon. In 1891 Congress established a 'Court of Private Land Claims' in an effort to remove the complex issue from the political arena.

By the time the court completed its work in 1904, it had heard suits concerning 35,491,020 acres. Claims confirmed by decrees of the court involved only 2,051,526 acres. Claims rejected involved 33,439,493 acres."[9] Court costs posed additional barriers to those pursuing land claims, and even successful claimants lost land because lawyers were paid in the form of a percentage of land. In frustration, villagers increasingly withdrew from interaction with the Anglo establishment in an attempt to preserve local values.[10]

At the same time, attractive goods from the United States drew Hispanos closer to Anglo culture. On a selective basis, Hispanics adopted conveniences like stoves and sewing machines. The desire for goods led to the need for more cash to purchase them, and the barter system lost ground to a cash-based economy. Hispanic life in the nineteenth century changed from a subsistence economy to a market-driven one. During spring, summer, and fall, men would leave home to work

in the mines or fields of Colorado or to tend sheep in many of the western states; migratory labor became a survival strategy as workers sent money back to their villages to sustain life at home.[11]

Weaving declined as a lucrative trade. The Emancipation Proclamation, which freed slaves in 1863, and the outlawing of peonage in 1867 had an effect upon the availability of servant labor for craft production in Hispanic homes.[12] More important, Hispanic handwovens were being replaced by commercially woven goods. However, it is unlikely that weaving totally died out, although marketing of the product on a large scale certainly declined drastically. Some home production and trade at the local level undoubtedly continued. Weaving was an entrenched part of the yearly agricultural cycle. It was what villagers did in the winter months between fall harvest and spring planting.

Sheep and Land

In the Anglo world in New Mexico during the last decades of the nineteenth century, a few sheep growers were amassing fortunes. Increasingly, sheep were being raised for meat rather than wool. Sheep raising was the "dominant activity" and the "foundation of the social class system."[13] There were two classes of people: the sheep owners (one-fifth) and the sheep tenders (four-fifths).[14] Many owners lived in the Río Abajo, but the best grazing land was in the Río Arriba. "Possession of a quarter to half million head was not uncommon."[15] There were Hispanic sheep growers, but they faded in prominence as Anglos secured increasingly larger tracts of land and gained control of the industry.

Sheepherding was organized on the *partido* system, whereby an agreed upon number of sheep (usually two hundred to twenty-five hundred) were turned over to a sheep herder, a *partidario*, who assumed full responsibility for the herd. In a typical working arrangement, at the end of the year the owner was entitled to his original number of sheep

Figure 3.1 | Churro sheep at Utah State University. Photo by Lyle McNeal, 1985.

plus a percentage of the offspring. If a loss occurred, for example, through disease or Indian raid, it was the herder's loss. Under such an arrangement, there was always the possibility the herder could turn a handsome profit, but more typically he broke even. The less-fortunate herders incurred insurmountable debts.

Efforts were made by Anglo sheep men to "upgrade" the indigenous sheep, known as churro, or Navajoso (fig. 3.1). The churro sheep of the nineteenth century was descended from those introduced by the Spanish into the New World. Over the centuries, the hardy churro sheep had adapted well to the semiarid regions of the Southwest; it was a real survivor. While it did not produce a heavy fleece, the wool, being long, straight, and relatively nongreasy, was easy to process by hand.[16] A silky yet durable yarn could be made from its fibers; the yarn was very well suited for the blankets of the Navajos and Hispanos.

For the Anglo sheep and wool market, the churro was clearly an inferior breed. Not only was its wool yield skimpy, but the long, straight, coarse fibers were not suitable for wool processing equipment in eastern woolen mills nor for the end products to which the processed wool was intended. In addition, the churro's meat yield was inadequate in comparison to other breeds. Therefore, one of the

French Merino strains of sheep, the Rambouillet, was brought into the region. This breed was capable of producing a more desirable type of meat and wool.

Yet when the new breed was used in traditional ways by the Hispanic and Navajo weavers, the results were less than satisfactory. The greasy Rambouillet wool was difficult for local weavers to clean. The excess grease attracted and retained large amounts of dirt, evidenced in many blankets of the era. Further, the Rambouillet wool was very kinky, making hand-carding extremely difficult and giving a matted appearance to the fabric when the yarn was loosely spun in the Hispanic-Navajo style.

The sheep market at the close of the nineteenth century was plagued with difficulties. In 1891–92 there was a drought, and many animals were lost. Then the price of wool dropped precipitously following the financial panic of 1893. At the turn of the century the sheep market changed. More emphasis was placed on lamb production than on wool.[17] Then in 1908 the Río Grande National Forest was created, placing further restrictions on grazing land.

The Emergence of Tourism

At the time when production of "Mexican blankets" was declining, changes were taking place in external markets. A new clientele was appearing in the Southwest, thanks to the growth of rail connections. The newcomers were travelers and adventurers, and they were succeeded by tourists.

The Tertio-Millennial Exposition, held in Santa Fe in the summer of 1883, was of major importance in establishing the tourist trade. This exposition was a six-week tricultural extravaganza celebrating the 333d anniversary of Europeans on New Mexican soil. "Thousands of tourists visited Santa Fe at this time and the substantial beginnings of the interest of travelers in Santa Fe and its many attractions date from this period."[18]

The Southwest became a haven during the Victorian era for people who sought contact with the exotic, primarily the American Indian. The new Santa Fe Railroad expended much effort generating interest in the Native American as described in their advertising promotions.[19] New tourist enterprises were stimulated. Native American artifacts became part of Victorian-era home decorating, arranged alongside exotica from all over the globe. Artifacts were incorporated into "curio corners" for home display.[20]

However, social limitations were imposed upon use of these items in home interiors. "A great deal of the Interior Decoration school of the period was a rigidly prescribed balance of social showmanship, cultural exhibitionism and esthetic propriety, and if a given object did not fit into that balance, it was not desired."[21] This was not a passive audience. The aesthetic of the time demanded that Anglo consumers play a role in dictating their wants. The years between 1880 and 1920 saw the burgeoning of Navajo and, later, Hispanic textiles as curio items for the tourist trade. But the paths taken by these developing crafts were quite distinct.

Reservation Trading Posts
and the Navajo Weaver

On the Navajo reservation, post traders relied on new transcontinental railroad systems to link Navajo woven goods and their new consumers: tourists and other curio collectors. The federal government issued licenses to traders and encouraged their development as an Anglo presence on the reservation. "By 1889 nineteen posts licensed by the Bureau of Indian Affairs were widely scattered over the reservation, with some thirty others established just outside the reservation boundaries."[22]

Indians from remote areas brought items for trade to the trading post: wool, blankets, animal skins. The trader exchanged these goods for others, such as "metal tools, flour, coffee, commercial

cloth and clothing, yarns, and chemical dyes." Often the granting of credit was involved. Traders "learned the Navajo's language and understood their cultural values. They served the people in many capacities—as friends, doctors, bankers, judges in disputes, and spokesmen before Anglo officials and courts."[23] Traders also assisted the Navajo in other matters, such as writing letters and helping with the burial of their dead.[24]

Navajo traders influenced the size, proportion, weight, and design of the Navajo blanket.[25] They facilitated the shift from blanket to rug, creating a product more complementary to Anglo needs.[26] In one abortive development, traders purchased blankets known as "pound blankets" by weight. The greasy wool used in these blankets attracted dirt, and sometimes weavers added dirt and grit to increase the blanket weight. The blankets were loosely woven and heavy, made of large-diameter handspun yarn. When dyed, the greasy wool used in the yarn led to uneven dyeing. During the period 1880 to 1910, eyedazzler blankets and pound blankets were the most abundant items produced on Navajo looms.[27] Eyedazzlers were made with handspun and Germantown aniline-dyed yarns (plate 17). These weavings were disparaged as "garish" until the 1970s when connoisseurs placed value on their strong, vibrant color juxtapositions.

Traders tried to mold weavers' products to Anglo tastes using new marketing strategies. J. L. Hubbell was one of the earliest such traders. His father was an Anglo from the eastern United States; his mother, an Hispanic woman from a prominent Santa Fe family.[28] Hubbell went to Ganado, Arizona, and established a trading post in 1879. There he attempted to standardize designs based on earlier classic period blankets with less intense color schemes. He "favored a color combination of red with natural black, white or grey yarns."[29] Another entrepreneur, C. N. Cotton, entered into a business relationship with Hubbell in 1884. In 1894 Cotton set up a wholesale Navajo

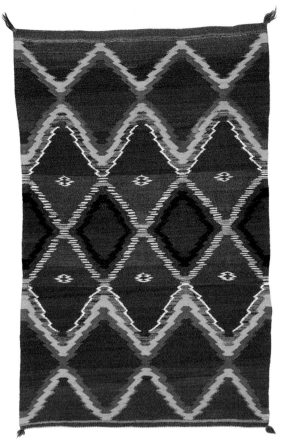

The Transitional Period

Plate 17 | Navajo eyedazzler blanket. Handspun wool warp, commercial weft with small amount of handspun weft, 82 x 54 in. William Randolph Hearst Collection, Natural History Museum of Los Angeles County, Los Angeles, California, A.5141.42.103.

weaving business in Gallup, New Mexico, and in 1897 he published a mimeographed catalog of his products.[30]

Hubbell was not the only trader to take an active role in defining the appearance of Navajo weaving. At Crystal, New Mexico, J. B. Moore "introduced his weavers to design layouts and motifs from . . . oriental rugs, adding such 'Indian' elements as arrows. Swastikas figured prominently on Moore's rugs, as they do on Navajo rugs woven on other parts of the reservation in the early 1900s."[31]

Later, traders discouraged Germantown yarn and cotton twine and encouraged the use of hand-

spun; in addition, they "outlawed certain garish colors."[32] "Dealers turned against the use of Germantown yarn and cotton warp at the beginning of the rug period [1895], in part because it prevented them from advertising their wares as genuinely handmade. The preference for handspun was also part of an effort to restore some economic value to native wool. The dealers' campaign was successful, and by 1900, most weavers had returned to the use of handspun yarns."[33]

In 1893 working in cooperation with the trading posts, two New Yorkers formed the Hyde Exploring Expedition. By 1896 they were supplying their own shops in Boston, New York, and Philadelphia with Indian goods. In an effort to upgrade quality, they, too, opposed aniline dyes and cotton warp. The shops declined after 1910 but they had served to promote an awareness of Navajo woven work.

Santa Fe Merchants and Hispanic Weavers

Less well understood have been the agents that played a role analogous to the post traders among the Hispanos of northern New Mexico, mediating between weavers and Anglo consumers. The mediators for Hispanic weavers were merchants in and around the city of Santa Fe. As in many remote areas of the West during this era, most of these merchants were of German-Jewish backgrounds. The best-known New Mexican merchant families were the Ambergs, the Ellsbergs, the Ilfelds, the Seligmans, the Spiegelbergs, and the Stabbs. Typically, the heads of these families were immigrants who eagerly seized new opportunities using time-honored skills in trade.

In a typical scenario, a man would begin peddling goods on pack animals through remote, rural areas. When he had accumulated enough capital, he would settle in a small town and open a mercantile store. Often younger or more recently immigrated relatives would serve as apprentices, then venture out on their own. Over and above their commercial ventures, these merchants often played important roles in their communities, such as serving in public office. They displayed a "social conscience buttressed with economic effectiveness."[34]

Ties to the eastern United States also afforded these merchants links to wholesalers and purchasing agents. Their access to sources of credit was unparalleled in the rest of the Anglo business world.[35] The merchants knew how to secure almost any kind of goods and could be responsive to the needs of local people. And when tourists and curio collectors became part of their clientele, they were able to meet their needs as well.

Little has been published on the Santa Fe merchants and curio dealers and even less on their effect on regional craft development. The following section provides a detailed description of two seminal dealers of the late nineteenth and early twentieth centuries.

Jake Gold

Undoubtedly many Santa Fe merchants were responsive to the new clientele, adding to their stock a few local Indian artifacts. However, one entrepreneur emerged as a "specialist" in the curio line. His name was Jake Gold. Judging from his portrait, Gold was a colorful Santa Fe character (fig. 3.2).

The Gold family's store was founded in 1862 by Jake Gold's father, Louis (or in Spanish, Luis). Since the store does not figure in the usual accounts of early Santa Fe merchandising businesses, it may have been one of a number of less-illustrious establishments in Santa Fe.[36]

One source states that in the 1870s Jake Gold was buying Indian pottery at the Pueblos. Notable figures, such as the archaeologist Adolph Bandelier, were among his customers in the 1880s. Referring to an encounter with Gold at Cochiti Pueblo in 1882, Bandelier wrote, "Jac. Gold bought pottery, old things, Victoriano's shield, and rubbish in general." But Bandelier also remarked about

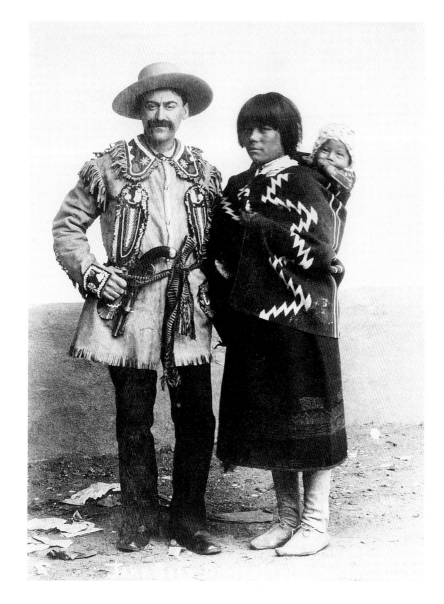

Figure 3.2 | Jake Gold with Native American woman. History Library, Palace of the Governors, Santa Fe, negative no. 9894.

Gold's "fine pottery collection" and his "magnificent collection of Indian goods."[37]

Soon after 1880, the year his father died, Jake Gold, then in his late twenties, opened Gold's Free Museum and Old Curiosity Shop in the old family store on San Francisco Street in Santa Fe (figs. 3.3 and 3.4). Twitchell notes that Jake Gold, whom he refers to as "the first dealer in curios," established his business about the time of the Tertio-Millennial Exposition of 1883.[38]

During the late 1880s Jake Gold appeared in the *Register of Licenses — 1885–1917* as a "Retail Dealer in Merchandise." His brother, Abe, was also listed as both a retail dealer in merchandise and a retail liquor dealer.[39] In 1889 Jake Gold published a catalogue of goods entitled "Gold's Free Museum–Old Curiosity Shop" (figs. 3.5 and 3.6). A wide variety of "wholesale and retail goods" was offered, including pottery, bridles and horse equipment, precious stones, mounted tarantulas and lizards, buffalo

Chimayó Weaving

Figure 3.3 | *Exterior of Gold's Store. History Library, Palace of the Governors, Santa Fe, negative no. 132690.*

Figure 3.4 | *Jake Gold in his Old Curio Store located at San Francisco Street and Burro Alley, ca. 1900. Lower left corner shows several Hispanic weavings. History Library, Palace of the Governors, Santa Fe, negative no. 10729.*

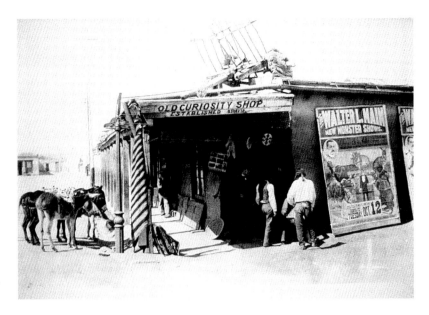

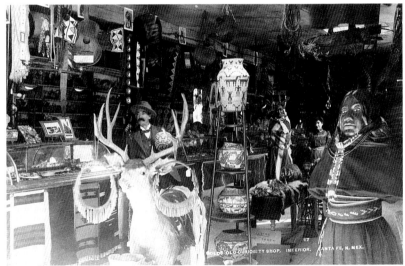

skins, figurines, moccasins, and archaeological relics. A customer could purchase complete collections ranging in price from one dollar to fifty dollars. The higher-priced collections included "Mexican blankets," as blankets from northern New Mexico were referred to in those days. A "fancy" Mexican blanket was in the fifty-dollar price range. Hispanic weavings are pictured in the lower-left corner of figure 3.4 in Gold's store.

The most widely advertised goods in the catalog were woven ones, particularly Navajo blankets, but also "Chihuahua blankets" and "Mexican blankets." Navajo rugs or robes were also mentioned, as were portiers (panels used as door coverings or curtains). Perhaps Gold encouraged the craft of Hispanic weaving north of Santa Fe to provide himself with a source of woven items closer to home. It is clear in the pages of the 1889 catalog that Gold offered goods for Anglo markets—blankets, rugs, portiers, figurines for the home, as well as collectible items such as relics and biological specimens.

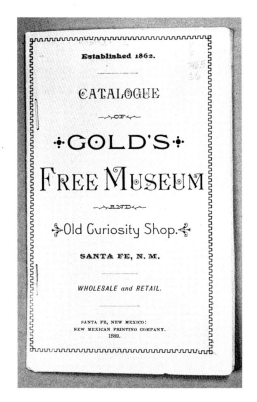
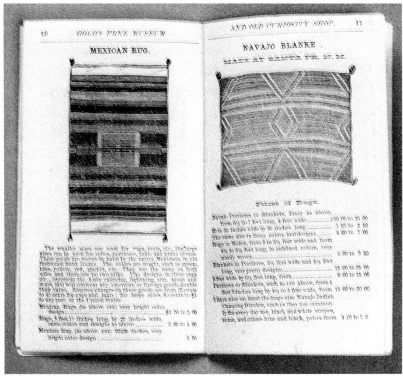

Figure 3.5 | Cover of Gold's Catalog, 1889. University of New Mexico, Zimmerman Library, F796.5 G6 (left).

Figure 3.6 | Drawing of Mexican blanket in Gold's Catalog, 1889. University of New Mexico, Zimmerman Library, F796.5 G6 (right).

Also included in Gold's catalog were glowing descriptions of New Mexico, the Pueblo Indians, and the Spaniards. "Americans—always comparatively ignorant of their own great nation—travel the earth over in search of novelties less marvelous than abound in New Mexico. Here in the oldest corner of the most civilized of nations, witches are still common and active, and the fanatic penitentes still scourge their bare backs with cactus whips and crucify one of their number on Good Friday of every year."[40]

His comments about Hispanic residents anticipate the romantic visions of the later arts revival texts of the 1920s. He wrote, "No less interesting historically and quaint socially, is the dominant Spanish civilization of the Territory. . . . The wars and the romances, the heroic achievements, the quaint life and customs surrounding the native population of New Mexico are full of charm for all." Revealed also in this catalog are hints of Gold's many networks in rural New Mexico. Speaking of himself in the third person, he wrote: "His

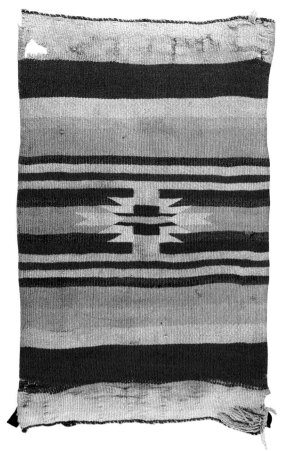

Chimayó Weaving

Plate 18 | *Early* congita, *stripes and central diamond,*
30 x 19 in., late 19th century. Southwest Museum, Los Angeles,
California, 609.G. 637.

collectors are all the time gathering curios from the remotest parts of the Territory where the stranger could not penetrate."[41] It is likely that Gold's collectors were some of the Hispanic-surnamed peddlers who roamed rural New Mexico with one or two pack animals. That there were many such peddlers is evident in the listing of licenses given to peddlers.[42] Three names are particularly prominent over the years of the register (1885–1917): Pedro Muñiz, Juan Olivas, and Julian Padilla.

These Hispanic itinerant merchants were undoubtedly heirs to the networks set up in the mid-nineteenth century to funnel blankets to the Plains Indians and the U.S. Army. It is conceivable that they were a conduit for wool or yarn in one direction, blankets in the other. They may have supplied weavers in the "putting-out system" probably instituted earlier in the nineteenth century.

It is significant that the names of the three Hispanic itinerant merchants, Muñiz, Olivas, and Padilla, also appear in the Fred Harvey Company Blanket Books, 1907–14 (see fig. 4.12). These books list blankets purchased by the Harvey Company, from whom they were acquired, the prices paid for the blankets, and the prices for which they sold. Apparently the itinerant peddlers would exchange goods for blankets and other curios and then sell these blankets to curio dealers such as Gold and Harvey. Gold, too, sold blankets to the Harvey Company, as did his brother, Abe.[43] There were many dealers in "old Chimayo blankets"; probably the bulk of these blankets are now known as "Río Grande blankets." Bert Phillips, a well-known Taos artist of the day, appeared both in the Fred Harvey Blanket Book and in correspondence with a later curio dealer, Jesus Candelario; Phillips offered to trade three of his "old Chimayós" for one of Candelario's.

Rural Hispanic families seriously underestimated the monetary value of their old blankets and succumbed to the appeal of cash offered for them. The unfortunate aspect of this wholesale collecting was that the best prototypes disappeared from the corpus of Hispanic work. Since weaving is traditionally learned by studying previously woven examples and sometimes counting the threads to duplicate or elaborate upon earlier designs, the loss of the early pieces was significant.

In the Harvey Company Blanket Books dating from the first decade of the century, one sees the use of the terms "Chimayo," "Chimallo," and "Old Chimayo" blankets and references to "Chimayo scarves." These scarves, which continue to be made today, are sometimes known as *congas* or, in the case of smaller versions, *congitas* (plate 18). According to one source, in the earlier part of the nineteenth century the word *conga* was used inter-

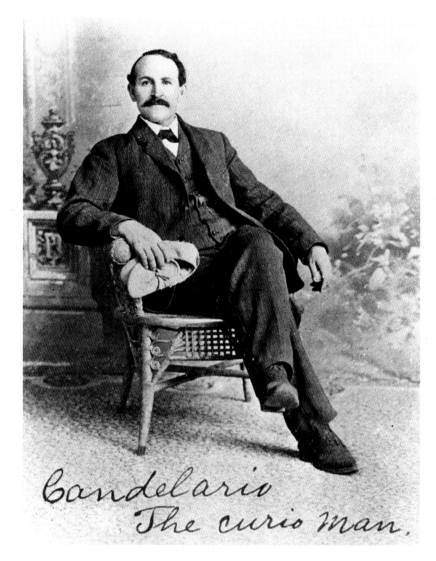

Figure 3.7 | Photograph of
J. S. Candelario, early 1900s.
J. S. Candelario Collection,
History Library, Palace of
the Governors, Santa Fe,
negative no. 132690.

The Transitional Period

changeably with the word *tilma* to refer to a short sarape.[44] Another source defines *frezadas congas* as multicolored saddle blankets.[45] For weavers who had been accustomed to making blanket-size pieces, anything smaller may have been termed a conga. Today the term refers to a table mat, such as a dresser scarf, placemat, or table runner.

Reference to Chimayó blankets and scarves in the Harvey Blanket Books may be the first written documentation of the use of the term *Chimayó* to designate Hispanic weaving.[46] However, Jake Gold is credited with adopting the term: "It is said that the trade name 'Chimayo' for all blankets of this region was given the native *serape* only fifty years ago by the forerunner of all curio dealers, Jake Gold. He first used the term in the same joking way the natives used it—'Chimayoso' meaning a country hick to the citified Santa Feans."[47]

Gold and Candelario

In the 1880s Gold's path intertwined with that of another merchant, Jesús "Sito" Candelario, born in 1864 to yet another Santa Fe merchant family, this time of Hispanic descent (fig. 3.7). In 1885 Candelario converted to the Protestant faith and

changed the spelling of his name from Candelaria to Candelario.[48] He then purportedly left Santa Fe to attend Park College in Missouri. Jake Gold was recruited to run Candelario's portion of the Candelario family business. It appears as if Jake Gold left the original Gold family store and hung a new sign on Candelario's: "The Original Q'Rosity *[sic]* Shop, Jake Gold, Manager," 301–303 San Francisco Street, Santa Fe. In July 1891 Candelario filed application for a pawnbroker's license, which indicates he had probably returned to Santa Fe.[49] In 1892 Candelario married Estefanita Laumbach, "a native born New Mexican of German extraction."[50] Throughout the years his wife worked at his side at the family business. Further evidence of Candelario's presence in Santa Fe in the 1890s was his tenure on the Santa Fe City Council between 1899 and 1900.[51]

In the late 1890s Jake Gold began to manifest symptoms of the disease that was to take his life in 1905—general paresis, or dementia paralytica. This condition is associated with the later stages of syphilis when progressive brain damage leads to personality disorders. Five years before his death, Gold was arrested on adultery charges and sentenced to serve time in the state penitentiary.[52] Candelario wrote letters to various politicians between 1900 and 1902 attempting to arrange Gold's release. He was eventually successful in securing Gold's release in 1902.[53] Letters refer to the problems that Gold's clients were experiencing, such as delays in meeting orders: "we used to do a good business with Gold until his stock run down."[54] Gold's obituary stated that he conducted business very successfully until about five years before his death in 1905: "His mental faculties then failing the business was sold."[55]

Candelario's records reveal credit slips bearing Gold's name in the first year of the century, indicating he was still carrying on some trade "among indian clife dwelars *[sic]*" (Pueblo Indians). Ledger books of 1903 indicate he was bringing goods in from the Indian reservations and Hispanic villages: "chimayos" (blankets and congas), shields, santos, war clubs, pottery, arrows. A letter to Candelario from Jake Gold, dated December 11, 1903, stated that Gold was broke and wondered if any of his debts had been collected. In September 1903 both Gold and Candelario sold old Chimayó blankets to Homer E. Sargent, blankets that were presented to the Field Museum, Chicago, in 1917.[56]

In June 1903 Candelario printed the following handbill:

To my Friends and Customers.

Mr. Jake Gold who for several years past has managed my Curio Store on San Francisco St., otherwise known as the "Original Jake Gold Curio Store," will sever his connection therewith next Saturday. The business will be continued under the name of the Old Curio Store, and the undersigned will wait upon his customers as usual with a full line of Indian and Mexican curios of every description.

Call and examine this wonderful and varied stock of curios in which I defy competition in quality and prices.

Yours very truly,
J. S. Candelario
301–303 San Francisco Street
Santa Fe, N.M., June 20, 1903[57]

This apparently marked the end of the long-standing business relationship between Gold and Candelario. The final report of Gold is his 1905 obituary, which stated that he died of "progressive paresis" at the age of fifty-four and was buried at the Territorial Insane Asylum at Las Vegas, New Mexico.[58]

Gold made many contributions to the development of the curio field. Surely he tapped into a network of artisans on his many trips to rural areas and in his contacts with itinerant peddlers. He also "tuned into" the sensitivities and desires of the

burgeoning tourist-collector market. During Gold's tenure as "original curio dealer," certain Hispanic woven forms, for example the conga, or small sarape, were transformed into the furniture scarf and pillow top. In all likelihood, Gold was the person responsible for the development of the simplified, tourist-oriented design styles in weaving that appeared before the turn of the century. Such designs differed, in part, from classic Río Grande styles because of the change from hand-processed to commercial yarn. The angles in the designs were much more acute in pieces made of commercial yarns than in earlier examples woven of handspun yarn.[59]

Gold may have developed standardized sizes in weaving. He also may have introduced new materials such as cotton carpet warp to weavers. If commercial yarns were being utilized by weavers, it is likely that the "putting-out" system was in operation. While there is no direct evidence that Gold was responsible for all these changes, the fact remains that by the time Candelario took control of the curio business in 1903, these modifications were well established.

Judging from the large number of license applications for mercantile establishments in the Santa Fe area, the business scene began to change in 1901. The number of peddlers' license applicants decreased drastically, just as new mercantile businesses opened in the rural areas of Santa Fe County.[60] Many Hispanos during the early years received licenses as retail dealers in merchandise. The itinerant merchants Pedro Muñiz and Juan Olivas became mercantile dealers in 1903 and 1904, respectively.

The Late Transitional Period (1900–1920)

The late transitional period of Hispanic weaving is characterized by the rapid expansion of external markets in woven goods, principally to tourists. One record of this growth is provided by the busi-

ness records of J. S. Candelario for the years 1901 to 1914. Data in these files reveal Candelario's impact upon weavers and upon their weavings as well as the organization of his business, his business networks, and his modes of operation.

Like Jake Gold, Jesús "Sito" Candelario was a colorful individual. In his advertising, he referred to himself as "the Only Native Born and Wholesale Curio Dealer in the Territory."[61] Even Candelario's letterhead, featuring a "partial list of curiosities," tantalized mail order customers with no fewer than 109 items (fig. 3.8). Over the years, the Old Curio Store became renowned as legions of visitors passed through its doors (fig. 3.9), even famous individuals like Williams Jennings Bryan and Leopold Stokowski.[62] Candelario charmed visitors to his store with his tall tales:

> In a large glass case Candelario had many, many human skulls on display. One skull, much smaller than the others, he took particular delight in showing to tourists as the skull of Henry Ward Beecher. If they protested that the skull of Beecher should be much larger, Candelario would say with his best smile: "That was of Henry Ward Beecher as a boy!" Hearing this story, Sinclair Lewis said on a visit to Santa Fe: "Candelario must have gotten that story in Rome where a guide shows the head of St. Paul."[63]

The interior of the store, as it appeared in a 1912 magazine article, is illustrated in figure 3.10.

Information about Candelario presented here was selected from the more than nine and a half feet of archival material that constitutes the Candelario Collection at the History Library, Museum of New Mexico, Santa Fe.[64] For the most part, the files contain unsolicited letters to Candelario and responses to letters Candelario had written. Copies of his letters do not normally appear in the files. Occasionally, however, correspondents wrote re-

THE OLD
CURIO STORE
Wholesale and Retail Dealers in
GENUINE INDIAN GOODS & CURIOSITIES.
GENERAL MERCHANDISE, GROCERIES AND HARDWARE.
Defies Competition in Quality and Prices.
All accounts subject to draft without notice at maturity — * — * Will not be responsible for goods lost or damaged in transit.
SEND FOR PRICE LIST. 301-303 SAN FRANCISCO STREET. J. S. CANDELARIO, PROP'R.

SANTA FE, N. M., *Dec 20*, 1905

sponses directly on Candelario's letters and mailed them back to him (see fig. 3.8). Through these letters and others, Candelario's style of doing business is revealed. With the exception of some printed forms, these letters are in Candelario's distinctive hand. In addition to Candelario's business correspondence, there is also a large volume of personal correspondence. This personal correspondence places Candelario in the center of a large network, ministering to family and friends with financial assistance and advice.

These papers are significant not only because they document a little-understood period. They also provide a glimpse into Hispanic life of the times because Candelario was of Hispanic heritage and because he worked directly with Hispanic weavers. Further, they document the development of the curio business during the first decade and a half of the twentieth century. From careful analysis of the files, information on several topics emerged: Candelario's contacts with Southwest curio dealers and the nature of the curio business

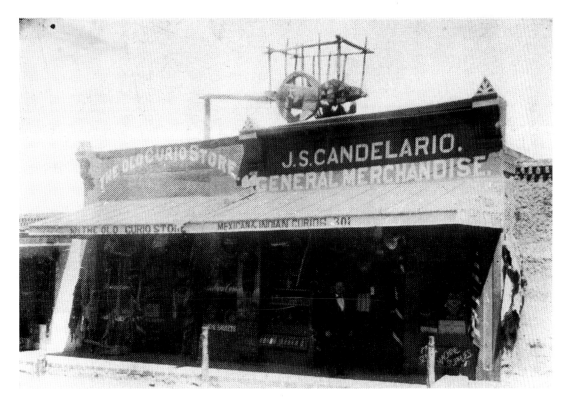

Figure 3.9 | Exterior of Candelario's Old Curio Store, undated. J. S. Candelario Collection, History Library, Palace of the Governors, Santa Fe, negative no. 132690.

in woven goods; Candelario's relationship with curio dealers outside the Southwest; the development of Candelario's business, particularly his direct mail order business; the role of Anglo consumers' special orders; Candelario's efforts to modify equipment and materials by introducing products from the eastern United States; Candelario's relationship with suppliers outside the Southwest; and Candelario's relationship with weavers from Chimayó and nearby towns.

Southwest Curio Dealers and Their Woven Goods

By the first decade of this century, the curio trade in the Southwest was dominated by several groups: the Navajo reservation post traders and their wholesalers, the Fred Harvey Company with its network of outlets in the Harvey House chain, and

other curio dealers in tourist areas throughout the Southwest. As a curio dealer, Candelario fell into this last category, but he had contact with all the other categories in the trading network.

Candelario was in contact with Navajo rug traders like J. L. Hubbell and wholesalers like C. N. Cotton and C. H. Algert, buying from them some Navajo rugs and selling to them Pueblo Indian curios. In 1901 Fred Harvey Company ordered "Chimallo serapes and scarves." One letter Candelario received from Cotton begins with the phrase, "knowing that you are a very large user of Navajo blankets."[65] In 1911 Cotton had written to Candelario offering one thousand pounds of Navajo blankets at 85 cents per pound. In this same year, Algert listed a variety of prices starting at 50 to 65 cents per pound and ranging to $1.00 to $1.25 per pound. In 1912 prices dropped to 75 cents per

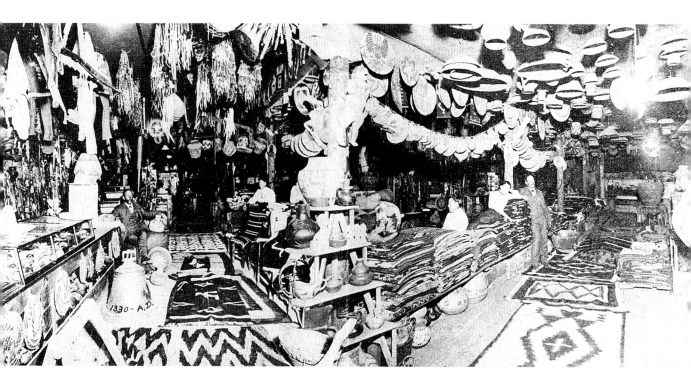

Figure 3.10 | *Interior of Candelario's Old Curio Store, ca. 1912. J. S. Candelario Collection, History Library, Palace of the Governors, Santa Fe, negative no. 20544.*

thousand pounds. Candelario sold Navajo weavings alongside Hispanic ones. Many Navajo weavings were sold by the pound during this period; Hispanic weavings were never marketed in this manner.

During this time, Candelario also imported and marketed Mexican sarapes and even traveled to Mexico in 1907 to explore new supply sources. He was capitalizing on the wide range of similar rug/blanket woven products that were on the market at this time. These products were woven by native peoples of the United States and Mexico and were made of wool or wool and cotton. Evidence of this complex textile market is documented in a letter received by Candelario from the Navajo Rug Company of Los Angeles. The words "Navajo Rugs" appear in bold type at the top of the letterhead. Under this heading in smaller type are listed the following types of weaving:

Oaxacas
Chilcotts [Chilkats]
Yaqui
Chimayo
Zerapes
Mexican Goods[66]

The woven items in smaller type were apparently being offered as suitable substitutes for the better-known prototype, the Navajo rug. Chimayó-style weaving, like other native woven products, evolved to fill gaps in the Navajo weaving market. Candelario and anyone else selling weavings at this time had to base their market appeal on "exoticness." The Hispanic weavers of northern New Mexico were a virtually unknown group. At times the "Mexican-ness" of the weavings was emphasized. For example, Maisel's Trading Post in Albuquerque advertised "Native Mexican Chimayos."[67] However, deal-

ers who based their market appeal on "Mexican-ness" risked associating Hispanic weavings with certain negative Anglo stereotypes.

More commonly, as in the listing above, the name "Chimayos" was used to suggest yet another tribe of Indians who wove. Capitalizing on the geographic proximity to Native Americans, particularly the Río Grande Pueblos, was the marketing strategy. "Many Chimayo fabrics were sold as products of the Pueblo Indians." However, in terms of designs used, "Thunderbird designs of the Great Lakes Indian Tribes" and "Swastikas from Oriental weaving" hardly fall within the Pueblo tradition.[68] These "Indian" designs were combined with others, such as war clubs and arrows, to produce Chimayó weaving designs of this period. The designs were woven in the same colors encouraged by Navajo traders, such as J. L. Hubbell, for use by the Navajos: deep red, black, white, and gray (plates 19–31). Allusions to "Chimayos" being of Indian manufacture are also found in advertising. In 1904 H. H. Tammen Curio Company of Denver refers to a picture in their catalog with the caption "Chimallo Indian Blanket" (fig. 3.11). Also, in 1904 Mariano Candelario, a cousin, took J. S. Candelario's blankets and rugs to exhibit in the Indian Building at the St. Louis World's Fair.[69]

The vagueness surrounding the identity of Hispanic weavers extended even into scholarly domains. In 1912 an anonymous author in the *American Museum of Natural History Journal* wrote: "Chimayo blankets made by Chimayo Indians of northern New Mexico, who are now practically extinct, are thought to be the connecting link between Navajo and Saltillo weaving." James, writing in 1914, remarked that "the Chimayos are part Indian and part Mexican, and their style of weaving and designs can be traced to both."[70]

Hispanic weaving was particularly well suited to filling the need for small-size weavings. Graburn and others have pointed out the importance

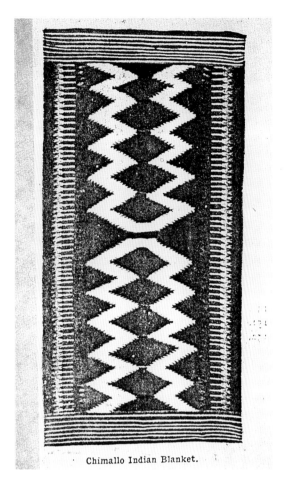

Chimallo Indian Blanket.

Figure 3.11 | Catalog illustration of "Chimallo Indian Blanket" sent by the H. H. Tammen Curio Co., Denver, Colorado, to Candelario, 1904. J. S. Candelario Collection, Box 85, History Library, Palace of the Governors, Santa Fe.

of size to the marketability of a tourist or curio object.[71] The tourist or collector often prefers a small-scale work of art because of its portability and because it will take up less space once it reaches its destination.

The Hispanic treadle loom was ideal for making quantities of smaller-size pieces. With one very long warp, many dozens of small congitas could be woven. By contrast, the vertical Navajo loom had to be rewarped for each piece of weaving. In the execution of a series of small pieces, a disproportionate

Chimayó Weaving

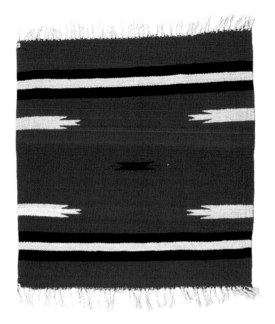

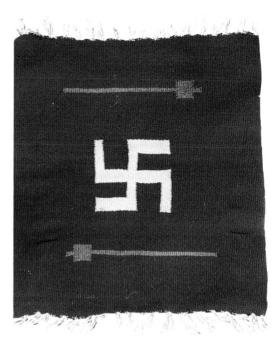

Plate 19 | *Pillow top with serrate motifs at center and entering field from selvage edges, Chimayó, 1910. Commercial yarns: cotton warp, wool weft, 20 x 20 in. Department of Library Services, American Museum of Natural History, catalog number 50.2/6779, neg./trans no. K 15427.*

Plate 20 | *Pillow top with swastika and war clubs, 1900–1920. Commercial yarns: cotton warp, wool weft, 21 x 19 in. Photo taken at Santa Fe Flea Market by Suzanne Baizerman, 1985.*

amount of time was spent on warping the loom. The demand for small, portable Navajo weavings was met for a time when small Navajo looms were offered as curio items. While the Navajo weaver had to warp the loom for each piece separately, she did not have to go through the arduous phase of finishing the fourth selvage edge of the weaving; it was left incomplete and sold on the loom.

Early in the twentieth century, many "Navajo looms" appear on lists of curio goods. However, it was not always easy to acquire the looms from reservation weavers. In 1907 S. E. Aldrich, a trader, wrote to Candelario saying, "in regard to the looms, the squaws will not make them."[72] The Navajo cultural emphasis on "finishing"—for example, "in beauty it is finished"—might explain the weavers' reluctance to make these looms. Hispanic weavers could produce small-size pieces

more easily than the Navajos and thus came to fill a distinct market niche (see plates 18-25).

When the Navajo weavers, at the urging of reservation traders, switched from making blankets to making rugs, there was yet another gap to be filled by Hispanic weaving. The market for a blanket with a more supple hand remained open to Hispanic weavers. A customer wrote to Candelario in 1912 with this request: "I want a few of your cheaper grades [of Chimayó blankets] to try to sell for auto robes, as I have demand for them and Navajo blankets are too heavy and costly." James pointed out that "the Chimayo weavers have never made as tightly spun a yarn, or as closely woven a blanket as did, and do, the Navajos. [Chimayo weavers'] blankets are softer, more adapted for bed coverings and for actually wrapping around the person." Another correspondent refers to Chi-

mayó blankets as "[B]uggy Ruggs." Some of these blankets, modeled on Navajo prototypes and produced with commercial yarns, were intricate and well made (see plates 26–31). Some bore Candelario's label (see plate 32). These may represent the "Balleta Weave" blankets he claimed to have "resurrected in 1907." They are large in size and high in price: 54" x 90" $30; 54" x 80" $25; 42" x 80" $15.[73]

Hispanic products were consistently priced lower than Navajo ones. According to Hubbell's 1905 catalog, Navajo rugs of 2 3/4' x 3 3/4' sold for $9.00 to $12.50, whereas, according to many price lists in the Candelario files, Chimayó blankets of comparable size (36" x 40") sold for $4.25, less than half the price of Navajo rugs. Navajo weavings of 4' x 5' sold for $17.50 to $25.00; Candelario advertised 42" x 80" Hispanic weavings for $10.00.[74]

Hispanic goods may also have filled gaps at times when Navajo goods became scarce. In 1908 and 1909 Candelario received letters from reservation dealers complaining of a scarcity of blankets. C. and H. Algert of Fruitland, New Mexico, was unable to fill Candelario's order for small Navajo weavings in 1907.[75] Candelario, who kept in close contact with his weavers, appeared to be in better control of his supply of weavings.

Candelario's Relationship with Dealers Outside of the Southwest

Candelario not only traded with dealers and traders in the Southwest but also with those located throughout the country. Orders were received from Colorado, Kansas, Nebraska, Oregon, California, Washington, Michigan, Minnesota, and New York. In fact, one of Candelario's greatest talents was his ability to expand the number of outlets for his line of curios. Candelario had a system for increasing outlets. Using his elaborate letterhead (see fig. 3.8), he would write to postmasters in cities in the United States where he sought outlets. As the text of the letters indicates, he would

Figure 3.12 | Drawing of blanket enclosed with an order, 1914. J. S. Candelario Collection, History Library, Palace of the Governors, Santa Fe, negative no. 132694.

The Transitional Period

offer a gift if the postmaster would identify likely outlets. These letters were sent not only to major cities but also to smaller towns with promising markets, those in resort areas or along tourist routes. Many of his outlets were curio shops, but there were also cigar stores, stationery stores, men's apparel stores, and taxidermists that offered a modest selection of curio wares. However, most of his wholesale business was with dealers in New Mexico, Arizona, and Colorado.

At times, private citizens served as wholesalers. In 1906 Candelario received a request for an estimate on twelve pillows from a University of Arizona student wishing to sell them to his classmates. They were to be made in blue and red, the

Figure 3.13 | Catalog illustration of a blanket sent by Francis E. Lester, Co., Mesilla Park, New Mexico, to Candelario, 1906. J. S. Candelario Collection, Box 87, History Library, Palace of the Governors, Santa Fe.

school colors, and were to feature the school's name on a pennant alongside a swastika.[76]

Trade also flourished because of the development of the rail transportation system. Like traders on Indian reservation trading posts, Candelario used the railroad to ship goods to distant outlets. It was not uncommon for him to ship 250-pound blanket bundles ("bondles," as he often referred to them) to a given destination. Barrels of pottery, the infamous Pueblo pottery "Rain Gods," often accompanied blanket bundles. Rain Gods were small, portable, stylized human ceramic forms conceived by dealers for the tourist market and produced by Pueblo artisans (see figure 3.14).

In his contacts with curio dealers, Candelario had to work with those who were marketing multiple copies of Hispanic blankets by mail. For example, in 1904 H. H. Tammen Company of Denver placed an order for multiple copies of a 36" x 72" blanket. The design was of the type pictured in figures 3.12, 3.13, and 3.14 lower center. The following year, Tammen Company requested "characteris-tic fancy patterns in bright colors," but added that "similar designs but of course not quite as elaborate are desired for smaller size. All must be woven more firmly than last lot which were very loose."[77]

The "fancy blankets" the Tammen Company referred to may be those illustrated in plates 33 through 44. In design, these blankets are not modeled after Navajo prototypes, but rather upon those of Río Grande and Saltillo blankets. Like the Navajo eyedazzlers of the late nineteenth century, these Hispanic eyedazzlers were woven with bright-ly dyed, commercially produced yarn. They reveal some of the highest quality weaving produced during this period.

In addition to Candelario, other curio dealers played a significant role in the development of Hispanic weaving. Writing in 1914 about one such dealer, James stated that Mr. Burns, owner of the Burns Indian Trading Company of Los Angeles, "has accomplished for the Chimayo blanket what Mr. Hubbell and Mr. Molohon are doing for the Navajo." Burns "personally visited Chimayó, bought

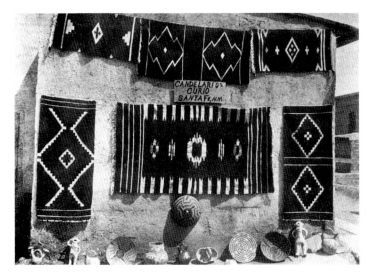

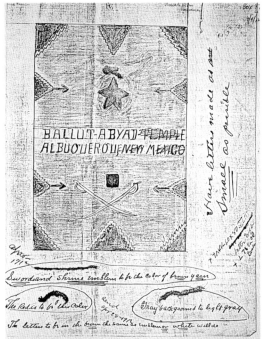

Figure 3.14 | Postcard picturing weavings, 1909. J. S. Candelario Collection, History Library, Palace of the Governors, Santa Fe, negative no. 132691 (left).

Figure 3.15 | Drawing of a blanket for Ballut-Abyad Temple, Albuquerque, New Mexico, 1912. J. S. Candelario Collection, Box 97, History Library, Palace of the Governors, Santa Fe (right).

several looms, and engaged the best weavers he could find to come to Los Angeles and there weave regularly for his growing trade."[78]

Candelario's business flourished in the first decade of the twentieth century. By 1908 his business was routinized and he had developed a formal system to handle hundreds of consignments. That same year, Candelario wrote to J. B. Field in Chicago to say that "my business has increas doveld [sic]." In 1909 he was advertising himself on the back of a new envelope as the largest curio store in the United States. The years 1909 and 1910 were very successful ones; Candelario shipped many 150- to 200-pound blanket bundles. In 1914 his form letter requesting payment of a small balance notes: "Remember every dollar counts here as we consign several hundred shipments monthly."[79]

Initially Candelario handled his growing business in a rather informal manner. However, as the number of accounts increased, Candelario's business became more complicated. Delinquent accounts developed, and soon he employed collection agents to collect on these bad debts. He had a printed form specifying the terms of consignment. He also demanded credit ratings for prospective accounts. By 1913 he investigated credit insurance. And in 1910 he wrote to the *Textile Manufacturing Journal* inquiring about a way to stencil a trademark on his goods.[80]

The Mail Order Business

Candelario advertised his wares in a number of magazines of the day, such as *Great Southwest,* the *Commoner, Philatelic West, Youth Magazine, Round the World Postcard Monthly, International Gazette,* and the *Christian Endeavor World.* His advertisement stated that he would send a "free souvenir for the ladies" to each person who requested a catalog. The Candelario Collection files are bursting with letters requesting the catalog and free gift; usually he sent a small piece of onyx. For decades he extended this free offer not only in magazines but also on the return address flap of his mailing envelopes.

Figure 3.16 | Candelario's sketches for blankets for the Democratic party, 1911–12, illustrated in Figure 3.17. J. S. Candelario Collection, Box 96, History Library, Palace of the Governors, Santa Fe.

Candelario also received many mail orders from people who had visited the store at one time or another. Mail order customers could order the goods listed on Candelario's letterhead (see fig. 3.8). Later, in special catalogs that appeared in 1905, he offered various assortments of curios referred to as "curio corners." Such corners were the rage in Victorian homes of the day. For ten dollars, the mail order customer could receive the "Starter for Your Curio Corner": "1 barrel containing not less than 20 assorted pieces from different tribes . . . 2 pillow tops (Chimayo) . . . 1 Navajo loom . . . 1 Chimayo scarf."[81]

Candelario used other methods to stimulate business. One letter from an Iowa man requested a catalog of goods "upon the suggestion of Shungopavi, the Moqui medicine man, who appears on a system of Chautauquas." In addition, Candelario's son-in-law, Arthur C. Weeks, was a traveling salesman in the automobile business. Weeks missed no opportunity to drum up business for his father-in-law, recruiting auto dealers to buy Hispanic blankets to use as auto robes. In 1911 Candelario ordered woven labels from the German Artistic Weaving Company of New York. The order specified that they were to be blue with gold script spelling "Candelario." He enclosed a Pendleton blanket label to be used for "style."[82] Plate 32 illustrates such a label sewn onto a blanket dating from this period.

Contact with Consumers

In the minds of consumers, Chimayó products were not clearly understood. As one dealer put it, "Of course, the Navajos have the reputation while the Chimallos are practically unknown."[83] This spelling was one of many; other versions of Chimayó included references to "Simneys" Indian blanket, "Cimaza Portiers," "Chemijo" Indian blankets, and "Chimazo."[84]

This vague understanding left plenty of room for customers to mold the product to suit their own specifications. There were few preconceived notions of just how the product was supposed to look. Concerning "Chemijo" Indian blankets, Candelario wrote: "These blankets are very cheap here, as this is where they are made, and if you want any special design you can send in your copy, and have one made to suit you, for a little more, than the prices quoted."[85]

Many custom orders came in with requests for special motifs, often accompanied by sketches (fig 3.12). A Pueblo, Colorado, auto dealer ordered an auto robe, one like his partner had ordered, with an initial in the middle. For his robe, however, he wanted the initial turned 90 degrees so it would be oriented in the horizontal rather than the vertical direction. He added, "I do not want one that is woven heavy like the ordinary navajo blankets." Sometimes customers wanted wording together

Figure 3.17 | Custom-designed blankets for the Democratic party, 1911–12. J. S. Candelario Collection, Box 96, History Library, Palace of the Governors, Santa Fe.

with Indian designs. In 1912 a blanket to be used as a parade banner was made for the Ballut Abyad Shrine Temple in Albuquerque (fig. 3.15). It featured a star, crescent, and crossed swords, emblematic of the Shriners. The letter accompanying the order noted, "If you want to run in any small indian designs you can do so but not swastickas [sic]." A weaving tour-de-force was commissioned in 1911–12 for the Democratic Central Committee of Albuquerque; it contained state and U.S. flags, names of recipients, and Indian motifs, including swastikas (figs. 3.16 and 3.17).[86]

Given Candelario's invitation to his customers to provide input into the design of their orders, retailers were very explicit about the type of Chimayó woven goods they wished to receive, particularly regarding design motifs and colors. Letter after letter stated variations on similar themes, illustrated by these sample quotations:

> *We do not want anything in pink, magenta, orange or any other odd color. In designs we prefer characteristic Indian designs zig-zag, diamond and cross patterns such as you know from experience are the best selling colors and designs.*[87]

> *We want the dark red ground with just about as much pattern on them as the grays you have just sent us. The reds I speak of have too much white in them, and one or two have long zig-zag designs, which certainly will not sell.*[88]

> *The air all to gray. Not a nuff read in them. The Desines air not indian a nuff. . . . I could sell some good indian Patterns if i had them. You know what I mean. The Dimon and zig-zag Pattern [sic].*[89]
> *I want always the bright clean colors.*[90]

Chimayó Weaving

est carpets and rugs, with the least amount of labor and **skill**, and at a price within the reach of any desiring to engage in a **profitable** business with small **capital**.

THE FRAME WORK is made of hard wood, the **best material** it can be made of, as iron looms are **heavy to handle**, and the constant jar to which they are subjected loosens the bolts and often causes breakages, and in a few weeks the finish looks dingy and greasy. The wood used has a nice grain, so that when oiled and varnished it makes a handsome appearance, and is an ornament to any home. It takes up about four and a half feet square of floor space which enables one to use it

WEAVER'S FRIEND LOOM.—PRICE, $38.00.

in a sitting-room of the house, which is a feature in the winter time, as it saves fuel.

Figure 3.18 | The "Weaver's Friend" loom as depicted in the catalog of the Reed Loom Co., 1905. J. S. Candelario Collection, History Library, Palace of the Governors, Santa Fe, negative no. 132692.

Clearly blankets suggesting an Indian connection were in demand: "Send plenty of swastika and arrow designs"; "send those emblematical of true Indian characteristics"; "the pinks and yellows in the ones you sent me ar [*sic*] not good Indian colors and consequently I do not want them."[91]

Practical considerations were important too: "What we wanted are bright, fancy diamond patterns, mostly red, blue and black predominating, with, of course, white figures among them, but none with a white background as they soil too easily."[92]

Retailers were also specific about technical matters. "All [blankets] must be the smooth soft weave and not the rough like some that you sent us last time." "The Chimayo blankets are very thin and flimsy and mostly poor colors." Size was also

a matter of importance. "We do not want any one article large and bulky as they are used principly [*sic*] for souvenirs—people do not care for anything bulky." That the Chimayó blanket filled a niche for a certain size blanket is verified by the retailer who wrote that he did not expect the larger sizes of Chimayó weavings to "take as well as the Navajo."[93]

During the time these letters were received, Candelario was experimenting with a variety of yarns from dozens of new yarn companies. He was walking a very thin line between low-cost yarn and adequate quality. That some of his experiments met with failure is well documented in the letters he received. In 1906 several letters complained about loose weaves that pulled apart or left warp showing. One dealer wrote, "don't send any more trashy ones"; he wanted goods that were "well woven and don't show the warp threads."[94] Yarn that was too small in diameter or not lofty enough did not cover the warp well. Weavers would have had to insert more weft passes per inch with smaller diameter or less lofty yarn. If they used the same number of weft passes as they were used to doing with larger yarn, warp coverage would not have been adequate.

Candelario's Introduction of New Equipment and Materials

The Candelario files contain a voluminous correspondence between Candelario and potential suppliers. To find these resources, he first wrote to various periodicals, such as the *Dry Goods Economist,* the *Textile World Record,* the *American Wool and Cotton Reporter,* and the *Textile Bluebook*. He circled ads, then wrote letters of inquiry. In particular, Candelario was trying to locate an inexpensive source for yarn. Variables included the diameter of the yarn, the number of plies, and whether the yarn was dyed, bleached, or scoured. Candelario even found yarn in 1909 with "wool outside and a cotton center"; its price ranged from a low of

twenty-four cents per pound to a high of eighty-five cents per pound.[95] Eventually, in 1906, Candelario settled on Clasgens Yarns of New Richmond, Ohio, as his major wool yarn supplier. From that point on, he ordered 120 pounds of wool from them every month or two. At times, orders reached 300 or even 900 pounds.[96] Candelario's main source of cotton carpet warp was the Rock River Cotton Company, located in Wisconsin, supplier of Crown Jewel Carpet Warp. Despite his consistent orders from these companies, Candelario never stopped shopping around for new yarn sources.

Loom catalogs in the Candelario files provide evidence that he was also trying to locate equipment for his weavers. The Reed Manufacturing Company offered a loom named the Weaver's Friend (fig. 3.18). Because the loom had an automatic shed changing mechanism, it had no treadles: the sheds changed as the beater was drawn forward. In 1905 the loom sold for $38.00. In addition, metal parts and other equipment could be ordered from these catalogs: heddle frames for $1.50 per pair; wire heddles at 25 cents per hundred; steel reeds at $2.00 for a forty-six-inch reed; and shuttles for 15 cents each.[97] Candelario may have been seeking wider looms in order to supply the demand for wider pieces. Spanish colonial Hispanic looms were able to produce pieces only two feet wide; wider pieces were woven double on the loom or had to be woven in two pieces and seamed together.

Candelario even looked into the possibility of ordering a small "Jaquard [sic] loom for weaving heads of persons and other designs in fabrics about 20 inches wide."[98] Perhaps he envisioned the Jacquard loom as a more efficient way to meet the demand for custom orders.

How Other Goods Were
Supplied to Candelario

Some of Candelario's curios and other goods came from Mexico, especially filigree jewelry and opals.

Candelario himself went to Mexico to enlarge his pool of contacts south of the border. He maintained a substantive business correspondence with Mexican suppliers. In New Mexico, at least one of the itinerant merchants who had a peddler's license in the 1890s and early 1900s appeared in Candelario's correspondence. Pedro Muñiz continued to supply Candelario with goods from Zía, Acoma, Isleta, and Santo Domingo Pueblos. As numerous letters in his files attest, Candelario also supplied convicts in the New Mexico State Penitentiary with raw materials, such as leather and horsehair, to make bridles and hatbands. Contacts with Hispanic weavers were handled by Candelario himself; Candelario saw the weavers as "his people."[99]

Candelario's Contact
with Rural Hispanic Weavers

There has been little written about the weavers who worked during the transitional period (1870–1920).[100] This period is largely beyond the memory of living weavers. Most written accounts of Hispanic weaving were published after the 1920s. These accounts often embellished earlier times with "folklore" or "myth." During the course of field research, oral history and kinship data were collected by the authors from older Hispanic residents of the region, augmenting other sources of data about the period.

The Candelario files added considerably to an understanding of Hispanic weavers working during the late transitional period because they contained many letters from the weavers. Weavers were identified by name and by village; the vast majority of weavers lived in Chimayó or the nearby communities of Truchas and Córdova. More important, these letters also offered a glimpse into the weavers' daily lives and into the commerce of the period. From the 113 letters Candelario received from weavers, a list of forty-two names

TABLE I

Various Wholesale and Retail Prices Found in J. S. Candelario Files: 1904–1910

SIZE (INCHES)	PAYMENT TO WEAVERS	WHOLESALE PRICE	RETAIL PRICE
15 X 30 (conga)	.50	.70 ea. 9.00/dozen	1.00
15 X 60	1.00	1.50	2.00
20 X 20	.50	9.00/dozen	.90
15 X 35 with letters woven in	.60	*	*
	-.65		
20 X 40	1.00	1.50	2.00
	-3.50		
24 X 24	*	.75	*
26 X 40	1.35	*	3.75
26 X 50	1.75	*	4.00
24 X 48	*	2.00	*
26 X 60	2.10	*	4.50
26 X 70	2.50	*	*
36 X 36	1.75	2.25	3.75
Serape	5.00	*	*
34 X 72	*	5.50	*
36 X 72	*	*	12.50 & 17.50
40 X 72	*	6.50	*
42 X 80	*	7.50	*

Data unavailable

emerged. Their names are listed in appendix 1. In all likelihood, these weavers were the descendants of earlier generations of weavers who wove for trade caravans and for government annuity payments as described in chapter 2.

Through the letters, reliable publications of the era, oral history data, and comparative data from current practices, it is possible to piece together a portrait of the organization of the weaving industry in the first decades of the twentieth century. Most of the correspondence consists of letters from weavers describing their shipments of congas and sarapes sent to Candelario via the Denver and Río Grande Railway from Española to Santa Fe; they were shipped at the weaver's expense.[101]

The letters also placed orders for yarn that Candelario would then ship from Santa Fe to Española. Candelario credited weavers' accounts with the amount due in payment for weavings he had received, deducting the price of yarn that the weaver ordered on credit. Such an arrangement is typical in a cottage industry system. Also, as might be expected, there was often quibbling by mail on both sides —weaver and curio dealer —about the accuracy of their accounts.

The price structure of Hispanic weaving is shown in table 1. It includes the prices paid to weavers for various sizes of weaving, which were consistent from 1904 to 1910. It also includes wholesale prices (amounts Candelario received from re-

tailers) and retail prices (amounts consumers paid to Candelario and other retailers).[102]

The largest volume of business was done in 20" x 20" weavings marketed as pillow tops. Orders for one hundred pillow tops were not at all uncommon. On such an order, Candelario would make a profit of fifty cents per pillow top or fifty dollars on an order for one hundred. The files seldom shed light on the prices that weavers paid for yarns. However, Candelario charged one man eighty-five cents per pound for wool yarn.[103] According to business correspondence, Candelario paid an average of fifty cents per pound for wool yarn.[104] Based on the average weight of a comparable 20" x 20" weaving today—approximately seven ounces—the weaver paid Candelario about forty cents for yarn. If the weaver was paid fifty cents for the weaving, this left only a ten-cent profit from which the weaver still had to pay shipping costs. At times, Candelario extended credit to weavers; in some of their letters weavers requested more yarn and indicated that they wanted to weave to settle their accounts. In addition to yarn, Candelario also sold metal reeds to weavers. He placed at least one loom in a weaver's home, and probably many more.[105] It is unclear whether weavers purchased, rented, or simply borrowed these looms; probably all three methods were employed. Some looms dating to this era are still in use today (see chapter 6).

While Candelario had a well-organized operation among rural weavers, he had some difficulty ensuring a steady flow of weavings to Santa Fe. Many of the weavers' letters apologized for delays in production attributed to illness, to the bridge to Española washing out, or to trips to Colorado. During the summer, Candelario could not expect much weaving production because of the seasonal demands of the weavers' farms. For most weavers, weaving filled the gap between fall harvest and spring planting. These were farming families: "During the fruit and vegetable season the people are fruit growers and agriculturalists, but in winter, when the ground is frozen, they uncover their looms."[106] Weaving meant access to cash income between seasons and was an accepted winter vocation.

Although almost all the correspondence in Candelario's files is between him and male weavers, women were also involved in the production of weaving.[107] Judging from weaving practices today, women probably wound bobbins for weavers' shuttles or knotted warp ends into fringe when pieces were taken off the looms. Women might also have woven at times when men were involved in agricultural duties; they were near the looms as they completed household chores and tended to children's needs. Most likely men attended to the public aspects of weaving, such as conducting business with Candelario. Certainly by the 1920s, according to older informants, such as Agueda Martínez, who were able to provide oral history data, women were a major force in the cottage weaving industry in the Chimayó area (see fig. 4.14).

Some letters imply that weaving was a family enterprise. Deciderio López wrote to Candelario in 1907 stating that he and his family were willing to learn to weave. Reyes Roybal wrote in 1908 saying that he had a large family that wanted to work. These letters implied that the women in the family would have played some role in the weaving process. An account published in 1914 notes: "In three-fifths of the houses the bump of the batten and the jerk of the treadle may be heard as the busy weaver plies her shuttle to and fro." The author does not even include men in his account of weavers; perhaps he visited in the summertime. His remarks also suggest how many families used this form of work to supplement their income: three-fifths of the families.[108] An article about Nicasio Ortega's early life as a weaver also suggests family involvement, noting that in 1912 or 1913 Señor Ortega contracted to weave a number of blankets "far more than he could weave . . . so he arranged

Chimayó Weaving

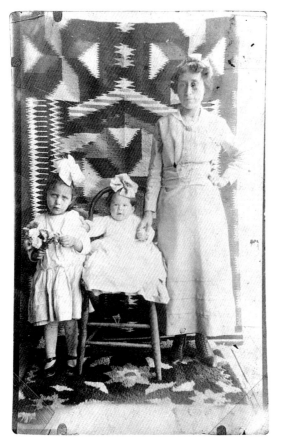

Figure 3.19 | Portrait of a woman and two girls. Left to right: Soledella Romero, Manuelita Fernández, and Sarita López, ca. 1911. Trampas/Vallero blanket in the background. Courtesy of Martina Lucero, Chamisal, New Mexico.

with some thirty other weavers nearby, his friends and in many cases his relatives, to help him."[109]

Little is known about how Candelario indicated to weavers what they were to weave. One weaver, José B. Martínez, wrote to Candelario stating that he wanted to weave and asking Candelario to send *muestras,* or samples. It is possible Candelario provided samples to insure uniform production and to meet his specifications.[110]

That certain weavers were more talented and accomplished than others is suggested by the correspondence in the Candelario files. Gavino Trujillo wrote in 1908 to say he had wanted to work for

Candelario but his sarapes were not as good as those woven by "Manuel de los Reis [Martínez] or Rumaldo [Ortega]." We know that Reyes Ortega set up a shop early in the century and was a recognized professional weaver. According to his daughter, Melita Ortega, Reyes in later years had twenty weavers working for him.[111] The hierarchy in weaving skills and professionalism in the craft is also revealed by a writer of the time who discusses small pillow cushions and table covers: "Some of the designs of these covers are exceedingly attractive, and they are worked out with artistic skill. Taste in color necessarily is a personal matter. What pleases one will not please another, and the Chimayo weavers are no exception to this universal rule. There are a few weavers, however, whose tastes seem more critical than those of others, and their work meets with the approval of those most qualified to judge."[112]

More talented and accomplished weavers probably wove year-round and specialized in sarapes and in the execution of weavings with more complex designs. However, seasonal weavers were more numerous, with weaving being supplemental to farming.

When wool quality was lower because Candelario was shopping around for cheaper yarn, weavers complained. They did not like the "common wool" and objected to Candelario's charging them the same price for an inferior product. Weavers also had preferences for what they wanted to weave. One weaver, Imperia J. Ortega, wanted to weave 20" x 20" and 20" x 40" pieces rather than 15" x 30" or 15" x 60" ones; she stated, *"No quiero tenerme de esclaba"* [I do not want to be a slave]. She added: "Give me work that I like."[113]

Weavers cleverly adapted household equipment to suit the needs of the weaving business. Small hand grindstones became bobbin winders (see fig. 6.7); bicycle wheels and treadle sewing machines became spinning wheels and bobbin winders (see fig. 6.8).

Often weavers came to each other's aid in delivering weavings. When a person traveled to Santa Fe before paved roads, he often took the work of one or more weavers from his community. Eventually, some of these men became more formal intermediaries between the weavers and Candelario. In fact, right alongside the growth of Candelario's business, it is apparent that some men in Chimayó began to distinguish themselves as middlemen-entrepreneurs. In 1905 Manuel Martínez established himself in the general merchandise field, complete with letterhead; he functioned as an intermediary between weavers and Candelario. In 1907 Victor Ortega opened a mercantile store on the Plaza del Cerro in Chimayó and asked Candelario to provide him with yarn to sell to weavers. That same year, Julian Trujillo also asked to distribute yarn to weavers and to receive their completed work for transport.[114] Reyes Ortega, the accomplished weaver mentioned earlier, was also a farmer, teacher, and justice of the peace; he hung a sign on his house identifying himself as a weaver, taught himself English, and began his weaving business in his home early in the century.[115] Today, these three families, the Ortegas, the Trujillos, and the Martínezes, are among the most prominent in the weaving craft.

There is no evidence that these and other Hispanic entrepreneurs served any but external cash markets. The internal commerce in weaving — the weaving circulated within Hispanic northern New Mexico — was (1) bartered in exchange for goods, such as beans, burros, or potatoes; (2) divided *a medias* (in half) between the weaver and those supplying wool, yarn, or rags; or (3) given as gifts for weddings or other occasions. That weavings were valued is evidenced by the number of portraits of the day that used local weaving as a backdrop (fig. 3.19).

Candelario's business files suddenly stop in 1913, even though he continued to operate his business until his death in 1939. Within a few years after Candelario's files cease, other influences signaled by World War I and U.S. involvement abroad began to affect the craft of Hispanic weaving.

Hispanic weaving as a commercial enterprise burgeoned during the early transitional period along with similarly designed Navajo products and, to a much lesser extent, those of the Pueblo Indians. Later in the transitional period, as new people and products entered the area from the eastern United States and as the need for home production of textiles declined, consumer demands changed. A study of the transitional period is, to a large degree, a study of the mediating agents between weaver and consumer: first the itinerant merchants and, later, the curio dealers. The curio dealers' influence on woven objects, weavers, and consumers was a significant factor in the development of Hispanic weaving between 1870 and 1920.

Chimayó Weaving

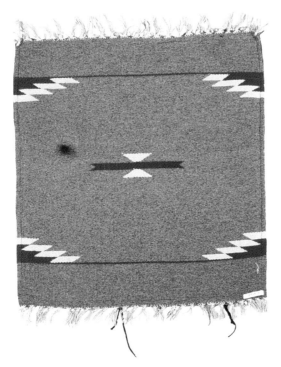

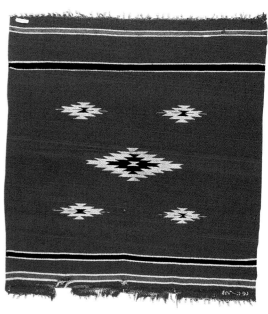

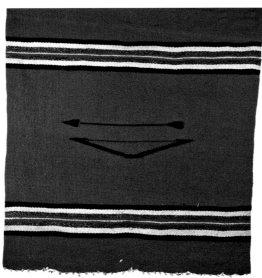

Plate 21 | *Pillow top with serrate center and corner motifs, 1900–1920. Commercial yarns: cotton warp, wool weft, 22 x 19 in. Arizona State Museum, University of Arizona, Tucson, Arizona, E5168 (upper left).*

Plate 22 | *Pillow top with serrate diamonds, 1900–1920. Commercial yarns: cotton warp, wool weft, 37 x 34 in. Southwest Museum, Los Angeles, California, 611.G.742 (upper right).*

Plate 23 | *Pillow top with bow and arrow motif, 1900–1920. Commercial yarns: cotton warp, wool weft, 20 x 20 in. Photo Archives, Denver Museum of Natural History, Denver, Colorado, 713/10B (lower left).*

Plate 24 | *Table mat with serrate motifs, 1900–1920. Commercial yarns: cotton warp, wool weft, 45 x 24-3/4 in. Southwest Museum, Los Angeles, California, 2087.G.47 (opposite, left).*

Plate 25 | *Table mat with serrate motifs, 1900–1920. Commercial yarns: cotton warp, wool weft, 30 x 13 in. Southwest Museum, Los Angeles, California, 911.G.27 (opposite, right).*

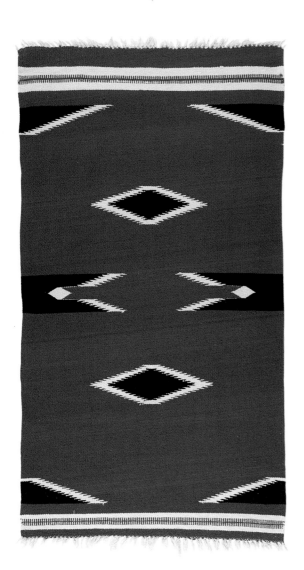
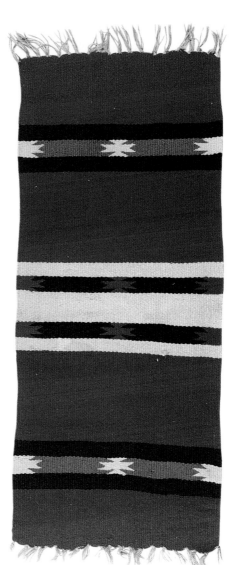

The Transitional Period

Chimayó Weaving

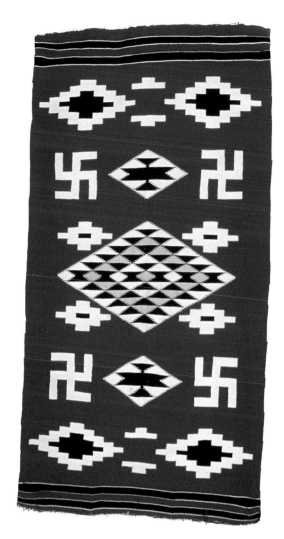

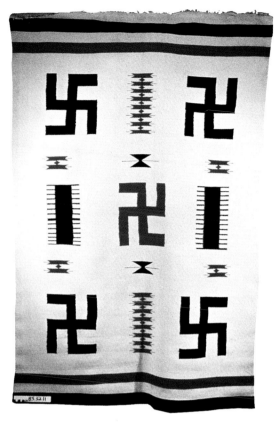

Plate 26 | *Blanket with central serrate diamond, swastikas, and terraced diamonds, 1900–1920. Commercial yarns: cotton warp, wool weft, 112 x 57 in. School of American Research, Santa Fe, New Mexico, IAF.T719 (left).*

Plate 27 | *Blanket with swastikas and serrate motifs, 1900–1920. Commercial yarns: cotton warp, wool weft, 78 x 50 in. Maxwell Museum of Anthropology, University of New Mexico, Albuquerque, New Mexico, 85.52.11 (right).*

Plate 28 | *Blanket with serrate diagonals and diamond with swastikas, 1900–1920. Commercial yarns: cotton warp, wool weft, 84 x 40 in. Southwest Museum, Los Angeles, California, 1596.G.2 (opposite, left).*

Plate 29 | *Blanket with diamonds and arrows, with Candelario label, ca. 1910. Commercial yarns: cotton warp, wool weft, 82 x 42 in. International Folk Art Foundation Collections at the Museum of International Folk Art, Santa Fe, New Mexico, FA.1990.52-1. Photo by Miguel Gandert, 1992 (opposite, right).*

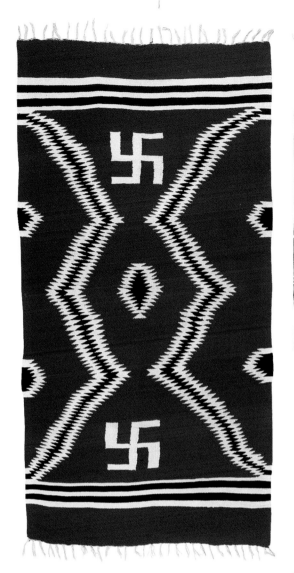
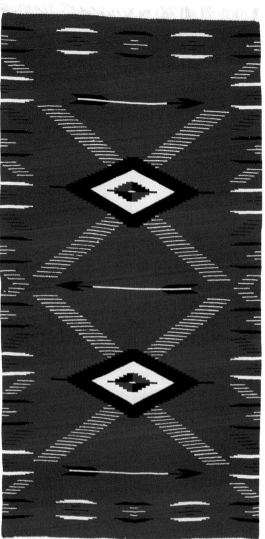

Chimayó Weaving

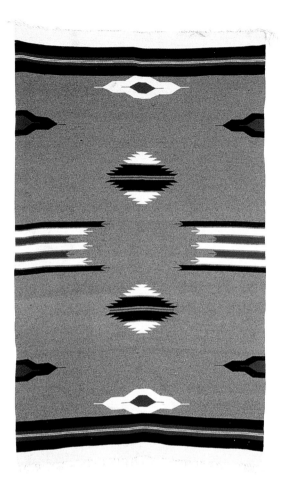

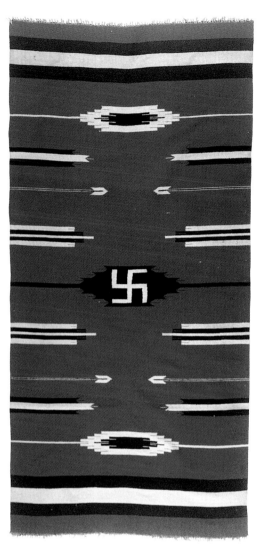

Plate 30 | Blanket, 1910s, similar in style to Figures 3.11 and 3.13. Commercial yarns: cotton warp, wool weft. International Folk Art Foundation Collections at the Museum of International Folk Art, Santa Fe, New Mexico, FA 1990.70-1. Photo by Miguel Gandert, 1992 (above).

Plate 31 | Blanket, 1910s, similar in style to Figures 3.11 and 3.13. Commercial yarns: cotton warp, wool weft, 72 x 34 in. Southwest Museum, Los Angeles, California. 913.G.95 (upper right).

Plate 32 | Candelario label, ca. 1910, on blanket illustrated in Plate 29. International Folk Art Foundation Collections at the Museum of International Folk Art, Santa Fe, New Mexico, FA. 1990.52-1. Photo by Miguel Gandert, 1992 (lower right).

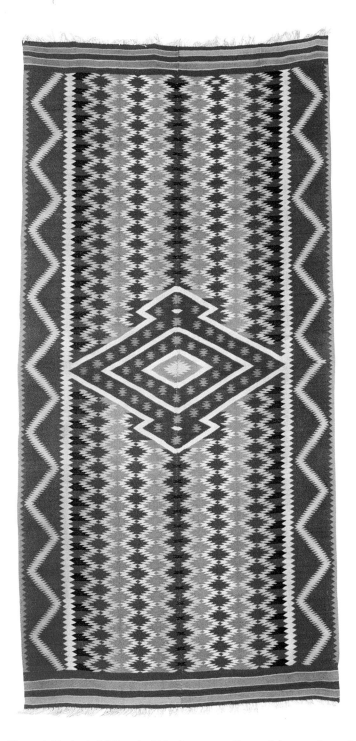

Plate 33 | Blanket in Saltillo style with borders, ca. 1900. Commercial yarns: cotton warp, wool weft, 92 x 39 in. Museum of New Mexico Collections, Museum of International Folk Art, Santa Fe, New Mexico, A.60.21-3. Photo by Miguel Gandert, 1992.

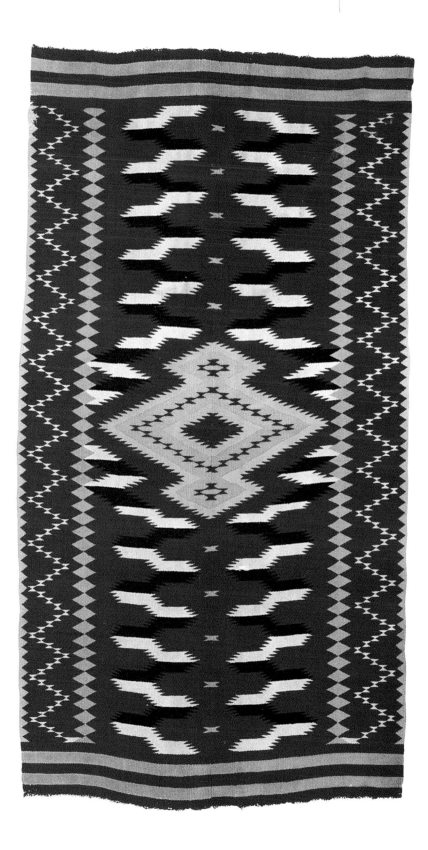

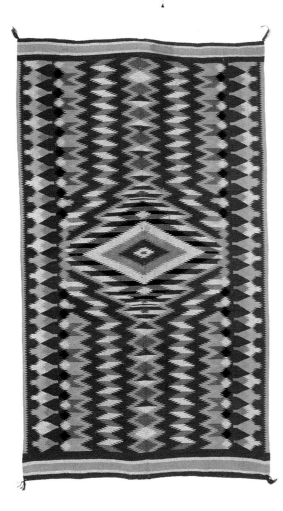

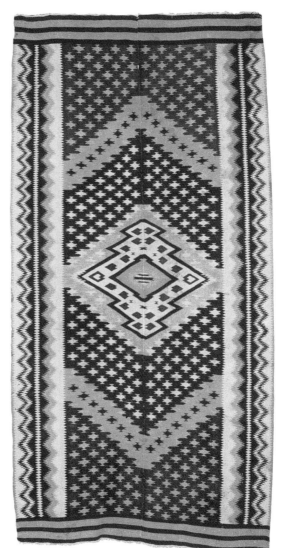

The Transitional Period

Plate 34 | *Blanket in Saltillo style with borders, ca. 1900. Commercial yarns: cotton warp, wool weft, 68 x 35 in. Museum of New Mexico Collections, Museum of International Folk Art, Santa Fe, New Mexico, A.64.20-3. Photo by Miguel Gandert, 1992 (opposite).*

Plate 35 | *Blanket in Saltillo style with borders. Commercial yarns: cotton warp, wool weft, 91 x 46 in. Millicent Rogers Museum of Northern New Mexico, Taos, New Mexico, 1983-10-4 (right).*

Plate 36 | *Blanket in Saltillo style with borders. Commercial yarns: cotton warp and wool weft, 78 x 45 in. Museum of New Mexico Collections, Museum of International Folk Art, Santa Fe, New Mexico, A.65.67-5. Photograph by Miguel Gandert, 1992 (left).*

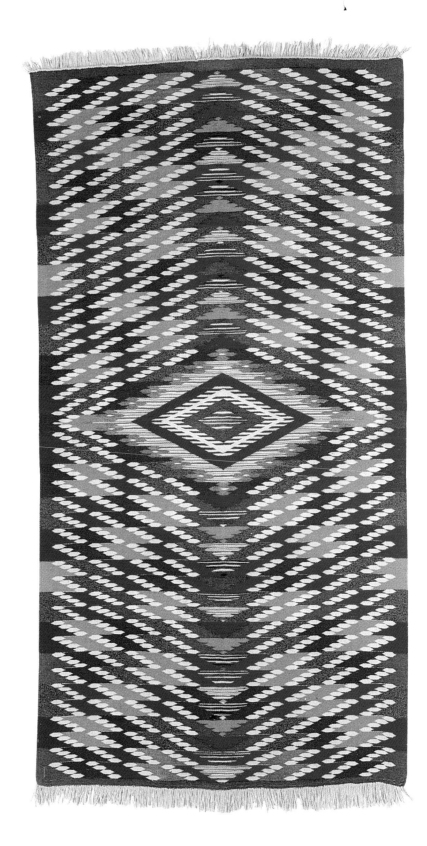

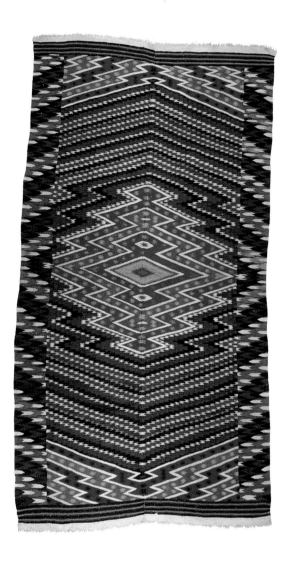

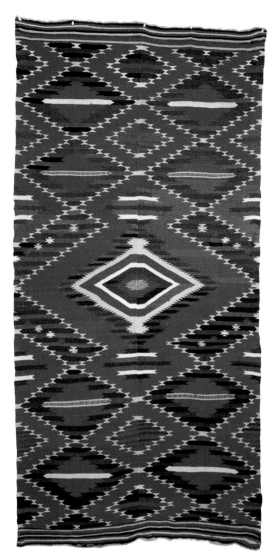

Plate 37 | *Blanket in Saltillo style with central diamond,*
ca. 1900. Candelario's label is attached to the lower right
corner. Collection of David Reneric (opposite).

Plate 38 | *Blanket in Saltillo style with central diamond.*
Commercial cotton warp, commercial and handspun wefts,
92 x 40 in. Southwest Museum, Los Angeles, California,
1520.G.5 (left).

Plate 39 | *Blanket with central diamond with stripes, ca. 1910.*
Commercial yarns. Collection of David Reneric (right).

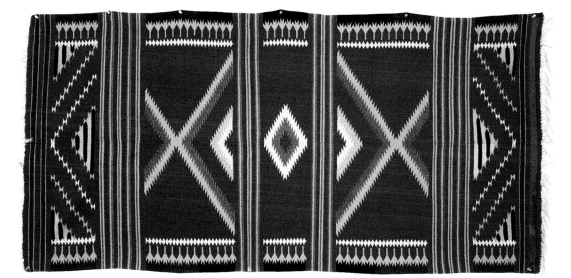

Plate 40 | *Blanket with bands with diagonals and diamonds. Commercial yarns. Courtesy of Andrew Nagen, Los Colores, Corrales, New Mexico (left).*

Plate 41 | *Blanket known as a "Playing Card Blanket" because it was used as an illustration on the back of playing cards. Commercial cotton or linen warp, handspun wool weft, 69 x 54 in. Millicent Rogers Museum of Northern New Mexico, Taos, New Mexico, MRM1985-01-001. (Nearly identical to blanket illustrated in James, 1914, p. 36, Plate 19.) Photo by Paul O'Conner (right).*

Plate 42 | *Blanket in Trampas/Vallero style, ca. 1910. Commercial wool weft, cotton warp, 79 x 41 in.; woven in two panels. Courtesy of Andrew Nagen, Los Colores, Corrales, New Mexico (opposite, above).*

Plate 43 | *Blanket with design made up solely of background pattern from a Saltillo-style* sarape, *commercial wool warp and weft, undated. Minnesota Historical Society, St. Paul, Minnesota, 10,000.1093 (opposite, below).*

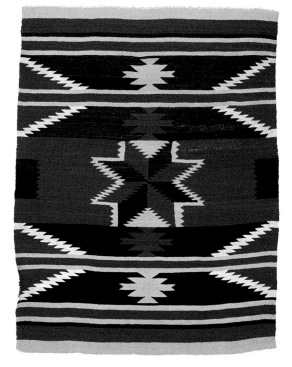

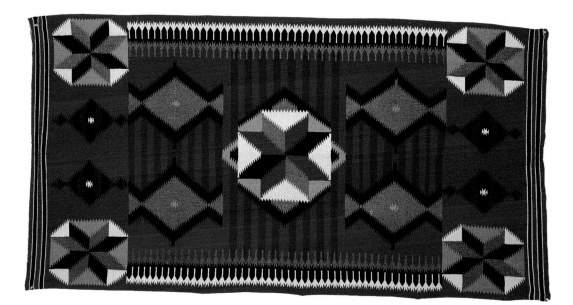

The Transitional Period

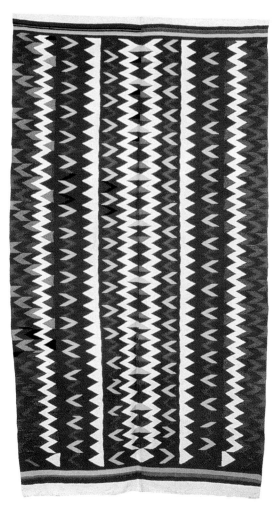

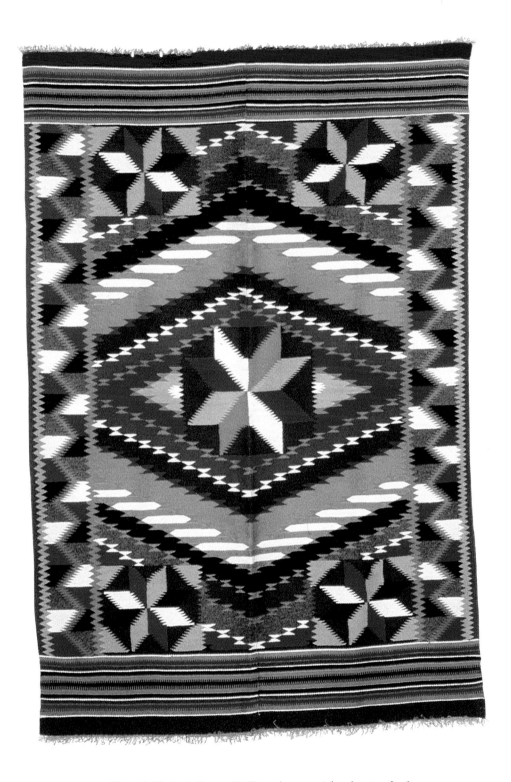

Plate 44 | Blanket in Trampas/Vallero style, commercial wool warp and weft,
undated. Minnesota Historical Society, St. Paul, Minnesota, 10,000.1070.

4

The Modern Period

1920–1995

The modern period, which began following World War I, was a time of dramatic change and growth for Hispanos and their weaving. Increasingly, Hispanos were drawn into contact with the Anglo world. Service in two world wars took Hispanic men out of New Mexico as more Anglos entered the state. Many of the Anglo immigrants have had a considerable interest in indigenous arts and culture and have exerted a strong influence on the development of Hispanic weaving. Anglo tourists have become more plentiful as the state's tourism industry has burgeoned; tourists have had a significant impact on the state's economy. However, these changes did little to alleviate the endemic poverty of Hispanic northern New Mexico, which has remained a pressing problem throughout the modern period. During the Great Depression of the 1930s, and again during the 1960s War on Poverty, organized government attempts were made to stimulate craft production, particularly weaving, as one pathway to economic development. Today, government, private, and religious organizations continue the ubiquitous effort to make weaving a viable source of livelihood for New Mexico Hispanic weavers.

Early Modern Period (1920–1940)

Prior to the modern period, crafts in New Mexico had been identified as a commodity within the tourist industry. However, just what form this commodity was to take in the decades after the war became the subject of a covert struggle. On one side of the struggle were the blanket dealers, those from rural areas as well as curio dealers from Santa Fe, who had shaped the woven curio product in the early years of the century. They continued to supply small, portable items of tourist art for the "popular taste" market. The other side of the struggle was carried on by educated, enlightened Anglos who promoted an alternative craft product based on a different aesthetic system. Both in terms of social class and educational and professional background, this second group represented a "high taste" culture.[1] They joined forces to promote the revival of Spanish colonial arts and crafts. Stimulated by severe economic need precipitated by the Great Depression, new institutions for the promotion of this alternate form of Hispanic crafts were born.

Within this social context the changes affecting the craft of weaving during the early modern period are discussed in two parts: first, examining the growing Anglo community and its influence on the craft; second, looking at changes in Hispanic life in rural New Mexico and how these changes influenced the craft.

Chimayó Weaving

Hispanic Weaving and the
Anglo Arts Revival in Santa Fe

Northern New Mexico began to attract Anglo artists in the late nineteenth century; by the 1920s art colonies had sprung up in Santa Fe and in Taos. Artists shared a common philosophical outlook with other educated Anglos who had settled in New Mexico after the turn of the century: writers, anthropologists, and philanthropists. They also shared an ideology that was related to larger social movements of the nineteenth century. These movements were negative reactions to the Industrial Revolution—to mass-produced goods and the nature of work performed by machines. The Englishman John Ruskin cast in philosophical terms the notion of rejecting machine-made products in favor of those produced by hand. Building on Ruskin's philosophy, William Morris, another Englishman, attempted to put these ideals into practice by establishing crafts workshops. Unfortunately Morris, a socialist, never resolved the conflict between the high cost of handcraft production and the low cost of mass-produced goods. The masses could not afford hand-crafted goods. However, based on Ruskin's and Morris's work, arts and crafts revival groups sprang up all over the Western world after World War I. "In the eyes of crafts' promoters, the baskets, pottery, and—most of all—textiles produced by women from 'folk' or 'primitive' societies became symbols of the self-expression possible within the family economy. As such, they suggested an alternative to the factory system for women forced to enter wage labor.

Philanthropic art industries would tap the potential of women's culture to provide wholesome, creative labor for the needy."[2]

The arts and crafts revival movement had a dedicated following in New Mexico. There were writers (for example, Mary Austin and Alice Corbin Henderson), anthropologists (such as Kenneth Chapman and Frank Mera), artists (like Frank Applegate and H. Cady Wells), philanthropists (such as Mary Wheelwright and Mabel Dodge Luhan), and an architect (John Gaw Meem). They were "muses seeking respite from the crunch of twentieth-century industrial culture."[3]

The strong idealism and social consciousness of these and like-minded individuals led to their involvement on behalf of the rights of Native Americans. The preservation of native arts was of special concern, and in 1922 the Pueblo Pottery Fund (later the Indian Art Fund) was established. One of the most active figures in this group was Mary Austin, a world-renowned literary figure and lecturer of the day. Prior to locating in Santa Fe in 1918, Austin had lived in California, New York, and London and had been exposed to her era's most progressive ideas. She set as her goal the "possibility of the reinstatement of the hand-craft culture and of folk drama, following the revival of those things in Mexico." As Austin herself put it, "I got up from my bed and set the revival of Spanish colonial arts in motion." The impact she had upon others is evident in the nickname given her by her writer-friends: "God's mother-in-law."[4]

In 1922 Austin met a kindred soul, her neighbor, artist Frank Applegate. Austin attributed Applegate's interest in Spanish crafts to his interest in collecting old Hispanic pieces and finding people to repair them. Applegate, and many others, used Spanish colonial antiques to decorate their adobe homes and ranches (fig. 4.1). Eventually the prices of colonial-era crafts, such as weaving, began to escalate. Fergusson wrote in 1928, "Blankets made of hand-spun wool on clumsy wooden looms now

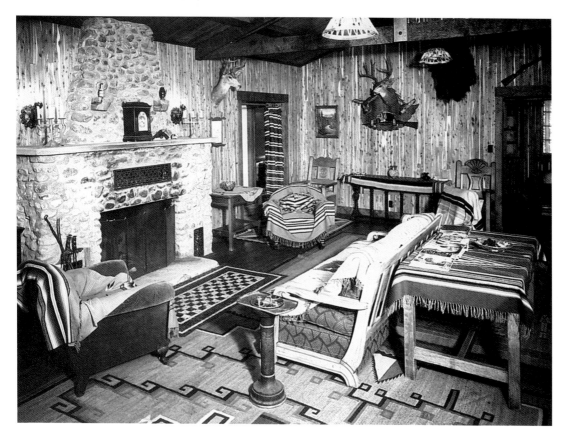

Figure 4.1 | *Sitting room, Jesús Baca Ranch, northern New Mexico. History Library, Palace of the Governors, Santa Fe, negative no. 88083. Photo by T. Harmon Parkhurst, ca. 1935.*

bring almost fabulous sums."[5] As antiques became scarcer, some Anglos felt that reproducing these old pieces could generate income for poverty-stricken Hispanos.

However, the revival movement in New Mexico was not strictly an Anglo affair. There were always some Hispanos associated with the movement and with related programs. For example, in 1929 the distinguished Ortiz y Pino family, led by Concha Ortiz y Pino de Kleven, established the Colonial Hispanic Crafts School in Galisteo.[6] These Hispanos shared the high taste culture ideals of their Anglo counterparts and viewed tourist weavings as inferior items with "debased Indian designs"; items of popular culture were considered inferior.[7] In 1935 Hispanic teacher and researcher Mela Se-

dillo-Brewster spoke of the "degeneration" of Hispanic weaving to the "so-called 'Chimayo blanket,'" which she later described as "an inferior article both in color and design."[8]

In support of their views, revival enthusiasts undertook fund-raising activities. They were politically active, working for civic improvement while trying to maintain the "ancient character and charm" of the area.[9] "They promoted the survival of native arts, crafts and ritual practices and at every step vehemently opposed visible manifestations of modernization and assimilation . . . ; they actively worked to preserve the quaint, rustic, scenic, and foreign character of the region as well as the 'traditional' appearance and practices of its native people."[10]

Chimayó Weaving

The Anglo activists worked cooperatively with groups such as the Chamber of Commerce, the Fred Harvey Company, and the Santa Fe Railway to stimulate tourism. Paradoxically, even as the artists and writers were struggling to maintain the "purity" of the region, they were affecting the direction of local crafts by promoting tourism. Furthermore, the revivalists were tourist attractions in their own right. Many relied heavily on income from the sale of their books and artwork to tourists. Some local tours organized for tourists included visits to artists' studios.

The Spanish Colonial Arts Society

In 1925 Austin, Applegate, and their associates established the Society for the Revival of Spanish Colonial Arts. The next year, Hispanic crafts were exhibited at a Spanish Market in the new Fine Arts Museum in Santa Fe in conjunction with the annual fiesta. By 1929 the society had incorporated as the Spanish Colonial Arts Society (SCAS). The goals of the organization were stated in its certificate of incorporation:

> The objects of this corporation are and shall be as follows: To encourage and promote generally in New Mexico and elsewhere Spanish Colonial Art; to preserve and revive the Spanish Colonial art of every character, to perpetuate and disseminate Spanish Colonial art in all its phases and manifestations; to promote and maintain suitable facilities and properties for the preservation of Spanish Colonial art and to that end to purchase, lease, or otherwise acquire real estate or personal property for the housing of collections of Spanish Colonial art; to educate the public generally and the members of this corporation especially in the importance of Spanish Colonial art in the civilization of New Mexico and elsewhere, present, past and future, and in the various phases of

earlier art as well as its modern development in every branch of the same; to promote, conduct and maintain a school or schools for the teaching of Spanish Colonial art and its development from the earliest possible material and information available for that purpose to the present time; to provide for and cause the delivering and holding of lectures, exhibitions, public meetings, entertainments, classes and conferences calculated directly or indirectly to cause interest in or the advancement of Spanish Colonial art; to print, publish, distribute and sell (not for profit) magazines, articles, pamphlets and reports for the dissemination of knowledge concerning Spanish Colonial art throughout the world; to acquire, preserve and protect places, property, both real and personal, things and articles relating to or exemplifying or representing Spanish Colonial art, and to provide for the custody thereof; to restore places, things, buildings and property, both real and personal, relating to or exemplifying Spanish Colonial art.[11]

That same year the society purchased the Santuario at Chimayó from the Hispanic descendants of the chapel's builder who could no longer afford its upkeep. Funds for this purpose were raised by Mary Austin who located a Catholic benefactor through her contacts in the eastern United States.

Government Programs during the Depression

In the early 1930s the imperative of the arts and crafts movement in New Mexico was intensified by the economic depression overlaid on endemic poverty. Arts and crafts were seen as one way for low-income groups—the rural Spanish-Americans, for example—to generate income. One leading Anglo supporter, Leonora Curtin, described her own efforts: "I had returned to Santa Fe from the gloom enveloped East and I saw everywhere in

the rural or village life of New Mexico, opportunities for the Spanish New Mexican people to help out their shrunken and meager economy by revival of their old and traditional handicrafts. . . . Ever mindful of the advantages in self respect that earning power offers over charitable or government aid, I made bold to speak out; I talked craft revival, teaching, marketing and every aspect to all who would listen."[12]

The ideology of the arts and crafts movement, as expressed by SCAS members, had great impact on the offerings of publicly sponsored programs and in the formation of new programs during the depression. The impact of the revival ideology can be seen in the case of the Normal School at El Rito. The Normal School had been established by the territorial government of New Mexico in 1909 to train Spanish-speaking teachers to serve the people of Spanish-speaking counties in the territory and to train students in vocations: industrial arts and useful trades, including rug weaving. A unique feature of the El Rito Normal School was that it was the only publicly sponsored boarding school of its day. By 1930 the El Rito School was a model school, a showplace for visiting professional educators.

There was even a special building for the weaving program at the school. A writer of the day proclaimed: "The school is making a beginning in promoting the old Spanish-Colonial Hand Crafts." The making of "modern Chimayó blankets" was de-emphasized in favor of blankets with Saltillo or Navajo designs (plate 45). "With the securing of new equipment, true copies of old Chimayo, old Navajo and old Spanish Colonial rugs and blankets can be made, as well as modern adaptations of rugs, vests, table runners, blankets and shawls. . . . In addition to the actual weaving, rug design is taught, originality is encouraged, and the history of the old designs and methods are studied."[13]

Public funds were made available for these programs. In 1917 the federal government had passed the Smith-Hughes Act providing federal aid for

The Modern Period

Figure 4.2 | Drawing of a banded blanket from the Weaving Bulletin, *published by the New Mexico State Department of Trades and Industries, 1937. History Library, Palace of the Governors, Santa Fe.*

vocational training at the secondary level. Under this law, the federal government covered 50 percent of the costs of such training. Additional provisions of the act provided for teacher training and research. In 1932 Brice Sewell was appointed state director for vocational education and training. He proceeded to develop a network of schools where crafts were taught in towns and rural areas throughout the state. Sewell skillfully blended a variety of federal, state, and local sources to fund these programs. Together with Leonora Curtin, he persuaded the U.S. government to use federal funds for

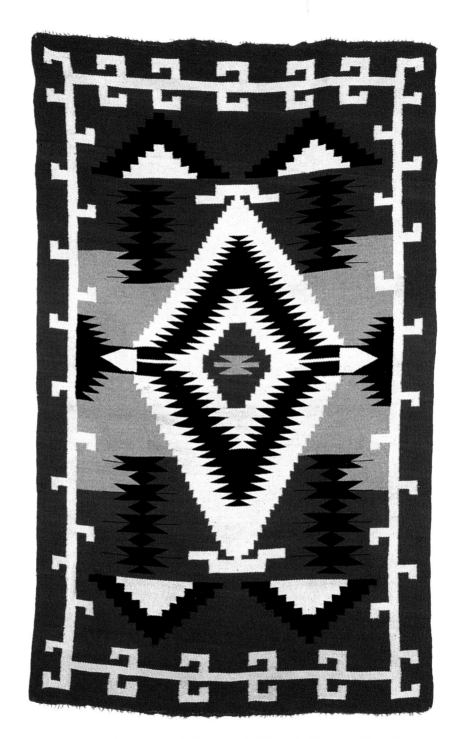

Plate 45 | Blanket from El Rito, probably woven at the El Rito School, based on a Navajo design, ca. 1930. Commercial yarns, 91 x 54 in. Spanish Colonial Arts Society, Inc. Collection on loan to the Museum of New Mexico, Museum of International Folk Art, Santa Fe, New Mexico, L.5.69-6. Photo by Miguel Gandert.

crafts education, making New Mexico the first state to receive federal aid for this purpose.[14]

Sewell also promoted the teaching of crafts in secondary schools. He launched the development of a series of mimeographed booklets as instructional material, including booklets on natural dyeing and blanket designs (fig. 4.2).[15] In addition to the El Rito program, craft programs were established in several other locations in the northern part of the state.[16] These vocational programs were very broadly conceived. Today they might be termed community development programs, since workshops served as "cultural centers" or "community gathering places." Students ranged in age from eighteen to sixty. Teachers would stay one to two years to establish the program and then move on. The schools trained craftspeople in a variety of crafts, which were then sold at places like the Spanish Arts Shop and, later, the Native Market, both managed by SCAS members.

WPA art programs focused primarily on fine arts. However, a museum exhibit in 1936 not only featured works in oil, watercolor, and pastel but also included woodcarving.[17] Clearly WPA fine arts projects were aimed at Anglo artists with the rare exception of a few Hispanic artists such as woodcarver Patrocinio Barela. Crafts projects were targeted primarily to ethnic minorities.

During the time these vocational programs were operating, the 1935 *Tewa Basin Study,* which provided a detailed picture of economic life in northern New Mexico, was published. The study was undertaken by the U.S. Department of the Interior to document economic life in northern New Mexico. It was both a study of the land and a study of ethnic groups. Compared to the typical romantic descriptions of northern New Mexican Spanish-American life written by most Anglos of the day, the *Tewa Basin Study,* an early example of applied anthropology, provided more objective and highly valuable information based on extensive fieldwork. It also contained plentiful data on the weav-

Figure 4.3 | *Interior of Spanish Arts Shop, Sena Plaza, Santa Fe, showing the range of goods sold, including weaving, early 1930s. Native Market Collection, El Rancho de las Golondrinas, La Ciénega, New Mexico.*

ing industry. The picture painted by the study differed from that painted by the glowing accounts of craft projects portrayed in popular magazines. The study states: "At the present time the State Vocational Training Department is attempting to start a revival of weaving and woodwork, and they have a couple of Smith-Hughes-paid teachers on the staff of the Santa Cruz High School. . . . 23 [students] are taking up weaving. . . . One of the teachers estimates that probably 10 percent of these will follow up and attempt to make a living at weaving or woodwork. The reason for this is that the wages per hour on handicraft work remain extremely low, 15 cents at best." This impression was substantiated by Ernest Lyckman who was a state handicrafts specialist under Brice Sewell. He calculated that a weaver could earn only ten cents an hour: "The economics of it were absurd."[18]

In 1930 the Spanish Colonial Arts Society opened its Spanish Arts Shop in Sena Plaza (fig. 4.3). The Spanish Arts Shop "bought and delivered materials to craftsmen in the villages, then bought the finished crafts from them and sold them at a small markup."[19] Woven blankets were among the most successful items sold in the store. Unfortunately, the shop closed in 1933, after having been in

Chimayó Weaving

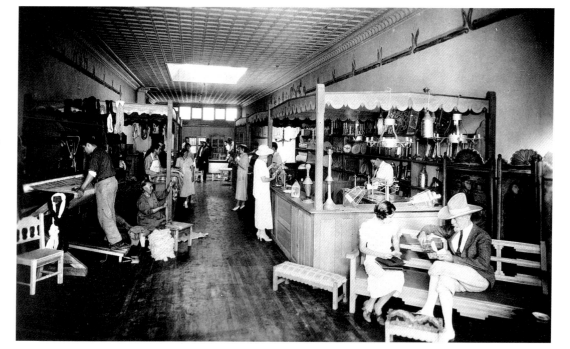

Figure 4.4 | Interior of Native Market, Santa Fe, mid-1930s. Native Market Collection, El Rancho de las Golondrinas, La Ciénega, New Mexico.

operation only three years. It never achieved financial solvency. The shop "failed to pay for its maintenance" but "attracted much favorable attention and did valuable spade work in bringing a realization to the native people that their crafts could be revived on a commercial basis: in other words, they learned that some of them knew how to make things their Anglo friends found desirable to own."[20]

Frank Applegate died the same year the shop closed, 1933, and in 1934, Mary Austin also passed away. The Spanish Colonial Arts Society languished during the next few years. It was revived briefly in 1938 and again reactivated in 1952. To date it enjoys a vigorous existence.

Native Market

Just as the Spanish Colonial Arts Society's vigor waned in the mid-thirties, another energetic leader emerged to stimulate the revival of Spanish colonial arts: Leonora Curtin. In 1934 six months after the Spanish Arts Shop closed, Curtin opened the Native Market to market Hispanic goods.[21] This new shop had much in common with its predecessor. For example, materials were procured for weavers and delivered to vocational schools and to those who worked in their homes. Leonora Curtin even went to Gallup in search of long-strand fleeces; they probably were of the *churro* variety.[22]

In contrast to the Spanish Arts Shop, the Native Market was bigger and had better "appointments"; it had a "larger and more elaborate stock." Weavers and spinners worked "in public view" (figs. 4.4 and 4.5). It was "one of the show places of Santa Fe."[23] About thirty weavers and one hundred spinners were among the craftspeople who contributed their work to the Market. Textiles were high-demand items. The Native Market sold upholstery, draperies, blankets, rugs, and bedcovers (plates 46–48). In addition to weaving produced on the premises, weaving was also done in homes

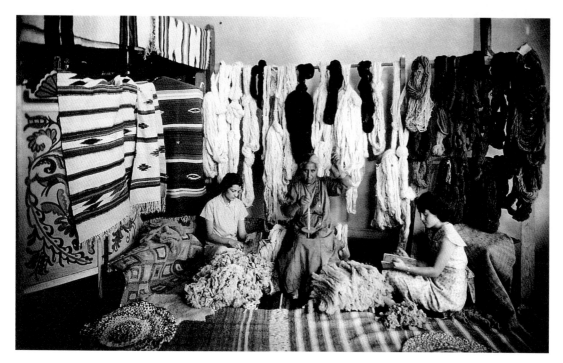

Figure 4.5 | *Yarn spinners at Native Market, Santa Fe, mid-1930s. Native Market Collection, El Rancho de las Golondrinas, La Ciénega, New Mexico.*

in Nambé, Taos, Española, Córdova, and Santa Rosa.[24] The work of Chimayó weavers was not sold at the Native Market because these weavers used commercial yarns and dyes; their products were thus considered inferior to those produced of handspun, hand-dyed yarn.

Dolores Perrault, who had written a booklet on natural dyeing for the State Department of Vocational Education and Training, took a leave from that agency to help with the selection of crafts for the Native Market and to supervise the dyeing of yarn. Other fiber goods were also sold, such as rag rugs, braided and hooked rugs, and pillows made of "rags woven through gunny sacks," which must have resembled hooked rugs.[25]

Business was supported by the Santa Fe arts community. Further, the Native Market became a tourist attraction and was included on the tour of the "Indian Detour" buses. Curtin also encouraged products that fit into the decor of the times: "The Market offered guidance in the design of

high quality, traditional New Mexican crafts. Designs were adapted for contemporary living when it seemed necessary, and craftsmen were also encouraged to experiment within this tradition."[26] "Individual taste, as well as comfort and convenience, was catered to."[27] In 1936 Leonora Curtin opened a Tucson branch of the Native Market.

In spite of Anglos' well-intentioned efforts, the Native Market suffered financial losses each year and was always dependent upon Leonora Curtin's subsidy. "The ordinary tourist, with no background for hand-made crafts, comes in, watches the spinning and weaving with interest, stares at the wood-work with curiosity, and walks out again."[28] As Mera notes, "Unfortunately, this attempt [at revival] seems not to have met with enough popular approval to continue the effort." Mera also points out the difficulty presented by "the cost of production under modern standards of compensation."[29]

The price of the revival blanket, for example,

Chimayó Weaving

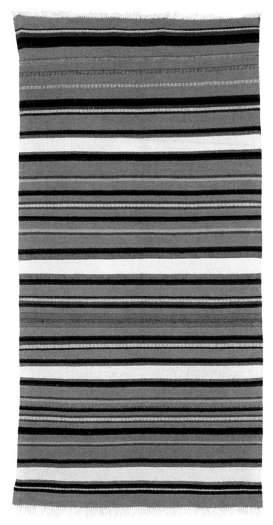

Plate 46 | Jerga *woven at Native Market by David Salazar,* *1930s. International Folk Art Foundation Collection at the* *Museum of International Folk Art, Santa Fe, New Mexico,* *FA.66.68-1. Photo by Miguel Gandert, 1992 (left).*

Plate 47 | *Brazilwood blanket woven during the Revival period.* *It reproduces the colorful striped pattern of the earlier Rio Grande* *brazilwood blankets but is woven with commercial yarn, ca. 1930s.* *Museum of New Mexico Collections, Museum of International* *Folk Art, Santa Fe, New Mexico, A.82.22-6. Photo by Miguel* *Gandert, 1992 (right).*

Plate 48 | *Probable Native Market blanket, judging from* *the desaturated hues. The smooth surface indicates the use of* *commercial yarns, 84 x 46 in. Millicent Rogers Museum of* *Northern New Mexico, Taos. MRM1981-37 (opposite).*

was higher in price than its Chimayó counterpart produced strictly for the tourist trade, much less the factory-produced blanket. It could also be argued that the revival-woven products did not have aesthetic appeal to the popular-taste culture consumer.

During this period, in spite of the enthusiasm of the wealthy Anglo patrons in northern New Mexico, Hispanic crafts never "caught on" nationally in the way Indian crafts did. Interest was fairly well limited to the Southwest and Southern California, the areas in which the adobe hacienda revival was taking place.

The major interest in Hispanic crafts was as furnishings for these comfortable Southwestern-style adobe homes. These crafts were not, as were the Indian, viewed as valuable art objects in themselves purchased with an eye for speculation.[30]

In 1937 and 1938 a major, though short-lived, undertaking brought together a number of businesses, including the Native Market, to form Parian Analco, a re-creation of a Spanish plaza. The Parian Analco had shops, restaurants, and a bar, as well as booths for produce and crafts. Entertainment was also provided in the form of concerts, dances, and plays.

Blanket dealers from the Chimayó area became involved in the Parian Analco. In 1937 E. D. Trujillo sold Chimayó blankets at a booth. José Ramón Ortega was in charge of weaving neckties. Other weavers included Alfredo Catanach, Valentín Rivera, and Max Ortiz. There can be no doubt that the Parian Analco enterprise was an undertaking designed for tourists. Leadership was in the hands of Leonora Curtin and Major R. Hunter Clarkson, head of the Indian Detour Company. After two years of operation, the Parian Analco closed: "The idealistic venture had proven to be on too large a scale to support itself."[31]

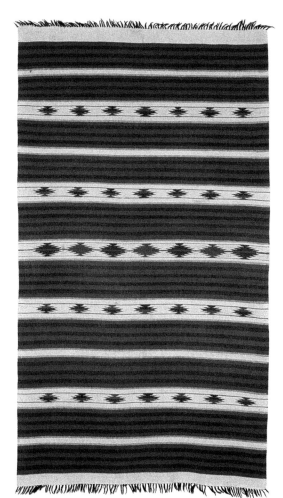

The Modern Period

Tie Dealers

The training weavers received as part of the government programs was also put to use in some nonrevival weaving businesses in Santa Fe. Helen and Preston McCrossen were weavers recruited in 1930 by Mary Austin to come to Santa Fe. Helen McCrossen had operated the Spanish Arts Shop when it first opened. The McCrossens then opened a handweaving business in the mid-1930s, which employed Hispanic weavers to weave fabric for neckties and other handwoven goods, such as scarves and handbags. The business was housed in

an old church in Santa Fe (fig. 4.6). Within eight years, the McCrossens had seventy-two employees. Between 1935 and 1938, the peak years, McCrossen weavers produced an average of seventy-five thousand ties per year (plate 49).[32] Hispanic Chimayó products were still being marketed as Indian goods in the early 1940s. McCrossen commented that "even as late as 1942 one of our good customers . . . publicized our ties as being handwoven by 'Chimayo Indians.'"[33]

Camille Padilla also owned a weaving business in Santa Fe in the 1930s. She was an Hispanic New Mexican from a sheep-raising family. Her business

Figure 4.6 | *"Weavers of Chimayo helped to establish Santa Fe's weaving industry," reads the caption of a photograph which appeared in Trumbo (1947:19). History Library, Palace of the Governors, Santa Fe, negative no. 57797.*

was one of several in the state financed by Nat Stern, "a New Yorker with millions."[34] Another firm was owned by E. M. Knox, a retiree from Kansas City. Knox went directly to rural New Mexican villages and recruited young weavers, whom he described as "all young, Spanish Americans with weaving in their blood."[35] Other shops employing Hispanic weavers were Burro Weavers, Southwestern Arts and Crafts, Southwestern Master Craftsmen, Rio Grande Weavers, Sandia Weavers, and Tewa Weavers. Ties from the tie-weaving industry enjoyed worldwide distribution. "Here too, the art of weaving has found a field in which it offers something of real worth . . . produced in as attractive patterns as a man could wish."[36]

Accomplishments of the Revivalists

The revivalist emphasis on quality materials heightened the aesthetic awareness of Hispanic dealers and weavers. By 1937 dealers were discontinuing

the use of cotton carpet warp.[37] In an era of bitter racism in the region, the revivalists were also a countervailing force helping to elevate Hispanic crafts and, by extension, Hispanos to a position that commanded some respect.

Early Anglo settlers had not drawn a distinction between local Spanish-speaking peoples and those from "South of the Border." Those in the revival movement began to use the term Spanish-American to refer to people who had been called Mexicans up until this time. In the 1930s some Anglos referred to Spanish-Americans as "irresponsible, shiftless, dishonest, untrustworthy, sometimes brutal as well as dangerous." "[T]eachers regarded their Spanish-American pupils as "subnormal in intelligence and generally inferior biologically."[38]

The new designation, Spanish-American, gave recognition to the distinctive characteristics of the culture of the rural northern New Mexican populace and fostered heightened awareness of their

cultural—particularly artistic—traditions. Stress was placed on *Spanish* roots and European antecedents were emphasized, forging a link between Anglo-Americans of European heritage and Hispanos.

However, this emphasis on Spanish heritage created two artificial impressions: first, that there had been little *Mexican* influence in northern New Mexico and, second, that there had been virtually no interchange between Spanish settlers and the local Indian population. The connection to a Mexican past and to Native American influence was severed; "in the process of lauding the Spanish roots of New Mexico culture, its Mexican roots were downplayed or ignored; . . . all aspects of Hispanic culture in colonial New Mexico were filtered through the colony of New Spain."[39]

Paternalism

Underlying the attitudes of those involved in the arts revival in Santa Fe was the "idealistic, uplifting, optimistic yet paternalistic spirit" of the arts and crafts movement in general.[40] A complex mix of romanticism, paternalism, and racial and religious stereotypes were reflected in statements about Hispanic New Mexican artisans. Ample examples are found in the Anglo literature of the 1920s and 1930s:

> Spanish people have just the temperament and artistic nature to devote themselves tirelessly to producing the useful and beautiful.[41]

> Perhaps his warm black eyes, his gay spirit, his love of play and his gift for beauty will bring into the life of New Mexico something which the rest of the country may well envy.[42]

> They wove and sang at their weaving for it had been ever thus.[43]

Plate 49 | Men's ties handwoven by Hispanos during the 1930s. Visible are labels used by two Santa Fe weaving concerns: left, Rio Grande Weavers, and right, McCrossen's Caballero line. Collection of Lane Coulter. Photo by Lane Coulter, 1995.

> The chief endowment of our native Spanish-speaking people is creative craftsmanship.[44]

> [Aesthetic expression] is in their blood and they cannot escape it.[45]

> [Of Celso Gallegos, a santero]: His carvings are primitive, not because of any conscious attempt on his part to make them so, but because he himself is primitive and has not lost the magic of religious emotion.[46]

Operating within this paternalistic framework, revivalists could speak of "discovering" Hispanic

Chimayó Weaving

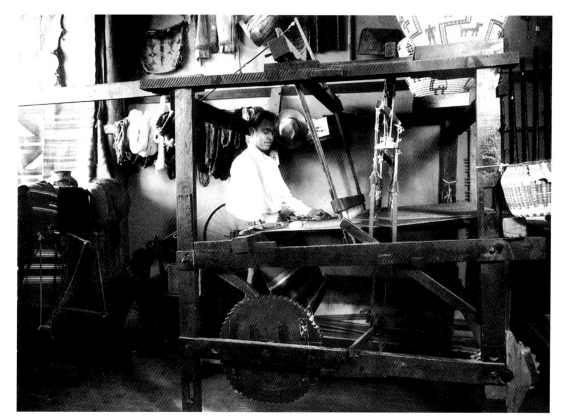

Figure 4.7 | Weaver at Julius Gans's Southwestern Arts and Crafts shop on the Plaza in Santa Fe. History Library,
Palace of the Governors, Santa Fe, negative no. 6918. Photo by T. Harmon Parkhurst, ca. 1935.

crafts: "Mary Austin and Frank Applegate and other members of the Spanish Colonial Arts Society have discovered a great many skillful craftsmen," and "Mary Austin and Frank Applegate, two of the Spanish Americans greatest friends, Dr. F. E. Mera, John G. Meem, George M. Bloom, and others, several years ago undertook to work out a plan that would awaken the slumbering abilities of the native craftsmen."[47]

Regarding Hispanic woodcarvers, Briggs noted: "When they did not find artists producing the types of objects they expected, they declared the art to be dead." However, the "assessment of the demise of Hispano culture was surely greatly exaggerated."[48] Revivalists appointed themselves arbiters of the Spanish colonial tradition, selec-

tively determining those aspects of the past to be emphasized: "The old blankets called Chimayo, but woven in the Spanish villages since the earliest days, are not so fine as the Saltillos of Mexico, but they are just as beautiful in color and design and have little relation to the blanket now sold under the name of Chimayo. An effort is being made to revive the older type of blanket with its happier color and design."[49]

Chimayó-style weaving of the northern villages was denigrated and ultimately deleted from the portrayal of traditional Hispanic crafts by Anglo revivalists. Weavers recruited by the revival programs sometimes wove in the Chimayó-style, but its legitimacy as a traditional craft was questioned. Undeniably, the definition of traditional was mold-

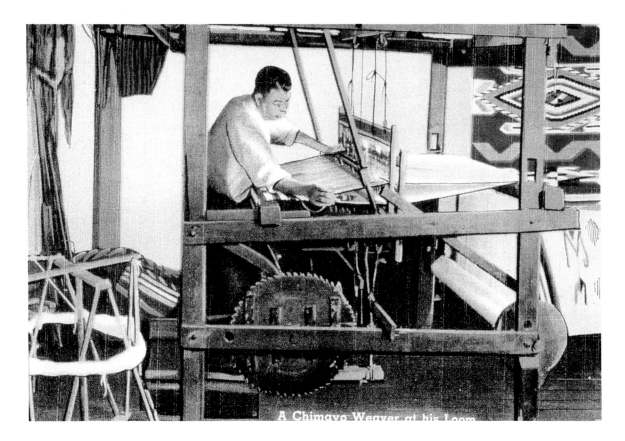

Plate 50 | Postcard of Chimayó weaver, 1930s. Collection of Helen R. Lucero. Photo by Suzanne Baizerman.

ed to suit Anglo tastes and sensibilities. Nontraditional products, such as purses, were marketed in revivalist-run stores in response to Anglo demand. Colcha and handspun weaving were used as upholstery fabric; in the words of one Anglo, this upholstery "lends the use of these seats to sophisticated surroundings." Furniture and carved designs were made in old patterns "unless a purchaser expressly orders otherwise."[50]

Emphasis was placed on the form, colors, and materials of an object. Among the Anglos in Santa Fe were "people with the training which would enable them to evaluate the decorative art of the New Mexican aboriginals." According to Briggs, "the 'revival' involved a classically patronizing formula—the appropriation of control over an ethnic resource primarily by members of a superordinate society. Accordingly, the patrons attempted to direct the evolution of the art according to a set of principles that emanated from the concerns of their cultural milieu rather than those of the Hispano artists."[51] An example is the woodcarving style that developed in Córdova, New Mexico, during the 1930s in response to Anglo aesthetic preference for unpainted, chip-carved sculpture.

The Revival Movement and Hispanic Weaving

For the craft of weaving, revival meant the abandonment of recently acquired commercial yarns and a return to handspun wool. It also meant a return to natural dyes. Although such a change

might appear simple, the carding of wool, the spinning of yarn, the gathering of dyestuffs, and the dyeing of yarn were time consuming and physically demanding processes, requiring much more time to perform than weaving. Therefore, a return to these more arduous phases of production might have seemed strange to the weaver grown accustomed to using a high-quality, commercially prepared yarn. James, in 1914, described asking a "keen-brained Mexican father" why he was using cotton warps and why spinning and weaving had been abandoned. The father replied: "Our girls do not want to work so hard as their mothers did. They would rather go to school and make a speech than card, spin, and dye wool."[52]

The more subdued colors of natural dyes and the textural richness of handspun yarns in Spanish colonial textiles appealed greatly to the tastes of the revivalists. In the name of "preserving" Spanish-American crafts, they attempted to control the aesthetic decisions, as well as decisions about the process of production. They "defined the category of 'traditional' Hispano art and determined which works conformed to this definition on the basis of their own historical assessment and aesthetic judgment rather than upon the Hispano artists' understanding of their heritage."[53]

In the case of the Hispanic blanket, the connoisseur wanted a high-cost, labor-intensive product that was handspun and hand-dyed but was not geared to a lucrative commercial market. Indeed from the most sinister perspective, the Anglo preference for these hand processes could be viewed as one way to keep the Hispanic artisan in an economically inferior position, perpetuating a "colonial" relationship.

While the revivalists saw themselves as attempting to revive dormant craft skills, in taking control of decision making they inadvertently became more involved in a creative process than a restorative one.[54] Their focus was on certain design systems and certain processes of production; these

informed decisions about what was to be promoted. However, these elements of design and processes were narrow ways of looking at, and defining, a traditional craft. Such a definition implies that craft is merely the object produced by the craftsperson. A broader view of craft would also consider the object's social and cultural context and see craft as an ever-evolving part of culture. Strictly speaking, reviving a craft is impossible unless the social conditions are revived as well. For the Hispano weavers this would have meant a return to a precash economy.

Weavers in the Early Modern Period

Little information has been compiled about weavers from before World War I. Fortunately, living weavers and families of weavers have been able to provide a more complete picture of the craft of weaving following the First World War. Other data, such as volume ii of the 1935 *Tewa Basin Study* also help illuminate the period.

The Growth of the Chimayó Weaving Industry

As tourism grew and brought more customers to northern New Mexico, Hispanic weaving businesses in Chimayó expanded to meet consumer demand. Among the Chimayó businesses were those of Nicasio Ortega, started in 1918 and joined shortly thereafter by Severo Jaramillo, Reyes Ortega, and E. D. Trujillo. In Santa Fe several other curio businesses opened in competition with Jesús Candelario to serve the growing number of tourists. For example, in 1916 Julius Gans, a lawyer-turned-collector from Chicago, opened his Southwestern Arts and Crafts shop on the plaza in Santa Fe. Both he and Candelario had weavers working in their stores (fig. 4.7). The La Fonda Hotel and Gift Shop, the Old Santa Fe Trading Post, and the Spanish and Indian Trading Company opened in the 1920s. By 1928–29 thirteen curio shops were listed in the first edition of the Santa Fe City Directory.

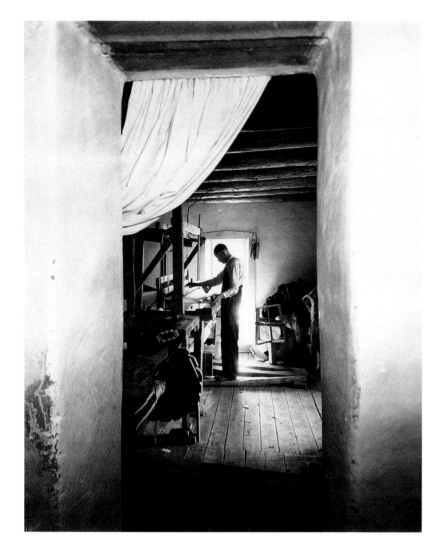

*Figure 4.8 | Reyes Ortega
at his loom, Chimayó, New
Mexico, 1939. Photo "Chimayo
Weavers" by Laura Gilpin.
P1979.202.241. Copyright
© 1979, Amon Carter
Museum, Fort Worth,
Texas, gift of the Estate
of Laura Gilpin.*

Before the roads were improved, tourism in northern New Mexico had been limited to an occasional scholar, such as James in 1912, and groups of tourists from guest ranches: "Guests at the El Mirador Ranch in the early 1900s rode on horseback to Chimayó to buy blankets."[55] By the 1920s touring cars could be rented in Santa Fe for "Roads to Yesterday" trips to Indian Pueblos and to see "Mexican settlers." In 1927 the ninety-mile round-trip from Santa Fe to Chimayó, including stops at Truchas and Córdova, cost thirteen dollars per person with a three-person minimum. Tourists could watch "the weaving of colorful blan-

kets growing before their eyes on 100-year-old foot looms" (fig. 4.9).[56] Most tourists were from the middle class, although the wealthy and famous also enjoyed these tours. By the 1930s the heyday of hired touring cars had passed. Tourists had acquired personal automobiles and drove themselves to the northern villages on the newly constructed national highway system.[57] They could now travel directly to Chimayó to visit weavers in their homes and stores.

In response to the growth of tourism, the number of Hispanic weaver-entrepreneurs increased. In fact, their keen abilities as businessmen earned Chimayósos the nickname "the Spanish-American

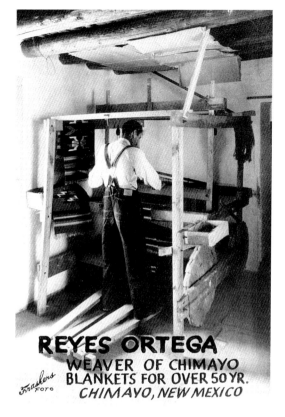

Figure 4.9 | Reyes Ortega's calling card, ca. 1930s. Southwest Museum, Los Angeles, California, photo no. N.42463 (Frasher Fotos).

Figure 4.10 | Esquipula DeAgüero (E. D.) Trujillo portrait in Chimayó jacket, 1917. Collection of Leo Trujillo, Chimayó Trading Post, Española, New Mexico.

go-getters."[58] The businesses of established weavers grew, with Severo Jaramillo selling woven goods from his gas station and Nicasio Ortega from his general store. Reyes Ortega continued his professional weaving establishment (fig. 4.8, plate 51). "The *sala* was always piled high with blankets." As testimony to his increasing business success, Ortega began to order large shipments of yarn from Germantown, Pennsylvania. He also developed a pool of weavers whose work he marketed and had calling cards printed with his photograph on them (fig. 4.9).[59]

More men were added to the ranks of the established businesses; most were working from their general stores. In 1921 Ursulo Ortiz Sr. began selling weavings in his gas station/grocery store.

Another Chimayó entrepreneur, E. D. Trujillo, opened a general store in Chimayó in 1921 (fig. 4.10). Trujillo began his career working at Ilfeld's Mercantile Store in Las Vegas. After Trujillo gained business experience, his boss at Ilfeld's helped him set up his own mercantile store in Chimayó.[60] Emilio Córdova, another weaver-entrepreneur, is shown in his general store in Córdova, New Mexico which also housed the local post office (fig. 4.11). Besides waiting on customers in the store and serving as postmaster, Emilio and his wife, Josefita, wove textiles for the blanket dealers (see plate 60).

The most enterprising entrepreneurs "put out" yarn to weavers and took in weavings to sell. Some, like Severo Jaramillo and Nicasio Ortega and his

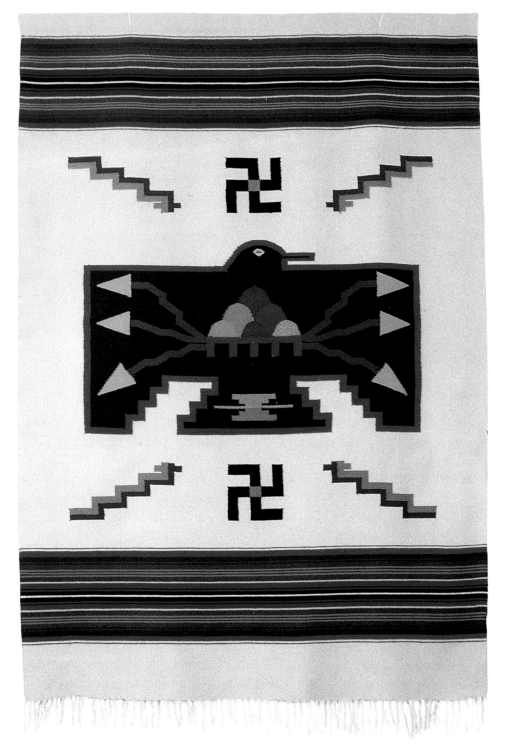

Plate 51 | Weaving with a stylized bird woven by Reyes Ortega, 1932. Collection of David Ortega.
Photo by Miguel Gandert, 1992.

Chimayó Weaving

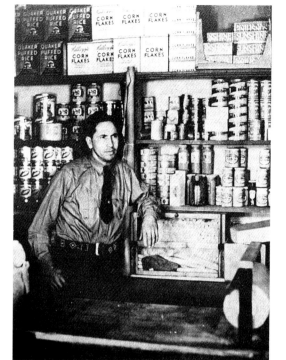

Figure 4.11 | *Emilio Córdova, postmaster of Córdova, New Mexico, in his general store, 1930s. Photo reproduced from Volume II of the 1935* Tewa Basin Study, *reprinted in 1975 as* Hispanic Villages of Northern New Mexico, *edited by Marta Weigle.*

family, also went "on the road" to sell weavings to national park gift shops and other tourist establishments. Their close association with Santa Fe curio dealers undoubtedly provided the Hispanic businessmen with valuable learning experience about this particular type of marketing strategy. For example, like the Santa Fe dealers, E. D. Trujillo sold directly to the Fred Harvey Company (fig. 4.12).[61] Nicasio Ortega's son, David, has also recounted his "on the road" travel experiences, which included trading Hispanic weavings to Navajos; the Navajo weavings received in return were then proudly displayed on the outside of the Ortegas' Chimayó store, hung over the railings alongside Hispanic weavings.[62]

Like their Santa Fe counterparts, the rural entrepreneurs diversified their line of goods to reach a bigger market. Santa Fe Anglo dealer Julius Gans was known for introducing new uses for Hispanic woven cloth. First was the "Chimayó jacket," designed by Ollie McKenzie in 1930. The jacket was nearly impossible to wear out because it could be turned inside out and relined. Full-length Chimayó coats and vests were also made of woven fabric. Gans even created a small clutch purse with a "talon zipper," moiré lining, and a silver Navajo button closure.[63] It did not take long for the Chimayó dealers to develop and market a similar line of goods, including jackets, coats, and purses (plates 52–54).

The highly developed nature of the blanket business in Chimayó is attested to by a letter of agreement in the records of David Ortega and family, signed in 1929 by the major Hispanic weaving entrepreneurs. Apparently to combat attempts to undersell one another during the nation's financial crisis and to compete more effectively with the Santa Fe dealers, the leading Hispanic blanket dealers drew up an agreement to fix prices. That they had formed an organization is indicated by the various offices held by the first three signatories: president E. D. Trujillo; vice-president Lorenzo Trujillo; and secretary Nicacio Ortega. Other members' signatures included Reyes Ortega, Severo Jaramillo, Ursulo Ortiz, Eugenio Martínez, and N. T. Martínez.[64]

Typically, a rural weaver would work for more than one dealer: a rural Hispano, like Lorenzo Trujillo; a Santa Fe Hispano, like Candelario; and an Anglo, like Julius Gans. During his most prosperous years, Gans had 150 families working for him. Juan Melquiades Ortega wove for J. S. Candelario, John Dendahl, Lorenzo Trujillo, Severo Jaramillo, Ursulo Ortiz Sr., Reyes Ortega, and Nicasio Ortega during a weaving career spanning eighty years.[65]

In a discussion of Chimayó's economy, the 1935 *Tewa Basin Study* noted that "the weaving industry has become the main source of money income, but it too is inadequate, as the weavers are tragically underpaid." The study details the way in which the

Figure 4.12 | *Fred Harvey Company Blanket Book 11, "Old Blankets A 101," showing a transaction with E. D. Trujillo dated 10/29/28. Courtesy of the Spanish Colonial Arts Society, Inc. Collection on loan to the Museum of New Mexico, Museum of International Folk Art, Library Archives, Santa Fe, New Mexico. Photo by Miguel Gandert, 1992.*

dealers bought commercial yarn at $1.20 to $1.45 per pound and sold it to weavers for $1.40 to $1.60 per pound. Later the study notes:

> To give an actual example, from 5 pounds of wool, thirteen 20" x 20" blankets can be made. The dealer then pays 84 cents per blanket. Five pounds of wool costs $8; 13 blankets are sold for $10.92, making a net wage to the weaver of $2.92. A good weaver can weave the 13 blankets in 3 days by putting in as much as 10 hours of hard labor per day. Average wages are never more than $1 per day, and this for a highly skilled craft.

Eighty to ninety percent of the output is sold by dealers to business houses in New Mexico, Arizona, Colorado and California. The sale is very uneven, the best months being October, November, and December. Most of the sales are sent out via parcel post, and the payment to dealers is made in 30 days, or after the blankets have been sold. Many of the weavers have to wait until the blankets have been sold before receiving payment.[66]

Although commercially processed yarn became the hallmark of Chimayó weaving, working with handspun yarns continued in practice until the 1930s as confirmed by the study. "Some ten families work up local wool and some wool [is] sent in from Colorado on shares. This is cleaned, carded, and dyed with commercial dyes. However, the blankets made from homespun wool are expensive ($22 to $25) because of the labor involved, and are rarely sold nowadays. The design of the

Chimayó Weaving

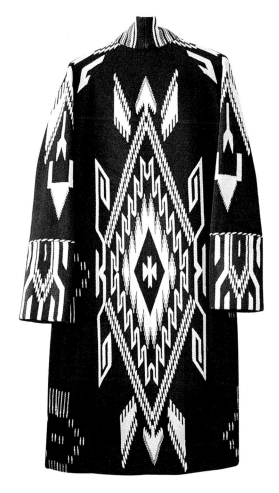

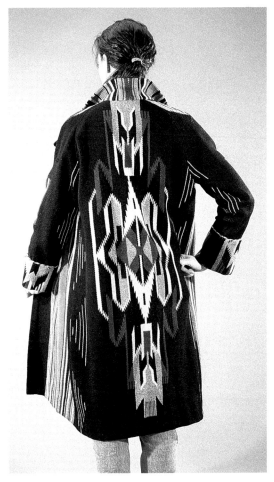

Plate 52 | Early Chimayó coat, 1920s. Collection of Ruth K. Belikove. Photo by John Nidecker, 1996.

Plate 53 | Chimayó coat, 1940s. Collection of Becky Love Yust. Photo by Linda Billings, 1996.

homespun blankets is old Spanish, which consists of straight stripes, as against the geometric designs of the present-day Chimayos."[67]

All in all, the study cast an unfavorable light on the role of crafts in the economy of the area. "The comparative unimportance of handcraft as a means of livelihood, and its exploitation by dealers" is listed in the concluding remarks about the dominant negative economic factors of the area. The study was undertaken during the depths of the Great Depression, and it is interesting to note that none of the data reveal the efforts of government and private programs to revive the crafts during

this same time period. In a study done in 1934, Hispanic scholar Arthur Campa noted that there were 176 weavers in New Mexico and that less than 15 percent wove full time. He concluded that weaving was a subsidiary occupation to farming.[68]

Rag rugs, popularly called *jergas* (or *pisos* by Hispanic weavers today), continued to be an important woven product in New Mexico in the early modern period. Made of twisted rags, these rugs were usually woven on shares *(a medias)*. The person who commissioned the rug would provide the rags typically cut into strips and wound into balls and receive half of the output. Hispanic farming

has also traditionally been done on shares with one person providing the land and perhaps the seed, another the labor. Metaphorically speaking, weaving may be seen as another cash crop. Rag jergas were widely used on floors for area rugs and wall-to-wall carpeting. The panels that made up the wider rugs were not sewn together, so they could be more easily transported to the river or irrigation ditch for washing.

Weaving was also used and continues to be used in some rare situations as a kind of currency. A person was able to trade weavings for produce or livestock. As Arturo Jaramillo, a prominent Chimayó businessman, described it in 1978, "When my grandfather wanted to buy me a pair of shoes, he'd weave a blanket in an afternoon and sell it to a retailer. Having a loom was like having extra money when you needed it."[69]

Weavings could also be used as gifts. Melita Ortega, daughter of Reyes Ortega, received a pair of blankets on her wedding day that were woven by her father (plate 55). They were woven with yarn spun by the groom's mother and aunt; the gift thereby had great sentimental value to Mrs. Ortega. Others have reported on the popularity of blankets as gifts for special occasions.[70]

Design

In the 1920s the sparsely decorated blankets of the early Chimayó weavers were replaced by a new, dramatically different design system. (This design system is described more fully on pages 102 and 178, and illustrated in plates 56 through 61.) Even scholars such as H. P. Mera were puzzled by the emergence of the new designs:

> It is readily apparent that in Chimayó work this feature [design] possesses a distinctive character all its own. Just why the principal units of decoration should differ so greatly from any of those preferred in the preceding periods cannot be satisfactorily determined

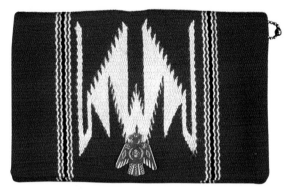

The Modern Period

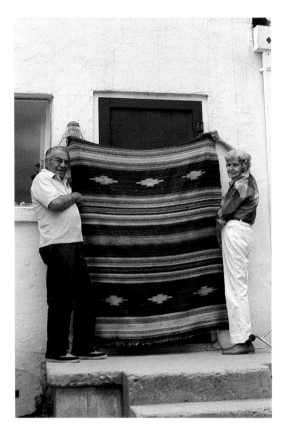

Plate 54 | *Chimayó purse of woven fabric with a silver buckle clasp and taffeta lining, 1940s. Collection of Suzanne Baizerman. Photo by Suzanne Baizerman, 1995.*

Plate 55 | *Isaias (Ike) and Melita Ortega holding their wedding blanket woven by the bride's father, Reyes Ortega, 1936, with wool spun and dyed by the groom's mother and aunt. Brown wool was from the groom's pet lamb. Collection of Melita Ortega. Photo by Suzanne Baizerman, 1985.*

Figure 4.13 | Weavers, Ildeberto (Eddie) Delgado (back), and Antonio Mier (front) in Delgado's Curio Shop, Santa Fe, New Mexico. In the background, a weaving depicts San Miguel Chapel, ca. 1920. (See Plate 56.) Photo courtesy of Angelina Delgado Martínez.

at this time, the type having already been in existence for years. Decorative schemes always embody, with exceedingly few exceptions, one of those curiously conceived units which normally occupies a prominent place in the center of the field.[71]

Frank Mier, a contemporary Hispanic weaver from Santa Fe, attributes this new design system to his father, Antonio Mier, who moved to Santa Fe from Mexico in the first decade of the twentieth century. Señor Mier was trained as a weaver by his parents. When he arrived in the United States, he set up a weaving workshop. He was, according to several reports, a very skilled weaver and worked for several curio dealers, including Julius Gans (fig. 4.13). The quality of his weaving was superior to that of the Chimayó weavers, who had for many years been weaving the simple styles of the late transitional period. According to Frank Mier, his father also took on weaving apprentices who learned design work from him (plate 62). Even such well-respected weavers as Severo Jaramillo and various members of the Ortega family spent time apprenticing with Mier to improve the technical and design aspects of their weavings. These apprentices, in turn, passed on the design techniques to other weavers in Chimayó. For example, Jacobo Trujillo was taught design work by his brother-in-law, Severo Jaramillo.[72]

There was evidently more exchange between Mexico and New Mexico during this period than has been recorded. One 1925 account of Mexican weaving notes changes in the size and shape of weaving in Mexico. These newer weavings appear to be similar to the pillow tops that were being produced for the New Mexico curio market. "In a late exposition held in the School of Mines during the month of September, we noticed small squares of blanketry for the making of cushions. This appears to be the last word in this ancient and noble industry."[73]

Differential Skill Levels

Some weavers distinguished themselves by their weaving stamina and skills. The 1935 *Tewa Basin Study* mentions that "there are comparatively few highly skilled weavers, and this ability seems to run in certain families."[74] Weavers competed with each other to create more and more complex designs. Some weavers would display almost Olympian skills as weavers.

Juan Melquiades Ortega could weave a patterned blanket in a single day. When interviewed at age ninety-four, he had been weaving for more than seventy-eight years, having first started to weave when he was fifteen years old. He reminisced about how, as a young man, he used to weave a *sarape* in one day: "*Había veces que me levataba a las tres de la mañana y me iba a tejer. Tejía hasta que me venía almorzar. Y luego tejía todo el día. Y luego, en la noche, trabajaba una o dos horas y hacía un sarape en el día de estos grandes. Este es de 54 pulgadas*" [There were times when I would get up at three o'clock in the morning, and I would go to weave. I would weave until I would come to breakfast. And then I would weave all day. And then, at night, I would work one or two hours and I would complete one of these large *sarapes* in a day. This one is 54 inches long]. David Ortega remembers that as a young man, he and another weaver, Willie Jaramillo, together wove a large fancy blanket in one and a half days.[75]

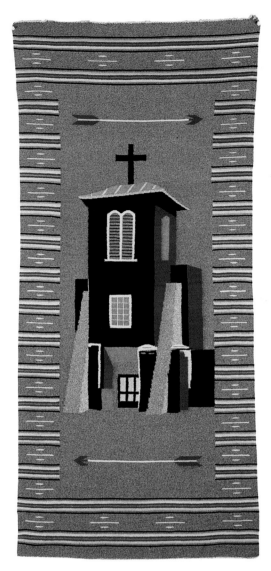

The Modern Period

Plate 56 | *San Miguel Chapel woven by Ildeberto Delgado, ca. 1920. Courtesy of Angelina Delgado Martínez. Photo by Blair Clark, 1992.*

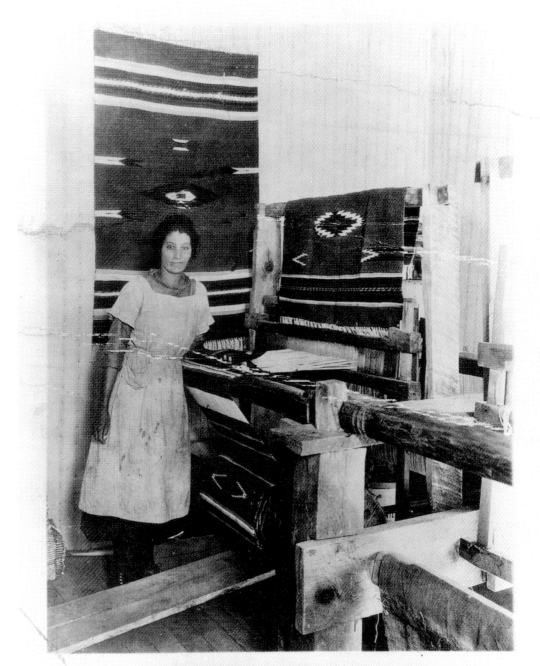

A CHIMAYO WEAVER AT HER PRIMITIVE LOOM

Figure 4.14 | Luisita Trujillo, 1920s. She was the aunt of David Ortega and the great-aunt of Helen R. Lucero, this book's co-author. Illustration courtesy of David Ortega.

Men were clearly the visible artisans and entrepreneurs. However, many women were weavers as well (fig. 4.14). David Ortega identified the woman in figure 4.14 as his aunt, Luisita Trujillo. This weaver is also pictured in Griswold's 1942 book *Handicraft,* in his chapter on Spanish weaving. Luisita's sisters, Martina, Crestina, Franke, and Agustina, also wove for blanket dealers most of their lives. Melita Ortega remembers that two of her sisters wove for her father.[76] Many female members of the Martínez family also wove during this time period.

Yet, even though women were involved with production weaving behind the scenes, it was a picture of a male weaving industry that was portrayed by Anglo writers:

> Behind high walls, in the shade of white portals, in the hollyhock filled patios these native weavers work at their looms as their fathers and grandfathers did before them.[77]

> Almost without exception the weavers are men.[78]

> Contrary to the Indian custom where the women are the weavers, the Chimayo blanket is woven by men.[79]

> Nearly all Chimayo weavers are men.[80]

This Anglo perception continued into the postwar era. In 1947 a writer noted that weavers passed their knowledge from father to son. Another wrote in 1960, "a boy may inherit a loom from his father or grandfather."[81]

The early modern period was a time of reaction to the direction of curio dealers: there were experiments with new equipment, materials, uses, and design systems, and new types of skills were developed. In the 1920s rural Hispanic dealers began to compete with Santa Fe dealers for markets, for weavers, and for weaving design control. The fervor that had characterized the revival movement of the early 1930s had waned by the end of that decade. Shops promoting revival-inspired Hispanic goods never operated at a profit. Chimayó weaving filled a niche in the tourist market.

Late Modern Period (1940–1995)

Hispanics' lives changed dramatically as they entered the late modern period. Four major factors combined to bring about these rapid changes. First, the impact of World War II on New Mexico in general and on northern New Mexico in particular cannot be overemphasized. As historian Gerald D. Nash states, "Perhaps only the coming of the Spaniards in the sixteenth century can rival World War II as providing a major turning point in New Mexico's history." The war thrust Hispanics into the world outside their villages. Hispanics from northern New Mexico enlisted in military service at a rate above the national average.[82] One particularly tragic period of the war, which had drastic consequences for New Mexican Hispanics, was the Bataan Death March. "Of the 1,800 New Mexicans sent to the Philippines (one out of every 200 men, women, and children then residing in New Mexico), only 900 survived to return to the United States as a result of the deprivation and atrocities suffered after their surrender on Bataan during the infamous death march and internment as POWs. Of those who returned, 50 percent would not survive their first year of freedom."[83] "Approximately 35 percent of the New Mexican contingent were Spanish Americans."[84] Because so many of the men who were subjected to the death march were Hispanics, the survivors consider it their responsibility to commemorate their time in captivity and honor their dead brothers by such means as marching as a group to the Santuario de Chimayó on Good Friday.

Second, the war brought federal government funding to New Mexico through military installations and top-secret science projects. In Albuquerque, Sandia National Laboratories and Kirtland Air Force Base played a key role in the growth of the state's largest city. Closer to the northern New Mexico villages, in Los Alamos, a completely new city was formed in a matter of years, beginning in 1943, to house the Manhattan Project, which developed the atomic bomb. Also, "from 1941–1945, the War Department located twenty-one separate military bases, training centers, prisoner-of-war, and Japanese internment camps within New Mexico."[85] The new industries created many jobs for local residents. For example, many Hispanics commuted from villages such as Chimayó and Córdova to work in Los Alamos primarily as groundskeepers, guards, and clerks.

Concomitantly, New Mexico experienced an influx of new immigrants to the state, many drawn by the more technical positions at the military bases. This diverse group of immigrants included an extremely large number of scientists and technicians, making Los Alamos the U.S. city with the largest number of Ph.D.'s for its population size.[86] These population shifts led to an unprecedented population growth during the 1940s.[87] The post–World War II baby boom also played a part in population growth; the town of Los Alamos made particularly noteworthy contributions to the rise in births in New Mexico.[88]

Third, the war stimulated out-of-state migration to factory jobs and field labor necessary for the war effort. Many men and women left northern New Mexico in search of jobs in urban factories and as rural migrant workers and sheepherders. Rural-urban migration rose in-state, and many Hispanics moved to find work in Albuquerque or Santa Fe. As Hispanos came into contact with new populations, assimilation accelerated and intermarriage became commonplace. "For the young people returning from overseas or from jobs in U.S. cities, it was clear that farming as a livelihood was over for good."[89] In Chimayó, "after the War, the people leaving for work stopped coming back."[90]

Fourth, the disruption of the war and the rationing of tires and gasoline meant a decline in tourism during the war years. However, the postwar years were characterized by a tremendous increase in road building, car sales, and tourism in the United States. Increased tourism directly affected the growth of the weaving industry in New Mexico. The popularity of automobile travel brought people to the state of New Mexico and into its rural areas, promoting sales of weaving through Santa Fe dealers and rural dealers as well.

In the post–World War II era, the most far-reaching impact of the war years in New Mexico would be the profound rise in federal government spending through military installations and science research centers. Federal moneys continued to flow into the state after World War II as military research was imperative during the Cold War years. In northern New Mexico, the Los Alamos facility continued to employ a large number of Hispanic villagers. Although most were employed in the lowest paying jobs, the pay was still higher than most had ever earned. Additionally, following an hour and a half daily commute, Hispanos could still participate in village life and farming activities after their work day.

The general economic expansion in government-related industries and services during the late 1940s and the 1950s ushered in nationwide prosperity. "By most standards of measurement, the 1950s was the best that New Mexico had ever seen." New jobs were available in-state and elsewhere. "By 1959, the federal government, with 218 separate offices representing 33 agencies, employed 17.3 percent of all New Mexicans."[91] The role of federal government spending in New Mexico has shaped the well-being of the state in the decades since the war. As military research was deemed important, such as during the Cold War, govern-

ment dollars flowed into the state. However, when federal moneys were needed for the ground war in Vietnam, there was a reduction in military research spending. International events such as oil crises and nuclear disarmament also affected the demand for the state's natural resources: natural gas, oil, timber, coal, copper, and uranium. As a result, the state's economic health has fluctuated during the late modern period as it has responded to national and international events.[92]

Although the 1960s and 1970s brought a decline in federal spending, federal programs related to the War on Poverty and the Great Society led to economic development programs in northern New Mexico. These were designed to use crafts as a means to create jobs, an approach reminiscent of the region's New Deal programs of the 1930s. An increase in environmental activism during this period, however, led to a decline in the use of the state's natural resources, resulting in lost revenues. Prosperity returned once again to New Mexico near the end of the Vietnam War; the national energy crisis brought federal dollars, and private manufacturing increased during this period.[93]

The 1960s and 1970s also brought a new group of Anglos to northern New Mexico: those escaping "the Establishment." They eschewed materialistic values and embraced a return to a simpler way of life. Building adobe homes, raising gardens, and producing hand-crafted items were ways to express their new values. From middle-aged business executives who had "dropped out" to adolescent hippies, newcomers flocked to the Southwest. Some undertook experiments in communal living in rural areas, such as the Hog Farm in El Llano. Drug use, spirituality, and a myriad of social causes came along with this new wave of Anglo immigrants.[94] Tension developed as the traditional values of the local Hispanic residents clashed with those of the Anglo newcomers.

Just as waves of new Anglos were arriving in the 1960s, Hispanic migration to urban areas across the country increased. Deeply etched routes between northern New Mexico and urban areas such as Denver, Los Angeles, and Salt Lake City were now firmly established and continue to the present day. Individuals, or whole families, migrated for employment. They returned to northern New Mexico periodically, usually for short visits. Many believed they would return home for good after retirement. In most families with ties to two locales, strong kinship bonds developed in both the urban environment and the rural homestead. Many Hispanic New Mexicans have experienced the angst of being split between two homes.[95]

During the 1980s and 1990s the northern New Mexico cities of Santa Fe and Taos grew as tourist centers. "If one excludes the federal and state payrolls, in 1992 tourism still ranked as the main source of income and employment for the state." The State Department of Tourism has continued to do its best to acquaint the nation with the wonders of New Mexico. In 1993 it was estimated that over fifty-three thousand New Mexicans were involved with tourism, which brought in $2.2 billion annually. With two hundred art galleries in 1990, Santa Fe had become a center for American art, ranking behind only New York City and Los Angeles.[96]

The Southwest's appeal for mainstream Americans increased during the 1980s and 1990s, and migration to the Sun Belt continued to swell the number of new immigrants, particularly retirees. The Southwest interior decorating style, an extension of Santa Fe style, also swept the United States during this period. Perhaps this craze reflected the Hispanicization of a nation where the Spanish-speaking population was increasing rapidly. Hispanics comprised 7.9 percent of the U.S. population in 1980; this figure is expected to reach 15 percent by the year 2000.[97]

In the villages, tourism and tourist-related industries continued to expand, and television and other mass media contributed to the end of what-

ever vestiges remained of Hispanic isolation. More Anglos moved to northern New Mexico, not the marginally poor "hippies" of earlier decades but well-to-do settlers who purchased property and built summer cabins or family homes. Some became involved in community affairs and sought to contribute to the well-being of their communities.

Meanwhile, the number of Hispanics who left the villages to work or to continue their education at the university level continued to climb. An increasing number of educated, sophisticated, and articulate Hispanic spokespeople have emerged. They serve their communities through civic and religious organizations such as the Caballeros de Vargas, the Hispanic Culture Foundation, the Hispano Chamber of Commerce, the Knights of Columbus, and the League of United Latin American Citizens. Others have bonded with colleagues in universities, forming faculty organizations such as the Southwest Hispanic Research Institute and the Latin American Programs in Education at the University of New Mexico and student organizations such as MEChA, La Raza Estudiantil, MALSA, and Las Comadres.

Another late twentieth-century phenomenon, Hispanic intermarriage with Anglos, has increased dramatically in New Mexico. In 1967 González analyzed intermarriage data from 1915 through 1964 and summarized her findings:

> In general, there is a clear trend toward increasing intermarriage over the fifty-year period. It must be kept in mind that another consistent trend throughout this period has been population increase; this increase augmented the size of both Hispano and Anglo groups, but tended to increase the proportion of Anglos. Thus, the proportion of endogamous Hispano marriages has tended to decrease as a direct function of their decreasing percentage of the total population.[98]

Comparative data on intermarriage have not been collected by the State of New Mexico in recent years, though there is hardly any doubt that the trend has continued. Intermarriage and assimilation have led to a decrease in fluency in the Spanish language among Hispanics. Intermarriage has also led to new problems for the *coyote* offspring (children of mixed ethnicity) who straddle two worlds: Anglo and Hispano.

Hispanic Weaving during
the Late Modern Period

While most weavers continued to work for the blanket dealers during and after World War II, additional opportunities for marketing handweaving and increasing its visibility appeared during the late modern period. Anglo-dominated arts societies were reestablished in the 1950s and by the 1960s were a significant factor in the marketing of weaving. A thriving ethnic art market developed in Santa Fe and Taos, while art galleries in both communities served as significant outlets for those weavers who began to define themselves as fine artists. Museums also helped turn attention to Hispanic weaving and to define the craft and its history. Some weavers undertook research on their weaving heritage, and a few have published their findings.[99]

Women have played a more prominent role in the weaving craft during this period. Although popular literature continues to portray weaving as a craft that is passed on from father to son, a study conducted in Taos and Río Arriba Counties in 1983 revealed that 76 percent of Hispanic weavers were women.[100] Most of these women fit weaving into everyday activities at home, such as child care, cleaning, and cooking. There are also students who weave during breaks from school and senior citizens who weave after retirement. For many, it is a significant source of income that augments their subsistence farming. Most weavers have been trained in an apprentice relationship, often with

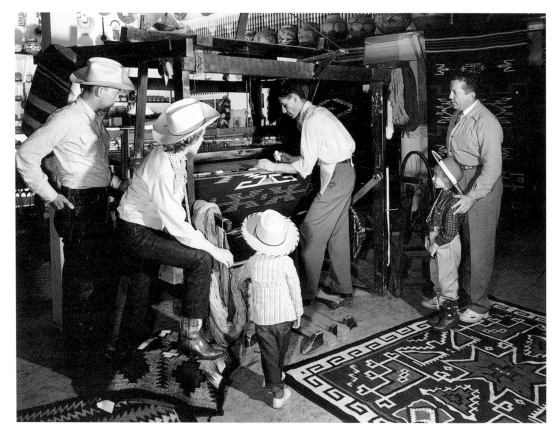

4.15. A Chimayó weaver demonstrates as tourists look on at the Southwest Arts and Crafts Store in Santa Fe, 1949. National Geographic Society, NGM 1949/12 789. Photo by Justin Locke.

relatives in their communities. Others have been trained in government or museum programs or, most recently, in educational institutions.

To deepen the understanding of the weaving craft in the late twentieth century, detailed portraits of three contemporary New Mexican Hispanic weaving families have been assembled (see chapter 5). The following section creates a larger context within which to view these families, portraying in a more general way the weaving industry and the various programs and events that have affected it.

Blanket Dealers and Weaving Shops

Three Hispanic entrepreneurs from the pre–World War II period continued in business after 1945: the

Ortega family, headed by Nicasio Ortega in Chimayó; E. D. Trujillo, based in Española; and Ursulo Ortiz Sr., working out of Santa Fe. Julius Gans's store, Southwest Arts and Crafts, continued as one of the major Anglo-Hispanic weaving outlets in Santa Fe (fig. 4.15). These entrepreneurs did not restrict sales to their retail stores; all sold blankets on a wholesale basis to tourist outlets throughout the Southwest and on the West Coast. National Park gift shops, resorts, and other shops along Route 66 were prime wholesale customers.[101] The various blanket dealers were well acquainted with one another and would come to each other's aid. For example, if one dealer was out of a particular color of yarn, he could borrow from another.[102]

Many of these blanket dealers continued in

Chimayó Weaving

Figure 4.16 | The Córdovas' Handweaving Workshop is typical of small weaving and sales outlet operations located throughout northern New Mexico, Truchas, New Mexico. Photo by Suzanne Baizerman, 1985.

business into recent decades. E. D. Trujillo closed shop in 1957, but his Española business was reopened in 1983 by his son, Leopoldo. Ursulo Ortiz Jr. continued his father's work contracting weavers. The Gans's family business was finally sold in 1962. Ortega's weaving business, on the other hand, has expanded and now includes an art gallery, opened in 1984. Among the newer dealers was the late Jacobo Trujillo, who, together with his family, opened Centinela Traditional Arts in 1982. Since Jake's death in 1990, his son, Irvin, and daughter-in-law, Lisa, have continued to operate the business and employ local weavers. Another important retail shop in Chimayó is that of John Trujillo, who owns Trujillo's Weaving House. In Truchas, there is the Córdovas' Handweaving Workshop where Harry Córdova and his parents, Alfredo and Gabrielita, weave and sell their work (fig. 4.16); and in Medanales, there is La Lanzadera, a shop and weaving school operated by Cordelia Coronado. She also displays and sells local weavings. As more Hispanos enter the weaving profession, they often hang up a sign and go into business, selling their work directly out of their homes.

The Goods in the Weaving Shops

In line with standard business practices, dealers stock a variety of goods in their stores. Best-selling items are weavings that range in size from 4" x 4" coasters to 54" x 84" blankets. Coats, vests, and purses woven by local weavers using Chimayó-style designs are stocked in some stores. Larger stores have a greater diversity of goods. There may be men's neckties and women's shawls made of handwoven cloth. Some are woven by urban, non-Hispanic weavers and sold on consignment. Ties and shawls are contemporary manifestations of the hand-weaving industry that thrived in Santa Fe and Albuquerque during the 1930s. Most weaving shops in northern New Mexico also carry books on Southwest topics, Indian pottery and jewelry, and a variety of generic Southwest tourist souvenirs.

Products Woven for Blanket Dealers

Most weavings produced for dealers are made with commercially manufactured wool. They have a characteristic design layout, known as Chimayó style. This distinctive style evolved in the 1920s and 1930s. Smaller Chimayó weavings, such as 10" x 10" mats, have a band of small stripes at each end and a tapestry-woven design motif in the center. Larger weavings, which may be used as table runners, dresser scarves, wall hangings, or bed coverings, may have secondary design motifs symmetrically arranged on either side of the central motif.[103]

There is great variation within the Chimayó style, especially as weavings become larger. Some weavings use a heavier rug-weight yarn. The more experienced and artistically confident weavers generally specialize in large-size weavings. A growing number of them produce tapestry-patterned weavings that differ from the Chimayó style. A few Hispanic weavers apprenticed under and worked for the artists Janusz and Nancy Kozikowski. This couple had an elaborate dyeing and weaving studio-workshop in Medanales, New Mexico, from the early 1970s to the mid-1980s. The Kozikowskis' work was characterized by images worked with de-

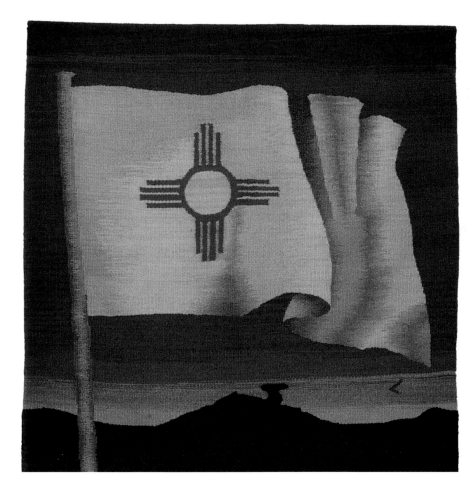

Plate 57 | New Mexico flag by Steve Chávez showing shading and modeling tapestry techniques learned while working for the Kozikowskis. Photo by Helen R. Lucero, 1985.

tailed shading and modeling in the European tapestry tradition. They designed large tapestries, and employed local Hispanic weavers to help execute their weavings. "Many are producing weavings today which exhibit the design elements of the [Kozikowski] Medanales studio" (plate 57).[104]

Weavers Who Work for Dealers

The majority of contemporary Hispanic weavers are affiliated with a dealer. They weave pieces at home that are not destined for a fine art market but are, instead, usually sold to tourists in shops throughout the Southwest. Some of the dealers deliver yarn to weavers' homes and pick up the finished weavings. Sometimes, weavers or their relatives take on the task of transporting yarn and weavings and may even provide this service for neighbors. Most weavers are paid by the piece, according to its size and the complexity of the design. Dealers calculate payment due the weaver by weighing the pieces to determine the amount of yarn used. The price of the yarn is then subtracted from the price of the weaving. More complex work with outstanding craftsmanship receives greater compensation. Weavers regard some dealers with fondness and respect. They see dealings with them as fair. Other dealers are described as

Chimayó Weaving

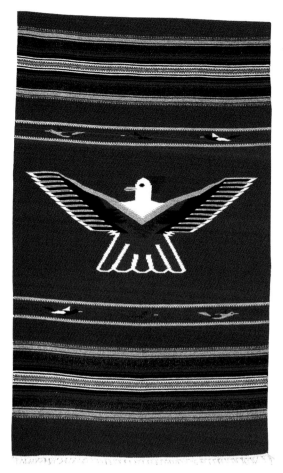

Plate 58 | Chimayó blanket with a spread eagle design by George Vigil woven for Ortega's Weaving Shop, Chimayó, New Mexico. Photo by Miguel Gandert, 1992.

stingy and stern. One weaver, who wished to remain anonymous, described saving every scrap of yarn cut from her weavings in a paper bag to prove she was not using the yarn for other purposes.

It is not uncommon for a weaver to work for a succession of dealers. For example, Agueda Martínez wove for E. D. Trujillo for thirty years, between 1929 and 1959. During the same time period, she also worked for Lorenzo Trujillo and wove special orders for Julius Gans and Jesús Candelario. Since the mid-1960s, she has sold her weavings directly from her home.[105]

There are variations in the ways in which fami-

lies are involved with weaving for blanket dealers. In some families, just one person weaves. For example, Dalio Gallegos, a retired gentleman who was interviewed in 1984, wove one hundred ten-inch-wide *congitas* every two weeks for a blanket dealer. Each one took him approximately forty-five minutes. The "formula" for the piece he was doing was pinned to the loom, guiding how many rows of one color or another he was to use.[106] In the Valdez family of Española, all members were involved in production. In 1995 their family of seven had six weavers and a seventh member who wound bobbins for the others. They produced hundreds of weavings per week.[107]

Yet another variation of family involvement in weaving can be found in the tiny mountain village of Cundiyó in northeastern Santa Fe County. Until only a few years ago, every person in Cundiyó shared a common surname: Vigil. Most of the Vigils have earned their living by producing Chimayó weavings for Ortega's Weaving Shop on a contractual basis (plate 58).[108]

Other weavers, many of whom worked for dealers, were included in a list of north-central New Mexico Hispanic weavers compiled by Lucero in 1983–84. At the time, this was a comprehensive list of weavers living in Río Arriba and Taos Counties (see appendix 2).

Additional Markets and
Programs Affecting Weavers

In addition to the blanket dealers and weaving shops, several other economic development programs and institutions have affected Hispanic weaving in the late modern period. These have had a profound impact on the evolution of this weaving tradition in northern New Mexico.

HELP

The earliest of the federal programs that supported weaving during the late modern period

was funded in 1965 by the Office of Economic Opportunity and later by the Department of Labor and the Ford Foundation. It was known as HELP, an acronym for the Home Education Livelihood Program, and was administered by the New Mexico Council of Churches. In the beginning, HELP stressed adult literacy programs and basic skills courses. Later it funded local businesses. Emphasis was placed on education programs in the home environment aimed at creating jobs. It was designed as a rural development program, helping community members identify needs, organize programs, and work toward self-sufficiency.[109]

HELP began weaving programs in 1968 and hired experienced weavers to teach weaving in a number of northern New Mexican villages, such as Canjilon, Cebolla, Cañones, Gallina, Coyote, and La Madera. Their best-known weaving program was organized under Del Sol in Truchas. There, Anglo weaving expert Kristina Wilson, a long-time Taos resident, set up an efficient operation training and employing Hispanic weavers to weave cost-effective, marketable items—rugs, handbags, pillows, runners, stoles, and throws. They were designed in a manner that would not compete with nearby Chimayó weaving and would meet the demands of the interior design market for colorful handwovens. Eight employees each earned $1.60 per hour. Designs were largely composed of simple bands of wide stripes rather than time-consuming tapestry techniques. In this way, the product could be standardized for successful marketing. Items were sold in New York, Los Angeles, and in a Del Sol shop in Taos. Administrative obstacles within the HELP hierarchy eventually led to the program's demise in 1974.[110]

In La Madera, another weaving collective, Los Tejidos Norteños, was formed and supported by HELP. Besides acquiring weaving skills, weavers engaged in the communal buying of fleece and yarn and in marketing their work. They also offered

spinning, dyeing, and weaving demonstrations at the Old Cienega Village Museum at El Rancho de Las Golondrinas and at the Pecos National Monument.[111]

HELP projects had a significant impact upon many weavers—broadening their skills and increasing social interaction. Ultimately, problems in distribution and marketing of woven products created obstacles to the program's survival. In 1976 HELP programs ended when funding sources moved from the Office of Economic Opportunity to the Department of Labor.[112]

Tierra Wools and Ganados del Valle

To date, the most successful example of weaving as an avenue to economic development is located in Los Ojos, New Mexico (figs. 4.17, 4.18, and 4.19). As part of a larger effort to improve the lives of the Hispanic residents of this region, an independently funded cooperative project, Tierra Wools, was organized in 1983. It complemented Ganados del Valle, a sheep-breeding venture. María Varela, community development specialist, worked with local Hispanic leaders to secure capital and develop more effective marketing strategies for the sheep business. One Ganados' undertaking has been the reintroduction of the churro breed of sheep, a joint program with the Navajo Sheep Project at Utah State University's Department of Animal, Dairy, and Veterinary Sciences.

Wool from the churro sheep was used by Hispanic weavers for blanket weaving through the first half of the nineteenth century. Tierra Wools' spinning and weaving program was designed to convert Ganados's fleeces into more valuable finished products made from the churro wool. Tierra Wools has established a production studio and retail showroom. Nationally recognized Taos designer and weaver Rachel Brown was enlisted to introduce commercial weaving techniques through a well-developed apprentice training program. Through its sophisticated marketing strategies and training,

Chimayó Weaving

Figure 4.17 | Billboard directing travelers to Tierra Wools and Los Pastores, Los Ojos, New Mexico. Photo by Miguel Gandert, 1992.

Figure 4.18 | Tierra Wools shop with a galvanized roof in a converted store, Los Ojos, New Mexico. Photo by Miguel Gandert, 1992.

Tierra Wools has dealt effectively with many of the problems that typically undermine community development programs. By 1993 Tierra Wools employed thirty people, including eighteen weavers, and sold $285,000 worth of woven products.[113] Like other Ganados programs, Tierra Wools has provided local employment, allowing families to remain in the area. The accomplishments of Ganados del Valle were publicly recognized in 1990 when community organizer María Varela received the prestigious MacArthur Award for her work at Los Ojos.

Ghost Ranch Conference Center

Under the auspices of the Presbyterian Church (U.S.A.), the center, near Abiquiu, has offered many outreach programs to local communities as a way to bring community members together. These have included programs supportive of crafts. From 1975 to the present, weaving classes in the community for Anglo and Hispanic residents have been subsidized by Ghost Ranch. In addition, local Hispanic weavers have taught Anglo college students and other visitors in summer and winter workshops at Ghost Ranch. Tours to local artisans' studios are also arranged by the ranch. During the summer months (June through October), there is a weekly crafts fair held on-site on Friday evenings. The fair is self-administered by the participating Anglo and Hispanic artisans from the local area; they set up booths each week where they sell their arts and crafts (fig. 4.20).[114]

El Rito Fiber Arts Program

Located on the campus of Northern New Mexico Community College (the old Spanish-American Normal School established in 1909) is an innovative fiber arts program begun in 1990 under the direction of weaving program director Barbara Berger. "Berger said that when she started the program five years ago, there were seven looms and five students. Now there are 45 looms (a loom-building class is part of the curriculum) and 73 students." Today El Rito is touted as being "the only place in the country where students can earn certificates and two-year associate arts degrees for becoming skilled in northern New Mexico folk arts once handed down only from parent to child."[115] In addition to weaving, the college offers instruction in Spanish colonial furniture-making, tin work, *santos* carving, silversmithing, and pottery-making.

Although the school is located in a predominately Hispanic area and promotes itself as "drawing upon a rich, local tradition," the weaving pro-

gram is increasingly serving more Anglo than Hispanic students; the instructors are also predominantly Anglo.[116] Most out-of-state students are enticed by the multiethnic population and beautiful locale; "the news [of this school] is spreading across the United States and attracting inquiries from potential students from as far away as Massachusetts and Hawaii."[117]

In addition to the usual color, design, and history of textile courses, students can learn about Navajo weaving, attend the Crown Point rug auction, and take field trips to Hispanic weaving shops. Guest lecturers and special workshops expose students to indigenous methods of textile manufacture from faraway places such as Guatemala and Indonesia. Hispanic tapestry weaving is but one component of this unique folk arts program.

Spanish Market

The founding of the Spanish Colonial Arts Society and the development of Spanish Market in the 1920s—and its waning in the 1930s—is discussed earlier in this chapter. The Spanish Colonial Arts Society was revived in 1952 as interest in Hispanic crafts regained momentum. Members of the revived SCAS bore a distinct relationship to the prewar Arts Society. Some were members of the earlier SCAS, while a few others are offspring of earlier members. In general, like their predecessors, members include collectors and scholars (including museum curators) and Hispanic artisans and other community arts leaders. Through the 1980s members of Hispanic heritage were in a distinct minority, but the 1990s has seen increasing participation by Hispanics. In fact, recent presidents of the society, Fred Cisneros and Carmella Padilla, are of Hispanic descent.[118]

By the 1960s SCAS had reestablished the traditional Spanish Market. This market has become the largest showcase in the country for Hispanic artists working in traditional New Mexican arts forms and media. In the spirit of the more wide-

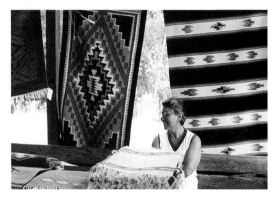

Figure 4.19 | Weaving showroom at Tierra Wools, Los Ojos, New Mexico. Photo by Miguel Gandert, 1992.

Figure 4.20 | Cordelia Coronado at Ghost Ranch's Friday night fair. Photo by Suzanne Baizerman, 1985.

spread American crafts renaissance of the 1960s, Spanish Market was reinstated as a midsummer, outdoor fair in the Santa Fe plaza. Held during the last weekend in July in Santa Fe's plaza, the two-day market is partially modeled after Santa Fe's highly successful Indian Market. Spanish Market weekend is the one weekend during the year when Indian vendors do not market their work under the portal of the Palace of the Governors (figs. 4.21 and 4.22). The market includes craft sales and demonstrations, as well as music and dance performances. The archbishop officiates at a Mariachi

Mass, where representative craft items are blessed, then leads a procession to the plaza to bless the market booths.

By the 1980s and 1990s the market had grown tremendously; additional tables and booths were added to accommodate the growing number of artists. Today, artists' booths are positioned on all sides of the plaza and spill into the plaza itself. In 1980 there were 34 adult exhibitors; by 1990 there were 99 adults and 37 children.[119] The number had swelled even more by 1995 when 149 adults and 42 children exhibited their work.[120] Because several family members oftentimes share a booth, the number of artists-exhibitors is actually larger.

Spanish Market has become the premier location to sell weavings for those who are self-employed. In 1990 there were fifteen weavers' booths at the summer market; by 1995 this number had grown to eighteen.[121] Children's weaving booths increased from two to five during the same time period.[122] Because Spanish Market is viewed as one of the more lucrative places to market work, weavers spend all year preparing for this one weekend. These weavers rely heavily on income derived from Spanish Market. In addition to selling goods outright, many take commissioned orders to fill in the months following the market.

Prizes are awarded annually by a panel of judges who make selections in different categories of work displayed in the market, such as *bultos* (three-dimensional religious wood carvings), *retablos* (two-dimensional religious paintings on wood), weaving, *colcha* embroidery, straw appliqué, tinwork, ironwork, jewelry, and furniture. In 1995 twenty-five prizes were awarded in adult categories, and twenty prizes in children's.[123] Collectors, including museum personnel, gravitate toward prize winners when making their selections.[124]

To set up a display table or booth at Spanish Market and be eligible for prizes, the artisan must first be selected for inclusion by a screening committee. Once selected, artisans are free to partici-pate in subsequent years unless they change the medium in which they work. However, as is the case at Santa Fe's Indian Market, the question of who is eligible to present work to the Screening Committee may be a controversial one. For example, in 1985 the SCAS board adopted the policy that 25 percent Hispanic blood was required, but in the realities of contemporary Hispanic life where Anglo intermarriage is commonplace, the question of who may exhibit can create heated debate.[125]

Work submitted to the Screening Committee must also meet the standard that it be "traditional." Crocheted pot holders and yarn "God's eyes" are not allowed in the market because they are not considered traditional, even though artisans might argue that their grandmothers had made them for years. Objects that do not meet the SCAS conception of tradition may be subject to removal by the Standards Committee.

In 1995, at the artists' request, SCAS produced written recommendations for market artists. The recommendations state: "The Standards of the Spanish Colonial Arts Society makes the following recommendations based on traditional Spanish colonial artwork produced in New Mexico and southern Colorado. . . . The board of SCAS has always felt that written guidelines could be limiting to both the organization and the artists themselves. These recommendations, therefore, are not meant to discourage artistic innovation, but to encourage quality and fidelity to the spirit of traditional arts." Guidelines for the textiles category state: "SCAS encourages the creation of colonial style handwoven flat textiles. To date, the only constructed pieces accepted in Market are vests and pillows. Wool yarn and natural vegetal dyes are encouraged, but not required. Pictorial designs are also discouraged. Artists and judges are encouraged to be attentive to the quality of the weaving itself, design, quality of yarns, and appropriateness of the colors." The list of inadmissible items included refrigerator magnets, Indian dolls

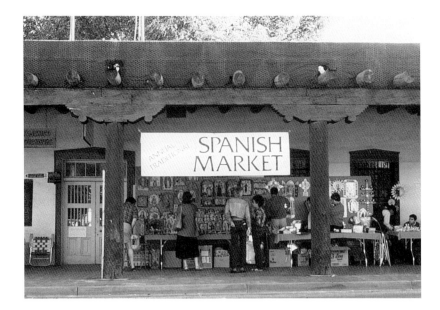

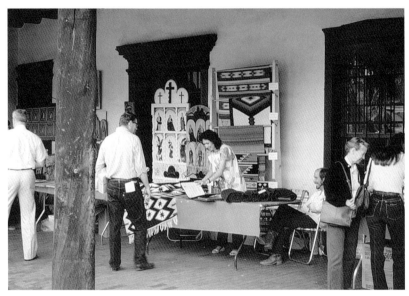

Figure 4.21 | Spanish Market under the portal of the Palace of the Governors, Santa Fe, New Mexico. Photo by Michael Baizerman, 1985.

Figure 4.22 | Teresa Archuleta Sagel's weaving display at Spanish Market. Photo by Michael Baizerman, 1985.

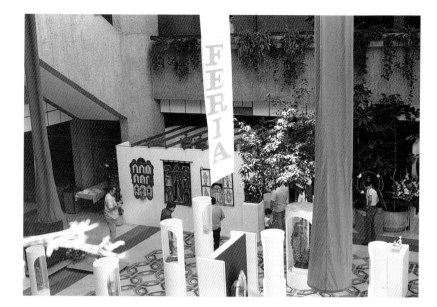

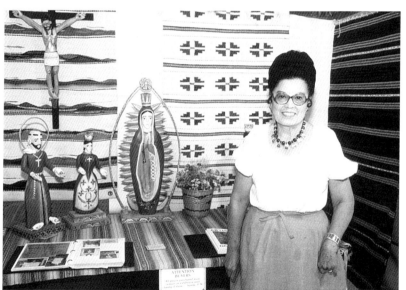

Figure 4.23 | Feria Artesana *exhibit at the Albuquerque Convention Center.*
Photo by Helen R. Lucero, 1985.

Figure 4.24 | *Zoraida Ortega displays her weavings and her husband's santos at*
Feria Artesana, *Albuquerque Convention Center. Photo by Miguel Gandert, 1986.*

and decorative motifs, coyotes and roadrunners, and plastic statues.[126]

Contemporary arts, such as painting, sculpture, and photography, are not eligible for Spanish Market. However, in 1985 a "contemporary Hispanic market" was established on Lincoln Avenue, next to Spanish Market. Sponsored by the Santa Fe Council for the Arts, this market has also grown significantly during the past ten years. In 1995 "seventy-three of New Mexico's best Hispanic and Chicano artists and craftspeople" displayed their "photography, sculpture, jewelry, painting, graphics, and other contemporary arts and crafts."[127]

A Winter Spanish Market, smaller than the summer one, began in 1989. It is now held annually during the first weekend in December. In 1995 101 tables were spread out over two floors of the La Fonda Hotel. For holiday gift-buying, artisans generally sold crafts that were smaller and less expensive than those sold at the summer market.

Recently, the Spanish Colonial Arts Society has expanded its scope: it published a well-documented and lavishly illustrated collections catalog as well as sponsoring artists' professional development and technical assistance workshops and elementary schools youth outreach programs. A concerted effort to recruit new SCAS members has resulted in an impressive membership roster numbering over five hundred persons, many of whom are of Hispanic heritage.[128]

Feria Artesana / Fiesta Artesana / Fiesta Artística

In 1980 the Albuquerque Museum sponsored the first weekend-long Feria Artesana at Tiguex Park, adjacent to the museum; subsequent ferias, or fiestas, were sponsored by the Albuquerque Parks and Recreation Department, now called Cultural and Recreational Services Department. Over the years, this event has experienced much internal, political, and financial strife and has undergone many transmutations. First held outdoors in Tiguex Park, since the mid-1980s it has been held at a downtown location. Some years the event has been held outdoors at the Civic Plaza, and other years it has been held indoors in the Albuquerque Convention Center. Shortly after the move downtown, Feria Artesana's name was changed to Feria Artística (1987–88), and then to Fiesta Artística (1989–present). Dates for the event have also varied from April through August.[129]

A separate gallery exhibition showcasing the best of Hispanic visual arts has been an important component in some fairs (fig. 4.23). Early ferias included an outdoor mass held on the Sunday morning of feria weekend where artisans brought their handmade objects to be blessed by the priest. One year's feria even included a low-rider car exhibit. Some years feria has included a space for Hispanic writers to sell and autograph their work, and authors from poet-novelist Rudolfo Anaya to land grants' activist Reis López Tijerina have participated. In recent years, the fair has sometimes been organized around a specific theme. For example, Fiesta Artística and a Gathering of Native American Arts shared a crossroads theme and exhibit space for the 1992 Quincentennial Celebrations. Plans for the 1996 event included still more changes: Fiesta Artística joined forces with the Albuquerque Founder's Day Celebration in an event called Fiestas de Albuquerque. The event was held in Tiguex Park on the third weekend of April.

Regardless of internal changes from year to year, some things have remained constant: fine artists and artisans set up sales displays of their work on tables or booths for two to four days (fig. 4.24). A variety of music is played all during the fair, with rock, Latino, and Mariachi bands predominating. Food vendors selling Mexican food contribute to the festive atmosphere.

Many of the exhibitors at the Albuquerque venue are also regular exhibitors at Spanish Market in Santa Fe. In comparing the two events, exhibitors say that, unlike Spanish Market, the Albuquerque

fair is not one of the best places to sell their work because there is a notable absence of rich, Anglo collectors. However, the Feria Artesana/Fiesta Artística is believed to have more "heart and soul." It is clearly an event shaped by Hispanics; visitors to the fair are about 75 percent Hispanic. Exhibitors relish the friendly atmosphere as they greet and embrace old friends and relatives. The ambiance and camaraderie, exhibitors claim, feed their souls even if not their pockets.[130]

Arts and Crafts Fairs

In addition to Spanish Market and Feria Artesana/Fiesta Artística, there are many other events where Hispanic weavers may display and sell their work. In Albuquerque these include the Río Grande Arts and Crafts Festival, New Mexico Arts and Crafts Fair, Spring Arts and Crafts Expo, New Mexico State Fair, and ¡Magnífico! Albuquerque Festival of the Arts, Inc.; in Santa Fe, the Santa Fe Plaza Arts and Crafts Festival; in Taos, the Old Taos Trade Fair at the Martínez Hacienda, Taos Spring Arts Celebration, and Taos Wool Festival (fig. 4.25). Other popular events include the spring, summer, and harvest festivals at El Rancho de las Golondrinas, and Tierra Wools Spring Harvest Festival in Los Ojos. Because festivals are good for tourism, they are scheduled year-round throughout the state; they generally include an arts and crafts component.

Art Galleries

In northern New Mexico's thriving art market, several galleries have played a prominent role in presenting the work of contemporary Hispanic artist/weavers in recent decades, including Bellas Artes, the Center for Contemporary Arts, Owings-Dewey Galleries (fig. 4.26), the Governor's Gallery, Laurel Seth Gallery, and the Wadle Gallery in Santa Fe; the Mariposa Gallery in Albuquerque; and Weaving Southwest in Taos. In Chimayó, Andrew Ortega and his wife operate Galería Or-

tega, and Max Córdova's family sells local and traditional art in their Los Siete Gallery in Truchas. Several other local and national galleries include Hispanic weavings in temporary sales exhibitions.

Museums

The following regional museums have formed major Hispanic textile collections over many decades. But not until the 1970s did most of the museums promote their collections and increase the public's awareness of historic and contemporary Hispanic weaving.

MUSEUM OF INTERNATIONAL FOLK ART (SANTA FE)— In 1979 a major exhibition of Hispanic weaving, *Spanish Textile Traditions of New Mexico and Colorado,* was mounted at this museum. A comprehensive catalog, edited by Nora Fisher, curator of textiles and costumes, accompanied the exhibition.[131] In preparation for the exhibit, E. Boyd, curator of Spanish colonial art, received funding for a large project to document Hispanic weaving in American museum collections. Over seventeen hundred Río Grande textiles were examined by museum personnel. Until this study was undertaken, Hispanic textiles had often been mistakenly identified as Navajo, Pueblo, or Mexican weaving, or as the infamous "Chimayo Indian weaving." Weaving and dyeing workshops, inspired by the exhibition, were also held at the Museum of International Folk Art in 1976 and 1979 to promote the revival of colonial weaving techniques and designs. The workshops were specifically targeted at Hispanics interested in learning their ancestors' traditional craft. In addition to learning dyeing and weaving skills, Hispanic weavers have commented that the class raised their consciousness about their artistic traditions and exposed them to museum collections, many for the first time.[132]

More recently, this museum has been at the forefront in educating the public about Hispanic textiles. In 1989 the museum opened the Hispanic

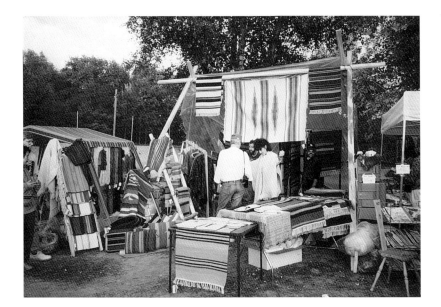

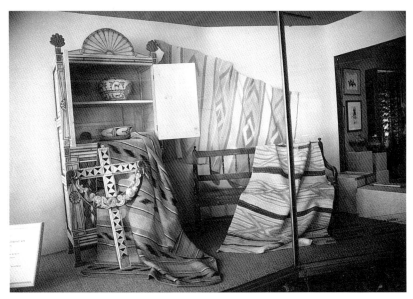

Figure 4.25 | Weavings on display at the Taos Wool Festival. Photo by Helen R. Lucero, 1991.

Figure 4.26 | Window at Owings-Dewey Gallery displaying Hispanic textiles and furniture.
Photo by Helen R. Lucero, 1988.

Chimayó Weaving

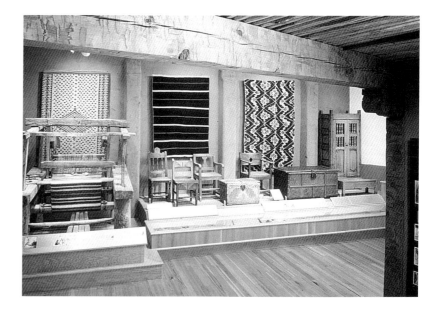

Figure 4.27 | *Weaving section of the* Familia y Fe *exhibition in the Museum of International Folk Art's Hispanic Heritage Wing, Santa Fe. Museum of International Folk Art, Santa Fe, New Mexico. Photo by Michel Monteaux, 1989.*

Figure 4.28 | *Cordelia Coronado demonstrates weaving at the Museum of International Folk Art, Santa Fe, New Mexico. Photo by Helen R. Lucero, 1990.*

Heritage Wing, a space permanently dedicated to exhibiting Hispanic arts. Its inaugural exhibition, *Familia y Fe,* includes a nineteenth-century loom as well as several textiles ranging from Saltillo sarapes to various types of Río Grande blankets (fig. 4.27). Museum visitors can also learn about the differences between Hispanic, Pueblo, and Navajo weaving from this exhibition. Several of the changing exhibitions in a small contemporary gallery adjacent to the permanent exhibit have also included Hispanic weavings, among them *Tradición de Orgullo/Tradition of Pride, I and II* (1989–90), *Across Generations: Hispanic Children and Folk Traditions* (1993), *Art of the Santera* (1993), and *From Land to Loom: Tierra Wools* (1994). Workshops and demonstrations taught by local weavers continue to be part of the museum's public programming (fig. 4.28).[133]

THE OLD CIENEGA VILLAGE MUSEUM AT EL RANCHO DE LAS GOLONDRINAS — This living history museum was developed and privately funded by the Paloheimo family. Mrs. Paloheimo was the former Leonora Curtin who had sponsored the Native Market back in the 1930s. In 1966 Mrs. Paloheimo, her husband, Y. A., and son, George, began to assemble a large collection of historic buildings on the site of this early eighteenth-century rancho. The living museum portrays all the structures and activities essential to a self-sustaining Spanish rural hacienda, including agriculture, defense, religion, and arts and industry. The exhibits are staffed by docents who don period costumes for the various festivals and bring to life an interpretation of Spanish colonial life. The museum's personnel work hard to educate and foster respect and understanding for Hispanic history and culture.

El Rancho de las Golondrinas owns a herd of churro sheep to use in conjunction with its many demonstrations of carding, spinning, dyeing, and weaving. Demonstrators have done much to raise Anglos' and Hispanos' appreciation of local weaving traditions by regularly showing the weaving process from beginning to end. Hispanic weaving classes have also been taught at El Rancho by Los Tejidos Norteños from La Madera and, more recently, by Tejidos y Lana from Las Vegas.[134]

MILLICENT ROGERS MUSEUM — Located in Taos, this museum was founded by Paul Peralta Ramos in 1953 to honor his mother, the late Millicent Rogers. Ramos has been very involved with the museum since its inception and has played an active role in augmenting his mother's extensive collection of Native American and Hispanic arts. The Millicent Rogers Museum houses a large collection of historic and contemporary Hispanic weavings and has been actively involved in educating the public about contemporary Hispanic weaving through its exhibitions, lectures, demonstrations, and classes. In late 1982 the museum mounted *Hebras de Visión/Threads of Vision,* a group show of Hispanic weavers, one of the first such exhibits in New Mexico. A 1985 exhibition, *Los Tejidos de los Trujillos: Weaving at Centinela Ranch,* featured the work of Jacobo Trujillo and his family. *Shared Traditions,* in 1993, juxtaposed Peruvian weavings with the work of several contemporary Hispanic weavers.[135]

ALBUQUERQUE MUSEUM OF ART AND HISTORY — One of the first major contemporary exhibitions to feature Hispanic arts, *One Space/Three Visions,* was held at the Albuquerque Museum in 1979. The Hispanic portion of the exhibition was curated by Reyes Newsom Jaramillo, who traveled throughout the state collecting Hispanic art for the exhibit. In 1980 the museum opened a large, permanent exhibition, *Four Centuries: A History of Albuquerque.* A major section of the exhibition is devoted to Hispanic weaving. Since then, the Albuquerque Museum has continued to exhibit contemporary Hispanic artists as part of several thematic exhibitions. For example, Hispanic weavings were included in *Crafted by Hand* (1991), *Unbroken Threads* (1992), and *Hispanic Heritage Celebration:*

Día de la Raza (1995). In 1993 the *Year of American Craft: Irvin and Lisa Trujillo* exhibition featured the weavings of one Chimayó couple. The museum has also been very active in promoting Hispanic weaving through its public programs: Helen R. Lucero, Teresa Archuleta Sagel, and María Vergara Wilson have all lectured at the Albuquerque Museum. As part of the museum's 1995 *Efectos del País* exhibition, northern New Mexico weavers were enlisted to demonstrate daily in the gallery through-out the seven-month duration of the exhibition. The museum also maintains a significant collection of Hispanic textiles.[136]

TAYLOR MUSEUM OF THE COLORADO SPRINGS FINE ARTS center (Colorado)—This museum has long supported the display of Hispanic crafts, including weaving. Exhibitions that included Hispanic textiles were mounted by the Taylor Museum as early as 1937. On more than one occasion, the museum has exhibited Hispanic weaving alongside textiles from other southwestern cultures, as was the case in the 1967 exhibition *Three Textile Traditions: Pueblo, Navajo, and Saltillo.* The 1977 exhibition *Hispanic Crafts of the Southwest,* with an accompanying catalog, was the first major show of its kind and set the stage for the Hispanic craft renaissance that followed in the 1980s. In 1983 the museum featured the southern Colorado Hispanic weavers in its exhibition *Las Artistas del Valle de San Luis.* New Mexico Hispanic weaver María Vergara Wilson and Al Qoyawayma, a Hopi potter, were paired in a 1985 exhibition, and Teresa Archuleta Sagel was included in the *Taylor Museum Masterworks* exhibition in 1986. This museum also has an impressive collection of Spanish colonial textiles and does extensive public programming in the form of lectures, demonstrations, and workshops.[137]

LOS COLORES MUSEUM—Weaving collector, dealer, and educator Andrew Nagen began collecting textiles for a museum in 1978. Los Colores Museum, located in Corrales, officially opened its doors in 1990 as the only New Mexican museum dedicated solely to the exhibition of textiles from Mexico and the American Southwest.

Between 1990 and 1995 Los Colores mounted over twenty textile exhibitions in Corrales, which were viewed by four thousand to six thousand people annually. Perhaps more important, Los Colores mounted a comparable number of exhibitions that traveled nationally and internationally to places such as Mexico City, Toronto, New York, San Francisco, San Antonio, Tucson, and Washington, D.C. These traveling exhibitions, which were viewed by more than two hundred thousand people, included *Mexican Sarapes from the Andrew Nagen Collection, De Colores,* and *Los Colores de Mexico.* The museum also produced a quarterly newsletter, several publications, and exhibition posters.[138]

Unfortunately, after only five years in operation, the museum was forced to close in 1995 because of Nagen's ill health. Los Colores's significant collection was donated to the Museum of International Folk Art, where it continues to be appreciated by the public.

OTHER MUSEUMS—Other regional museums that have exhibited Hispanic weaving include the Fuller Lodge Art Center in Los Alamos; the Harwood Foundation and the Martínez Hacienda in Taos; the Roswell Museum; and the Maxwell Museum of Anthropology and the University Art Museum in Albuquerque. Most have mounted temporary thematic exhibitions featuring historic textiles or the work of contemporary Hispanic weavers.[139]

Weavers' Guilds

All across the United States, professional and avocational handweavers join voluntary organizations known as guilds. While most are not formal guilds with apprenticeships and master weavers, they are valuable arts organizations, where members learn new techniques, exchange ideas, and

exhibit and market their work. Hispanic weavers have been involved in several weavers' guilds in northern New Mexico, including the Taos Weavers Guild and Las Tejedoras de Ancianos in Taos, the Española Weavers Guild and Art through the Loom in Española, and Las Tejedoras de Santa Fe y Los Alamos.[140]

Guild representatives from Arizona, Colorado, Nevada, New Mexico, and Utah sponsor the Intermountain Weavers' Conference, which is held in different locations biannually. In 1985 the conference was held in Albuquerque, where several Hispanic weavers participated in panels and workshops. Anglo and Hispanic weavers have shared much information with one another in these settings, and their work often reflects the exchange of technique, design configurations, subject matter, and materials.[141]

Contemporary Hispanic Weavers

Following is a brief listing of some of the best Hispanic weavers working in New Mexico today: Teresa Archuleta Sagel from Española, Juanita Jaramillo Lavadie from Taos, Irene López from Española, Karen Martínez from Córdova, Armando Ortega from Albuquerque, and María Vergara Wilson from La Madera (figs. 4.29–4.34). They have all received well-deserved honor and recognition for excelling in their work.[142]

These weavers were singled out to provide visual documentation of the current status of Hispanic weaving (plates 65–70). Most of these weavers have been featured in newspaper and magazine articles, and some have exhibited nationally and internationally. In addition, many of these weavers believe it is their responsibility to serve as advocates of Hispanic art and culture, a responsibility they take very seriously. In 1989 Teresa Archuleta Sagel, a well-known and articulate member of this group, wrote: "When I lecture, teach, or give interviews, it is with a sense of responsibility to

Figure 4.29 | Teresa Archuleta Sagel working on a colcha embroidery, Española, New Mexico. Photo by John Running, 1991.

those who have given me their words and the memories of a northern New Mexican way of life. It is with urgency and conviction that I speak out about Hispanic art and culture. Because of that urgency, a new aspect of my work has developed that of serving on various museum and community boards. I work on these boards to build a greater awareness of Hispanic art and a broader market for continuing generations of artists."[143] These weavers are the living legacy of the Hispanic weaving tradition. Their work and commitment to their art and culture merit a separate publication.

The late twentieth century has shared many features with the early modern period. The craft of

Chimayó Weaving

Figure 4.30 | Juanita Jaramillo Lavadie, Taos, New Mexico. Photo by Helen R. Lucero, 1985 (upper left).

Figure 4.31 | Irene López (center) looks on as Irvin Trujillo leads Spanish Colonial Art Society Professional Development Weaving Workshop at the Museum of International Folk Art, Santa Fe, New Mexico. Photo by Helen R. Lucero, 1992 (lower left).

Figure 4.32 | Armando Ortega wrapped in a blanket made by his grandfather, Juan Melquiades Ortega. Photo by Barney McCullough, 1994 (upper right).

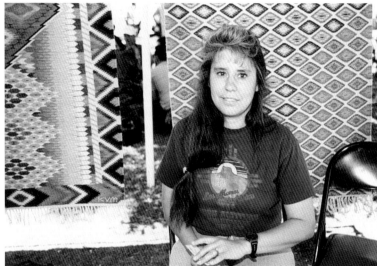

Figure 4.33 | *María Vergara Wilson sits with her colcha embroidery in her front yard, La Madera, New Mexico. Photo by Helen R. Lucero, 1988 .*

Figure 4.34 | *Karen Martínez in front of her weavings at Spanish Market. Photo by Kaoru Kato, 1995.*

weaving was seen as an avenue to economic development as government and private funds were channeled into it. Additional support for Hispanic weaving came from an enlightened Anglo arts community that involved Hispanic artisans in art fairs and museum and gallery exhibitions. Much of the work in galleries and museums reflects the artists' exploration of historic New Mexican, Mexican, and Anglo textiles and their synthesis of designs and techniques through new interpretations. A few artists draw on themes from the fine arts world. The development of Hispanic weaving parallels the growing assimilation resulting from migration, intermarriage, and exposure to mass media. Rather than detracting from the craft, however, a kaleidoscopic American society has augmented New Mexican Hispanics' creativity in weaving. The craft of Hispanic weaving in the late twentieth century continues to draw upon a myriad of influences as the transformation of tradition continues.

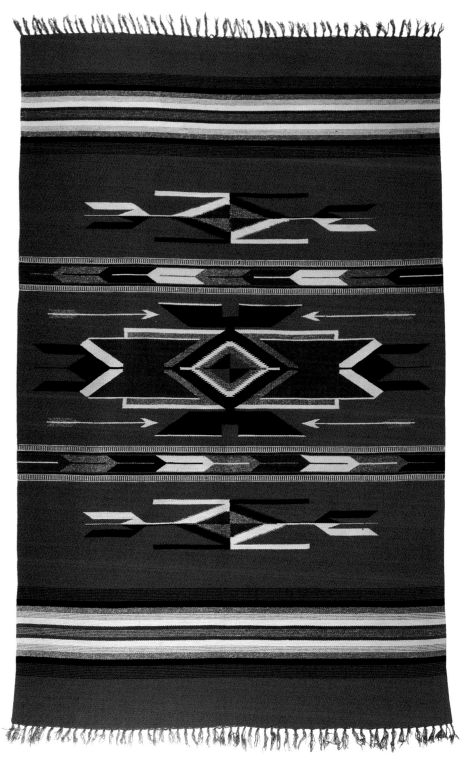

*Plate 59 | Chimayó blanket with red background, 1940s. Commercial yarns: cotton warp,
wool weft, 120 x 51 in. Southwest Museum, Los Angeles, California, 1874.G.1.*

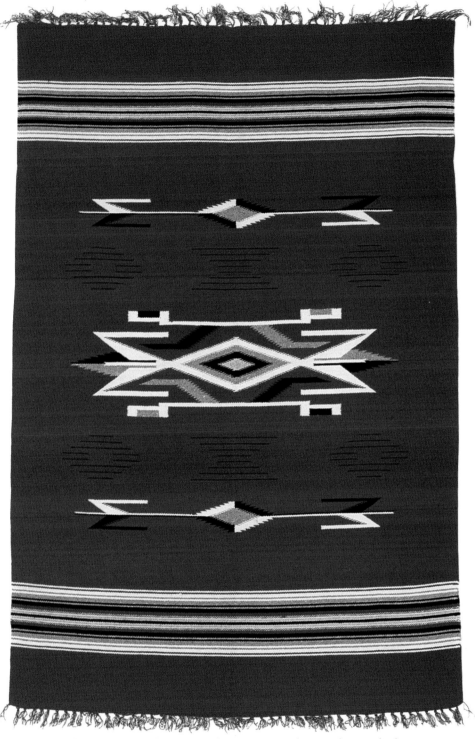

Plate 60 | Chimayó blanket, late 1930s to early 1940s. Commercial yarn, wool warp and weft, 73 x 46 in. International Folk Art Foundation Collections at the Museum of International Folk Art, Santa Fe, New Mexico. FA.1987.440-1. Photo by Miguel Gandert, 1992.

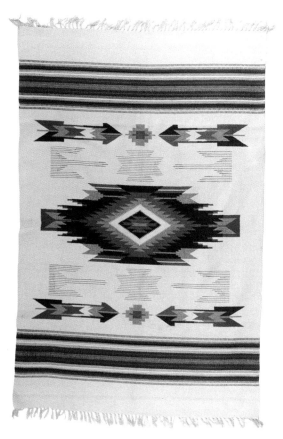

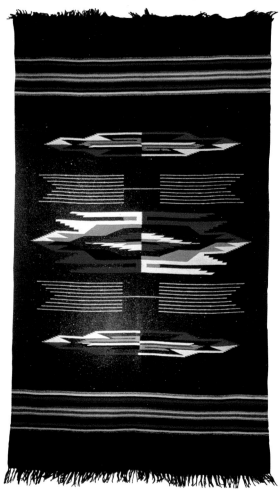

Plate 61 | Chimayó blanket with white background, 1930s–40s. Commercial yarn, wool warp and weft, 70 x 48 in. Southwest Museum, Los Angeles, California, 1894.G.22 (left).

Plate 62 | Chimayó blanket, after 1930. Commercial yarn, wool warp and weft, 87 x 49 in. Millicent Rogers Museum of Northern New Mexico, Taos, New Mexico. 1981-58-52. Photo by Vicente Martínez (right).

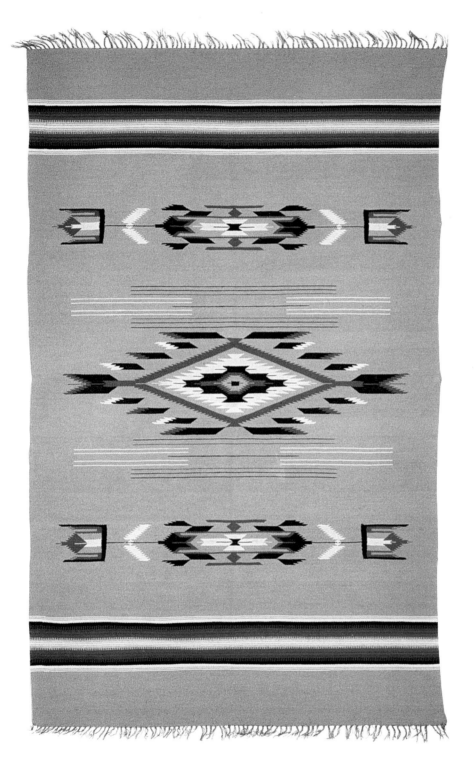

Plate 63 | Chimayó blanket with blue-grey background, woven by Emilio Cordova, 1940s. Commercial yarn, wool warp and weft. Collection of Elvira Salazar. Photo by Miguel Gandert, 1997.

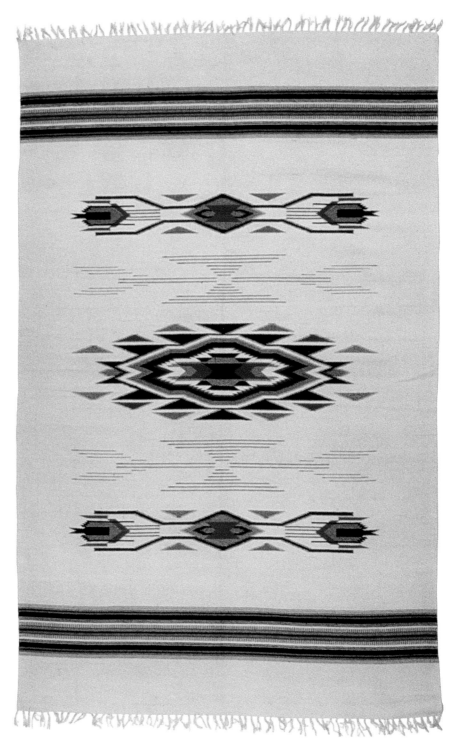

Plate 64 | Chimayó blanket with white background, 1940s.
Commercial yarns: wool warp and weft, 87 x 53 in. Arizona State
Museum, University of Arizona, Tucson, E-6102.

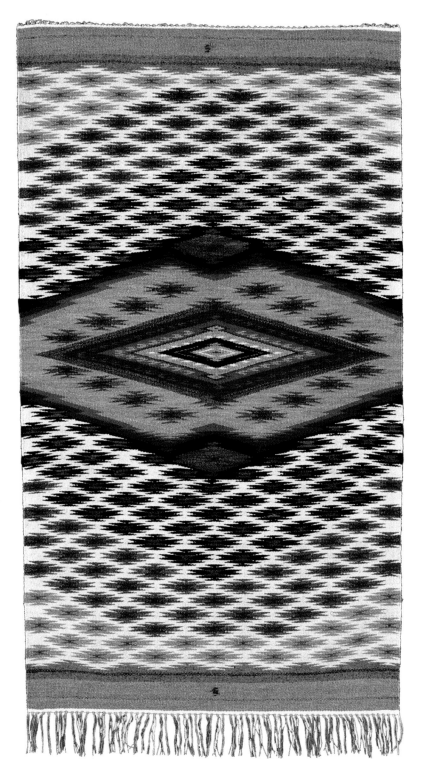

Plate 65 | Alba Little Dawn *by Teresa Archuleta Sagel, 1995.*
Courtesy of the artist. Photo by Eric Swanson.

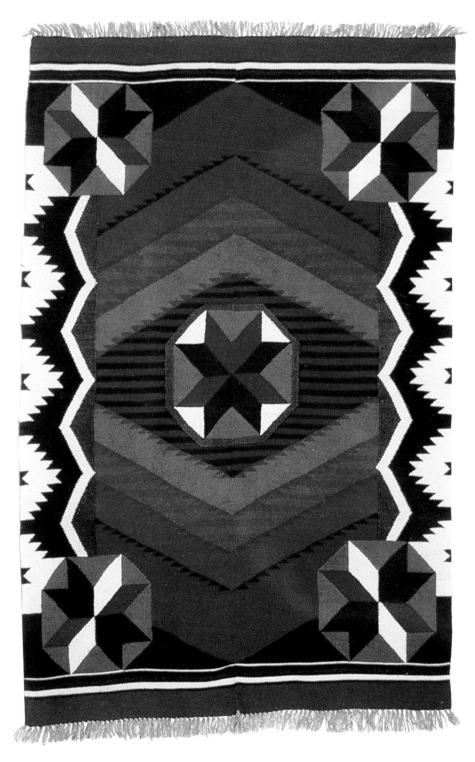

Plate 66 | Vallero/Reconociendo Raices *by Juanita Jaramillo Lavadie, 1982, 90 x 57 in. Millicent Rogers Museum of Northern New Mexico, Taos, New Mexico. 1982-74-5. Photo by Vicente Martínez.*

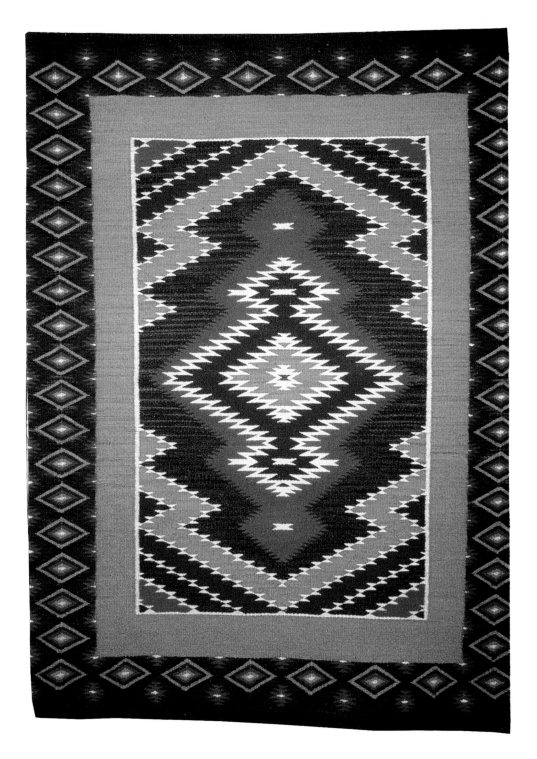

Plate 67 | Estrellas en la Noche *by Irene López, 1994. Courtesy of the artist.*
Photo by Richard Rieckenberg.

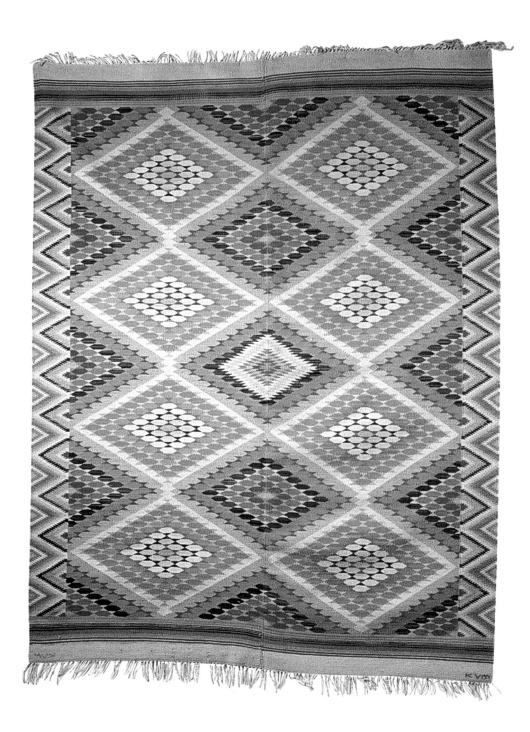

Plate 68 | Eye Dazzler *by Karen Martínez, 1992. International Folk
Art Foundation Collections at the Museum of International Folk Art,
Santa Fe, New Mexico, FA.1993.66.1. Photo by Miguel Gandert (left).*

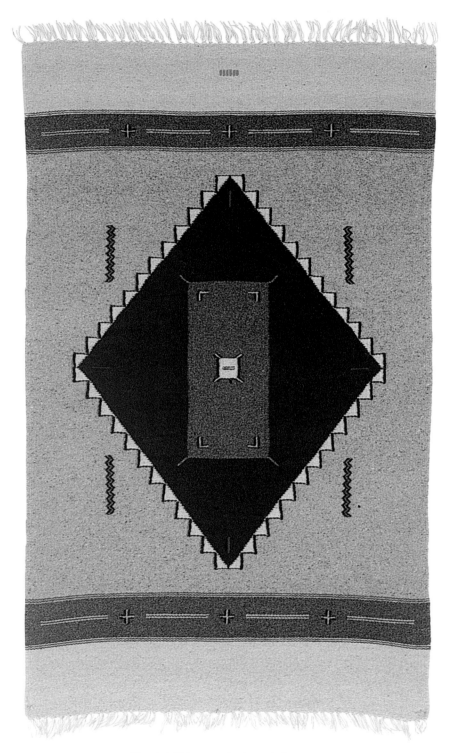

Plate 69 | Chimayoso *by Armando Ortega, 1994.*
Courtesy of the artist. Photo by Barney McCullough.

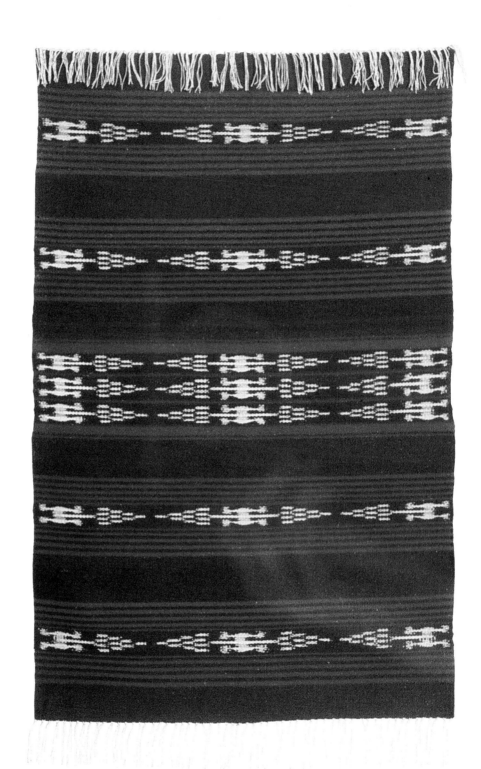

Plate 70 | Ikat II *by María Vergara Wilson, 1982, 67 x 38 in. Millicent Rogers Museum of Northern New Mexico, Taos, New Mexico, MRM1982-74-2. Photo by Vicente Martínez.*

5

Tres Familias
Profiles of Three Contemporary Hispanic Weaving Families

Events and institutions of the late modern period are described in chapter 4, but the way in which these events and institutions have interwoven with the lives of weavers provides a more intimate look at the craft. Choosing which families to describe was not an easy task. In 1995 more than two hundred Hispanic weavers were working in northern New Mexico. No two weavers weave exactly alike nor have the same weaving experiences. The three families described here — the Ortegas of Chimayó, the Trujillos of Chimayó, and the Martínezes of Medanales — were selected because their weaving involvement reflects three dominant themes: commercialism, innovation, and intergenerational continuity. In many ways these three families are more alike than different. All live in rural northern New Mexico as members of large, extended families; all can trace their weaving heritage back through several generations; all create unique and beautiful weavings affected by the weaving designs of their ancestors, yet responsive to their own inspirations and to contemporary influences; and all deal in trade in textiles, especially to tourists.

The Ortega Family

The best-known family of weavers in northern New Mexico is the Ortega family of Chimayó.

Figure 5.1 | Billboard on Interstate 25 north of Santa Fe advertises Ortega's Weaving Shop. Photo by Suzanne Baizerman, 1985.

Billboards along the main highway between Santa Fe and Taos direct visitors through the countryside to this village where the family business is located (fig. 5.1). Tour buses regularly stop at the Ortegas on their north- and southbound routes.

Nicasio and Virginia Ortega originally established their business as a general store in 1918. Since then, it has gone through many remodelings, and today visitors find a large store geared to tourists' needs (fig. 5.2). Ortegas' weavers produce a full range of woven items (plate 71). Weavings generally feature what has come to be known as the classic Chimayó design format and are available in standardized sizes ranging from twin or full-size bed blankets *(frazadas)* to 4" x 4" coffee

131

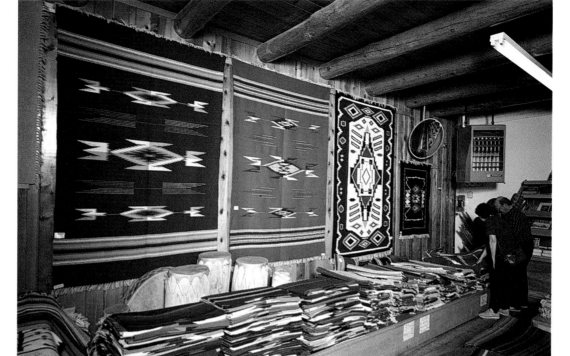

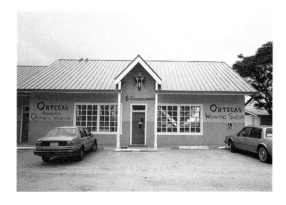

mug coasters to the ever-popular 10" x 10" mats (plate 73). Rugs and cushions also come in standard sizes. Made from loom-woven fabric are various items of clothing such as vests, coats, ponchos, and purses; these are prominently displayed along the wall in racks and shelves (fig. 5.3).

More than a place to buy weavings, Ortega's Weaving Shop is a place where visitors can make contact with weavers even when converging tour buses create a frenzied atmosphere (fig. 5.6). The

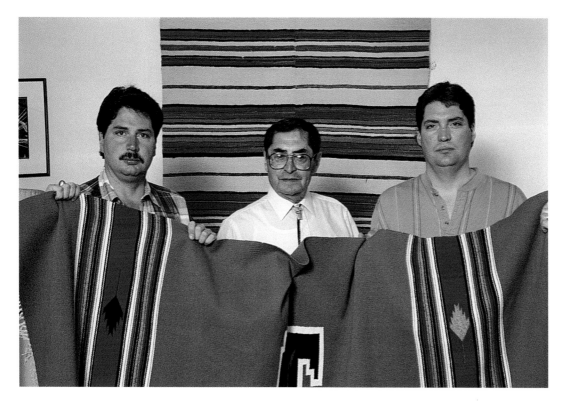

Tres Familias

Plate 71 | Interior of Ortega's Weaving Shop, Chimayó, New Mexico. Photo by Miguel Gandert, 1992 (opposite).

Plate 72 | David Ortega (center) with two of his sons: Robert (left), and Andrew (right). Photo by Miguel Gandert, 1992 (above).

Plate 73 | 10 x 10-inch mats from Ortega's Weaving Shop, Chimayó, New Mexico. Photo by Miguel Gandert, 1992 (lower right).

Figure 5.2 | Exterior of Ortega's Weaving Shop, Chimayó, New Mexico. Photo by Miguel Gandert, 1992 (opposite, middle).

Figure 5.3 | Chimayó jackets, vests, and purses are prominently displayed in Ortega's Weaving Shop. Photo by Miguel Gandert, 1992 (opposite, lower).

Figure 5.4 | David Ortega surrounded by customers. Photo by Suzanne Baizerman, 1985 (opposite, middle).

Figure 5.5 | Nicasio Ortega (center) with two of his sons: José Ramón (left), and David (right). Original photo by Maurice Eby, 1958 (opposite, right).

Chimayó Weaving

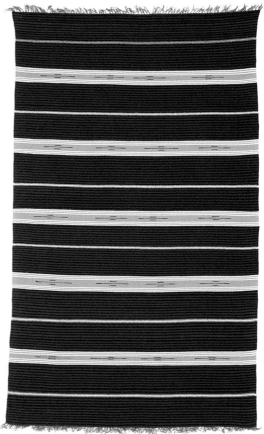

Plate 74 | Two-piece (seamed) blanket of handspun yarn woven by Nicasio Ortega's father, José Ramón Ortega, ca. 1875. Collection of David Ortega. Photo by Miguel Gandert, 1992 (left).

Plate 75 | Handwoven striped blanket by Nicasio Ortega, 1953. Museum of New Mexico Collections, Museum of International Folk Art, Santa Fe, New Mexico, 1328 AW. Photo by Miguel Gandert, 1992 (right).

store also carries a vast array of conventional tourist goods: American Indian jewelry and pottery, postcards, and an extensive selection of books about southwestern geography, history, and art.

David Ortega, the current patriarch of the Ortega family, was born in 1917. After almost fifty years in the business, he retired in 1992 and passed the shop on to one of his four sons, Robert. Another son, Andrew, owns and operates a related

family business next door, an art gallery (plate 72). David's "making way" for his sons was not unlike his own experience when his father, Nicasio Ortega, founder of the store, turned the business over to him.

Nicasio, one of fourteen children, learned to weave from his father, José Ramón Ortega (fig. 5.5 and plates 74, 75). Nicasio had entered the business world in 1912, when he accepted a large order for weavings and then had to recruit his relatives to help him fill the order. Nicasio's brother Reyes, also of Chimayó, developed his own weaving concern, having already been involved with the business side of weaving while working for curio dealer J. S. Candelario of Santa Fe. Another brother, Victor, had a general store in Chimayó where he also sold weavings. By 1922 Nicasio's own business was successful enough to enable him to buy the first car in

Chimayó.[1] As Nicasio's four sons, José Ramón, Ricardo, Medardo, and David, grew up they became accomplished weavers and contributed to the expansion of the family business.

Trade in weavings was nothing new to the Ortega family. Their weaving heritage dates back to the original resettlement of northern New Mexico in the last years of the seventeenth century when they were issued a family land grant. The first documented Ortega weaver, Nicolás Gabriel Ortega, was born in 1729. He and later Ortega descendants undoubtedly participated in the widespread trade in blankets that prevailed during the Spanish colonial and Mexican periods of New Mexico's history, a trade that stretched as far as Mexico and California.

The Ortegas' longevity in Chimayó and their prominence as weavers have made them a part of northern New Mexico's elite. A main *acequia* (irrigation ditch) was named after the Ortegas, and the family maintains its own nineteenth-century chapel, the *Oratorio de San Buenaventura,* in the old Plaza del Cerro. During the past half-century, David Ortega has been active in politics, has promoted the revival of Spanish colonial arts, and has been instrumental in bringing paved roads, a fire department, and a garbage dump to the village of Chimayó.

However, the Ortegas' success lies not only in the family's historic connection to the area but also in the way in which they have developed their business acumen, drawing on business practices outside of northern New Mexico. In the 1930s, when Anglo commercial weaving ventures opened in Santa Fe and sought Hispanic weavers to operate looms, David went to work for Burro Weavers. This experience provided him with an education on then-modern Anglo business practices. Later, when two Santa Fe weaving concerns, McCrossen Textiles and Southwest Arts and Crafts, closed their doors, David bought their weaving equipment.

At his father's request, David returned to Chimayó after service in World War II to save the fam-

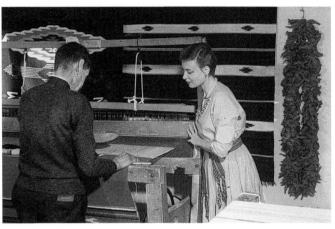

Figure 5.6 | Ortega's Weaving Shop label.
Photo by Miguel Gandert, 1992.

Plate 76 | Postcard advertising Ortega's Weaving Shop.
Nicasio Ortega weaves as Suzanne de Borhegyi looks on,
ca. 1950s. Collection of David Ortega. Photo by Miguel
Gandert, 1992.

ily business, which had deteriorated during wartime because of the shrinking tourist market (plate 76). David brought with him his wartime bride, Jeanine Williamson. Between 1947 and 1950 the Ortegas remodeled the family store, adding a new front room and closing the grocery business in favor of a shop devoted primarily to weaving. David also instituted some important changes at Ortega's Weaving Shop. For example, he added

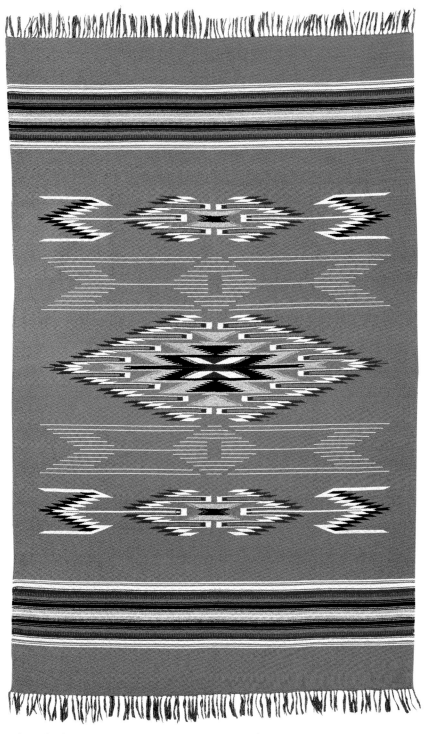

Plate 77 | Chimayó blanket with turquoise background, 1950s. Commercial yarn, wool warp and weft. Dr. and Mrs. Carson received this blanket as a wedding gift in July 1956. Collection of Mrs. Norman Carson. Photo by Petronella Ytsma, 1997.

jackets, coats, and vests to his inventory. He also substituted more durable wool warp for cotton carpet warp, allowing him to market Ortega's weavings as 100-percent wool (fig. 5.6).

The Ortega family has continued to respond to changes in consumer needs. During the 1940s and 1950s David and his brother José Ramón began marketing Ortega's weavings beyond Chimayó. They traveled throughout the Southwest, wholesaling Chimayó weavings at national parks and shops. As tastes changed in the late 1940s, highly saturated turquoise-blues and reds replaced the muted color harmonies of the war years (plate 77). In the 1960s, when tourist interest in Navajo rugs increased demand for woven floor coverings, a line of rugs was added to the inventory. Handwoven shawls were added in the 1980s.[2]

In the mid-1970s, following Nicasio's death in 1964 and José Ramón's in 1972, "new blood" was recruited; David's sons entered the family business. The business expanded further in 1978 when David's brother Medardo opened an Ortega's Weaving Shop outlet in Albuquerque's Old Town.

As Santa Fe and Taos gained prominence as art centers, the Ortegas capitalized on their High Road location linking the two cities and expanded their marketing efforts in the arts. In 1983 David's son Andrew and his wife, Evita, opened the Galería Plaza del Cerro, now called the Galería Ortega. At the gallery, the couple exhibits and sells the work of Hispanic, American Indian, and Anglo artists and artisans of the area. Andrew also continues the Ortega weaving tradition by exhibiting his own weavings at the Galería and elsewhere.

More than any other weaving family in New Mexico, the Ortegas have been featured in numerous newspaper and magazine articles over the years. On May 9, 1953, the *Saturday Evening Post* published an article by Neil M. Clark, "The Weavers of Chimayo: An Ancient New Mexico Craft Lives On."[3] Other notable articles have appeared in the *New York Times,* the *National Geographic, Vista*

Magazine, Countryside, Southwest Profile, Culture and Leisure, and *New Mexico Magazine.* Many television, film, and video programs have also featured the Ortegas.

The relatively small physical scale of Ortega's Weaving Shop belies the scope of this large enterprise. Behind the scenes are dozens of weavers who weave in their own homes in a cottage industry. According to David, in 1983 the Ortegas had 115 looms and sixty active weavers to whom they paid a total of about a quarter-million dollars in wages. The number of weavers has remained relatively constant. A decade later, Robert's roster of contract weavers still numbered sixty, but more were working full time, indicating a greater commitment to the weaving profession. The weavers are located in a wide geographic radius. Most live in northern New Mexico, but some are scattered throughout the state; one weaver even resides in El Paso, Texas.

An important ingredient in the business's success has been recruitment and retention of good weavers. The first Ortega weavers were Nicasio's relatives and in-laws. A cousin, Juan Melquiades Ortega, wove for the Ortega family business well into his nineties. Another distant cousin, Georgia Serrano, daughter of Agueda Martínez, has become one of the Ortegas' best weavers. Others, such as the Vigil family of Cundiyó and various members of the Trujillo family of Chimayó, are linked to the Ortegas through ties of marriage and *compadrazgo* (godparenthood). Nonrelated community members have also been trained to weave. Today, some of the most prominent Ortega weavers include members of the following families: García, Martínez, Manzanares, Rodríguez, Serrano, Trujillo, Valdez, and Vigil.[4] Constant recruitment is necessary as weavers work seasonally, leave to work for themselves or for other dealers, or move on to pursue other endeavors.

David Ortega speaks with pride of the weavers the family has trained, many of whom have worked for the Ortegas for decades. He also points out

that many families have stayed off welfare because of their weaving. Ortega's weavers include young mothers, women whose families have grown and left home, retired people, and college students home on vacation. Most are individuals who prefer to work part-time at home in their own communities.

The Ortegas supply the weavers with yarn, and a loom can be supplied if the weaver does not own one. The loom is warped in the basement of Ortega's shop using a large warping device, ensuring a uniform warp tension critical to the quality and evenness of the finished piece. Yarn is ordered primarily from J. and H. Clasgens of Richmond, Ohio, and Crescent Woolen Mills of Two Rivers, Wisconsin. In 1991 ten thousand pounds of commercially spun and dyed wool were purchased by David Ortega, 88 percent of which was weft yarn.[5] The brightly colored wool is warehoused in a large room behind the store showroom.

When completed, weavings are brought to the Ortegas and weighed. Finished pieces are then steam-pressed before being sold in the showroom. Each weaver is assessed the cost of yarn used per weaving according to its weight. In 1992 David generally sold a 54" x 84" blanket for about $350.00. The weaver was paid approximately one-quarter to one-third of the sale price depending on the product's complexity and weaving quality. From all accounts, David has made a substantial income from serving as middleman and has, in turn, played a benevolent role in the lives of the weavers and the community.

The Ortegas maintain a high degree of control over their weavings. Regarding the quality of work brought to him by his weavers, David stated: "If it's good, we pay them immediately. If it's bad, we sort of reprimand them and try to correct [it]. If it's not salable, we do something else with it. We don't just sell it as straight goods. . . . We have the facility to turn a piece of weaving into other than a straight line of goods, like a cushion, or a purse, or a coat, or a jacket something like that."[6]

In addition to the work displayed in the store, the Ortegas fill many special orders. "Send anything, we can weave it," has been their motto. They take pride in weaving complex organizational emblems, logos, lettering, and pictorial images, as well as replicas of historic Hispanic or Navajo blankets. For example, the Ortegas do not hesitate to produce blue, black, and white striped blankets, patterned after the old Spanish colonial designs, to meet Anglo consumers' demand for replicas. They have designed blankets for many dignitaries, including two presidents: Richard Nixon owned an Ortega Chimayó weaving, and Franklin Delano Roosevelt wrote to Nicasio Ortega in 1934 expressing his pleasure with an eagle-motif blanket that Señor Ortega had woven.[7]

Despite resounding success in the weaving business, the Ortegas still maintain their agricultural holdings, depending on local farmers to work their property. It is likely that the farm is worked more out of a sense of continuity with the past and ethnic identity than for its viability as a source of livelihood.

Outside the community, David Ortega has been involved with the support of Hispanic arts and crafts. He has been a member of the board of the Spanish Colonial Arts Society and has served as a judge at Santa Fe's annual Spanish Market. David is proud of his *Nuevomexicano* heritage and loves to tell people about his family's role in the continuation of Hispanic weaving in New Mexico. He believes strongly in the role of Hispanic weaving as a vehicle for transmitting information about Hispanic culture. He has helped fill the notebooks of dozens of researchers and journalists seeking information about Chimayó and Hispanic weaving, opening family records and photo archives, and proudly displaying family heirloom weavings.

Mr. Ortega is a successful entrepreneur who has earned the respect of his community. His sensitivity to his market, his ability to recruit and retain weavers, his participation in the greater business world, and his alertness to changing business practices enabled him to become a leader in the weaving industry. At the same time, his local roots and the Ortegas' eight-generation weaving heritage have remained of utmost importance to him. Having retired, he can now survey what he has accomplished and become his sons' adviser as they carry on the Ortegas' family business.

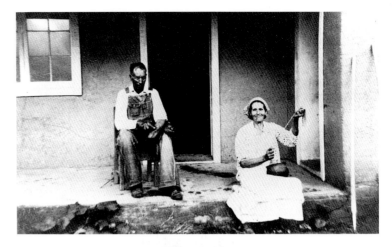

The Trujillo Family

No family better exemplifies the conflict between the rural Hispanic community ruled by time-honored family values and the fast-paced, competitive, Anglo-dominated outside world than the Trujillo family of weavers—Jacobo, Irvin, and Lisa. Jacobo "Jake" O. Trujillo was born in 1911. He grew up in rural Chimayó but spent thirty years of his life in Los Alamos. There he worked for the federal government by day and taught weaving classes by night. His son, Irvin L. Trujillo, born in 1954, grew up in Los Alamos but, after college and an engineering career, chose to return to the homestead to establish a weaving business. For many years, father and son commuted between Los Alamos and Chimayó, maintaining contact with both worlds.

Jake Trujillo was born into a family with a long weaving tradition (fig. 5.7). In fact, Jake could lay claim to being a sixth-generation weaver descended from Nicolás Gabriel Ortega and a third-generation weaver descended from his paternal grandfather, José Concepción Trujillo. Jake and his five siblings—Teresita, Fedelina, Mercedes, Antonio Maximo, and Rosinaldo—all learned to weave (fig. 5.8). The family wove handspun yarn into striped blankets and also produced weavings of commercial

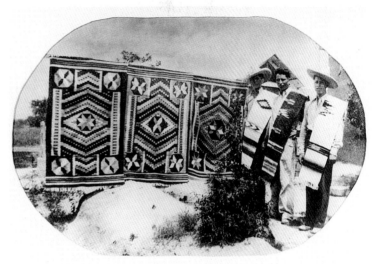

Figure 5.7 | Jacobo Trujillo's parents, Isidoro Trujillo and Francisca Ortega Trujillo, ca. 1940. Photo courtesy of Mercedes Trujillo.

Figure 5.8 | Trujillo brothers (left to right): Rosinaldo, Antonio Máximo, and Jacobo Trujillo stand beside three Trampas/Valleros. Draped over their shoulders are typical Chimayó blankets, 1937. Photo courtesy of Irvin Trujillo.

Figure 5.9 | Jacobo Trujillo spinning wool, 1933.
Photo courtesy of Irvin Trujillo.

yarns for blanket dealers. Jake was taught to weave by his mother in the 1920s when he was fourteen or fifteen. He then worked as a cottage-industry weaver for his brother-in-law Severo Jaramillo, husband of his oldest sister, Teresita; Señor Jaramillo had opened a weaving shop in Chimayó in 1922. Jake refined his skills while working for his brother-in-law and, while still in high school, was assigned to fill the more difficult special orders.[8]

In the fall of 1932 Jake was recruited to serve as a teacher in a new WPA program set up by the State Vocational Education Department at the San José Training School in Albuquerque. Soon Jake was teaching teachers from all over New Mexico how to card, spin, dye with natural dyes, warp a loom, and finally, weave blankets (fig. 5.9). After his tenure at San José, Jake was sent to the El Rito Vocational School (1934–35) and then transferred to Española (1936–37). At each place he had to set up a weaving classroom and gather more dye plants. When his WPA employers attempted to move him to yet an-

other site, he quit, and returned home to weave. During his years as a teacher, he was liked and respected by the many weavers whom he taught, several of whom are still weaving today.[9]

In 1942 Jake was inducted into the navy, went to gunner's school, and expected to be shipped overseas. He was already aboard ship in Norfolk, Virginia, when he received a telegram instructing him to report to Treasure Island, near San Francisco, for a special assignment. Reflecting on his military service, Jake reminisced: "I thought they were going to send me where the fighting was really going on. But the officer had been checking the records and they discovered that I had been an instructor in arts and crafts here in New Mexico and they wanted somebody to be in charge of a rehabilitation center where they could teach the sailors different crafts and keep them occupied in learning some kind of trade."[10] Jake was delighted with the news and spent the duration of the war supervising the arts and crafts program and teaching weaving.

After the war, Jake searched for a job to earn money to start his own weaving shop. Employed as a timekeeper with the Atomic Energy Commission, he moved to Los Alamos with his new bride, Isabelle García. Later he worked as a property manager with the National Laboratory, operated by the University of California. He thought he would work in Los Alamos for two or three years "but thirty years went by very fast" and his dream of having his own shop did not materialize until 1982.[11]

After Jake retired in 1975, weaving became his major occupation. However, always the workaholic, Jake also continued to work long hours tending his gardens and orchards and teaching weaving classes at Los Alamos High School. Together with his wife, Jake also attended many markets and fairs in those succeeding years, including the Feria Artesana, Rancho de las Golondrinas, the Los Alamos Fair, the New Mexico State Fair, and Spanish Market in Santa Fe.

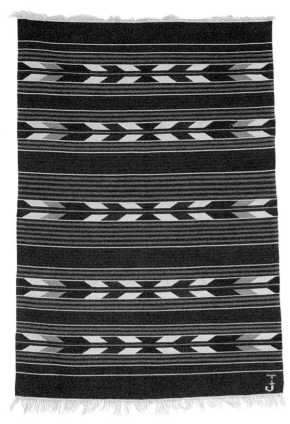

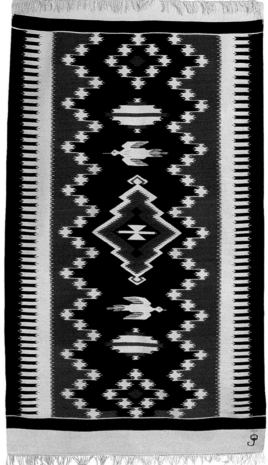

Tres Familias

At the fairs and in his weaving shop, the loquacious Jake was able to pursue his other love, educating people: "I get a real satisfaction from telling people the type of work that we do and how we do it . . . because it is very important that people understand and know, be able to tell the difference between good quality work and bad quality."[12]

Jake always had high standards. During sixty-five years spent at his loom, Jake mastered every style associated with the Hispanic weaving tradition: Saltillos, Classic Río Grandes with stripes or tapestry designs, Trampas/Valleros, *jergas,* and Chimayó blankets (plates 78, 79). He won numerous ribbons and other awards for his work.

This country boy, who got swept along by the global events of his day, spent much of his life working in an Anglo culture. However, he always maintained strong ties to his Hispanic community. Through his Hispanic values, Catholic church

Plate 78 | *Río Grande striped bands and tapestry weaving by Jacobo Trujillo, 1984, 79 x 54 in. International Folk Art Foundation Collections at the Museum of International Folk Art, Santa Fe, New Mexico. FA.1984.327-2. Photo by Miguel Gandert, 1992 (left).*

Plate 79 | Las Palomas *by Jacobo Trujillo, 1985. Collection of Irvin Trujillo. Photo by Miguel Gandert, 1992 (right).*

affiliation, Spanish language, *compadrazgo,* and congenial personality, he remained a valued citizen of Chimayó. Jake died on April 18, 1990, and was buried a thousand feet from where he was born. He left a marvelous legacy in his work and another in his incredibly creative family.

When Jake's son, Irvin, was ten years old, his father taught him to weave by placing a little soap box next to his own loom where his young son could watch him create the woven designs. Irvin proved to be a fast learner. After only two weeks of experimentation, Jake told Irvin he was ready to weave on his own. Ten-year-old Irvin spent his entire summer vacation in 1965 as an Ortega production weaver working "from 8:00 in the morning until 9:00 at night . . . weaving 20" x 20"s; it's very difficult to design a new design every 20" x 20". My record at that time was weaving ten [pieces per day] with a 2-1/2" design . . . [working] about twelve hours."[13] Irvin exhibited an unusual precocity for learning whatever he set his mind to. He also inherited his father's penchant for hard work.

Although Irvin was precocious and hardworking, weaving would not really become important in his life until he reached his twenties. Until that time, Irvin had pursued a career as an engineer, as well as a serious avocation as a musician, a drummer with a preference for rock music. Only after selling his weavings at Spanish Market in 1977 and seeing wonderful examples of Spanish colonial weaving in the 1979 publication *Spanish Textile Tradition of New Mexico and Colorado* did he reevaluate his ideas about his father's craft and the examples of weaving that had surrounded him all his life. Having grown up in an environment that valued higher education over manual labor, Irvin was encouraged to do well in school so he could someday obtain better-paying and more prestigious employment than his father. It was, therefore, not surprising that as a junior high school student, Irvin held a negative opinion of Chimayó weaving:

I really got sick of Chimayó [weaving] I had a lot of shame about it. I was very [ashamed] that I was a Chimayó weaver because the Chimayó designs were not very complex. . . . I was really bored with Chimayó [weaving]. Since . . . that time to now, I've really gained a lot of respect for the designers of Chimayó blankets because not everybody weaves simply. . . . And I've gained a respect for my father's work because he was doing it without diagrams or without books to look at. He was . . . basically doing it from his mind. And I've since learned that doing pieces without sketches is very difficult.[14]

Irvin also resented the low wages weavers were paid by dealers; he wanted to earn a better salary.

His feelings about Chimayó weaving notwithstanding, Irvin continued to weave throughout high school. Later, he remembers a turning point in his life: "I got a music scholarship to go to Eastern New Mexico University to study . . . a full four-year scholarship and I turned it down . . . because my parents felt that being a musician was a hard life, and it wasn't a very lucrative way of making a living."[15]

After acceding to his parents' wishes that he pursue a different area of study, Irvin earned two associate degrees in 1974 from Eastern New Mexico University in civil technology and machine design technology. He then went to work as a technician, drafting for Sandia Laboratories in Albuquerque. He was quickly bored by the work, so he returned to school, this time at the University of New Mexico, where in 1979 he earned a bachelor of science degree in civil engineering. Although he majored in engineering, Irvin never abandoned his love for music and took private lessons whenever possible. He satisfied his passion for music by playing drums and percussion instruments in different bands.

Irvin met his future bride in 1980 when she asked his band for help in finding a drummer for a rock band she was forming. The meeting between Irvin and Lisa Rockwood, an eighteen-year-old California native, resulted in their marriage two years later. In addition to playing the electric guitar with her band, Lisa was also studying at the University of New Mexico, where she graduated with a bachelor's degree in business administration in 1982.

Shortly after their marriage, Lisa learned to weave from Irvin. Lisa and Irvin also immersed themselves in learning about natural dyes, spinning, and traditional weaving techniques. Jake was a willing instructor, and the couple read everything they could find on the subject. Although Lisa is of Jewish-American ancestry, she quickly became a highly accomplished weaver in the Hispanic tradition. Falling in love with Mexican Saltillo sarapes, Lisa challenged herself to weave her own handspun, natural-dyed sarapes with extremely fine and intricate designs. Today, Lisa's Saltillos are without rival; they are superior to any produced by Anglo or Hispanic weavers.

In 1980 the Trujillos held a family meeting in Chimayó; present were Jake and Isabelle, Irvin and Lisa, Irvin's sister, Patricia (Pat), and her husband, Marco Oviedo. They discussed their life goals and decided to open a business where they would not only produce and sell their creative work but also could strive to be self-sufficient; they gave themselves seven years. Theirs was a fortunate situation because Jake owned good roadside property on which to build a shop, and he had extensive knowledge about the weaving business. Moreover, Lisa's last class project at the university—development of a business plan—helped immensely when they launched their own shop. Centinela Traditional Arts officially opened on the weekend of July 4, 1982 (fig. 5.10). Deriving its name from the historic importance of the site as a sentinel outpost, a lookout for marauding Indians,

Tres Familias

Figure 5.10 | *Centinela Traditional Arts Shop sign on Highway 85 on the north end of Chimayó. Photo by Suzanne Baizerman, 1985.*

Figure 5.11 | *Exterior of Centinela Traditional Arts Shop. Photo by Miguel Gandert, 1992.*

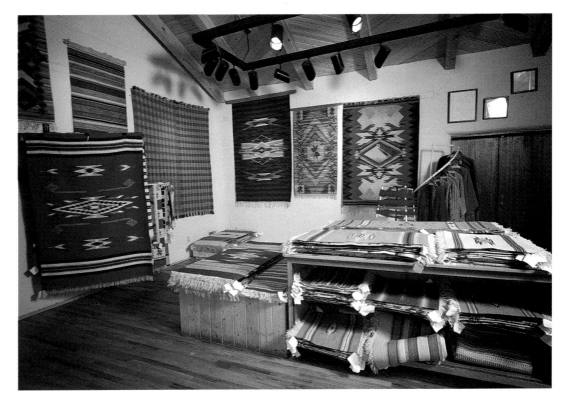

Plate 80 | *Interior of Centinela Traditional Arts Shop showing its gallery-like setting. Photo by Miguel Gandert, 1992.*

the shop was located next to the Trujillo's fields and orchard, which provided a lovely ambience.[16]

Centinela Traditional Arts was initially conceived as a single-family business. It soon developed into a multifaceted family enterprise consisting of four businesses operating out of the same showrooms. Weaving was the family's major product. However, during the shop's early years, Irvin's brother-in-law, Marco, displayed and sold his looms, weaving accessories, carved corbels, *vigas, santos,* and wooden figurines under the banner of Oviedo's Wood Carving. His wife, Pat, also sold her hand-painted *retablos* in the shop and operated a business, *Paseo de la Tierra Vieja,* which provided guided trail rides on burros and donkeys or in a mule-drawn wagon. Pat and her mother were instrumental in operating yet another subsidiary business, *Miel de Chimayó* and Centinela Fruit Stand where their local produce and honey were sold.

Unfortunately, disputes soon arose over the way in which the business was run. Lisa's desire to use her marketing skills to upgrade the business were pitted against Jake's ways of doing things. To resolve their problems, Irvin and Lisa built a separate shop next door to Jake's (fig. 5.11). In 1988 the Oviedos also separated their business from the Trujillos and opened their own shop, Oviedo's Carving and Bronze, across the road.

The Centinela Traditional Arts shop initially had three rooms: two for display, one for storage, and a connecting hallway. In recent years Irvin and Lisa have expanded the shop to include three display and two storage rooms. They also have added postcards, books, and woven clothing to their array of merchandise. Their showroom—with its high ceiling, light walls, and track lighting, which spotlights their large weavings—was designed like an art gallery (plate 80).

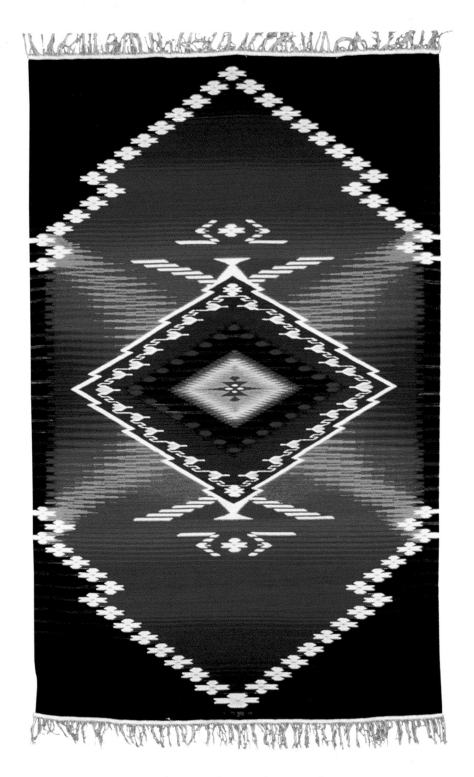

Plate 81 | Río Grande Fusion *by Irvin Trujillo, 1989.*
Courtesy of the artist. Photo by Richard Wickstrom.

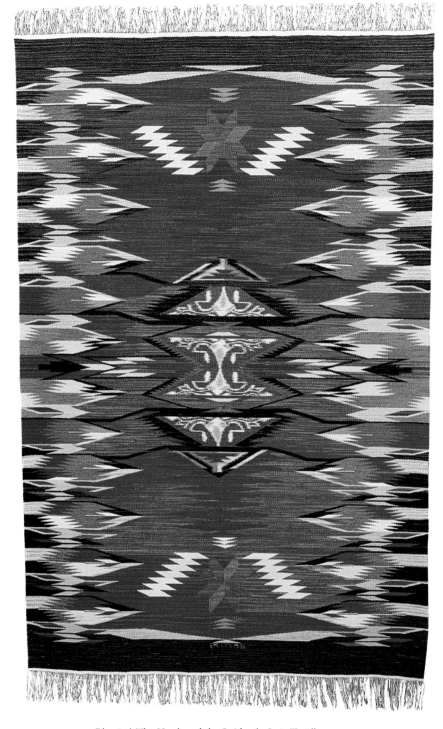

Plate 82 | The Hook and the Spider *by Irvin Trujillo, 1995.*
National Museum of American Art, Smithsonian Institution,
1995.51. Gift of Mr. and Mrs. Andrew Anderson III.

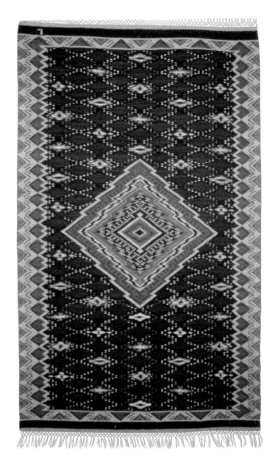

Plate 84 | Passion in the Web *by Lisa Trujillo, 1989. Courtesy of the artist. Photo by Richard Wickstrom.*

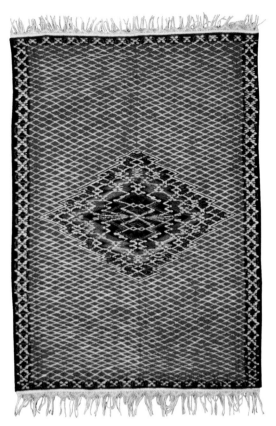

Plate 83 | Hyperactive *by Lisa Trujillo, 1984. Courtesy of the artist. Photo by Rod Hook.*

Although they sometimes weave standard Chimayó-style weavings with a central motif framed by two end bands of variegated stripes, Lisa's and Irvin's work has increasingly moved away from the Chimayó style and into a fine art sphere. Their designs are oftentimes painterly, and weaving sizes are determined by the image, not the utilitarian function. An explicit illusion of volume is produced by their use of value and hue made possible as a result of the couple's mastery of natural dyes. They have also mastered ikat dyeing, a resist-dye process that requires tying and dyeing the yarn prior to weaving. Although Irvin and Lisa research and draw upon historic examples, they usually reinterpret and add a totally contemporary

twist to their work. A growing number of Irvin's weavings have recognizable subject matter such as people, birds, and insects. Irvin and Lisa not only employ the artistic convention of giving titles to their pieces but also weave in their signatures, yet another hallmark identifying them as fine artists.

Irvin's pieces have evolved into bold, highly individualistic and expressive statements. In his *48 Roses to the Vallero Spirit* (1986), Irvin combined older techniques, such as tapestry-woven Vallero stars, with newer applications, such as the pictorial element of an ikat-dyed dove in the center. Some of Irvin's more impressive weavings include *Chimayó, Topical Paradise* (1987), *Buscando la Malinche* (1989), *Río Grande Fusion* (1990), (plate 81), and *Una*

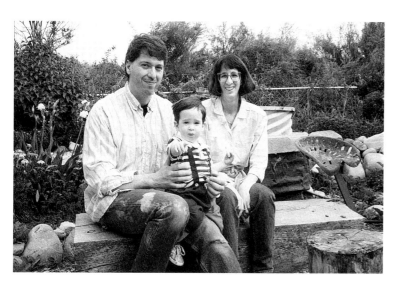

Figure 5.12 | Irvin and Lisa Trujillo with their son, Adam, in the garden beside their Chimayó shop. Photo by Miguel Gandert, 1992.

Pieza Galáctica (1991). One particularly striking weaving, *Spider from Mars* (1988), was included in the Smithsonian Institution's Quincentenary exhibit, *American Encounters,* at the National Museum of American History.[17] In 1995 the Smithsonian's National Museum of American Art added Irvin's *The Hook and the Spider* to its permanent collection (plate 82).

For the creation of her increasingly intricate works, Lisa depends upon the "chromatic complexities derived from natural dyes." She frequently spins yarns as fine as kite string for her Saltillo-inspired weavings.[18] Her interpretation of historic Saltillo sarapes has become her specialty. Lisa's weavings bear titles such as *Hyperactive* (1984; plate 83), *Devotion* (1987), *Spider Soul* (1988), and *Passion in the Web* (1989; plate 84).

Perhaps because of their insider-outsider status in Chimayó, Irvin and Lisa are freer to experiment than most other weavers in the area. The numerous tourists who stop by the shop, and their own personal outside interests, make the Anglo world ever-present in their lives. However, they do not have the security that Jake did in being rooted in

Chimayó even as he dealt with the outside world. They are pulled by many conflicting forces as they straddle two worlds: Hispanic vs. Anglo, Catholic vs. Jewish, rural vs. urban, production craftsman vs. fine artist, and weaver vs. scholar (fig. 5.12).

Irvin's challenge also has always been to integrate a great many talents and skills. When asked about his profession, Irvin reveals his complex personality by stating: "I am an artist, musician, engineer, and weaver." He said he left "weaver" for last because "it's what holds everything else up . . . how I make most of my living. Music is what I really want and weaver is what I've got."[19]

The Trujillos have been exhibited in national and international venues.[20] Both Irvin and Lisa have won many awards for their weavings. They consciously produce pieces with the goal of winning competitions, and their success has helped establish them in the fine arts market. In 1994 their weavings ranged in price from two thousand to forty thousand dollars. Those created by their cottage industry employees sold for a lot less.

Jake's weavings remain on display in a memorial gallery located in the entryway to Centinela Traditional Arts. There, Adam and Emily, Irvin and Lisa's children, who were born after Jake's death, play and greet customers. Jake would have been proud of his grandchildren, the new generation of Trujillos who are growing up amidst their grandfather's, father's, and mother's weavings, in much the same way that he and his son grew up with weaving as an integral part of their lives.

The Martínez Family

A dusty dirt road in north central New Mexico takes you past the post office and a small Catholic church to the L-shaped, tin-roofed adobe home of the "matriarch of Hispanic weaving," internationally known folk artist and weaver Agueda Salazar Martínez, who was born in 1898. Each fall, her Medanales home is alive with bright-red chile

ristras hanging from the walls, piles of orange pumpkins, plots of colorful cosmos, and kittens basking in the sunlight. Although she is nearing the century mark, Doña Agueda, as she is respectfully known, continues to weave almost daily.

This feisty *anciana* wove for blanket dealers for half a century. During this time she also raised her large family. In 1992 Doña Agueda had 10 children, 66 grandchildren, 114 great-grandchildren, and 14 great-great-grandchildren. When added together, her family numbered 204. Figuring that she has done more than her share toward insuring that the government's taxes are paid, Doña Agueda wittily remarks, *"Ya me hubiera de dar una pensión el presidente porque tengo tan grande familia y todos trabajan"* [The president should give me a pension because I have such a large family and they all work].[21]

In 1994 Doña Agueda was "the head of the largest family of Hispanic weavers in the state—a clan that numbered 64 active weavers spanning five generations."[22] Because it is impossible to do justice to this large family in this limited space, what follows is a portrait of Doña Agueda and a brief introduction to some of the Martínez women who have particularly distinguished themselves through their weaving: daughters Epifania (Eppie) Archuleta (b. 1922), Georgia Serrano (b. 1925), and Cordelia Coronado (b. 1933); granddaughter Norma Medina (b. 1941); and great-granddaughter Delores Medina (b. 1967).

Agueda Martínez was born on March 13, 1898, in Chamita, New Mexico, a small village a few miles from Medanales. Although of Hispanic descent, she can also trace part of her ancestry to a great-grandfather, Enríquez Córdova, who was a Navajo weaver raised by the Spanish. Doña Agueda is very proud of her Indian heritage but identifies herself as a *Mejicana*. Spanish is her native language, although she kiddingly says she can also speak English because she can say "yes" and "no."

While still a teenager, Doña Agueda was taught to weave rag rugs by an elderly neighbor. How-

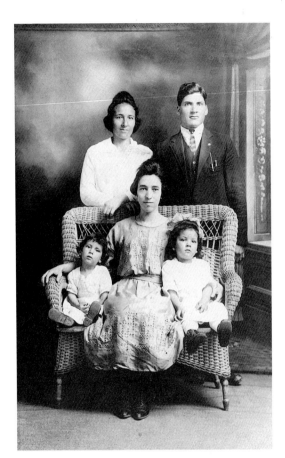

Tres Familias

Figure 5.13 | Agueda and Eusebio Martínez (standing) with two of their children: Gertrudis and Ferdinando, and Agustina Trujillo (seated), ca. 1925. Collection of Helen R. Lucero.

ever, it was not until 1921, after she married Eusebio Martínez, a weaver from Chimayó, that her weaving skills were refined under the tutelage of her *compadre* Lorenzo Trujillo (fig. 5.13). From nearby Río Chiquito, Trujillo was a prominent weaver of Chimayó blankets and was godfather to Epifania, Agueda's daughter.

Eusebio Martínez's ancestry and weaving tradition in Chimayó date back to the seventeenth century. Although the Martínezes are not directly related to the Ortega and Trujillo weaving families of Chimayó, they, like so many families in northern New Mexico, are related through *compadrazgo* and marriage. The Martínez family is related to the

Chimayó Weaving

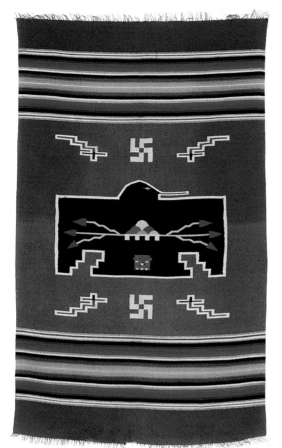

Plate 85 | *This stylized eagle motif with swastikas and lightning bolts was a popular Chimayó blanket design during the 1930s. Commercial yarns, 83 x 51 in. Both Agueda and Eusebio Martínez wove this type of blanket for the Santa Fe blanket dealers, ca. 1930. International Folk Art Foundation Collections at the Museum of International Folk Art, Santa Fe, New Mexico. FA.1991.13-1. Photo by Miguel Gandert, 1992.*

Trujillos through the mid-nineteenth-century marriage of Manuel Trujillo and Antonia (Toñita) Martínez Trujillo.

In 1924 the Martínezes moved to the village of Medanales. Weaving became an important source of income for Doña Agueda and her husband, especially as their family grew to include ten children. Weaving became the means by which they could augment their limited income from subsistence farming. As a young couple, the industrious Martínezes worked their farm—and sometimes even neighbors' farms—during summer days. At night, they wove by kerosene lamp into the early hours of the morning. One of their children's first memories was the sound of the loom beater beating in the middle of the night. In winter, weaving became their primary occupation. As their children grew, they helped with weaving-related tasks such as carding and spinning, gathering dye plants, and filling bobbins with yarn for the shuttles. When tall enough, they joined their parents at the loom.

The family's weavings were marketed through blanket dealers, primarily to tourists (plate 85). Doña Agueda continued to weave for blanket dealers for ten more years after the death of her husband in 1962. Then, because of her initiative and weaving mastery, she made the transition from working for others to selling directly from her home.

One of Doña Agueda's three handmade treadle looms occupies a prominent position in her kitchen today. Adjacent to the kitchen is a room with two large looms. One loom is more than one hundred years old and is used to weave the larger pieces. To weave, Doña Agueda stands at her loom, shifting her weight from treadle to treadle. Complex concentric diamonds, hourglasses, and chevrons slowly take form as she rhythmically manipulates the dozens of colored threads across her loom. Although she can no longer weave the long hours she once did, she is noted for saying, "There are

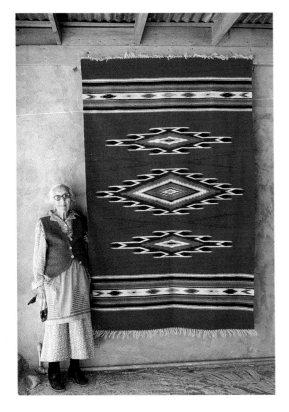

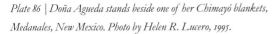

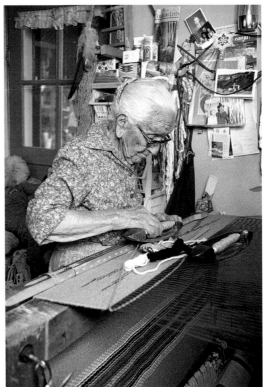

Plate 86 | *Doña Agueda stands beside one of her Chimayó blankets,*
Medanales, New Mexico. Photo by Helen R. Lucero, 1995.

Plate 87 | *Agueda Martínez at her loom with personal memorabilia*
hanging on the wall. Photo by Miguel Gandert, 1992.

times that I weave until twelve at night. As they say, from sunrise 'til sundown. . . . Until then you'll find me dancing on the loom."[23]

Doña Agueda's weaving is based on several traditional weaving design formats. She draws upon a large repertoire of Saltillo, classic Río Grande, and Chimayó weaving motifs. Laying claim to her American Indian ancestry, she sometimes also weaves Navajo designs. Her weaving designs are not drawn beforehand but spring forth from her mind from an endless reservoir of images. Doña Agueda's weavings reflect her personality: determined, independent, and confident. After producing thousands of blankets and hundreds of rag rugs in more than seventy years of weaving, Doña Agueda confidently juxtaposes colors and designs in a daring and original manner. Much of her work

is recognizable because of the vitality and boldness of the variegated colors in her diamond motifs (plate 86).

Surrounding Doña Agueda in her weaving room are not only the tools of her trade and piles of colorful skeins of yarn but also an array of personal memorabilia ranging from religious icons to an American flag (plate 87). The amazing variety of artifacts and images in this room reflects Doña Agueda's roots and her continuing awareness of the outside world, despite the isolation of the rural village in which she has spent most of her life. Here is a tough individual, a hardy woman of dry wit and humor, a woman whose lively conversations are punctuated by *dichos* and *cuentos* (sayings and tales) meant to guide and entertain her listeners. Consider her views on widows who remarry:

"El que enviuda y se vuelve a casar, algo le debía al diablo, y le debe de pagar" [A person who is widowed and remarries must have owed the devil something and must pay up].[24]

During the past twenty years, Doña Agueda's artistic talents have attracted much public recognition. In 1975 New Mexico awarded her the prestigious Governor's Award for Excellence in the Arts. Critical to the growth of her reputation was her role in a documentary about her life that was nominated for an Academy Award. The 1977 film, entitled *Agueda Martínez, Our People, Our Country,* catapulted her into national prominence. Suddenly she was in great demand, and everyone wanted her to attend a showing of the film. In typical fashion, she questioned, "Why? They've already seen the face on the film—why do they want to see it in person, too? I don't have the time to go everywhere just so people can look at me. I've got work to do."[25]

In 1980 she was selected as the first honoree of an annual Hispanic arts and crafts fair held in Albuquerque, the Feria Artesana. Doña Agueda's work has been shown in numerous fairs and markets and has been included in exhibits and collections nationwide. One of her rag rugs with tapestry design was selected as the official poster image for the 1992 Festival of American Folklife sponsored by the Smithsonian Institution, and in 1993 the National Women's Caucus for Art selected Doña Agueda as their first Hispanic honoree for outstanding achievement in the visual arts. In 1995 the Smithsonian's National Museum of American Art included Doña Agueda in a video on Latino artists and purchased one of her rag rugs for its permanent collection (plate 88).

The continuity of Doña Agueda's craft is assured by her many descendants who are successful weavers. In her family, it is the women who have distinguished themselves in weaving, dispelling an old myth that it is the men who are the Hispanic weavers.[26] Three of her daughters have received national recognition for their weaving. Eppie Archuleta was even awarded the highest honor bestowed on a folk artist: a 1985 National Heritage Fellowship presented by the National Endowment for the Arts (plate 89).

Living in Capulín in southern Colorado, Eppie has taken her family's weaving tradition one step further and established the San Luis Valley Wool Mill, where she prepares much of the yarn used by the rest of her family. In 1991, like her mother before her, Eppie received a Governor's Award for her weaving, this time from the state of Colorado. Also like her mother, this strong and feisty woman loves a challenge. When told that it was impossible to weave a portrait, she promptly wove one of the Archbishop of New Mexico. She has since woven many other "pictorials" and, on her nine-foot-wide loom, has produced some of the largest pieces attempted by any Hispanic weaver.[27]

In 1986 Doña Agueda accompanied Eppie, granddaughter Norma, and great-granddaughter Delores, to Washington, D.C., where the four generations demonstrated carding, spinning, dyeing, and weaving at the annual Festival of American Folklife (fig. 5.14). Doña Agueda also tended the plot of chile peppers growing beside their booth, planted from the seeds she had sent from Medanales, New Mexico, to the Smithsonian.

In 1992 another daughter, Cordelia Coronado, was selected to represent New Mexico's Hispanic weavers at the same festival. Cordelia has distinguished herself as a "weaver, farmer, shop owner, mother, school board candidate, ditch commissioner, carpenter, community activist, and Medanales postmaster" for over thirty years.[28] She sells many of her own and her family's work—especially pieces produced by her daughters Marcela and Teresa—in her weaving shop, La Lanzadera, where she has taught weaving classes to hundreds of students during the past twenty years (fig. 5.15 and plate 90). This dynamic woman has a philosophy about teaching that transcends the transmis-

Plate 88 | Tapestry Weave Rag Jerga *by Agueda Martínez, 1994. National Museum of American Art, Smithsonian Institution, Washington, D.C., 1995.46. Museum purchase in part through the Smithsonian Collections Acquisitions Program.*

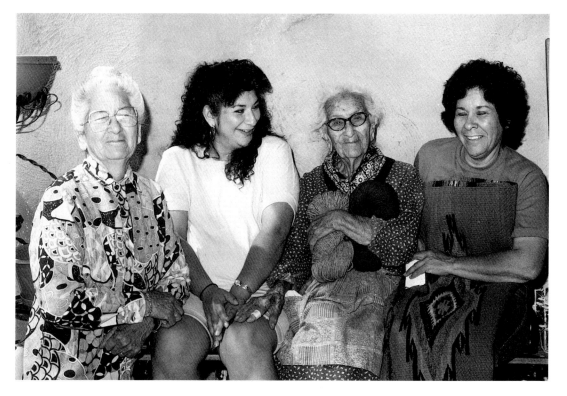

Figure 5.14 Four generations of weavers: Eppie Archuleta (daughter), Delores Medina (great granddaughter), Agueda Martínez (mother), and Norma Medina (granddaughter). Museum of International Folk Art, Santa Fe, New Mexico. Photo by Blair Clark, 1992.

sion of weaving skills. "The most rewarding part in teaching is to share not only the knowledge of weaving, but also the therapeutic values that they pick up. I get a lot of nurses, doctors, lawyers, and therapists, that come for therapy here and I don't really say, 'Well, this is therapy.' But you automatically feel very, very serene, very at home, quiet. Weaving doesn't give them time to think about other problems. And they have something to show for it at the end and they're very happy with it."[29]

Another of Doña Agueda's daughters, Louisa García, has been living with her for the past few years. During this time, she has started to weave, producing pieces quite similar to her mother's. Yet another daughter, Georgia Serrano, lives next door and has been weaving since the late 1970s when she and her family returned to Medanales after spending twenty-four years living in Utah

(fig. 5.16). For years, Georgia has woven almost exclusively for the Ortegas, producing some of their finest Chimayó blankets. Georgia sometimes weaves pieces for family use and has woven some rag rugs, not unlike her mother's, with intricate tapestry designs (plate 91). During the 1980s Georgia also worked for a weaving concern owned by Janusz and Nancy Kozikowski.[30] Their weavings, shown in art galleries and collected by museums and private collectors, are noted for pictorial designs with variegated shading, characteristic of the European tapestry tradition.[31]

Eppie Archuleta's daughter Norma Medina (fig. 5.17) and her granddaughter Delores Medina are perhaps the best weavers in the third and fourth generations of Martínez weavers working today. Although Norma has mastered all the styles of weaving regarded as Hispanic, she specializes in a

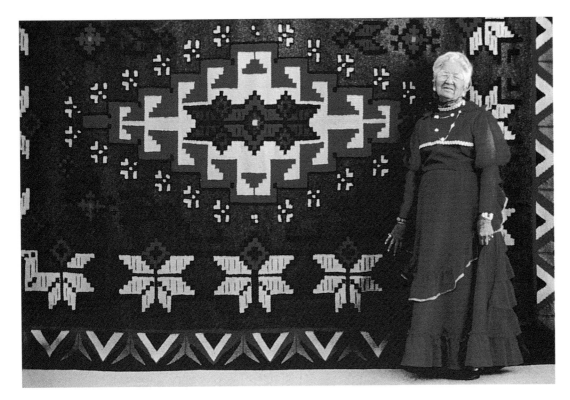

Plate 89 | *Eppie Archuleta stands beside her large Navajo-inspired weaving. Photo by Michael Olson, 1985.*

style she calls "contemporary."[32] She weaves pictorial tapestries depicting landscapes, churches, and still-lifes (plate 92). She dyes her own colors and blends them so delicately that, seen from a distance, many of her weavings appear to be painted canvases. Delores prefers to work in the most traditional of styles, excelling in weavings with alternating banded stripes and tapestry, weavings that are called *colonias* by the family and are reminiscent of those produced by her great-grandmother Agueda (plate 93).

Doña Agueda introduced dozens of women to weaving during the 1960s and 1970s through a government-subsidized program called HELP. As an instructor and mentor, she played a role in keeping the weaving tradition alive at a time when few were aware of its significance. In 1983 the ever-pragmatic *anciana* reflected on the teaching of His-

panic weaving to non-Hispanics: *"Pues, yo soy de opinión que todo el que quiera aprender, tiene uno que ayudarle. Si es americano, mejicano, indio, lo que sea. Todos estamos obligados hacer la vida, según la habilidad de la criatura* [Well, I am of the opinion that one must help all who wish to learn, whether they are American, Mexican, Indian, or whatever. We are all obligated to make a living to the best of our ability].[33]

Doña Agueda continues to practice a folk art that is intimately connected with the rhythms of the daily and seasonal cycles. Her life has been remarkably prolific—acres and acres of chiles, hundreds of descendants, and thousands of weavings. While she has received national recognition as a premier folk artist, she continues to be nourished as much by her life as a farmer, a member of her nearby church, and the head of a large family. As she approaches the century mark, Doña Agueda's own words best de-

Figure 5.15 | Cordelia Coronado in her weaving classroom at La Lanzadera Weaving Shop, Medanales, New Mexico. Photo by Miguel Gandert, 1992 (upper left).

Figure 5.16 | Georgia Serrano at her extra-wide "Weaver's Friend" loom, Medanales, New Mexico. Photo by Miguel Gandert, 1992 (lower left).

Figure 5.17 | Norma Medina in her weaving studio, Medanales, New Mexico. Photo by Miguel Gandert, 1992 (upper right).

Plate 90 | Coronado family weavings on display at La Lanzadera Weaving Shop, Medanales, New Mexico. Photo by Miguel Gandert, 1992 (opposite).

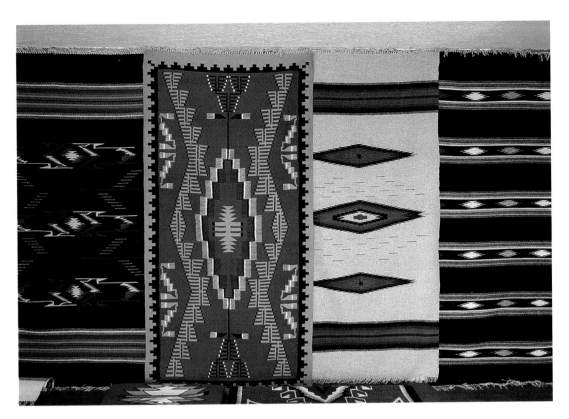

scribe the intimate and vital connection her craft has to her life: *"Pues, lo único que yo pienso es que mientras que yo me pueda mover, yo voy a tejer"* [Well, the only thing I can say is that as long as I can move, I will continue to weave].[34]

Although the Ortega, Trujillo, and Martínez families differ in their weaving involvement, the connecting thread through all their lives is one of Hispanic roots and endless yards of woven cloth. The very fabric of Hispanic life is exemplified by these three families—a distinctive fabric of strong, colorful, and beautiful patterns—which endures through the weavers' commitment to a well-integrated and creative way of life.

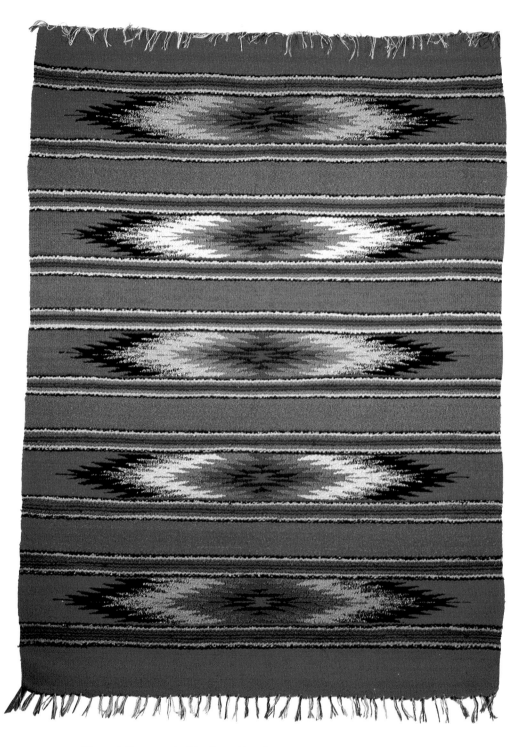

Plate 91 | Rag rug made with polyester fabrics by Georgia Serrano, 70 x 48 in., 1986. International Folk Art Foundation Collections at the Museum of International Folk Art, Santa Fe, New Mexico, FA.1986.399-1. Photo by Miguel Gandert, 1992.

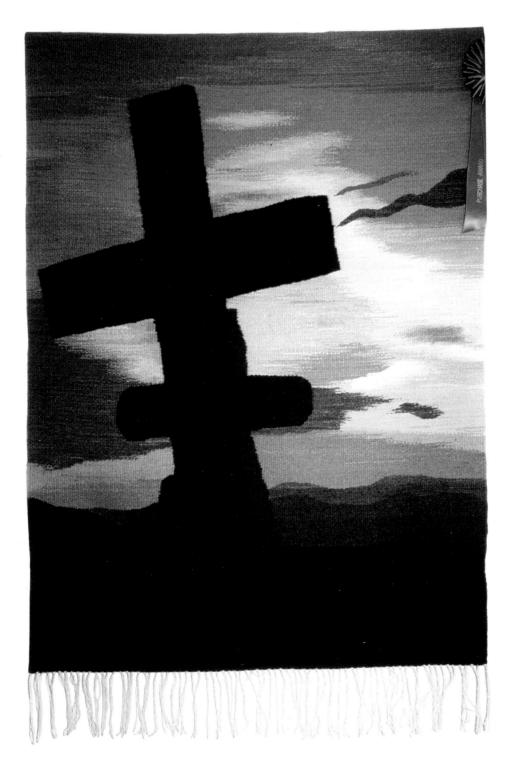

Plate 92 | A Lonely Cross in Truchas *by Norma Medina, 1985. Collection of the Feria Artesana Foundation, Albuquerque, New Mexico. Photo by Suzanne Baizerman.*

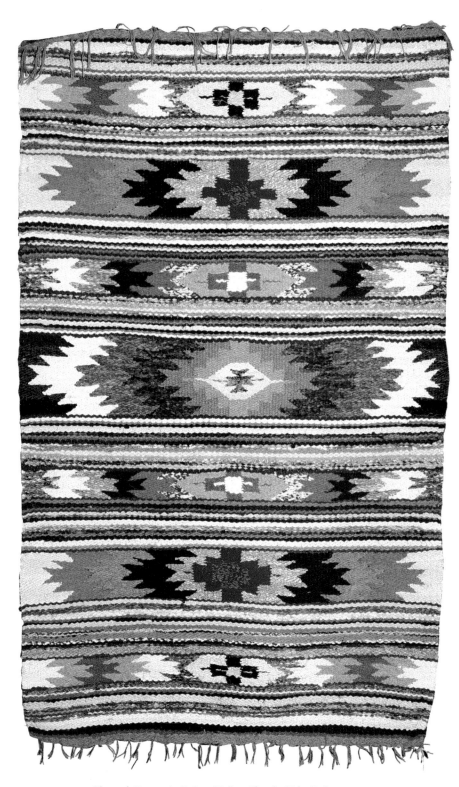

Plate 93 | Rag rug by Delores Medina. Photo by Helen R. Lucero, 1992.

6

The Technology of the Art Form

A weaving tradition is composed of many threads: family ties, shared history, shared values about innovation, way of life, trade. However, when most people think of a weaving tradition, they think of the unique way in which weavers weave cloth: what weavers do in their day-to-day weaving life to produce cloth, and what they teach others who seek to become skilled in the craft. From this technical point of view, what makes the Hispanic weaving tradition unique is the equipment and materials used, most notably the treadle loom and sheep's wool. Also of significance are the surface of the cloth—weft-faced and worked in tapestry techniques—and the design layout and finishing techniques.

Looms and Related Equipment

Weavers typically weave on the same type of loom, the horizontal treadle loom (fig. 6.1). The loom *(telar)* is modified so that the weaver stands upright to weave, shifting the feet in a walking rhythm to change the shed. In fact, this loom in many ways symbolizes the craft of Hispanic weaving and is invariably pictured in newspaper and magazine accounts of the craft. It clearly differentiates Hispanic weavers from their Navajo and Pueblo counterparts who weave on the upright, or vertical, loom while seated on the ground or a low stool (see fig. 2.2). The standing position extends the reach of the Hispanic weaver. In addition, this position takes stress off the weaver's back and prevents the back pain commonly associated with long hours seated at a loom.

Many Hispanic weavers have inherited their looms. These are not the bulky looms hand-hewn from large beams used in colonial times. They are looms made locally of milled lumber, which became more readily available in the area after the arrival of the railroad. Most of these looms are homemade; some are of commercial manufacture.[1] All three families introduced in chapter 5 still use family looms that they have inherited (fig. 6.2). Looms continue to be built today by relatives and friends. A few weavers own contemporary commercially manufactured looms such as those made by the LeClerc Company of Canada. Looms vary in width from twenty to ninety inches. Many weavers own two or more looms, enabling them to work on more than one piece at a time and to switch from simple to more complex weaving as desired.

Generally speaking, the loom is a device for holding warp threads under tension in order to interlace weft threads (fig. 6.3). Resting within the loom frame are two beams, the warp beam *(julio de hilo)* and the cloth beam *(julio de tela)*. Between these

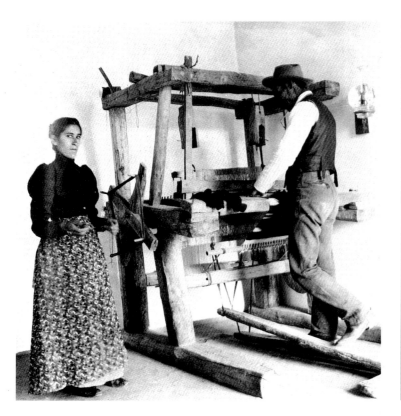

Figure 6.1 | *Mr. and Mrs. Esquipula Martínez, Chimayó, New Mexico, with massive counterbalanced, horizontal treadle loom, ca. 1910. Prudence Clark Collection, Menaul Historical Library of the Southwest, Albuquerque, New Mexico (left).*

Figure 6.2 | *"Weaver's Friend" loom manufactured by the Reed Loom Company, owned by Norma Medina, Medanales, New Mexico. Photo by Suzanne Baizerman, 1985 (right).*

beams the warp *(tela)* is stretched tautly. The warp beam stores unwoven warp; as cloth is woven, it is wound on the cloth beam. The warp may be many yards in length—twenty yards or more. Ratchets and pawls *(manedas)* serve as loom brakes, maintaining warp tension and allowing the warp to be advanced as needed.

To ready the loom for weaving, the weaver must prepare the warp by measuring each component yarn of the warp to a uniform length while keeping warp yarns in order. This process is called winding the warp. In the most basic method, warp may be measured by winding it around stakes pounded into the ground. Most contemporary Hispanic weavers have adopted warping boards (fig. 6.4) or warping reels used by other contemporary handweavers for this purpose. These serve the same function as the ground stakes but allow the user to stand while warping. Whatever equipment the weaver uses, a warp cross is formed in the

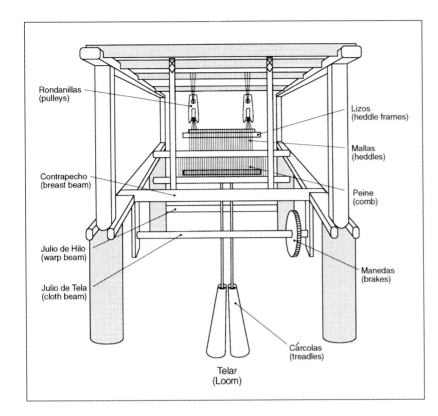

Rondanillas
(pulleys)

Lizos
(heddle frames)

Mallas
(heddles)

Contrapecho
(breast beam)

Peine
(comb)

Julio de Hilo
(warp beam)

Julio de Tela
(cloth beam)

Manedas
(brakes)

Cárcolas
(treadles)

Telar
(Loom)

Figure 6.3 | Line drawing of a loom (telar) with parts identified in English and Spanish. Drawing by Frances Trice.

The Technology of the Art Form

warp as it is wound by carrying the yarn over and under certain pegs. The crossed threads establish the order of the yarn, allowing the yarn to be taken from the warping device and attached to the loom in an orderly fashion.

After winding the warp, it is sleyed (threaded) in the reed *(peine)* (fig. 6.5), a comblike device. Then it is threaded into the heddles *(mallas)*. These procedures may take several hours and are more easily accomplished with a helper. After threading the heddles, the warp is beamed (wrapped) around the warp beam, usually a two-person operation because tension has to be evenly maintained as the warp is wound. Warp tension affects the resulting cloth surface: even tension results in a uniform surface, uneven tension leads to an uneven surface. Today, most weavers merely tie a new warp onto a previous one (fig. 6.6), warp end by warp end. The new warp is then pulled through the reed and heddles, and finally tied onto the cloth beam. Some

older looms have raddles built into the back beam—usually nails spaced at even intervals of approximately one inch across the back beam of the loom. The presence of raddles on these looms confirms that at least some weavers warped from the back of the loom to the front.

Weavers who work for blanket dealers may not have to warp their looms. Blanket dealers have special room-size warping reels to secure evenly tensioned warp threads to warp beams. When weavers run out of warp, they simply bring their beams to the dealer to be rebeamed with warp. Weavers maintain that warps prepared on the dealers' giant reels are very evenly tensioned. Dealers report that even inexperienced weavers can get a more even surface on their cloth due to the superior tension.

Heddles are arranged in frames known as harnesses or shafts *(lizos)* (see fig. 6.3). Harnesses, usually two or four in number, are suspended from

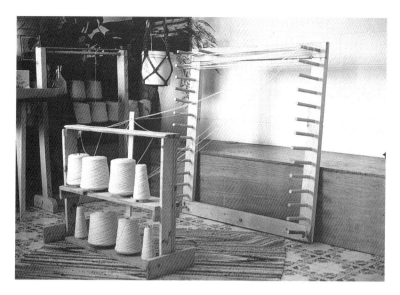

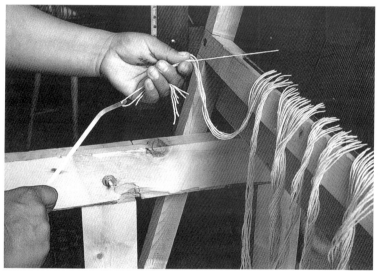

the upper structure of the loom and connected to treadles *(cárcolas)*. Lams connect harnesses to treadles on some looms. On others, harnesses are tied directly to treadles. When harnesses are raised or lowered by the treadles, openings called sheds are created in the warp. When one harness or pair of harnesses is raised, the opposite harness or pair is lowered; hence, this type of loom is known as a counterbalanced loom.[2] Foot treadles are used to change the warp shed, thereby freeing the weaver's hands to concentrate solely on the passage of the weft.

For most Hispanic weaving, a two- or four-harness loom is used to weave plain-weave cloth. Twill-patterned rugs *(jergas)* are woven on a four-harness loom. Four-harness looms are also used to weave double-width blankets.

Once the loom is dressed, weft yarn must also be prepared. First, skeins of yarn are placed on a swift *(aspa),* usually homemade, which holds the skein for transfer to a bobbin *(canilla).* Yarn is wound onto the bobbin from the swift using a winding device *(torno).* Small, hand-cranked, commercial home-grindstones made for home use(fig. 6.7) are often adapted for use as bobbin winders by welding a rod to the grindstone, thereby forming a spindle to hold the bobbin. Old spinning wheels, even those made out of bicycle wheels, can be adapted for use as bobbin winders (fig. 6.8). Other weavers have modified treadle sewing machines to create bobbin winders. Today, commercial electric bobbin winders are often used.

The stems of the wild sunflower plant *añil del muerto* were once used for bobbins. The stem was hollowed out with a hot wire. These bobbins were somewhat brittle and had to be replaced frequently. Nowadays, cardboard wound around a spindle is used to form a bobbin. Cereal boxes are a popular choice because they are the correct thickness. Cardboard rectangles are cut and soaked in water, then wrapped around the spindle and encased in yarn. When dry, the cardboard becomes a hard, durable bobbin, to be wound with yarn again and again.

Figure 6.4 | Warping board and spool rack at La Lanzadera, Medanales, New Mexico, owned by Cordelia Coronado. Photo by Suzanne Baizerman, 1985.

Figure 6.5 | Sleying the reed (peine) *on a loom as part of dressing it in preparation for weaving. Photo by Miguel Gandert, 1992.*

Figure 6.6. Warping the loom by tying new warp to old warp. Photo by Miguel Gandert, 1992 (opposite).

The bobbin is placed within a shuttle *(lanzadera)* (fig. 6.9). Most shuttles used by Hispanic weavers are large, to accommodate a large quantity of weft. They are often carved by hand from fruitwood and are treasured as family heirlooms. The cardboard bobbin filled with yarn is inserted into the shuttle. In the patterned portions of the cloth, when a single weft does not extend from selvage to selvage, weft yarn may be manipulated in the form of "butterflies" *(cadejos* or *mariposas)* of yarn (fig. 6.10) or by using yarn-wound bobbins without a shuttle. In tapestry-patterned areas, any single shed or opening in the warp may use anywhere from two to dozens of butterflies, depending on the complexity of the pattern (fig. 6.11).

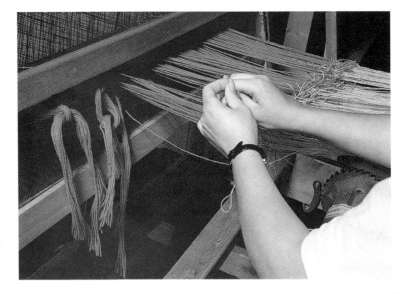

To weave small 4" x 4" glass or mug coasters, three to seven at a time, warp can be set up on the loom in such a way that five- to six-inch spaces are left between groups of warp yarns in the reed. There is a separate weft butterfly for each of these subgroups of warp yarns. With each change of sheds, wefts are inserted into each of these subgroups of warp so that weaving progresses on all coasters simultaneously.

Suspended from the loom frame, either from the top or the bottom, is the beater. Inside the beater rests the reed *(peine)*, which has evenly spaced openings that serve to separate individual warp threads across the width of the cloth. In Spanish colonial times, because of the lack of metal reeds, reed parts were laboriously hand-carved out of a juniper hardwood *(sabina)* or a fruitwood, and the tiny pieces were lashed together with rawhide or cord. During the last hundred years weavers have been able to obtain metal reeds from manufacturing companies or middlemen.

To weave, the weaver steps down on a treadle that shifts the heddles, thereby separating the warp into two planes (fig. 6.12). Into this V-shaped opening in the warp, called a shed, the shuttle carrying the weft is inserted. The reed and beater together beat the weft into place and align the weft at right angles to the warp. A temple or stretcher (fig. 6.13)

is used to help maintain an even cloth width and straight selvages. It may be commercially manufactured or homemade.[3]

Commercially manufactured looms have been imported into northern New Mexico since the turn of the century. One commercial loom that has survived from the early twentieth century is the Weaver's Friend loom made by the Reed Manufacturing Company (see fig. 6.2). This is an unusual loom because it has no treadles. Harnesses are raised and lowered automatically when the beater is brought forward to beat the weft into place. One such loom is currently in use by a woman who inherited it from her mother, who in turn inherited it from her mother. The family refers to it as the *máquina,* or machine, distinguishing it from their other looms. Another weaver owns an Ideal Loom made by the same company; she inherited her loom from her father. Since the Reed Loom Company catalog is found in the files of J. S. Candelario, it is not inconceivable that the loom was one purchased by Candelario for distribution in northern New Mexico.

A few woodworkers specialize in making looms for weavers. For example, weavers at Tierra Wools in Los Ojos use looms made by Hans Leitner of Chimayó. Marco Oviedo, also of Chimayó, has built

Chimayó Weaving

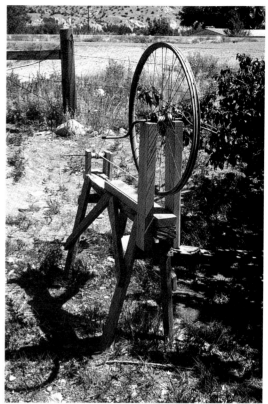

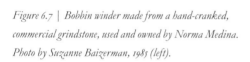

Figure 6.7 | Bobbin winder made from a hand-cranked, commercial grindstone, used and owned by Norma Medina. Photo by Suzanne Baizerman, 1985 (left).

Figure 6.8 | Spinning wheel/bobbin winder (torno) made from a bicycle wheel, called by its owner caballito because its four-legged stance suggests a little horse, Chili, New Mexico. Photo by Suzanne Baizerman, 1985 (right).

Figure 6.9 | Boat shuttle (lanzadera) made and used by Helen Lucero's grandfather, Margarito Romero of Vadito, New Mexico, ca. 1930. Collection of Helen Lucero. Photo by Miguel Gandert, 1992 (opposite, above).

Figure 6.10 | Norma Martínez demonstrates making a butterfly (cadejos), Tierra Wools, Los Ojos, New Mexico. Photo by Miguel Gandert, 1992 (opposite, below).

looms for various weavers. Some contemporary Hispanic blanket dealers provide homemade looms for their weavers. They are often based on a style promoted by the New Mexico State Department of Trades and Industries during the depression era.[4] Today, a few weavers or their family members build looms based on the WPA design. Most of the bulky, hand-hewn looms of colonial times met their demise when their timbers, unusually straight and strong, were recycled for use in house construction as lintels and for framing windows.[5]

Fibers and Yarns

Just as the equipment of modern Hispanic weavers has been modified from that used by their colonial ancestors, materials have undergone dramatic changes as weavers have made a transition from

working with handspun, hand-dyed yarn to weaving with commercially manufactured yarns.

Prior to the advent of commercial yarns, yarn was handspun from the carded wool of the churro sheep raised in the area. Churro wool fibers are long, coarse, and straight with very low grease content (fig. 6.14). Because the fiber is a straight one, it reflects more light than the kinky, fine wool fibers of other breeds. Thus, the surface of cloth has a characteristic shine or luster.

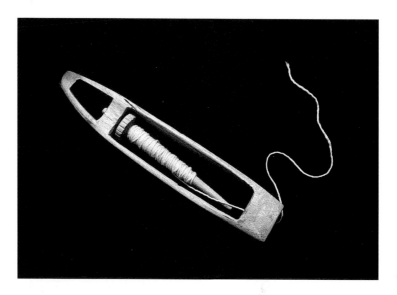

In general, wool fibers are processed for spinning in two ways: carding prior to spinning yields a woolen yarn (fig. 6.15); combing prior to spinning yields a worsted yarn. Churro fibers were prepared using a worsted system. Legend has it that churro fibers could be used straight off the sheep —there are references to weavers "plucking the sheep." However, more typically, sheep were sheared and their fibers were combed to align them in a parallel fashion. Wool combs were used to align fibers for this type of spinning (fig. 6.16). Then, using a drop spindle *(malacate)*, the fibers were drawn and spun from the mass of combed fibers (fig. 6.17).[6] Since Indian servants were strongly involved in carding and spinning in Spanish homes, it is not surprising that the drop spindle used by Hispanos appears to be of Pueblo origin. Drop spindles were commonly used in New Mexican homes well into this century (fig. 6.18). Although adopted early on in Mexico, the European spinning wheel was not commonly used in New Mexico. Eventually, the sawhorse type wheel found in Mexico was adopted. Homemade spinning wheels imitated this sawhorse type (see fig. 6.8).

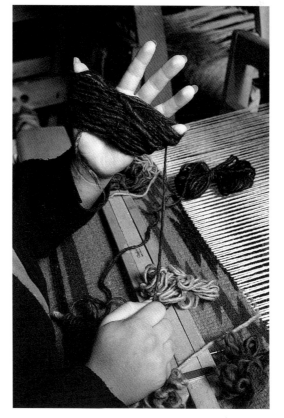

In the late nineteenth century Anglo Americans introduced new sheep breeds, primarily the Rambouillet-Merino sheep. This new sheep was gradually interbred with the native churro sheep. The resulting wool was much finer, shorter, softer, kinkier, and greasier. It was not as well suited to local weaving needs. First, the region's perennial

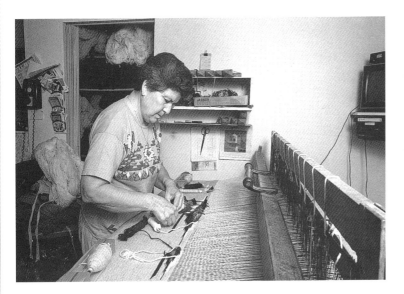

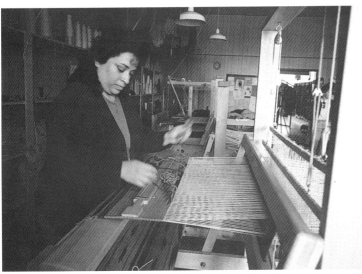

Figure 6.11 | *Georgia Serrano weaving with butterflies (*cadejos*), Medanales, New Mexico. Photo by Miguel Gandert, 1992.*

Figure 6.12 | *Norma Martínez weaving on loom showing V-shaped weaving shed, Tierra Wools, Los Ojos, New Mexico. Photo by Miguel Gandert, 1992.*

Figure 6.13 | *Norma Martínez weaving with a wooden stretcher or temple (*templar*) to maintain even selvages, Tierra Wools, Los Ojos, New Mexico. Photo by Miguel Gandert, 1992 (opposite, upper left).*

Figure 6.14 | *Churro fleece detail showing long, lustrous staple. Photo by Margery M. Denton (opposite, lower left).*

shortage of water made it difficult to remove grease from the fleece. Second, the new wool fibers required a different spinning method based on the woolen system. In this system, wool fibers were carded, rather than combed, to achieve alignment.

Wool cards were first introduced by Anglo Americans in the nineteenth century, together with the new breeds of sheep. Using wool cards, fibers are made into a roll *(colita de borrega*—sheep's little tail), commonly referred to by the Scandinavian term *rolag*. Yarn was spun from the end of the roll, resulting in a different yarn structure than yarn spun using the worsted system. Using either the woolen or the worsted system, the yarn produced for the weft was a relatively thick, one-ply yarn, spun in the Z direction (fig. 6.19).[7] Warp was two-ply yarn, composed of two smaller diameter plies than the weft: Z-spun, then S-plied.

A movement to reintroduce the churro sheep to Hispanic and Navajo sheep growers and weavers was begun in the 1980s by Lyle G. McNeal at the Animal, Dairy, and Veterinary Sciences Department of Utah State University. McNeal located a small number of surviving churros in remote Hispanic villages and on the Navajo reservation and through careful breeding and monitoring developed a modern churro. Several contemporary Hispanic weavers are now using churro wool. A large proportion of the flocks belonging to Ganados del Valle flocks in Los Ojos, New Mexico, is composed of churro sheep.

Dyes

Before the 1860s colors were limited to the natural colors of the sheep (white, black, brown, and blended shades) and to colors produced by natural dyes. Indigo dyestuff and cochineal were imported from Mexico and South America.[8] Other dyes were prepared from indigenous plants that had been gathered, boiled, and steeped to make a dye solution.[9] Each plant would yield a different hue (plate 94). The best known of these were *cota,*

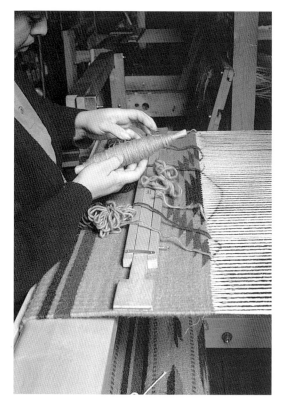

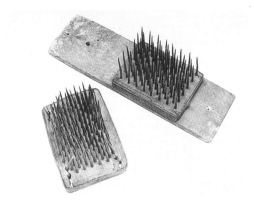

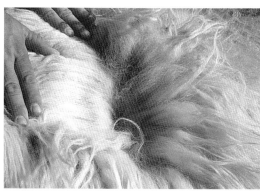

Figure 6.15 | Wool cards (cardas) used for aligning fleece prior to spinning. International Folk Art Foundation Collections at the Museum of International Folk Art, Santa Fe, New Mexico, FA. 81.15-1V(2). Photo by Miguel Gandert, 1992 (upper right).

Figure 6.16 | Wool combs, 19th century. Millicent Rogers Museum of Northern New Mexico, Taos, New Mexico, 1982 2A-B. Photo by Blair Clark, 1993 (middle right).

Figure 6.17 | Spindle (malacate) used in Chimayó, New Mexico, owned by Melita Ortega. Photo by Suzanne Baizerman, 1985 (lower right).

Chimayó Weaving

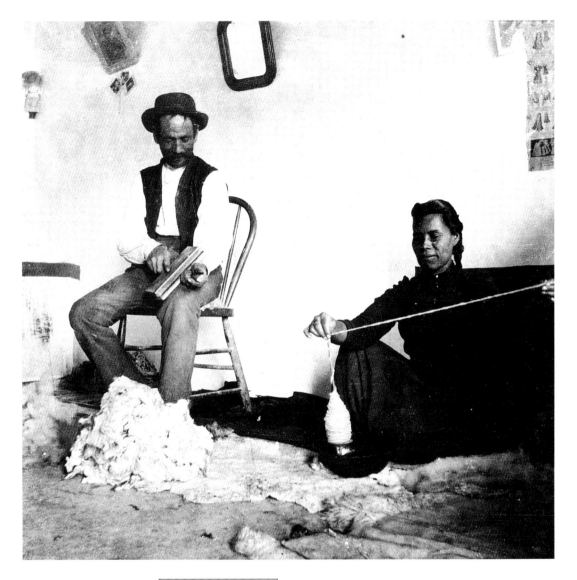

Figure 6.18 | *Mr. and Mrs. Maximino Martínez, Chimayó, New Mexico. He is using wool cards (*cardas*); she spins on a drop spindle (*malacate*), ca. 1910. Prudence Clark Collection, Menaul Historical Library of the Southwest, Albuquerque, New Mexico.*

Figure 6.19 | *Line drawing of S and Z twist on yarn. Drawing by Frances Trice.*

chamisa, and mountain mahogany (plates 95, 96). After 1860 synthetic dyes became commercially available to dyers. Hispanic dyers favored a characteristic palette that included lavender, pink, orange, red, and blue (see plate 15).[10]

Some weavers still use some, or all, natural-dyed yarns in their products, particularly those weavers who target the connoisseur market. However, most Hispanic weavers today use commercially manufactured yarns for their weavings. These yarns began to arrive in the Southwest in the 1830s. Initially they appeared in very small amounts in local weavings, as accents to design motifs. By the 1880s, when the railroad brought commercial goods in larger quantities, commercial yarns were imported to the area in a wider range of colors. The new yarns were undoubtedly welcomed by craftspeople. Handcarding, spinning, and dyeing yarn are, after all, arduous and time-consuming processes. For most people, they are less enjoyable activities than weaving.

Most of the new commercial yarns were out of the reach of Hispanic weavers' pocketbooks and were primarily purchased by curio dealers who could afford to make the capital investment in yarn. Dealers then gave yarn to weavers in exchange for woven goods in a "putting out" system. Cotton carpet warp caught on readily. The early cotton carpet warp was of good quality, with a slightly lustrous appearance. Weavers found it strong, easy to work with, available to them locally, and relatively inexpensive.[11] Commercial yarns of wool used for weft (the three-ply Saxony's and later the three- and four-ply Germantown's) were also imported into the area starting in the 1860s.

Today, blanket dealers supply their weavers with yarn just as the early dealers supplied weavers at the turn of the century. Dealers order yarn from a few main sources. The preferred and largest volume manufacturer of wool yarn used by New Mexican Hispanic weavers is J. and H. Clasgens Company of New Richmond, Ohio. Weavers who work

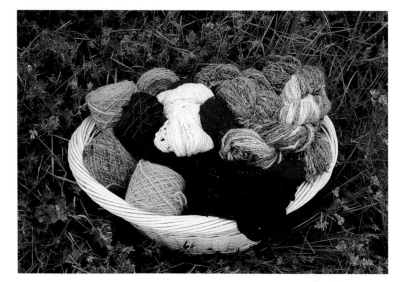

Plate 94 | Basket of natural dyed yarns. Collection of Tejidos y Lana. Photo by Carol Burns, 1995.

Plate 95 | Cota plant used for yellow dyes, Jémez Mountains, New Mexico. Photo by Michael Baizerman, 1985.

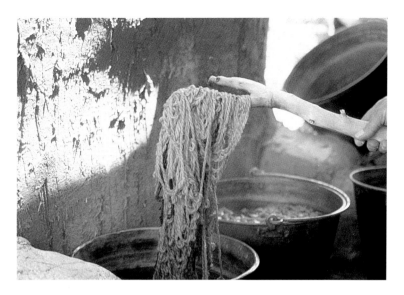

independently also order from Clasgens, individually or cooperatively through weavers' groups. This company produces both a lightweight and a heavyweight four-ply yarn, used to weave cloth of different thickness and weight. Weavers weaving for the connoisseur market sometimes order from suppliers to mainstream contemporary handweavers and fiber artists. Overall, since World War II, yarns have improved in quality, and they are available in a wider range of colors.

When Anglos sought to revive Spanish colonial traditions during the 1920s and 1930s, they placed great emphasis on hand spinning and hand dyeing. In 1976 and again in 1979 the Museum of International Folk Art of the Museum of New Mexico, Santa Fe, sponsored two weaving and dyeing workshops. The museum sought to upgrade the quality of weaving and to promote the use of natural dyes by Hispanic weavers.[12]

From the weaver's standpoint, however, the availability of commercially spun and dyed yarn was probably most welcome. It took far more time to card, spin, and dye yarn for a blanket than it did to weave it. Cleaning and carding was also a physically demanding process. Although dyeing had the intrinsically satisfying dimension of allowing the

weaver to see yarns change colors, dyeing was a messy, time-consuming chore. Today, many weavers have learned hand spinning and dyeing with natural and synthetic dyes. Weavers who produce for the connoisseur market will sometimes invest time in hand spinning or hand dyeing yarn or both, but it is difficult to sell their weaving for a price that is commensurate with the labor invested in it.

Finishing

One identifying characteristic of Hispanic weaving is the knotted warp fringe that spans the ends of blankets and other weavings. From the earliest known weavings to present-day examples, warp ends have been finished with knots.[13] Early Hispanic examples show the half hitch as the knot of choice (fig. 6.20). Since the late nineteenth century, the overhand knot has replaced the half hitch, and it has been used exclusively in the twentieth century (fig. 6.21). Visible warp fringe is the result of the type of loom used, the treadle loom. The treadle loom allows the weaver to weave successive items on one warp, but the items must be cut apart when all have been woven. Knots prevent the first and last rows of weft from unraveling.

As a Hispanic weaver creates a series of blankets, or *congas/congitas,* on the loom, unwoven warp is left between woven pieces. When the entire length of the warp has been woven, it is removed from the loom. The individual woven pieces are cut apart and the warp ends are finished with overhand knots. Knotting these warp ends is a time-consuming activity. It may be eased by the help of relatives and friends, often done while watching television or conversing.

The vertical frame looms used by Navajo and Pueblo weavers are designed to produce one finished piece of fabric at a time. As it is removed from the loom, the piece is already finished on all four sides; a twisted cord is worked into the vertical sides during the weaving process. The result is

four-selvage cloth. Mexican weaving, also woven on a treadle loom, can be distinguished from Native American and from New Mexican Hispanic work by its typically longer, twisted fringe or a fringe with more elaborate knotting.

The Woven Cloth

The characteristic smooth, matte surface of historic and contemporary examples of Hispanic blankets is achieved through the use of the most basic weave, plain weave.[14] Weft yarn, "bubbled" into the weaving shed (figs. 6.22 and 6.23), enables the weft yarn to pack down and completely cover the warp as it is beaten into place, creating a cloth with a smooth surface, where only weft shows. The resulting cloth is known as weft-faced. If bubbling is not done correctly, the cloth pulls in and becomes narrow during the weaving process, or the surface of the cloth is not smooth and even.

Plate 96 | Dyeing with brazilwood at El Rancho de las Golondrinas. Photo by Michael Baizerman, 1985 (opposite).

Figure 6.20 | Half-hitch knots, an end finish found on many older Río Grande blankets. This example knotted by Irvin Trujillo, 1986. International Folk Art Foundation Collections at the Museum of International Folk Art, Santa Fe, New Mexico. FA.1986.243-1. Photo by Miguel Gandert, 1992 (left).

Figure 6.21 | Overhand knots, the type of finish found on most contemporary Hispanic weavings, shown on a blanket woven by Jacobo O. Trujillo, 1984. International Folk Art Foundation Collections at the Museum of International Folk Art, Santa Fe, New Mexico. FA.1984.327-2. Photo by Miguel Gandert, 1992 (right).

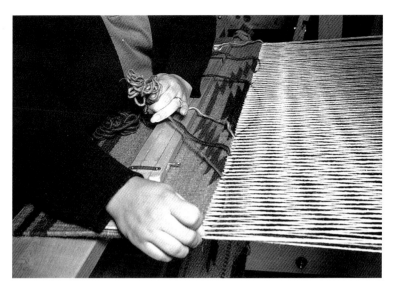

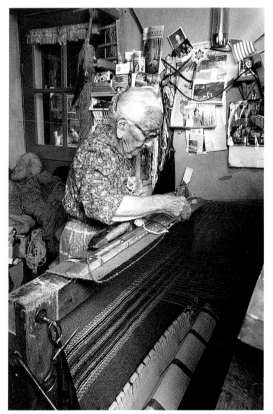

Many "classic" utilitarian Hispanic blankets of the nineteenth century were patterned with stripes woven in weft-faced plain weave (see plate 1). To achieve a blanket of sufficient width, two identical panels (ranging in size from twenty-one to thirty inches) were woven and then sewn together using a simple joining stitch (fig. 6.24). Careful planning is needed to correctly match the two panels. Many museum examples show the puckering along this central seam created by attempting to reconcile mismatched panels.

Another way in which weavers could make wider striped blankets on narrow looms, without having to join two pieces, was to weave them double width *(doble-ancho)* on the loom. *Doble-ancho* blankets are also called *doble tela,* or double-warp, blankets. These blankets were called "seamless blankets" in Candelario's turn-of-the-century brochures. Using a loom with four harnesses, a weaver could allot two harnesses to weave one layer of cloth and two harnesses to weave another, one above the other. Both layers were woven at once. During the weaving of the layers, the shuttle was inserted in a special sequence, closing the two layers of cloth along one selvage edge while leaving the layers separate along the other selvage. When removed from the loom, this fabric could be opened up to its full double width. These blankets can be identified by the additional warp threads that tend to crowd together at the weaving's center where the weaving was once folded on the loom (fig. 6.25). From the standpoint of weave structure, these double-width blankets are identical to their plain weave, two-panel counterparts.

Tapestry Weave

Tapestry weave is a special variant of weft-faced plain weave and is used in Río Grande and Chimayó blankets to pattern the cloth. "If the weft is interworked only part way across the web and others are successively substituted to fill out the row,

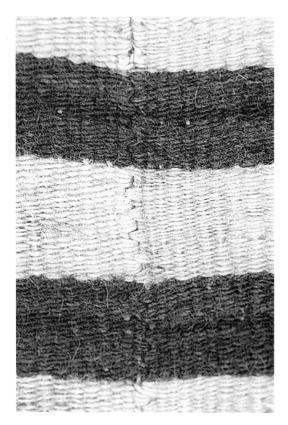

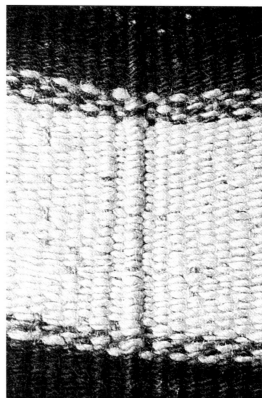

solid color or texture areas (of easily varied size and shape) can be created by working each weft back and forth in its own area."[15] By creating tapestry shapes consisting of diagonal lines, the weaver avoids open slits where vertical lines appear. Most Hispanic weaving makes use of motifs composed of horizontal and diagonal lines. Steep diagonals are termed *corrida rápida* and less-steep ones, *corrida despacia*. A diagonal with fringed or hatched edges is called *corrida de uñitas*.

When vertical lines appear in a design, their edges may form an opening or slit. These edges can be joined together during weaving. Hispanic weavers use the single dovetail method, termed *corrida de cuadro*, whereby "wefts from adjacent areas turn back alternately round the warp which is their common boundary" (fig. 6.26).[16] This single dovetail method used by Hispanic weavers creates a reversible (two-faced) fabric with two identical

Figure 6.22 | Norma Martínez demonstrates the way weft is placed in the weaving shed in arcs prior to beating the weft into place. This handling is sometimes called "bubbling the weft." Such placement of the weft allows for its displacement around the warp threads as it is packed tightly into place. Tierra Wools, Los Ojos, New Mexico. Photo by Miguel Gandert, 1992 (opposite, above).

Figure 6.23 | Agueda Martínez positions the weft in a wide arc in the weaving shed, Medanales, New Mexico. Photo by Miguel Gandert, 1992 (opposite, below).

Figure 6.24 | Joining technique along the center seam of a Río Grande blanket woven in two lengths. Museum of New Mexico Collections, Museum of International Folk Art, Santa Fe, New Mexico, A.60.21-1. Photo by Miguel Gandert, 1992 (left).

Figure 6.25 | Center ridge on a double-weave Río Grande blanket. Museum of International Folk Art, Santa Fe, New Mexico (right).

Figure 6.26 | *Tapestry techniques: (a) plain weave; (b) diagonal lines in weft faced tapestry weave; (c) single dovetail vertical tapestry join; (d) pick-on-pick patterns, after Jenkins, 1951. Drawing by Suzanne Baizerman.*

faces. Loose ends at the beginning and end of pattern areas are worked into the body of the fabric and hidden during weaving.

In general, in most tapestries found the world over, the tapestry patterning covers the entire surface of the cloth. "There are few if any wefts that extend the full width of a tapestry-woven cloth."[17] In contrast, Hispanic blankets economically combine bands of tapestry patterning with large bands of plain weave where the shuttle is passed from selvage to selvage. These plain weave areas may involve a planned succession of colors to form striped patterns and pick-on-pick patterns (see fig. 6.26).

Yarn Count

The relationship between the number of warp ends per inch and the number of weft picks per inch can provide a picture of the relative fineness and hand (or feel) of two different cloths. Warp count on the handspun Hispanic blankets from the colonial period averaged 5 to 7 warp ends per inch (epi), 25 to 50 weft picks per inch (ppi), a relatively loose, coarse cloth. These figures can be compared to those of Navajo weaving: 6 to 12 epi, 20 to 100 ppi. In general, Navajo textiles are thinner, denser, and sturdier cloths.[18] Hispanic weaving using commercial yarns has a count of 6 to 11 epi and 30 to 34 ppi. This is a finer cloth than colonial Hispanic ones and is more supple than the Navajo examples. These data also show the very labor-intensive nature of handweaving. Each pick is a pass of the shuttle through the shed across the entire weaving width. In a plain, unpatterned blanket sixty inches in length with 30 picks per inch, the weaver would pass the weft through the shed eighteen hundred times. As tapestry patterning is added to the weaving process, the weaving time increases several times over.

Design Characteristics

Most patterned Hispanic weavings share certain design features. The external shape of most weavings is rectangular with the length most often twice the width. Rarely is the illusion of three-dimensional space created. Rather, colors, lines, and internal shapes are manipulated to emphasize a two-dimensional plane. Patterning is arranged symmetrically around the vertical and horizontal axes. Typically there are striped, transverse end bands and a central field. Within the central field are central and auxiliary motifs. The central motif is usually large and formed of angled lines that focus the attention of the viewer. The auxiliary motifs are found in the space between the transverse end bands and the central motif. These auxiliary motifs may be arranged to fill the space densely or leave it relatively empty.

The Saltillo sarape was the prototype for the design of northern New Mexican patterned weaving. In the Saltillo sarape, the central diamond was

surrounded by auxiliary motifs in a dense mosaic pattern, completely filling the field. Lateral and transverse bands worked in contrasting tapestry patterning formed a frame around the central field.[19] Shapes used in creating patterns are shown in figure 6.27. Due to the large number of warp ends per inch and fine yarns used, the surface of the Saltillo sarape was very smooth.

Until the Saltillo design system appeared in northern New Mexico, blankets were plain, solid-colored, or striped. The striped blankets had striping at the transverse ends or stripes arranged in bands across the whole of the cloth. Bands sometimes incorporated weft patterning devices, such as pick-and-pick patterns (see fig. 6.26).

Río Grande blankets with tapestry patterning adapted elements of the Saltillo sarape designs. Some versions retained the large central diamond. However, lateral borders, when present, were simplified, and transverse borders were modified into stripe patterns. The mosaic-patterned backgrounds were either enlarged or eliminated. Other Río Grande blankets feature bands of tapestry-patterning, based on the shapes shown in figure 6.27, enclosed in bands of stripes. Compared to the Saltillo sarape, the surface of Río Grande blankets is more textured due to the larger-diameter yarns and wider warp setts. (Sett refers to the number of warp ends per inch in the reed.)

Northern New Mexican weaving designs were less refined than their counterparts in Mexico. One explanation holds that the more rough-and-tumble life of the frontier was reflected in rough-hewn weaving. There are more satisfactory technical explanations. For example, few metal reeds for spacing warp ends on the loom were available in the northern frontier. Wooden reeds could not be carved as finely as metal ones. Moreover, the New Mexican weavers probably did not have access to a grade of wool that could be finely spun nor the extra time required for fine spinning. Their less-expensive patterned blankets may also have filled

Figure 6.27 | Saltillo design motifs, after Jenkins, 1951, Figure 7. Drawing by Frances Trice.

an important market niche, given that there was less demand for the elegant Saltillo sarapes on the less-affluent northern frontier.[20]

Weavings of the early transitional period (1870–1900) were affected by the availability of commercial yarns and commercial dyes. Commercial yarns produced a smooth and even cloth surface compared to weavings produced with handspun yarns. Commercial yarns also affected designs woven into the cloth. As the new weft yarns were beaten into place over the warp, they packed down more compactly. This compacting caused a compression of the designs and made the diagonal lines of the designs less acute. The commercial yarns also stimulated the development of designs more intricate than Río Grande styles, for example, the "Hispanic eyedazzlers" (see plates 33–44). These used commercially processed yarns colored with synthetic dyes. A new design, unique to northern New Mexico, appeared during this period in handspun and commercial yarns, taking full advantage of the new palette afforded by commercial dyes.

Called the Trampas/Vallero after the villages in which it originated, this design featured an eight-pointed star, often arranged in groups of five (see plates 15, 44, 66).

In the late transitional period (1900–1920), designs were simplified even further, as a direct result of increased production for external markets, but motifs derived from Saltillo sarapes were still used (see fig. 6.27; see also plates 19, 21, 24, and fig. 3.11). These motifs were used in isolation, with large, undecorated areas. Transverse bands were much simplified or eliminated. Central motifs were even eliminated sometimes, replaced by corner motifs or motifs extending inward from the sides. Designs associated with American Indians—such as war clubs and arrows—were used liberally during this period as central or auxiliary motifs. The swastika, known as the whirling log or the Navajo good luck symbol, appeared frequently (see plates 20, 26, 27, 28, and 31). Colors, too, mimicked the Native American color scheme introduced by Indian reservation post traders: red, black, white, and gray. For special orders, weavers often produced blankets with wording and pictorial images.

A characteristic Chimayó style of weaving developed in the early modern period (1920–1940). It continues to be employed up to the present (see plates 56–61). The easily recognizable style has well-developed transverse bands with the striping and ticking characteristic of Spanish colonial striped blankets. In addition, a central motif with auxiliary motifs is prominent. The central motif is usually an elaborate diamond or hourglass shape with a base and wings.[21] The basic shapes may be divided into quarters, and the colors may be counterchanged within subdivisions. Auxiliary motifs often consist of small, modified versions of the central motif. Additional auxiliary motifs, called *jaspes,* consist of a series of parallel, horizontal lines forming a motif in a complementary shape (see plate 61). Outlining of central and auxiliary motifs is frequent. Mera suggests these elaborated motifs were probably derived from Mexican weaving designs.[22] Some contemporary weavers attribute the introduction of the technique to Antonio Mier, a Mexican weaver who moved to Santa Fe in 1908.[23] Throughout the modern period, the number of colors available to weavers has increased; forty shades are stocked by one blanket dealer.

While most Hispanic weaving today is based on the Chimayó design format, there are other weaving styles to be found. Some weavers are producing reproductions of classic Río Grande blankets (both striped and tapestry-patterned), as well as reproductions of Saltillo sarapes and Trampas/ Valleros. There are also weavers who weave highly individual expressive pieces, sometimes reinterpreting older styles in unique ways, combining different styles, or including pictorial images or ikat techniques.

One part of a weaving tradition is embedded in its technical concerns: tools, materials, processes, and products. Learning the use of tools and materials is a major part of what one weaver passes along to another in the unfolding of a craft tradition. Such a tradition is not a static entity. Each generation is exposed to new materials, new tools, even new ideologies that can impact the craft. In the case of Hispanic weaving, changes in materials and design alterations for new markets have transformed the appearance of the woven cloth. Yet new generations learn on the same type of loom, using the same wool fibers, executing the same weft-faced tapestry weaving techniques, and employing the same finishing techniques. Continuity based on technique upholds the vitality of this ongoing weaving tradition.

7

The Transformation of a Tradition

Chimayó weaving in northern New Mexico has provided an example of the interactions that take place when an object crafted by one group enters the marketplace and is influenced by another group. The interest of one group in the art production of another is not new. Through the ages, pilgrims and travelers have typically returned home with mementos of faraway places. However, the colonization of Third World countries after the fifteenth century brought different groups and different traditions of artistic production together. The products of indigenous people began to be seen in new ways, ways that centered on their potential for export to outside markets. Less powerful, indigenous groups modified their arts in pursuit of new markets. More powerful colonizers pursued a kind of "aesthetic colonialism" and saw in the arts another local resource that could be revamped and exploited.

The particular system that resulted from this reformulation of artistic production has been referred to as an "ethnic art market."[1] Typically it involves two or more ethnic groups who exchange art across hypothetical ethnic boundaries.[2] Also typically, a hierarchical relationship exists between groups, a relationship defined by factors such as economic and political status, social class, and race. Within this hierarchical framework, ethnic art forms a pathway of contact between the groups and "smooths the flow of personal interaction."[3] The ethnic art object serves as a visual metaphor for this type of hierarchical, cross-cultural contact.[4] Meaning associated with an object is not static; it may change across time in response to changes in social context and in power dynamics.

In addition to its meaning as a symbol of cross-cultural contact within an ethnic art market, an ethnic art object may also have distinct meanings for different participants in this market. In the example of Hispanic weaving, the participants are weavers, their customers, and those who have facilitated the connection between weavers and consumers — such as curio dealers and shop or gallery owners.

To a Chimayó weaver from northern New Mexico, Hispanic weaving may represent Hispanic culture.[5] It may stand for the individual's and the family's tie to heritage and ethnicity. It may connote self-reliance, pride, self-sufficiency, versatility, and skill.

To travelers visiting the area, Chimayó weaving is one of a large assortment of objects, including pot holders, ceramic tiles, and clothing that visually represent the Southwest and a treasured visit to a unique physical environment.[6] It may represent the place where, in one's own country, one

can have the experience of touching "the Other." To the uninformed consumer, Chimayó weaving may even represent Native American culture. Indeed, the designs woven into the cloth have been referred to as Pan-Southwest designs.[7] Back home, the weaving may speak of the traveler's multi-cultural interests, to nonprovincialism. It may be a visible sign that its owner has the resources to travel or the cleverness to spot a bargain. Some consumers may view their purchase as a means of saving a craft tradition from extinction. Others, who consider themselves educated in the arts, may see woven objects as emblems of their connoisseurship and good taste, to be collected and displayed.

To the person who facilitates the transaction between artisan and consumer, the meaning of the object centers on its economic value. However, this individual must understand and work within the system of symbols and meanings of the ethnic art market.

It is clear in the example of Hispanic weaving that ethnic art has multiple meanings. To view ethnic art in this fluid fashion poses a certain paradox, because it is customary to think of ethnic art as linked to ethnic traditions. Traditions are thought of as stable and unyielding, passed on from one generation to the next. However, studies in recent years have challenged this view of tradition and have offered a more fluid view of the phenomenon.

Beginning in the 1980s, when Shils's book *Tradition* was released, there has been a shift in the way in which tradition has been viewed. Shils suggested that tradition was "a much more plastic thing, more capable of being retrospectively reformed by human beings in the present."[8] Such re-creations were tied more explicitly to social change by Hobsbawm and Ranger in *The Invention of Tradition*. They noted that tradition was invented when "rapid transformation of society weakens or destroys the social patterns for which 'old traditions' had been designed, producing new ones to which they were not applicable, or when such tra-

ditions and their institutional carriers and promulgators no longer prove sufficiently adaptable and flexible or are otherwise eliminated."[9] Handler and Linnekin's 1984 paper placed even more emphasis on tradition as a symbolically constructed phenomenon, "a model of the past . . . inseparable from the interpretation of tradition in the present."[10] In 1990 Horner asserted that "all tradition contains aspects of invention." This succession of scholars ties the definition of tradition to present social and economic realities and ideologies. This idea, however, runs counter to commonly held notions of the concept of tradition. It frames tradition in a new way, acknowledging that "the great power of tradition is to be flexible while seeming immobile."[11]

Tradition within this framework connects to the construction of ethnic identity and to the ethnic arts market. Tradition's "most salient characteristic is the creation of identity by affiliating people with past events, places, persons and things." In an ethnic art market, consumers "define back to the producers what they think is 'traditional'" within a "negotiated exchange of images and impressions."[12]

This book explores some of these exchanges of images and impressions as the craft of Chimayó weaving evolved after the United States assumed political control of the region in the mid-nineteenth century. It elucidates the way in which Hispanos and Anglos have participated in the task of defining the craft that has, in turn, contributed to the shaping of Hispanic ethnicity.

At its inception, Hispanic weaving was a craft brought to a remote frontier, affecting and being affected by the weaving of the local indigenous people. It was part of the economy of New Spain and, later, Mexico. Indeed, well after Anglos entered the area, local residents referred to themselves as "Mejicanos."[13] Then, as a result of inroads created by annexation to the United States, Hispanos were gradually exposed to the Anglo world,

which brought many new products and possibilities. But it was also a world marked by land fraud, exploitation, and racism. The transition of Hispanos from being the politically dominant group to a less powerful, though numerically superior, group was not a smooth one. Many Anglos were wary of Mexicans and uneasy about Catholicism. Conversely, Mexicans were distrustful of Anglos and Protestantism.

In this context, a new consciousness and a new group identity was formed as the contrast between Anglo and Hispanic values and lifestyles was highlighted. There was an increasing awareness of what was unique about northern New Mexican Hispanic life: the rural, agrarian lifestyle, religious practices, language, foods, music, crafts, and other distinctive features that had been forged in this remote region. Out of this heightened awareness of difference—and a desire to ensure cultural survival—emerged an ethnic identity or ethnicity.[14] Until there was a strong Anglo presence in New Mexico, there was less need for a defined Hispanic ethnic identity.

Crafts for the curio and tourist market, developed in the late nineteenth and early twentieth centuries, became a cultural form that aided cultural and economic survival. Weaving, for example, provided an avenue to marginal economic participation in the new, cash-oriented society. With the help of mediating agents, a highly interactive process developed between consumer and weaver, the details of which are revealed in Jesús Candelario's files.

The shaping of Hispanic weaving into a form that would meet the needs of the consumer meant understanding those needs. A visual representation evocative of a people or place was required. This representation had to be in a form that could be displayed in the buyer's home, fulfilling decorating needs, and where it could say something about the consumer's taste or worldliness.[15] In addition to the proper visual representation, "trade lore," stories about objects and their makers evolved.[16] These provided a vital link between the object and the Other and developed parallel to visual images. For example, references to artisans descending from Spanish *conquistadores* were circulated even in the nineteenth century in catalogs selling Hispanic artifacts.[17]

The first attempts to provide the correct images and trade lore for consumers came from items heavily influenced by curio-oriented mediators. These mediators built upon consumers' interest in American Indian designs. Dealers sought a low-priced item that could be sold on retail and wholesale markets within and beyond the region. They also made available custom-made items that could garner higher prices. Solving these marketing and design problems created opportunities for Hispanic weavers to explore new dimensions of their craft. Indeed, some weavers became virtuosos who took on elaborate, challenging assignments. The skills honed for the curio market, coupled with the influence of new forms of weaving in Mexico, led to Chimayó weaving in the 1920s. Chimayó weaving was also influenced by its contact with Native American weavings and associated images as well as by Anglo tastes, but it emerged as a distinctively and uniquely Hispanic art form.

However, solutions to consumer wants and needs that arose from the curio-tourist market did not fill the prestige or decorating needs of a more-sophisticated, educated, economically advantaged clientele, which Gans identifies with a "high taste culture."[18] Consumers could easily view curio products as unauthentic and debased forms of newly revived, older examples.[19] Although their marketing efforts were also partially directed toward tourists, Anglos stressed the revival of Spanish colonial weaving. Ironically, they were encouraging the replication of blankets in museums and private collections that dated primarily from the Mexican and territorial periods (after 1821) rather than the Spanish colonial period.[20]

By stressing the Spanish roots of weaving and other crafts, New Mexicans were subscribing to what Chávez has termed "the myth of pure Spanish blood."[21] The myth arose when the Anglo presence began to be more keenly felt in the Southwest. Immigration from Mexico was increasing, and the more-entrenched Hispanos—those who had lived in the region for generations—sought to dissociate themselves from newer immigrants who were economically disadvantaged. Hispanos emphasized their European connections and de-emphasized centuries of interaction with local Native Americans. The myth of pure Spanish blood was embraced by Hispanos and Anglos alike and paved the way for the revival of Spanish colonial arts. As such, the evolution of the emphasis on Spanish colonial antecedents of this regional art form was a natural corollary of this myth.

While overemphasizing the Spanish connection at the expense of the Mexican one, revivalists nonetheless did much to honor Hispanic artisans and to publicize their craft. Their feedback was very beneficial to the development of the craft and to upgrading the quality of materials used in the tourist-oriented Chimayó weavings. In addition, the emphasis on Spanish roots allowed Hispanos to establish themselves in a more elevated position in relation to the Mexican newcomers. Other positive outcomes of the revival movement were the depression-era programs that were shaped by revival efforts. Weavers had new opportunities to teach and to market their products to a more affluent clientele in new settings. These experiences paved the way for the fine art weaving of later decades. Yet the tension between those Hispanic weavers who produced for revival-oriented consumers and those who produced for tourist consumers has persisted well into the late twentieth century. During the 1960s the Spanish Colonial Arts Society was reactivated and ushered in a second revival wave; many government programs developed to support craft as a form of economic development.

In the 1970s scholarly attention turned to tourism and tourist art; these were identified as legitimate and worthwhile foci of scholarly attention. In 1976 MacCannell's book *The Tourist* was published, identifying tourism as part of a much broader social phenomenon. That same year, Nelson Graburn's book on ethnic and fourth world arts appeared.[22] Graburn provided a useful typology that showed the range of production that could be subsumed under the ethnic arts label. However, implicit in this typology was the evaluation of the authenticity or genuineness of the artistic production as determined by those outside the culture.

By the mid-1980s scholarly attention shifted from concerns about authenticity to an examination of tourist art as part of a larger social system. Becker's work *Art Worlds* emphasized art in the context of social networks, of which artists were only one part. Extending this more holistic view, tourist art was seen as part of a system influenced by artisans, consumers, and those who mediated their interaction. In 1984 Jules-Rosette referred to tourist arts as "vital symbols of social change . . . at once a statement about the identity of the artists and a commentary on the audience for which it is produced." In 1988 Clifford mapped the way in which tourist art could be transformed through time and redefined as ethnographic object or fine art.[23]

The 1990s witnessed the publication of many more case studies of ethnic arts, particularly from an economic perspective.[24] As is the case for artisans in most parts of the world, the majority of Chimayó weavers are economically marginal to the mainstream market economy. A few weavers, especially those who market the work of other weavers, are able to support themselves and their families. For most weavers, weaving is a culturally valued way to supplement income. This form of economic organization, marginal though it might be, is tacitly accepted.

While accepting certain economic limitations, weavers in the past decade have played a more ac-

tive role in shaping tradition. Berlo speaks of the concept of reciprocal appropriation that "positions indigenous people as active agents of their own artistic styles, not simply passive recipients of a hegemonic culture which constantly erodes and undercuts their own so-called 'traditional' culture."[25] Ethnic artists are not merely passive reactors to outside forces but active participants in a system, seeking out and developing symbols that can communicate with outside groups, that can be palatable and digestible by outside consumers, but that can still maintain the integrity of the artist's group. Most often these are "adapted for Euro-American display yet designed to be interpretable in that context as indigenous form."[26] The history of Hispanic weaving is replete with examples of the ways in which weavers have balanced market demands and cultural expression.

In this book, we make a case for the importance of viewing tourist art as an aspect of the whole of artistic production. The profiles of weaving families show the way in which weavers have woven simultaneously for both the curio-oriented and revival-oriented markets and have embraced new markets that developed in the late twentieth century, such as weaving for fine art and folk art markets. In addition, a review of the technological aspects of weaving demonstrates the many ways that tools, materials, and surface design maintain continuity with the past and have been used to establish ethnic definitions. Looking at weavers'

lives, products, and work styles, it is easy to identify the entrenched ways in which production for the curio-tourist market has been a viable and continuous, if overlooked, part of the Hispanic weaving tradition.

Throughout the decades covered in this book, Hispanic families have been refining their weaving skills and adding to the skills that have prepared them to conduct business in the Anglo world. The very versatility of the Hispanic weaver has been a strong underpinning of the weaving tradition. Today, Chimayó weavers may be well educated in art or business, or may be the scholars and museum curators who document the tradition and define its parameters. They comprise many of the voices that are being heard most loudly. However, they straddle a difficult line: on the one side, they must maintain their personal artistic vision or desires; on the other side, they must be responsive to the consumers' desire to display the arts of another group and to the exigencies of consumer preferences. Consumers continue to play a viable role in sustaining ethnic identity through their interest in, and consumption of, craft. This interaction between the weaver and the customer has been a part of Hispanic weaving as it has evolved from Spanish, Moorish, Mexican, Far Eastern, American Indian, and Anglo influences. Through these influences, coupled with individual inventiveness, Chimayó weaving has become a unique synthesis—a distinct, regional weaving tradition in the New World.

Appendix 1
Rural Weavers of Northern New Mexico in Correspondence Files of J. S. Candelario, 1905–1913

Río Arriba County
(living in Chimayó unless otherwise noted)

Arinitez, Josinio, 1912 (Santa Cruz)

Belasques, M.A., 1905, 1910 (Trampas)

Chávez, Miguel, 1906, 1907

Córdova, Ignacita, 1906 (Mariana)

Cruz, José Leandro, 1911

Deagüero, José Hilario, 1907

Deagüero, Juan, 1908, 1909

Deagüero, Manuel, 1908, 1909

López, Deciderio, 1907 (Truchas)

Martínez, Anieto, 1908

Martínez, Brigido, 1906, 1908

Martínez, Félix, 1907

Martínez, Jacinta, 1907, 1908 (mother of José)

Martínez, José, 1907

Martínez, (first sister of José), 1908

Martínez, (second sister of José), 1908

Martínez, Manuel, 1905, 1906, 1907, 1908,
 1909, 1912

Martínez, Marcelino, 1908

Martínez, Patricio, 1907, 1908

Martínez, Raphael, 1908

Martínez, Teodoro, 1912, 1913

Martínez y Baca, Bonifacio, 1908

Montoya, Bentura, 1908

Montoya, Francisco, 1906, 1907, 1908,
 1909, 1911

Naranjo, Reyes, 1907, 1908, 1911

Ortega, Imperia, 1913

Ortega, Nicasio, 1907

Ortega, Reyes, 1905, 1908

Ortega, Rumaldo, 1906, 1907, 1908,
 1909, 1910, 1911

Ortega, Teofilo, 1908

Ortega, Victor, 1907

Ortiz, José, 1908

Ortiz, Santos, 1906

Pacheco, E. M. (Esquipula Martínez),
 1905, 1906, 1907, 1908

Romero, Francisco, 1908

Roybal, Reyes, 1908, 1909 (Trampas)

Roybal, Ricardo, 1911 (Valle)

Salazar, Adolfo, 1907

Sandoval, Esquipula, 1913

Trujillo, Gavino, 1907, 1908, 1911, 1912

Trujillo y Martínez, Julián, 1905, 1907, 1908

Vigil, Ysabel (Isabel), 1906, 1907, 1908, 1911

Appendix 2
Hispanic Weavers of North-Central New Mexico, Compiled by Helen Lucero, 1983–1984

Río Arriba County

Aguilar, Gregorita A.
Archuleta, Eric
Archuleta, Matilde
Archuleta Sagel, Teresa
Arellano, Ellen C.
Atencio, Bernice
Baca, Molly
Blea, Judy
Blea, Wanda
Branch, Elalia
 Rodríguez
Chacón, Rosalia
Chávez, Frances
Chávez, Steve
Córdova, Alfredo R.
Córdova, Gabrieleta
 Trujillo
Córdova, Harry L.
Coronado, Cordelia
 Martínez
Coronado, Marcela
Coronado, Oscar
Coronado, Teresa
Coronado, Victor
De Vargas, Tina
Domínguez, Velma
Gallegos, Dorothy
García, Maxine E.

Herrera, Amada Salazar
Leyba, Sarita
López, Gregorio
López, Irene
Lovato, Edna
Lucero, Benita
Lucero, Tina
Maestas, Olibama
Manzanares, Diana
Manzanares, Eusebio
Manzanares, Mario
Manzanares, Molly B.
Manzanares, Ramón
Manzanares-Bulky,
 Dolores
Martínez, Adonilia
Martínez, Agueda
 Salazar
Martínez, Avenicia
Martínez, Consuelo
 Salazar
Martínez, Laurita
Martínez, Vences
Martínez, Victoria
Medina, Dolores
Medina, Kayleen
Medina, Norma
 Archuleta

Medina, Ramos
Mier, Francisco
Montaño, Sally
Montoya, Gloria
Ortega, Andrew
Ortega, Connie Varela
Ortega, David
Ortega, Francine
Ortega, Juan
 Melquiades
Ortega, Lillian Salazar
Ortega, Ricardo
Ortega, Robert James
Ortega, Virginia Varela
Ortega, Zoraida
 Gutiérrez
Pina, Denise J.
Rael, Andy
Rodríguez, Eva López
Romero, Carmelita Vigil
Romero, Elisanda
Romero, Euphelia
Romero, Pete
Salazar, Cecilia Sebada
Salazar, Cleo Trujillo
Salazar, Don, Jr.
Salazar, Santana
 Velásquez

Sánchez, Onofre
Sandoval, Bernarda
Serrano, Angie
Serrano, Georgia
 Martínez
Serrano, Lino
Serrano, Selina
Trujillo, Albino
Trujillo, Irvin L.
Trujillo, Jacobo O.
Trujillo, John
Trujillo, Nick
Ulibarrí-Probst, Josie
Valdez, Grace
Valdez, Loretta
Valencia, Patsy
Velarde, Rose
Vergara Wilson, María
Vialpando, Christela
Vigil, Dolores
Vigil, Dora
Vigil, Dulcinea Trujillo
Vigil, Jeanette
 Rodríguez
Vigil, Lourdes
Vigil, Nelson
Vigil, Ruth
Vigil, Wilfred

187

Chimayó Weaving

Anglada, Maclovia
Archuleta, Benita
Chacón, Rosalia
Chávez, Francis
Cisneros, Eloisa
Coca, Alex
Córdova, Darlene
Cruz, Fedelina
Cruz, Francis
Des Georges, Bernice
Durán, Tomasita Varos
Griego, Lupita
Jaramillo Lavadie,
 Juanita

Lavadie, Carol
López, Filia Cruz
Luján, Pita Vigil
Madrid, Casimira
Maestas, Norma
Mares, Lucy
Martínez, Dorotea
Martínez, Escolastico
Martínez, Ida Segura
Martínez, Pearl
Pacheco, Maclovia
Quintana, Cecilia
Quintana, John
Rodríguez, Lila

Romero, Elma
Romero, Roberta
Salazar, Delia
Sisneros, Eloisa
Tafoya, Elena
 Gonzáles
Tafoya, Florida
Trujillo, Ruperta
Trujillo-Ramsey,
 Victoria
Vargas, Virginia
Vigil, Helen

Notes

Archival materials cited in the notes are not included in the bibliography. The following abbreviations are used for frequently cited archives:

CCHL: Candelario Collection, History Library, Museum of New Mexico, Santa Fe, New Mexico

NMSA: New Mexico State Archives and Record Center, Santa Fe, New Mexico

Preface

1. Berlo 1991, 453.
2. See, for example, Hobsbawm and Ranger 1983, and Handler and Linnekin 1984.
3. In devising a dating system for Hispanic weaving, an effort was made to parallel the system used in analyzing Navajo weaving in order to facilitate cross-cultural comparisons. See Kent 1985.
4. Nora Fisher, ed., *Spanish Textile Traditions of New Mexico and Colorado,* Santa Fe, Museum of New Mexico Press, 1979. A new, revised edition, entitled *Rio Grande Textiles,* was published in 1994.
5. Spooner 1986 coins the term "trade lore" (197).

Chapter 1

1. Stoller 1979a, 65.
2. *Manito* or *hermanito* is a colloquial expression used to identify New Mexican Hispanos. It implies brotherhood and solidarity and is derived from *hermano* (brother). See Meléndez 1993.
3. Kutsche and Van Ness 1981, 2.
4. Stoller 1979a, 77.
5. According to the 1990 census, Río Arriba and Taos Counties had a combined population of only 57,483 (The Bureau of Business and Economic Research, University of New Mexico 1992, 68, 72)). In the two most prominent counties of the region, Río Arriba and Taos Counties, federally owned land accounted for 52 percent and 51 percent of county land, respectively (Williams 1986, 261). Statewide, the percentage of federally owned land was 32 percent (U.S. Department of the Interior, Bureau of Land Management, *Public Land Statistics,* 1993, v. 178, 5.)
6. Median family income in Río Arriba County was $12,038 in 1980 and $22,441 in 1990. In Taos County, it was $12,518 in 1980 and $19,465 in 1990. Statewide, median income was $19,923 in 1980 and $34,585 in 1990 (*Census in New Mexico* 1995, 166, 178, 32.) Median Hispanic family income was substantially lower: 25.7 percent of families in Río Arriba County and 26.7 percent of those in Taos County lived below the

poverty level in 1990 (*1990 Census of Population* 1993, 317, 320).

7. New Mexico, County Surveys, Economic Development Directory, The Bureau of Business and Economic Research, University of New Mexico 1992.

8. Forrest 1989, 15.

9. Ellis 1982, 331.

10. Miller 1986, 30. For more background on the Penitentes, see Weigle 1978.

11. Lamadrid 1994 provides excellent firsthand accounts of these activities (73-140).

12. For more background on the Santuario de Chimayó, see Kay 1987.

13. James [1914] 1974, 169.

14. Bustamante 1982, 187.

Chapter 2

1. Minge 1979, 9.

2. Stoller 1979a, 153.

3. Wheat 1976 notes that Oñate's 1598 settlers brought "hundreds of yards of cotton, wool, and silk cloth, of Mexican, Spanish, French, Chinese, and English origin . . . ; two years later they received more hundreds of yards" (199). Minge 1979, 13.

4. Swadesh 1974, 21–22.

5. Intermarriage or inbreeding with Indian servants was frequent; the children of the unions were adopted into Spanish families with "full social and cultural suffrage" (Stoller 1979a, 400). Other Christianized Indians were known as *genízaros;* they were at times servants and at other times free men and women. Border area settlements of genízaros formed buffer zones between Hispanos and Indians. The recognition of the variety of racial types was reflected in the *casta* system, in which the non-European population of New Spain was categorized along racial lines. Fine distinctions were made, for example, between *mestizos* and *mulatos.*

6. Bustamante 1982, 85.

7. Minge 1979, 14.

8. Lamar 1970, 28.

9. Swadesh 1974, 134, 196, 24, 263.

10. Toward the end of the classic period, *churro* sheep wool showed evidence of "contamination" by sheep imported by American settlers. These new sheep were introduced to improve meat and wool yield. However, their wool was of smaller diameter (finer) and kinkier. Yarn from this wool had a matted, dull appearance.

11. Saltzman and Fisher 1979, 216 n.

12. Brazilwood is not native to the American Southwest nor is there evidence of trade in brazilwood. Dye analysis has not indicated the presence of brazilwood in textiles. The reference to brazilwood, therefore, is based on the similarity of color. See Spillman 1979, 66–67.

13. Wheat and Fisher and Wheat 1976, 1979.

14. This book uses the proper Spanish spelling *frazada,* although *frezada* is also used in northern New Mexico. Minge 1979, 13.

15. Lamar 1970, 27.

16. Kent 1985, 11, 2.

17. Ibid., 3.

18. According to James [1914] 1974 the Navajos called the striped blanket *nakhai bi cliidi,* translated as Mexican rug or pelt, suggesting Spanish derivation (116).

19. See Minge 1979, 22; Bowen 1979b, 142; and Wheat 1979a, 31.

20. Boyd 1974, 205. *Ikat,* the Indonesian term for warp-resist patterning, has become common in English usage.

21. See Kagan 1976.

22. Jeter and Juelke 1978, 20.

23. Minge 1979, 24–28.

24. Wheat 1979a, 32.

25. Swadesh 1974, 199.

26. Forrest 1989, 9.

27. Ibid., 27.

28. For example, see Gregg [1954] 1974, 154.

29. Bustamante 1982, 100.

30. Stoller 1979a, 62.

31. Swadesh 1974, 136, 198.

32. Kutsche and Van Ness 1981, 16, 15.

33. Swadesh 1974, 160.

34. Stoller 1979b, 42.

35. Wheat 1979b, 77.

36. Jeter and Juelke 1978, 21. See also Armella de Aspe and Yturbide 1989.

37. Jeter and Juelke 1978, 27.

38. Information about Mexican nationalism from Jeter and Juelke 1978, 27; synthesis information from Wheat 1979b, 75.

39. Fontana et al. 1977.

40. The warp is wound around warp beams in a circular fashion, creating two layers of warp. As the weaver progresses, the completed weaving is moved around to the underside of the loom and unwoven warp is brought closer to the weaver. When weaving is completed, the warp is cut between where the weaving started and where it ended to remove it from the loom, leaving a fringe at each end of the piece. The completed weaving is roughly twice as long as the loom.

41. Schevill 1994, 53–58. Wool blanket weaving was also introduced by the Spanish in Peru during the colonial era. These Peruvian weavings have been termed "Quechuan Rugs" (Fabish 1986). Part of Fabish's collection was displayed at the Millicent Rogers Museum, Taos, N.Mex., in 1992 in the exhibition *Shared Traditions: New Mexican and Peruvian Weavings.*

42. *Bayeta* was the Spanish term for woven, flannel cloth. Bayeta was painstakingly unraveled into fine strands of single-ply yarns. Then the strands were loosely grouped together and used in place of regular handspun weft yarn. s various parts of the world and followed trade routes to the Southwest. Before the widespread availability of aniline dyes, these raveled wefts were sought after to increase the palette of colors, particularly reds. (See Kent 1985, 35, 44.)

43. Wheat, personal communication with S. Baizerman, 1985.

44. Amsden 1934, 174.

45. Wheat, personal communication with S. Baizerman, 1985.

46. Ibid.

47. Mallery 1886, 569.

48. Amsden 1934, 164; Wheat 1976, 215.

49. Wheat 1976, 215.

50. Germantown, Pennsylvania, now part of Philadelphia, was the location of a thriving yarn-spinning industry. While not all yarn was produced at Germantown, this type of plied, commercial yarn became identified by that name. See Amsden 1934, 183; Kent 1985, 36; Wheat 1994, 14.

51. Wheat 1977, 432.

52. Deutsch 1987, 13.

53. Davis [1856] 1938, 82–83.

54. Otero 1936, 47.

55. Tushar as quoted in Stoller 1979a, 49.

56. The large-frame, hand-hewn loom better suited the size and strength of the male body build.

Chapter 3

1. Amsden 1934, 185. Mordants are substances — usually mineral — that chemically fix colors to fiber in the process of dyeing yarns.

2. Fisher 1979, 126–27.

3. Wheat 1976, 204; Kent 1976, 91.

4. Kapoun 1992, 4.

5. Maria Vergara Wilson, personal communication with S. Baizerman, 1985.

6. Today, both striped and tapestry-design rag rugs are produced by Hispanic weavers.

7. Bustamante 1982, 122, 125.

8. Forrest 1989, 10. See also deBuys 1985, 171–92.

9. Beck and Haase 1976, 21.

10. Swadesh 1974, 85; Swadesh describes this with-

drawal as the "process of social enclavement" (199).

11. See Deutsch 1987 for a detailed description of this migratory labor pattern.

12. Stoller 1979b, 42–44.

13. Stoller 1979a, 366.

14. Lummis [1893] 1952, 15.

15. Wentworth 1948, 113–14, quoted in Stoller 1979a, 367.

16. In some areas of the Southwest, where water was not abundant, removing excess grease from sheep wool was a daunting chore.

17. Stoller 1979a, 367.

18. Twitchell 1925, 408–9.

19. McLuhan 1985.

20. Thieme et al. 1984.

21. Dockstader 1977, 470.

22. Kent 1985, 15.

23. Ibid., 15, 16.

24. Hubbell 1930, 28. The Navajo have a cultural taboo against handling the dead.

25. Brody 1976a, 97; Rodee 1987, 72.

26. Kent 1985, 97.

27. Brody 1976a, n.p.

28. Utley 1961, 26; Kent 1985, 16.

29. Kent 1985, 86.

30. Simmons and Stout 1976, 16; Amsden 1934, 175.

31. Kent 1985, 87.

32. Ibid., 1976, 97.

33. Ibid., 1985, 85.

34. Parish 1960, 8, 141.

35. Ibid., 21.

36. Abraham Gold obituary, *Santa Fe New Mexican*, 8/14/1903, p. 4, col. 3, notes that Luis Gold's store was founded in 1862. Abraham Gold was Jake Gold's brother.

37. Wade 1976, 53; Bandelier 1966, 1:341, 72, 238.

38. Luis Gold obituary, *Santa Fe New Mexican*, 1/10/1880; Twitchell 1925, 409.

39. NMSA, Santa Fe County Outsize Record Books Inventory, July 1981.

40. "Gold's Free Museum."

41. Ibid.

42. NMSA, Santa Fe County Outsize Record Books Inventory, July 1981.

43. Fred Harvey Blanket Books, Museum of International Folk Art Library, Santa Fe.

44. Tushar quoted in Stoller 1979b, 50. *Tilma* derives from the Aztec *Tilmatl*, translated into Spanish as "manta" and into English as "cloak" or "cape." Its length and decorations signified rank, and its use was subject to sumptuary laws. See Anawalt 1981.

45. Cobos 1983, 34.

46. Cerny and Mather 1979, 238.

47. Barker 1930, 131; Clark 1938 repeats this bit of folklore in an article of later date (35).

48. Doyle 1968, 5.

49. According to Candelario's obituary in the *Santa Fe New Mexican*, 7/30/38, Candelario graduated from Park College in 1888. However, the college has no record of Candelario ever having been a student there, according to Harold Smith, archivist at the college, personal communication with S. Baizerman, 1992. In January 1903 Jake Gold's brother, Abe, sent a letter to Candelario demanding that the name "The Original Q'Rosity Shop" not be used by Candelario, CCHL, S-22, 1902. NMSA, Santa Fe County Outsize Record Books Inventory, July 1981. Candelario's letterhead from 1895 also bears the word *montepío* (pawnbroker). CCHL, Box 89, 1907.

50. Doyle 1968, 5.

51. *Representative New Mexicans 1912,* 37. There is much evidence in Candelario's correspondence files of his involvement in Democratic party politics. For example, in 1912 he was invited to Woodrow Wilson's inauguration by Rep. H. B. Fergusson. Letter from H. B. Fergusson, 11/15/12, CCHL, Box 96.

52. Jake Gold obituary, *Santa Fe New Mexican*, 12/20/05, p. 1; letter from Hopkins and Cox,

Coronado Beach, California, to Hyman Lowitski, Jake Gold Collection, History Library, Museum of New Mexico, Santa Fe, New Mexico, file S-4.

53. Jake Gold obituary, *Santa Fe New Mexican,* 12/20/05, p. 1.

54. NMSA, Territorial Archives of New Mexico, Roll 141, Frame 1261. Gold was arrested in 1900.

55. CCHL, Box 85, 1901.

56. Ibid.; CCHL, 522, #6b; CCHL, Box 85, 12/11/03; Field Museum of Natural History, catalog cards for accession numbers 57733 and 57734.

57. CCHL, Box 104, 1903.

58. Jake Gold obituary, *Santa Fe New Mexican,* 12/20/05, p. 1.

59. The difference in the appearance of designs relates both to the loft, or fluffiness, of the yarn, the sett of the warp (the number of warp ends per inch in the reed), and the warp-ends-per-inch/weft-ends-per-inch ratio. See chapter 6 this volume.

60. NMSA, Santa Fe County Outsize Record Book Inventory, July 1981.

61. Candelario used this slogan on many of his advertising flyers. See, for example, CCHL, Box 97, 1913.

62. Doyle 1968, 11–13.

63. Ibid., 9. Henry Ward Beecher was a Protestant minister, widely known in his day for his liberal views and his support for the common man.

64. The main body of the records covers the period from 1901, when Candelario became actively reinvolved in his family's business, until 1914, when the records cease. A small collection of papers housed at the New Mexico State Archives and Record Center was also studied. It contains material from the 1920s and also from the 1940s; these latter documents postdate Candelario's death in 1938 but pertain to the Original Curio Store, which remained in the family until the 1950s. The building still stands at 303 San Francisco Street in Santa Fe and has gone through several changes in ownership. It continues to function as a curio store and to bear its original name.

65. CCHL, letter from C. N. Cotton, 8/9/12, Box 96.

66. CCHL, letter from the Navajo Rug Co., Los Angeles, 1914, Box 99.

67. Maisel's Trading Post, Albuquerque, advertising flyer, copy in the collection of Joe Ben Wheat.

68. Wheat 1979a, 36.

69. CCHL, Tammen Co., Denver, advertising flyer enclosed with letter dated 1/26/04, Box 85; CCHL, letter from Mariano Candelario, 1904, Box 101.

70. "Anson W. Hard Collection of Saltillo and Chimayo Blankets," *American Museum of Natural History Journal,* 1912, 33; James [1914] 1974, caption, plate 252.

71. Graburn 1976, 15.

72. CCHL, letter from Aldrich, 4/15/07, Box 89.

73. CCHL, letter from B. A. Whalen, 12/3/12, Box 99; James [1914] 1974, 172; CCHL, letter from José Durán y Montoya, Las Animas, Colo., 8/5/06, Box 87; CCHL, price list, 1913, Box 98.

74. "Catalogue and Price List, Navajo Blankets and Indian Curios, J. L. Hubbell Indian Trader," 195 (reprint), 4.

75. CCHL, letters from McAdam, 11/05/08, Box 92, Aldrich, 11/28/09, Box 94, Algert, 1907, Box 86.

76. CCHL, drawing for a pillow cover, Box 88, 1906.

77. CCHL, Tammen catalog, 1/26/04, Box 85, Tammen catalog, 1905, Box 86.

78. James [1914] 1974, 208, 173.

79. CCHL, letter to J. B. Field, 1908, Box 92; CCHL, envelope, 1910/11, Box 95; CCHL,

form letter sent by Candelario, 12/1/14, Box 99.

80. CCHL, files during 1913–14 contain many credit reports, Boxes 98 and 99; response to inquiry from American Fidelity Credit Indemnity Co., 9/13/13, Box 98; CCHL, letter from *Textile Manufacturing Journal,* New York, N.Y., 4/11/10, Box 95.

81. CCHL, 1905, Box 86.

82. CCHL, 1912, Box 97; CCHL, letter from Arthur C. Weeks, 5/19/12, Box 101; CCHL, letter from the German Artistic Label Co., 1911, Box 95.

83. CCHL, letter from W. H. Haines, Pueblo, Colo., 1905, Box 86.

84. CCHL, 1908, Box 91; 4/17/13, Box 97; 11/24/14, Box 99.

85. CCHL, 11/1/05, Box 86.

86. CCHL, letter from Pueblo Automobile Co., 12/14, Box 99; CCHL, letter from C. A. Wright's Trading Post, Albuquerque, to Candelario, 4/9/12, Box 97; CCHL, letter from Democratic Central Committee of Albuquerque, 1911–12, Box 96.

87. CCHL, H. H. Tammen, 10/23/05, Box 86.

88. CCHL, letter from Verkamps, Grand Canyon, 9/20/13, Box 98.

89. CCHL, Pat Ryan, 10/10/08, Box 92.

90. CCHL, T. P. Getz, Ramona's Marriage Place, North San Diego, Calif., 6/20/13, Box 96.

91. CCHL letters: Frank M. Covert, New York, N.Y., 10/5/06, Box 88; George Hopper, U.S. Fish Hatchery, Leadville, Colo., 12/2/09, Box 94; J. C. Bushinger, Monte Vista, Colo., 6/27/06, Box 87.

92. CCHL, letter from Tammen, Denver, 11/14/05, Box 86.

93. CCHL, letters: Verkamps, Grand Canyon, Ariz., 4/25/11, Box 95; Kohlbergs, Denver, 7/12/11, Box 96; Starns-Orendorf Book and Stationery Co., Ouray, Colo., 3/6/05, Box 87; L. L. Ferrall, Cameron's Hotel and Camps, Grand Canyon, Ariz., 5/05, Box 87.

94. CCHL, 1906, Box 88; CCHL, letter from Frank M. Covert, New York, N.Y., 2/07, Box 89.

95. CCHL, 5/23/06, Box 88. Candelario found such a yarn at the Perry Yarn Mills, Webster, Mass., in 1909; they were able to put 5 percent, 10 percent, or 20 percent cotton into their wool yarn, CCHL, 11/26/09, Box 94.

96. Clasgens continues to be the major supplier of yarn to dealers and weavers in northern New Mexico today.

97. CCHL, 1905, Box 103.

98. CCHL, 1913, Box 97.

99. John Candelario (grandson of J. S. Candelario), personal communication with S. Baizerman, 7/23/85.

100. Cerny and Mather 1979 noted that for the period from 1880 to 1920 weavers' names were unknown (169).

101. Chimayó's proximity to Española and the railroad, compared to other Hispanic villages, may account in part for its growth as a weaving center.

102. These figures were compiled from several sources in CCHL: Box 95, Flyer, 1910; Box 94, letter written by Candelario, 11/29/09; Box 85, order from M. Harris, Denver, 5/23/04; Box 88, letter from Frank Covert, New York, N.Y., 1906; Box 85, order from El Rito Mercantile, N.Mex., 5/23/04. Prices remain constant through these years.

103. CCHL, Manuel Martínez, 4/20/12, Box 97.

104. This figure is based on prices in dozens of letters in CCHL, Boxes 85, 88, 89, 92–95, 97–99, and 106.

105. CCHL, letter to Candelario from Esquipula Sandoval, 7/13/03, Box 98.

106. James [1914] 1974, 169.

107. One weaver whose name appears on the list, Imperia J. Ortega, is clearly female, and females are mentioned in other letters.

108. CCHL, letter to Candelario from Deciderio Lopez, 2/18/07, Box 89; CCHL, letter to Candelario from Reyes Roybal, 12/14/08, Box 93; James [1914] 1974, 169.

109. Clark 1953, n.p.

110. CCHL, letter to Candelario from José Martínez, 1907, Box 91; dealers sometimes provide such *muestras* to guide weavers today, especially novices.

111. CCHL, letter to Candelario from Gavino Trujillo, 10/11/08, Box 92; Melita Ortega, personal communication with S. Baizerman, 5/30/85.

112. James [1914] 1974, 173.

113. CCHL, letter to Candelario from Imperia J. Ortega, 10/16/13, Box 98.

114. CCHL, letters to Candelario: Manuel Martínez, 1905, Box 86; Victor Ortega, 3/09/07, Box 89; Julian Trujillo, 1/19/07, Box 89.

115. Melita Ortega, personal communication with S. Baizerman, 5/30/85.

Chapter 4

1. In *Popular Culture and High Culture,* Herbert Gans proposes that an individual may belong to what he terms a "taste culture." Taste cultures "consist of values, the cultural forms which express value . . . and the media in which these are expressed" (10–11). Examples would be the art people collect, the homes they live in, the movies they watch. Taste cultures "entertain, inform and beautify life, among other things, . . . and express values and standards of taste and aesthetics." Popular culture is "chosen by people who lack the economic and educational opportunities of high culture" (x). Popular culture fits the tastes and budgets of the majority of consumers. Members of the high taste culture "are almost all highly educated people of upper and upper middle-class status, employed mainly in academic and professional occupa-

tions" (76). It is the culture of "serious writers, artists, and the like" (75).

2. Boris 1986, 122.

3. Gibson 1983, 271.

4. Austin 1932, 358; Gibson 1983, 199.

5. Fergusson 1928, 442.

6. Nestor 1978, 6; Barela 1993, 56–57.

7. Austin 1933, 49.

8. Sedillo-Brewster 1935, 15, 71.

9. Gibson 1983, 249.

10. Rodríguez 1989, 88.

11. Certificate of Incorporation no. 15923, filed with the New Mexico State Corporation Commission, October 29, 1929, reprinted in Weigle 1983, 181.

12. Nestor 1978, 11.

13. Lawler 1930, 28.

14. Nestor 1978, 12.

15. Wroth 1985 has reproduced some of the weaving designs from these booklets together with *colcha* designs.

16. Wroth 1983, 29: Taos County: Taos, Peñasco, Las Trampas, Questa, Costilla; Santa Fe County: Chupadero, Galisteo, Cerrillos, La Ciénega, Agua Fría, Cundiyó, Pojoaque, Santa Cruz; Río Arriba County: Española, Abiquiu, Coyote, El Rito; Mora County: Mora; Guadalupe County: Puerto de Luna, Antón Chico, Delia; Bernalillo County: Albuquerque, San José (Training School).

17. Spurlock 1974, 92–94.

18. Weigle 1975, 71; Ernest Lyckman, interview with S. Baizerman, 2/19/85.

19. Nestor 1978, 9.

20. Mauzy 1936, 67.

21. Berkenfield 1992, 14–15.

22. Nestor 1978, 23.

23. Mauzy 1936, 68–69.

24. Nestor 1978, 31. Valentín Rivera, Margaret Baca, David Salazar, Filiberto Salazar, and Manuel Tafoya were among the weavers who worked for the Native Market.

25. Ibid., 26.

26. Ibid., 32, 1.

27. Mauzy 1936, 29.

28. Ibid., 71.

29. Mera 1987 (1947), 38, 31.

30. Wroth 1977, 6.

31. Nestor 1978, 40, 47, 52.

32. Clark 1938, 35–36.

33. G. McCrossen n.d., 2.

34. Ibid.

35. Clark 1938, 36.

36. Mauzy 1936, 72.

37. David Ortega, personal communication with S. Baizerman, 7/11/85.

38. Kluckhohn and Stodtbeck 1961, 77.

39. Wroth 1980, 100.

40. Boris 1986, xv.

41. Coan 1935, 13.

42. Fergusson 1928, 444.

43. Clark 1938, 35.

44. Letter from Mary Austin to J. F. Zimmerman, 11/25/30, p. 2. T. M. Pearce Collection, University of New Mexico Library, Coronado Room, Archive 255, Box J, Folder 13, Austin letters.

45. Letter from Cyrus McCormick Jr. to Mary Austin, 10/15/31. T. M. Pearce Collection, University of New Mexico Library, Coronado Room, Archive 255, Box J, Folder 21, Austin letters.

46. McCrossen 1931, 456, 458.

47. Ibid., 456; Mauzy 1936, 67 (the F. E. Mera referred to was probably Dr. H. P. Mera).

48. Briggs 1980, 58, 51.

49. McCrossen 1931, 458.

50. Mauzy 1936, 69–70.

51. Austin 1928, 381; Briggs 1980, 50.

52. James [1914] 1974, 172.

53. Briggs 1980, 46–67.

54. See Handler and Linnekin 1984.

55. Zimmerman 1956, 12.

56. Thomas 1978, 155–57.

57. See Manchester 1982.

58. Weigle 1975, 85.

59. Melita Ortega, personal communication with S. Baizerman, 5/30/85.

60. Leopoldo Trujillo, personal communication with S. Baizerman and Helen R. Lucero, 5/9/85.

61. Jacobo Trujillo, personal communication with S. Baizerman, 3/31/85.

62. David Ortega, personal communication with S. Baizerman, 7/11/85.

63. Harold Gans, personal communication with Helen R. Lucero and S. Baizerman, 1/16/85.

64. Correspondence files of David Ortega.

65. Harold Gans, personal communication with Helen R. Lucero and S. Baizerman, 1/16/85; see also Fisher 1985, 32–33; Juan Melquiades Ortega, personal communication with Helen R. Lucero, 10/17/83.

66. Weigle 1975, 87, 90, 101–2, 91.

67. Ibid., 91.

68. Ibid., 38; Campa 1979, 262.

69. "The High Road," quoting Arturo Jaramillo, a Chimayó businessman, 13.

70. Melita Ortega, interview with S. Baizerman, 5/30/85, and letter to Helen R. Lucero, 6/13/92; Josie Lujan, interview with S. Baizerman, 8/22/85, and Josefita Córdova, interview with Helen R. Lucero, 3/15/92.

71. Mera 1949, 36–37.

72. Frank Mier, personal communication with S. Baizerman and Helen R. Lucero, 8/26/85; Jacobo Trujillo, interview with Helen R. Lucero, 4/5/83, and S. Baizerman, 3/31/85.

73. Mena 1925, 26.

74. Weigle 1975, 91.

75. Juan Melquiades Ortega, personal communication with Helen R. Lucero, 10/17/83; David Ortega, personal communication with S. Baizerman, 4/11/85.

76. Elvira Romero, Helen R. Lucero's grandmother, was Martina Trujillo's daughter. Elvira related this information to Lucero,

whom she raised. Lucero visited with three of the aunts and watched them working at their looms in Río Chiquito, Truchas, and Cundiyó. The sisters' brother, Lorenzo Trujillo, was also a prolific weaver and entrepreneur. Melita Ortega, personal communication with S. Baizerman, 5/30/85.

77. Clark 1938, 36.

78. Casey 1936, 16.

79. Barker 1930, 172.

80. Hurt 1934, 11.

81. Trumbo 1947, 35; Haddon and Branham 1960, 11.

82. Nash 1994, 5, 6.

83. King 1994, viii.

84. Thomas et. al. 1994, ix.

85. Welsh 1994, 70.

86. Nash 1994, 13.

87. New Mexico's state population in 1940 was 531,818; by 1950 it had risen to 681,187. Szasz 1994, 161.

88. Hunner 1992, 8. See also, Robinson 1993, 12–14.

89. Ibid., 236.

90. Usner 1995, 232.

91. Welsh 1994, 73, 74.

92. Nash 1994, 21.

93. Welsh 1994, 76.

94. Tate and Law 1987. See text by Tate and photos by Law for a view of this "back-to the-earth" movement in New Mexico.

95. Deutsch 1987 describes the history of these migration patterns.

96. Szasz 1994, 172, 176.

97. "A Surging New Spirit.

98. González 1969, 169.

99. The most active Hispanic weaving researchers in 1995 included Teresa Archuleta Sagel, Juanita Jaramillo Lavadie, Helen R. Lucero, Irvin and Lisa Trujillo, and María Vergara Wilson.

100. Lucero 1986, 75.

101. Harold Gans, interview with S. Baizerman and Helen R. Lucero, 1/16/85.

102. David Ortega, interview with S. Baizerman, 6/20/85.

103. See Trujillo 1987 for a good description of Chimayó blanket design elements.

104. O'Leary 1994, 11. See also, Elliott 1986, 23–36, and Jenkinson 1981, 16–19.

105. Agueda Martínez, interviews with Helen R. Lucero, 5/12/83, 12/17/91, and 8/25/94. See also Lucero and Baizerman 1993, 22–25.

106. Dalio Gallegos, interview with S. Baizerman and Cordelia Coronado, 7/17/85.

107. Members of the Española Valdez family include Rudy, father; Ginnie, mother; and grown children, Rudy Lee, John, Joseph, Valerie, and Vicky. Another family of Valdez weavers, from Cañones, includes a husband and wife team, Felix Sr. and Grace; their two sons, Felix Jr. and Levi; and daughters, Andrea, Tara, Soledad, and Gracie. The two families are closely related; Rudy is Felix Sr.'s brother. Grace Valdez, personal communication with S. Baizerman and Cordelia Coronado, 6/4/85, and with Helen R. Lucero, 6/6/95.

108. Most of the elders who wove in Cundiyó were husband and wife teams. They included Esqui-pula (Pula) and Francisca (Franke) Vigil, Canuto and Agustina Vigil, Noberto and Elena Vigil, and Elizardo and Trinidad Vigil. Today's weavers include Adelina, Florida, George, Marie, Rebecca, Sabino, and Samuel Vigil. Sophie Vigil, personal communication with Helen R. Lucero, 12/27/95.

109. Uvaldo Velasquez, interview with S. Baizerman and Kate Peck Kent, 4/3/85.

110. Harry Córdova, interview with Helen R. Lucero, 9/2/83; Kristina Wilson, personal communication with S. Baizerman and Helen R. Lucero, 5/10/85.

111. María Vergara Wilson, interview with Helen R. Lucero, 5/11/83.

112. Uvaldo Velasquez interview with S. Baizer-

man and Kate Peck Kent, 4/3/85.

113. Jackson 1991, 40; Cindy Friday, personal communication with Helen R. Lucero, 12/5/95.

114. Deborah Hunter, personal communication with Helen R. Lucero, 12/5/95.

115. Zoretich 1995, D-2.

116. Barbara Berger, personal communication with Helen R. Lucero, 6/6/95.

117. Zoretich 1995, D-1.

118. Lucero attended Spanish Market sporadically between 1960 and 1984. She has attended the summer market every year since, as well as three winter markets. During her nine-year tenure (1984–93) with the Museum of International Folk Art, Lucero was required to attend the market to purchase Hispanic traditional folk art. Lucero also served as a Screening Committee member for three years, and both Lucero and Baizerman have served as judges for the market. SCAS and the 1950s revival owe a great debt to the late E. Boyd. She was a self-educated expert on Spanish Colonial arts and crafts and became curator in this field when an important donor made her hiring a condition of his bequest. Her prolific publishing on Spanish Colonial arts, and the enormous respect with which she is regarded, attest to her scholarly and curatorial abilities. Her protégés and friends continue to be some of the most ardent supporters of Spanish arts in New Mexico.

119. *Spanish Market: The Magazine of the Spanish Colonial Arts Society, Inc.,* July 1990, vol. 3, 10–11; Bud Redding, personal communication with Helen R. Lucero, 9/21/95. Children's booths were added to Spanish Market in 1986.

120. *Spanish Market: The Magazine of the Spanish Colonial Arts Society, Inc.,* July 1995, 30–33.

121. These weavers included Irene López; Dorothy, Eppie, Karen, and Yvonne Martínez; Norma and Delores Medina; Gloria Montoya; Lillian Ortega; Cleo and Santana Salazar; Don Leon Sandoval; Irvin and Lisa Trujillo; Grace Valdez; Jeanette, Rose, and Eugene Vigil; and several weavers from Tierra Wools. Additionally, Carla Gómez, who specializes in replicating Río Grande blankets, had a booth for the Tejidos y Lana weavers from Las Vegas, New Mexico.

122. *Spanish Market: The Magazine of the Spanish Colonial Arts Society, Inc.,* July 1995, 30–33.

123. Ibid., 35; Bud Redding, personal communication with Helen R. Lucero, 9/21/95. In the early 1980s the cash value of the prizes awarded at Spanish Market was quite low. However, it has grown steadily each year as different benefactors have funded prizes named after themselves or in honor of a deceased relative or friend. In 1995 the Grand Prize was $500. There were eleven first prizes in different categories at $250 each and fourteen other awards of $100 to $200. The twenty awards for children, in three age categories, ranged from $15 to $200.

124. For example, the International Folk Art Foundation, a governing board of the Museum of International Folk Art, uses the Spanish Market as the preferred venue to select additions to the museum's contemporary Hispanic collection.

125. Screening is held once a year about five months in advance of Spanish Market. The Screening Committee consists of six to eight members, including Anglos and Hispanos. During the 1995 Winter Market, participating artists were rescreened for the first time in an effort to maintain top-quality work. In 1984 the SCAS board discovered there were participants in Spanish Market who were non-Hispanic but who currently were, or had been, married to Hispanics. The Hispanic father-in-law of one non-Hispanic weaver defended her right to be included on the basis of her acceptance into his family and on the grounds that she should not be deprived of a portion of her livelihood.

126. Spanish Colonial Arts Society 1995, 1, 2, 4. Some SCAS members expressed concern about determining what is traditional in a culture other than their own. For example, one board member indicated that weavers were just encouraged to look at older Hispanic blankets. They claimed that Arts Society members' personal aesthetics were not the measure, but rather the aesthetic contained in the older pieces. These older pieces were collected and saved by society members in personal and museum collections. The vast SCAS collection, housed at the Museum of International Folk Art, continues to be utilized by market artisans as prototypes, which they strive to replicate, emulate, or use for inspiration for their own work. SCAS's well-illustrated publications serve a similar function.

127. "Contemporary Hispanic Market" 1995, 40. The close proximity of the two markets is mutually beneficial and adds to the festive atmosphere. Tourists and collectors generally visit both markets. Armando Ortega exhibited his nontraditional weavings in the Contemporary Market in 1994 and 1995.

128. Bud Redding, personal communication with Helen R. Lucero, 9/21/95. Since 1994, all Spanish Market artists have automatically become members of SCAS when they pay their booth fee to participate in the market.

129. Data for markets, fairs, museums, galleries, and artists were compiled over the course of several years. Lucero has regularly attended many of the events listed in this section. Additionally, she has led or participated in many of the lectures, demonstrations, and workshops associated with the events and has contributed to exhibition catalogs, newsletters, and promotional material. After more than fifteen years, many of the weavers have become Lucero's friends. The December 1995 note citations are included to indicate verification by weavers or representatives of the institutions listed, not to indicate first-time contact.

130. Reyes Newsom Jaramillo, personal communication with Helen R. Lucero, 4/26/85; Francis Rivera, personal communication with Helen R. Lucero, 12/8/95; and Linda Ulibarrí, personal communication with Helen R. Lucero, 12/21/95. Lucero was a weaving exhibitor at the 1982 Feria Artesana and has attended the event almost every year since.

131. This catalog has become the most extensively used resource for Hispanic weavers because of its many color illustrations and descriptive material. It is even referred to by some weavers as "the Bible" of Hispanic weaving.

132. See Archuleta Sagel 1994.

133. As curator of New Mexican Hispanic Crafts and Textiles at the Museum of Folk Art (1984–93), Lucero was in charge of approximately five hundred eighteenth- to twentieth-century Hispanic textiles. This is undoubtedly the single largest collection of New Mexican Hispanic textiles in one museum. Together with William Wroth, Lucero also codirected the *Familia ye Fe* exhibition and was the primary curator responsible for the weaving section of the permanent exhibit.

134. See Jenkins 1984; George Paloheimo, personal communication with Helen R. Lucero, 10/2/95; Carla Goméz-Victor, personal communication with Helen R. Lucero, 10/2/95.

135. Guadalupe Tafoya, personal communication with Helen R. Lucero, 12/18/95.

136. Marilee Schmit Nason, personal communication with Helen R. Lucero, 12/6/95.

137. See Wroth 1977; Kathy Wright, personal communication with Helen R. Lucero, 12/28/95.

138. Andrew Nagen, personal communication with Helen R. Lucero, 5/15/93 and 12/19/95.

139. Several out-of-state museums have notable collections of Hispanic textiles, including the Colorado History Museum, Denver; the Heard Mu-

seum, Phoenix; the Southwest Museum and the Los Angeles County Museum of Natural History, Los Angeles; the San Diego Museum of Man; the Art Institute of Chicago; the Museum of the American Indian and the American Museum of Natural History, New York; and the Smithsonian Institution, Washington, D.C.

140. There are also weavers' guilds in southern New Mexico with fewer Hispanic members. They include *Las Arañas* in Albuquerque, Río Abajo Wool Gatherers in Socorro, Mesilla Valley Weavers, Hobbs Fibercrafts Guild, Carlsbad Spinners and Weavers Guild, Southwestern New Mexico Handweavers in Silver City, and the Roswell Fibercrafts Guild.

141. Mary Rawcliffe Colton, personal communication with Helen R. Lucero, 12/20/95.

142. This list is not meant to be comprehensive. It does not include some excellent weavers mentioned in chapter 5. Additionally, the list continues to grow yearly as weavers reach creative and technical maturity.

143. Teresa Archuleta Sagel, "Biography/Résumé" 1989, p. 1.

Chapter 5

1. David Ortega, personal communication with Helen R. Lucero, 3/13/92. Ortega says this was a Nash touring car, which his father paid for with gold coins.

2. David Ortega, personal communication with Helen R. Lucero, 7/5/83.

3. See Clark 1953.

4. Ortega's Weaving Shop promotional flyer, 1992.

5. David Ortega, personal communication with S. Baizerman, 6/20/85, and Helen R. Lucero, 3/13/92.

6. David Ortega, personal communication with Helen R. Lucero, 7/5/83.

7. Ibid., 3/13/92. (Letter from Roosevelt in personal files of David Ortega.)

8. Jacobo Trujillo, personal communication with Helen R. Lucero, 7/5/83.

9. Ibid.

10. Jacobo Trujillo, personal communication with S. Baizerman, 3/31/85.

11. Ibid.

12. Jacobo Trujillo, personal communication with Helen R. Lucero, 7/5/83.

13. Irvin Trujillo, personal communication with Helen R. Lucero, 12/18/91. All interviews conducted in December 1991 were done by Lucero for the Smithsonian Institution's Office of Folklife Programs' Quincentennial Project.

14. Ibid.

15. Ibid.

16. Ibid., 9/20/83.

17. See Morrison 1992 and Padilla 1992b.

18. See Olson 1990.

19. Irvin Trujillo, personal communication with Helen R. Lucero, 12/18/91.

20. Ibid. and 11/28/95. Some of these exhibitions include Millicent Rogers Museum (May–June 1985), San Angelo Museum (December 1988), Roswell Museum and Art Center (March–July 1990), Bukhara, Uzbekistan, in the Soviet Union (June–September 1991), the Heard Museum, Phoenix (February 1991–January 1992), the Albuquerque Museum (February–March 1993), the Governor's Gallery, Santa Fe (July 1993) and Los Colores Museum, Corrales (October 1993).

21. Agueda Martínez, personal communication with Helen R. Lucero, 12/17/91.

22. Clark 1994, 34.

23. Documentary film entitled *Agueda Martínez: Our People, Our Country,* produced by Moctezuma Esparza Productions, 1977.

24. Agueda Martínez, personal communication with Helen R. Lucero, 12/17/91.

25. Sagel 1981, E-6.

26. See Baizerman 1991.

27. Eppie Archuleta, personal communication with Helen R. Lucero, 2/2/93.

28. Sagel 1987, 8.
29. Cordelia Coronado, personal communication with Helen R. Lucero, 12/17/91.
30. See Elliott 1986 and Jenkinson 1981.
31. Georgia Serrano, personal communication with Helen R. Lucero, 5/13/83.
32. Norma Medina, personal communication with Helen R. Lucero, 12/4/91.
33. Agueda Martínez, personal communication with Helen R. Lucero, 5/12/83.
34. Ibid.

Chapter 6

1. Horizontal treadle looms used by Hispanic weavers were introduced into the New World by Spanish colonists. While the history of the horizontal loom in Europe is not totally understood, it appears to have originated in the eleventh century. The horizontal loom reflects roots in the Near East. During the Middle Ages further influences from the Far East are evident. See Hoffmann 1964, 334–36, and Hoffmann 1977, 19.
2. There are other types of looms, such as jack-type, countermarch, and Jacquard. These looms are designed to permit greater variety in loom-controlled patterning. The basic weave structures used by Hispanic weavers—plain weave and twill—make the counterbalanced loom, used in New Mexico from early colonial days, well suited to their needs.
3. According to Hall 1976 the temple has seldom been used in Mexico (45). Its use in New Mexico may be a remnant of the work some Hispanic weavers did in the necktie industry in Santa Fe in the 1930s and later. Temples are commonplace in the production of yardage on handlooms. Such yardage was used in the production of neckties during the 1930s.
4. The New Mexico State Department of Trades and Industries published and disseminated printed instructions for loom construction.

These instructions have been reprinted in Wroth 1985, 80–87.
5. Agueda Martínez, personal communication with S. Baizerman, 5/16/85.
6. Illustrations of worsted spinning appear in Fannin 1970.
7. This type of yarn structure is found consistently in museum collections and is also reported in Kent 1983, 150, and Fisher, ed., 1979, 196.
8. Cochineal is derived from an insect, *Dactylopius coccus,* a parasite whose host is the nopal or prickly pear cactus, *Opuntia coccinellifera.* See Fisher, ed., 1979, 214. To prepare the dyestuff, the insects are dried, then ground into a fine powder. See Bowen and Spillman 1979, 207.
9. Sedillo-Brewster 1935.
10. Kent 1983a, 152–53.
11. James [1914] 1974, 172.
12. Archuleta-Sagel 1994, ix.
13. The one exception to this rule may be found in some museum and private collections: Río Grande blankets that were modified in the 1930s by Anglo blanket dealers who paid craftsmen to weave warp ends back into the fabric of old blankets to give them a four-selvage, Navajo-like appearance.
14. The typology adopted for fabric classification is that developed by Irene Emery and recorded in her book *The Primary Structures of Fabrics.* Within Emery's terminology the structure of both Río Grande and Chimayó blankets is a simple weave known as plain weave, a type of interlacement of warp and weft. As Emery states: "The principle of interlacing is unvarying alternation. Each weft passes alternately over and under successive warp units, and each reverses the procedure of the one before it. The warps are separated into only two groups. All warps that lie above one passage of weft lie below it the next, above the third, and so on" (196 6, 76).

15. Ibid. 78.

16. Ibid., 80. There are tapestry traditions the world over that make use of this and other dovetail methods. Interlocking tapestry weaves are also used by tapestry weavers in other cultures. Still other cultures use sewn vertical slits, closed after weaving, or leave slits unsewn for decorative effect. Navajo weavers may create diagonal lines in solid color areas that are particularly wide, creating a subtle diagonal line across the cloth known as a "lazy line."

17. Ibid., 79.

18. Kent 1983a, 151.

19. Wheat 1979b and Jenkins 1951 have described the Saltillo design system.

20. Campa 1979, 253.

21. Irvin Trujillo, personal communication with S. Baizerman, 5/9/85. See also Trujillo 1987.

22. Mera 1951, 37.

23. Frank Mier, personal communication with S. Baizerman and Helen R. Lucero, 8/26/85.

Chapter 7

1. Wade 1981, 1.

2. The view of ethnic boundaries represented here is based on Lynn Stephen's (1991) definition of ethnicity: "a concept used by a group of people in particular situations where they are trying to assert their status vis-à-vis another group of people, often for political, economic, or social reasons." Ethnicity may be "defined and redefined within specific historic contexts" (11).

3. Parezo 1990, 573.

4. Jules-Rosette 1984, 229.

5. Weaving becomes a metonym for northern New Mexican culture, a relationship based on a part representing the whole.

6. Here, these assorted objects become metaphors for the Southwest. During the past decade, the popularity of Southwest design motifs has become apparent in the proliferation of their use on all manner of household goods (towels, upholstery, pot holders) and clothing, which appear in abundance all across the United States and abroad in advertisements and mail order catalogs.

7. Cerny and Mather 1979, 170.

8. Shils 1981, 195.

9. Hobsbawm and Ranger 1983, 4–5.

10. Handler and Linnekin 1984, 276.

11. Horner 1990, 28, 306.

12. Ibid., 308, 304.

13. Bustamante 1982, in his exploration of ethnic self-referents in northern New Mexico, found that the older generation of Hispanos preferred the term "Mexicano."

14. Rodríguez 1989 discusses the definition and refinement of ethnic distinctions after the arrival of Americans in 1821 (80). See also Stephen's definition of ethnicity, n. 2, this chapter, above.

15. Cohodas 1995 refers to the creation of "objects made in the context of one society for consumption and display in the context of another society" as "intersocietal display objects" (3).

16. The term "trade lore" was used by Spooner 1986 in his discussion of the Oriental rug trade (197).

17. "Gold's Free Museum" refers to the "dominant Spanish civilization of the Territory."

18. Gans 1974, x, 75, 76. See n. 1, chap. 4, above.

19. Cohodas 1994 discusses at length the issue of authenticity. He cites examples of items made for the curio market (i.e., for home display) that were later deaestheticized and recontextualized as ethnographic artifacts in museum collections.

20. Wroth 1994, 86.

21. Chávez 1984 has ascribed the inception of the myth of pure Spanish blood to California Anglo writers of the 1880s; it later spread to New Mexico through the writings of Charles F. Lummis (90). In speaking of the established Hispanic population in the Southwest, Chávez notes that "the older residents were to an ex-

tent cut off from the vibrant, incoming currents that could rejuvenate their culture. Consequently, the earlier settlers became a curious anachronism studied by Anglo anthropologists, especially in New Mexico, while the recent arrivals were treated like aliens in California and Texas" (84).

22. Valene Smith's edited volume (1977) on the anthropology of tourism was an important addition to the literature as well.

23. Jules-Rosette 1984, 229. Complementing Clifford's work is a 1988 novel by Susan Lowell entitled *Ganado Red*. It is a fictionalized account of the travel of a Navajo weaving on the type of journey described by Clifford.

24. See, for example, Nash 1993 and Kleymeyer 1994.

25. Berlo 1991, 453.

26. Cohodas 1994, 31.

Glossary
New Mexican Spanish Weaving-related Terms

Abrir la lana—To separate the heavy dirt from the clip of fleece in preparation for carding the wool.

Acequia—Irrigation ditch. *Acequias* have played a key role in northern New Mexican agriculture and in the social organization of village life.

Algodón—Cotton. The seed hair of fibrous substance that surrounds the seeds of the plants of the genus *Gossypium*. The threads spun from these fibers. A textile woven of cotton thread.

Amole—Root of *Yucca glauca* used by Spanish settlers and Native Americans of the Southwest for cleansing wool yarn after spinning.

Añil—Indigo of the genus *Indigofera;* dye from a plant whose stems and leaves produce various shades of blue after processing. Historically, commercially prepared lumps of dark blue indigo were imported into New Mexico from Mexico and Central America.

Aspa—Reel. A device on which thread may be wound to make a skein of yarn of a predetermined length; a device similar to a niddy-noddy.

Bayeta—A term used to refer to a wide variety of commercially manufactured wool flannel cloth. In the nineteenth century, the Navajo (and to a limited extent Hispanos) used unraveled fine strands of this cloth in their weaving. The strands were grouped together and used as a single weft. Red bayeta, sometimes referred to as baize, was a popular trade item at a time when red dyestuff was not readily available.

Bloques or *Cuadritos*—Vertical dovetail tapestry design technique where the wefts of two different colors turn around a common warp. Generally used to create blocks or squares with ninety-degree angles.

Brasil—Brazilwood, *Caesalpinia brasiliensis*—a soluble red wood used to produce various shades of red-brown to tan colors. Its use as a dye in Spanish colonial New Mexico has not been proven, but it is used today by contemporary weavers.

Cadejo—A small skein or hank of yarn, including "butterflies," used to weave small areas in tapestry technique. In New Mexico, the terms *cadeja* and *cuenca* are also used.

Cambalache—Barter; also contractual work engaged in by weavers with dealers.

Cañaigre—Native New Mexican dock plant, *Rumex hymenosepalus*. The roots of the plant were used as a dye to obtain various shades ranging from yellow to tan.

Canilla—Bobbin or spool for a shuttle; the spool

is made of wood, paper, cardboard, or other material on which the weft is wound for insertion into the shuttle. A dried corncob was sometimes used for this purpose.

Capulín—Chokecherry or wild cherry, *Prunus melanocarpa,* whose bark and roots were used to produce dyes in colors ranging from brown to purple; the leaves produced various shades of green.

Cárculas—Foot pedals of a treadle loom. Treadles are operated by a weaver to raise or lower one or more of the harnesses. The European horizontal loom used by Hispanics requires that the weaver "walk" on the treadles in a standing position. In New Mexico, *cálculas* or *cárculas,* a corruption of the Spanish *cárcolas,* also are used.

Cardar—To card fibers into a loose but ordered roll or sliver in preparation for spinning; after carding, the roll of wool is referred to as a *colita de borrega* (sheep's tail), or by the Norwegian term *rolag.*

Cautivo—Captive; an Indian slave. Many *cautivos* played a vital role in the Hispanic weaving industry well into the nineteenth century; they prepared yarn and wove blankets on Spanish-style treadle looms. When adopted into a Spanish family they were referred to as *criados* (servants).

Chamisa—Rabbit brush; a plant dye of the species *Chrysothamnus nauseosus,* whose flowering tops produce various shades of yellow.

Churro—The generic term used to describe the hardy sheep introduced into the New World by Spanish colonists; they adapted well to the arid climate of the Southwest. The churro's fleece is long, straight, and lustrous, with low grease content.

Cochinilla—Cochineal. The *Hemipteran* insect of the genus *Dactylopius,* which lives on the prickly pear (nopal) cactus, genus *Opuntia.* Approximately seventy-thousand dried female insects are required to produce a pound of dye material. Before synthetic dyes were available, cochineal was imported into New Mexico from Mexico and Central America and was used extensively to obtain various shades of red.

Colcha—A type of New Mexican Hispanic embroidery that utilizes a kind of couching stitch called *colcha.* The term *colcha* also means a bed-covering *(sobrecama).*

Compadrazgo—Godparenthood. In addition to family ties, Hispanic communities are strengthened by the relationships between families formed by godparenthood.

Conga—A variety of small woven pieces used to drape over chair backs, on dresser tops, or as furniture scarves. These small items have been especially popular on the tourist art market. Smaller versions are known as *congitas.* According to Tushar (quoted in Wheat 1976, 50), during colonial times the *conga* referred to a short version of the poncho.

Contrapecho—Breast beam on a loom; stationary beam at the front of the loom over which the cloth passes before being wound onto the cloth beam. In Spain, it is more commonly referred to as an *antepecho* or *entrepecho.*

Corrida rápida—Fast-slanted diagonal dovetail tapestry technique where the turn wefts advance two warp ends at a time, creating a steeply sloped angle.

Corrida despacia—Slowly slanted diagonal tapestry technique where the turn wefts advance one warp end at a time, creating a mildly sloped angle.

Corrida de cuadro—Vertical dovetail tapestry technique where the turn wefts share the same warp end, creating a ninety-degree slightly raised vertical edge.

Corrida de uñitas—A diagonal dovetail tapestry technique where one color of weft advances two or more warp ends at a time, while the adjacent color of weft advances and then back steps, so that the wefts overlap. Produces a hatched edge called *uñitas* ("little fingernails").

Criado/a—A maid. During the nineteenth century, *criados* were often integrated into New Mexican Hispanic families by adoption or marriage.

Culebras—Literally, snakes. In this context, tapestry designs that meander diagonally one way and then the other creating a snakelike weaving design.

Doble-ancho—Double-weave technique employing a *doble tela* (double warp). One warp is superimposed on the other, and both warps are woven simultaneously, in such a way that one selvedge is woven closed. When completed, the blanket is opened to its full, double width. This technique permits the weaving of wider pieces on narrow looms. Most *doble-ancho* (*doble-ancha* in New Mexico) blankets are striped and can be recognized by the presence of doubled warp threads at the blanket's center.

Efectos del país—Local products of the country. The term distinguished between imported goods and native products for the purpose of exports during the Spanish colonial period. High tariffs were imposed by customs inspectors for imported goods. Annual trade shipments during the Spanish colonial period included many New Mexican textiles.

Ejidos—Common pasturelands of the Spanish land grants. The *ejidos* were particularly important as communal range land for large flocks of sheep. The U.S. government refused to recognize many of the *ejidos,* resulting in a decline in sheep raising.

Entrada Literally, entrance. In northern New Mexico, this term often refers to de Vargas's reentry into northern New Mexico in 1692-93; the Spanish colonists had been driven out of the area following the Pueblo revolt in 1680.

Feria—A fair or market where goods are sold.

Fleco—Fringe. Employed as ornamentation on the borders of some woven items and *colcha* embroideries, especially bedspreads.

Frazada A blanket generally used as a bedcover and woven of either wool or cotton. Also spelled *frezada* in New Mexico. The plain blankets were referred to as *frazadas del campo,* whereas the fancier blankets were called *frazadas atilmadas* or *frazadas labrado al gusto.*

Genízaros—Nomadic Indians who were taken captive by the Spaniards and later adopted into Hispanic communities. The term generally applied to those Indians who were baptized, given property, and became citizens of New Spain.

Gremios—Guilds. Based on European models, *gremios,* such as weavers' guilds, were set up in central New Spain. No such guilds were established in northern New Mexico.

Hacienda—A large farm or estate. Quite common in the Río Abajo but relatively rare in the Río Arriba of northern New Mexico.

Hilar—To spin; the process of twisting fibers together to form a continuous thread, by hand with a *malacate* (spindle) or with the aid of a *torno de hilar* (spinning wheel). In New Mexico, spinning usually was done with the hand spindle, rather than with a spinning wheel.

Ikat—From the Malaysian word *mengikat,* meaning to tie or bind. The term is used worldwide to describe the process by which a pattern is resist-dyed on a warp, weft, or both, before the weaving begins. The term also refers to the woven fabric deriving its patterned surface from the process. This nontapestry weaving technique continues to be an anomaly in Hispanic weaving.

Jerga—Usually a checkered, coarse-grade wool fabric. *Jerga* is woven on a four-harness loom in twill weave patterns such as *ojo de perdiz* (partridge eye) and herringbone. Jergas are used for floor coverings as rugs or carpets and for packing material or blanket batting. The term has also come to be used to refer to rag rugs and modern-day carpets.

Julio de hilo—Back roller or warp beam. A cylindri-

cal beam at the rear of the loom where the warp is stored and advanced as the weaving progresses. Called *enjulio* and *enrollador* in Spain and *árbol de urdimbre* in Central America.

Julio de tela—Front roller or cloth beam. A cylindrical beam at the front of the loom where the woven fabric is rolled and stored as the weaving progresses. Called *plegador de tela* in Spain and *árbol de tela* in Central America.

Labor—The process of weaving tapestry designs and the product that results from this weaving process. The weave is composed of weft-faced plain weave utilizing discontinuous wefts. Also called *tapiz*.

Lana—Wool. The covering or fleece of the domesticated sheep; also the fiber obtained from the coat of other animals in which the name of the specific animal is included, for example, llama wool. Sheep's wool is not indigenous to the American Southwest; it was introduced by the Spaniards in the sixteenth century.

Lanzadera—Shuttle. The tool used to pass the weft through the opening in the warp called the shed in the process of weaving. In New Mexico this tool is usually a handcrafted, carved boat shuttle made of local hardwood.

Lienzo—A coarse cotton cloth made of *hilo casero,* a coarse-spun cotton yarn. The term also described a length of cloth that covered the wooden *vigas* (beams) on ceilings.

Lizos—Harnesses, the rectangular frames on treadle looms that hold the heddles. Harnesses move the warp up and down in the process of weaving. Most looms have two or four harnesses. Wire or string heddles are arranged on the harnesses, and warp yarns are threaded through openings in the heddles. Weaving patterns are determined by the order in which the heddles are threaded and the order in which the harnesses are used in the process of weaving. Also spelled *lisos* in New Mexico.

Madejas—Skeins. Quantities of yarn that have been measured around a winding device. Skeins are usually prepared in advance of dyeing. Yarn is wound from skeins onto bobbins for weaving.

Malacate—Spindle. A tool for spinning yarn, consisting of a weighted stick or rod. As fibers are drawn from the mass of fibers, the spindle is rotated and a twist is transferred to the fibers, forming yarn. In New Mexico, the hand spindle was about eighteen inches long and had a whorl *(rotundo)* about three inches in diameter.

Mallas—Loom heddles made of string, wire, or metal suspended between harnesses, or *lizos*. The warp ends are threaded through the eyes of the heddles to establish a patterned-weave design. Also called *canales*.

Manedas—Loom brakes that control the warp tension. Brakes are crucial to the quality of the finished weaving. With firm and even tension, the surface of the cloth and its selvedges may be woven smoothly and evenly formed. Also called *breca* in New Mexico.

Manta—A shawl; a white cotton cloth; a form of tribute payment. Among the Pueblo Indians a *manta* is a type of dress. The term is also used in Spanish colonial documents to describe a fabric used as tribute (as in the *repartimiento* paid to Spaniards by the Indians in the colonial era). In addition, *manta* refers to treadle-loom-woven commercial cloth or unbleached sheeting. finally, the term *manta* was used during the Spanish colonial period to describe a *lienzo de algodón,* a length of cotton cloth measuring one *vara* (2.759 feet) in length.

Máquina—Literally, machine. In northern New Mexico, it often refers to a commercially manufactured loom without treadles, designed for production weaving. Weaving sheds are changed automatically by a mechanism attached to the beater.

Medias (a medias)—Literally, halves. This term refers to the division of labor and the sharing of the

results, whether it be agricultural crops or woven goods. In New Mexico an individual would provide rags to a weaver in return for half of the finished rag rugs *(pisos)*.

Mercedes—Land grants issued to colonists by the Spanish and Mexican governments. The loss of these land grants following the Treaty of Guadalupe Hidalgo in 1848 greatly affected sheep raising activity and weaving in New Mexico, since the terms of the treaty were not adhered to fully by the American government.

Mordiente—Mordant. The color obtained from natural and synthetic dyes is affected by the mordant used to fix colors. Some of the more common mordants include alum, tin, copper, iron, and chrome.

Nogal—Wild walnut tree, *Juglans major*. A dark brown color is obtained from walnut hulls, used extensively as a dye source in New Mexico.

Obraje—A workshop or factory-like workplace. *Obrajes* played an important role in the Mexican colonial weaving industry; debtors and prisoners were sent to work in obrajes. In Spanish colonial New Mexico during the eighteenth and nineteenth centuries, obrajes relied heavily on Indian labor.

Ojal—Eye. On a weaving loom, the loop or opening at the center of the heddle through which a warp end is passed.

Ojo de perdiz—Literally, partridge eye. A diamond pattern (sometimes also called goose eye) found in some New Mexico twill-woven *jergas*. This loom-controlled twill weave results in concentric lozenge patterns.

Partido—A system whereby an agreed-upon number of sheep were assigned by an owner to a herder, a *partidario,* who assumed full responsibility for the sheep. At the end of a specified period, the *ovejas* (sheep or lambs) were divided between owner and herder according to agreed upon terms.

Pavilo—Weft. The transverse threads of a textile that pass through the sheds or openings made in the warp. As wefts intersect warp threads, cloth is formed. Also call *pavilón* and *trama*.

Peine—Comb or loom reed. An instrument made of wood or metal through which the warp ends are passed to keep them evenly spaced and aligned during weaving. The *peine* is part of the beater and is used to pack weft into place. The term *temprel* is used in Spain.

Repartimiento—An assessment. During the Spanish colonial period, Pueblo Indians were required to pay such an assessment in labor or cloth.

Rondanillas—Pulley wheels. These are attached above the harnesses on a treadle loom and aid in raising and lowering warp ends. They are operated by the treadling action.

Sabanilla—Plain weave cloth of fine-to-medium weight handspun yarn, woven on a treadle loom and used for a variety of purposes including clothing and as the ground cloth for all-wool embroidery (*bordado tupido* or *colcha*).

Sabina—A juniper hardwood used in New Mexico for making boat shuttles and reeds.

Saltillo—A city in the state of Coahuila, Mexico, known for its magnificent *sarapes*. Saltillo sarapes were also produced in other parts of Mexico during the eighteenth and nineteenth centuries.

Sarape—A blanket-type garment, in the shape of a large rectangle, often with an opening in the center as in the modern-day poncho. Some versions are striped, others are decorated with elaborate tapestry patterning. Also spelled *serape*.

Sayal—Strong and coarse sackcloth fabric. Used for many purposes in Spanish colonial New Mexico, *sayal* was the fabric generally used to make the Franciscan friars' habits.

Tejer — To weave. The process of making a textile on a loom or other weaving device by interlacing warp and weft threads in a specified order.

Tejido — Woven cloth. A general term for fabric or textile.

Tela — Warp. The longitudinal threads of a textile that are arranged on a loom. Sheds, or openings, are formed in the warp into which the weft is inserted, forming woven fabric. In New Mexico, tela is also referred to as *pie, hebra,* and *estambre. Urdimbre* is the term most often used in Spain.

Telar — Loom. The Spaniards introduced the European horizontal floor loom that made the weaving of almost infinite lengths of fabric possible. This important tool usually has two to four harnesses.

Templar — A stretcher or temple. A narrow wooden or metal device used to hold the cloth on a loom at a constant width during weaving; helps to maintain even selvages.

Tilma — A blanket used as a cloak; a short version of the *sarape;* a short saddle blanket made by the Navajo or Pueblo Indians in New Mexico.

Torno — Bobbin winder; a device or mechanical implement used to wind weft onto bobbins that are to be placed in shuttles for weaving. The same device is sometimes used in New Mexico to spin rags in preparation for the weaving of rag rugs. This tool is often adapted from bicycle parts or simple hand grindstones.

Urdir — To warp; the process of preparing the warp for the loom by measuring threads to equal lengths and then arranging them in parallel fashion on the loom. A warping reel *(urdidor)* was sometimes used in New Mexico to measure the warp. The terms *torno* and *devanadera* are used in Spain for similar warp-winding devices.

Valleros — Hispanic blankets, the earliest dating from the nineteenth century, that incorporate tapestry designs with eight-pointed stars. Also referred to as Trampas Valleros after the names of the two villages where they are believed to have originated. Contemporary weavers from various areas currently weave Valleros.

Yerba — Plant; weed; herb. Used for dyeing fibers, *yerbas* were the major colorants in New Mexico.

Bibliography

Ahern, Julie. 1986. "Jacobo Trujillo and His Chimayó Weavings." Manuscript.

Ahlborn, Richard Eighme. 1975. "Comments on Textiles in Eighteenth-Century Spanish New Mexico." In *Imported and Domestic Textiles in Eighteenth-Century America,* ed. Patricia Fiske. Washington, D.C., The Textile Museum.

Alley, Carol, and Sue Farrington. 1978. "Hispanic Weaving: The Revival of an Ancient Art." *New Mexico Crafts Magazine* 1 (1): 16–17.

Amsden, Charles Avery. 1934. *Navajo Weaving: Its Technic and Its History.* Santa Ana, Calif.: Fine Arts Press.

Anawalt, Patricia Rieff. 1981. *Indian Clothing before Cortes.* Norman: University of Oklahoma Press.

"Anson W. Hard Collection of Saltillo and Chimayo Blankets." 1912. *American Museum of Natural History Journal* 22 (1): 32–34.

Archuleta-Sagel, Teresa. 1994. Introduction to *Río Grande Textiles.* Santa Fe: Museum of New Mexico Press.

Arellano, Anselmo, ed. 1978. *La Tierra Amarilla: The People of the Chama Valley.* Tierra Amarilla, N.Mex.: Chama Valley Public Schools.

Armella de Aspe, Virginia, and Teresa Castelló Yturbide. 1989. *Rebozos y Sarapes de Mexico.* México, D. F.: Grupo Gutsa.

Armistead, John. 1983. "Chimayó Family Weaves Culture with Tradition to Make Home Furnishings." *New Mexican* (May 4): A6–A7.

Armstrong, Ruth, and the staff of New Mexico Magazine. 1980. *Enchanted Trails.* Santa Fe: New Mexico Magazine.

Ashton, Patricia. 1982. "Spanish Market Outlet for Traditional Crafts." *Bienvenidos,* supplement to *New Mexican* (May 30): 116.

Atkins, Carolyn. 1978. *Los Tres Campos, The Three Fields: A History of Protestant Evangelists and Presbyterians in Chimayó, Córdova, and Truchas, New Mexico.* Albuquerque: Menaul Historical Library of the Southwest.

—— 1980. "Chimayó: 1900 and Beyond." *Río Grande History* 11: 12–15.

Atwood, Sam. 1985. "Threads of Life: Father and Son Weavers Share a Traditional Craft." *New Mexican* (June 16) D1–2.

Austin, Mary. 1928. "Indian Arts for Indians." *Survey Graphic* 60 (7): 381–88.

—— 1932. *Earth Horizon.* Boston: Houghton Mifflin.

—— 1933. "Spanish Colonial Furnishings in New Mexico." *Antiques* 23 (2): 46–49.

Baizerman, Suzanne. 1987. "Textiles, Traditions, and Tourist Art: Hispanic Weaving in Northern New Mexico." Ph.D. diss., University of Minnesota.

—— 1991. "The Role of Gender in the Social Con-

struction of Gender." Paper presented at the Forty-seventh International Congress of Americanists, New Orleans.

Bandelier, Adolph F. 1966. *The Southwestern Journals of Adolph F. Bandelier, 1880–1882,* eds. Charles H. Riley and Carroll L. Riley. (Vol. 1 of 4 vols.) Albuquerque, University of New Mexico Press; Santa Fe: School of American Research.

Bannon, John Francis. 1970. *The Spanish Borderlands Frontier, 1513–1821.* New York: Holt, Rinehart and Winston.

Barber, Ruth K., and Edith J. Agnew. 1981. *Sowers Went Forth: The Story of Presbyterian Missions in New Mexico and Southern Colorado.* Albuquerque: Menaul Historical Library of the Southwest.

Barela, Margaret. 1993. "High Ideals Motivate Galisteo's Grande Dame: Concha Ortiz y Pino de Kleven, a Woman Ahead of Her Time." *New Mexico Magazine* (January): 54–59.

Barker, Ruth Laughlin. 1930. "The Craft of Chimayo." *El Palacio* 28 (26): 161–73.

Batchen, L. S. 1942. "How Señora Petra Clothed Her Family." Typescript, Museum of New Mexico History Library, Santa Fe.

Baxter, John O. 1987. *Las Carneradas: Sheep Trade in New Mexico 1700–1860.* Albuquerque: University of New Mexico Press.

Beck, Warren A., and Ynes D. Haase. 1976. *Historical Atlas of New Mexico.* Norman: University of Oklahoma Press.

Becker, Howard. 1982. *Art Worlds.* Berkeley: University of California Press.

Berkenfield, Barbara. 1992. "Leonora Curtin Paloheimo: Reflections on Native Market." *Spanish Market: Magazine of the Spanish Colonial Arts Society* (July): 14–15.

Berlo, Janet Catherine. 1991. "Beyond *Bricolage:* Women and Aesthetic Strategies in Latin American Textiles." In *Textile Traditions of Mesoamerica and the Andes: An Anthology,* ed. Margot Blum Schevill, Janet Catherine Berlo, and Edward B. Dwyer, 437–79. New York: Garland.

Bloom, Lansing B. 1927. "Early Weaving in New Mexico." *New Mexico Historical Review* 2 (3): 228–38.

Boles, Joanna Ferguson. 1977. "The Development of the Navaho Rug, 1890–1920 as Influenced by Trader J. L. Hubbell." Ph.D. diss., Ohio State University.

Bolton, Herbert E. 1964. *Coronado on the Turquoise Trail: Knight of Pueblos and Plains.* Albuquerque: University of New Mexico Press.

Boris, Eileen. 1986. *Art and Labor: Ruskin, Morris, and the Craftsman Ideal in America.* Philadelphia: Temple University Press.

Bowen, Dorothy Boyd. 1979a. "Bands and Stripes with Saltillo Design Elements." In *Spanish Textile Tradition of New Mexico and Colorado,* ed. Nora Fisher, 83–99. Santa Fe: Museum of New Mexico Press.

—— 1979b. "Handspun Cotton Blankets." In *Spanish Textile Tradition of New Mexico and Colorado,* ed. Nora Fisher, 140–43. Santa Fe: Museum of New Mexico Press.

—— 1979c. "Saltillo Design Systems." In *Spanish Textile Tradition of New Mexico and Colorado,* ed. Nora Fisher, 100–123. Santa Fe: Museum of New Mexico Press.

Bowen, Dorothy Boyd and Trish Spillman. 1979. "Natural and Synthetic Dyes." In *Spanish Textile Tradition of New Mexico and Colorado,* ed. Nora Fisher, 207–11. Santa Fe: Museum of New Mexico Press.

Bowman, Jon. 1990. "Los Colores." *New Mexico Magazine* (April): 64–69.

Boyd, E. 1961. "Ikat Dyeing in Southwestern Textiles." *El Palacio* 68 (3): 185–89.

—— 1964. "Rio Grande Blankets Containing Hand Spun Cotton Yarns." *El Palacio* 71 (4): 22–28.

—— 1974. *Popular Arts of Spanish New Mexico.* Santa Fe: Museum of New Mexico Press.

Briggs, Charles L. 1980. *The Woodcarvers of Córdova, New Mexico.* Knoxville: University of Tennessee Press.

—— 1985. "The 'Revival' of Image-Carving in New

Mexico: Object Fetishism or Cultural Conservation?" In *1985 Festival of American Folk Life Program Book,* 57–61. Washington, D.C.: Smithsonian Institution National Park Service.

Briggs, Charles L., and John R. Van Ness, eds. 1987. *Land, Water, and Culture: New Perspectives on Hispanic Land Grants.* Albuquerque: University of New Mexico Press.

Brody, J. J. 1971. *Indian Painters and White Patrons.* Albuquerque: University of New Mexico Press.

——1976a. *Between Traditions: Navajo Weaving toward the End of the Nineteenth Century.* Iowa City: Stamats Publishing.

——1976b. "The Creative Consumer: Survival, Revival, and Invention in Southwest Indian Arts." In *Ethnic and Tourist Arts: Cultural Expressions from the Fourth World,* 70–84. Berkeley: University of California Press.

Brown, Lorin W., with Charles L. Briggs and Marta Weigle. 1978. *Hispano Folklife of New Mexico: The Lorin W. Brown Federal Writers' Manuscripts.* Albuquerque: University of New Mexico Press.

Bullock, Alice. 1973. *Mountain Villages.* Santa Fe: Sunstone Press.

Bureau of Business and Economic Research, University of New Mexico. *The Census in New Mexico: Population and Housing Characteristics for the State and Counties from the 1980 and 1990 Censuses. Albuquerque: January 1992.*

Burnham, Dorothy K. 1980. *Warp and Weft: A Textile Terminology.* Toronto: Royal Ontario Museum.

Burns, Barney. 1978–79. "Mayo Weaving—A Continuing Sonoran Art Form." *American Indian Art Magazine* 4 (2): 54–63.

Burroughs, Jean M. 1977. "From Coronado's Churros." *El Palacio* 83 (1): 9–13.

Bustamante, Adrian Herminio. 1982. "Los Hispanos: Ethnicity and Social Change." Ph.D. diss., University of New Mexico.

Campa, Arthur L. 1979. *Hispanic Culture in the Southwest.* Norman: University of Oklahoma Press.

Carlson, Ward. 1969. "New Mexico's Sheep Industry, 1850–1900: Its Role in the History of the Territory." *New Mexico Historical Review* 44, no. 1 (January): 25–49.

——1974. "El Rancho and Vadito: Spanish Settlements on Indian Land Grants." *El Palacio* 85 (1): 28–39.

Casey, Pearle R. 1936. "Chimayo, The Ageless Village." *Southwestern Lore* 1 (4): 12–13.

Cassidy, Ina Sizer. 1940. "Art and Artists of New Mexico: New Mexico–Crafts Center." *New Mexico Magazine* (September): 25, 44–45.

——1941. "Art and Artists of New Mexico: Handcrafts Center." *New Mexico Magazine* (May): 23, 35–37.

——1949. "Art and Artists of New Mexico: New Mexico Craftsmen." *New Mexico Magazine* (November): 26, 49.

——1952. "Art and Artists of New Mexico: Statewide Craft Exhibit." *New Mexico Magazine* (September): 35, 47.

——1955. "Art and Artists of New Mexico: New Mexico Wholesale Crafts." *New Mexico Magazine* (January): 22, 39.

"Catalog and Price Lists, Navajo Blankets and Indian Curios, J. L. Hubbell Indian Trader," 195 (reprint) 4.

Census in New Mexico. 1995. Vol 4, *Social and Economic Characteristics for the State and Counties.* Albuquerque: Bureau of Business and Economic Research, University of New Mexico.

Chávez, John R. 1984. *The Lost Land: The Chicano Image of the Southwest.* Albuquerque: University of New Mexico Press.

Chávez, Thomas E. 1989. "Traditional Roots in Common Ground." *Spanish Market: The Magazine of the Spanish Colonial Arts Society* (summer): 9.

Clark, Anna Nolan. 1938. "Art of the Loom." *New Mexico Magazine* (November): 9–11, 35–36.

Clark, Neil M. 1953. *The Weavers of Chimayo.* Santa Fe: Vergara Printing.

Clark, William. 1994. "Dancing on the Loom." *El Palacio* 99 (1–2): 32–37.

——1995. "Musing on Medanales." *Spanish Market: The Magazine of the Spanish Colonial Arts Society* (July): 42–43.

Clifford, James. 1988. *The Predicament of Culture: Twentieth-Century Ethnography, Literature, and Art.* Cambridge: Harvard University Press.

Cerny, Charlene, and Christine Mather. 1979. "Textile Production in Twentieth-Century New Mexico." In *Spanish Textile Tradition of New Mexico and Colorado,* ed. Nora Fisher, 168–90. Santa Fe: Museum of New Mexico Press.

Coan, Mary W. 1935. "Handicraft Arts Revived." *New Mexico Magazine* (February): 14–15, 52.

Cobos, Rubén. 1983. *A Dictionary of New Mexico and Southern Colorado Spanish.* Santa Fe: Museum of New Mexico Press.

Cohen, Erik. 1984. "The Sociology of Tourism: Approaches, Issues, and Findings." *Annual Review of Sociology* 10:373–92.

Cohen, Ronald. 1978. "Ethnicity: Problem and Focus in Anthropology." *American Review of Anthropology* 7:379–403.

Cohodas, Marvin. 1995. "The Authenticity Paradigm, As Evidenced in Marketing and Recontextualizing of the Kickox Baskets." Manuscript.

Collingwood, Peter. 1969. *The Techniques of Rug Weaving.* New York: Watson-Guptill.

Conner, Veda Neville. 1951. "The Weavers of Chimayo." *New Mexico Magazine* (August): 19, 41, 43.

"Contemporary Hispanic Market." 1995. *Spanish Market: The Magazine of the Spanish Colonial Arts Society, Inc.* (July): 40.

Conwell, Douglas. 1984. "Ortega's of Chimayo." *Southwest Profile* (February): 8–10.

Craver, Rebecca McDowell. 1982. *The Impact of Intimacy: Mexican-Anglo Intermarriage in New Mexico, 1821–1846.* Southwestern Studies, no. 66. El Paso: Texas Western Press.

Dauber, Kenneth. 1990. "Pueblo Pottery and the Politics of Regional Identity." *Journal of the Southwest* 32 (4): 576–96.

Davis, Kathryn. 1988a. "Woven Across Time: The Rich Legacy of Colorado's Hispanic Textile Tradition." *Colorado Heritage* no. 3:16–36.

——1988b "A Weaving Revival in Southern Colorado." *Colorado Heritage* no. 3:37–41.

Davis, William Watts Hart. [1856] 1938. *El Gringo or New Mexico and Her People.* Reprint, Santa Fe: Rydal Press.

Deitch, Lewis I. 1977. "The Impact of Tourism upon the Arts and Crafts of the Indians of the Southwest." In *Hosts and Guests: The Anthropology of Tourism,* ed. Valene Smith, 173–84. Philadelphia: University of Pennsylvania Press.

de Borhegyi, Stephen F., and E. Boyd. [1956] 1987. *El Santuario de Chimayo.* Reprint, Santa Fe: Ancient City Press.

deBuys, William. 1985. *Enchantment and Exploitation: The Life and Hard Times of a New Mexico Mountain Range.* Albuquerque: University of New Mexico Press.

de Lallier, Alexandra. 1985. "The Rediscovered Folk Tradition of Rio Grande Textiles." *Clarion* (winter): 38–47.

Dentzel, Carl S. 1978. "Salute the Saltillo Sarape." In *The Saltillo Sarape,* James Jeter and Paula Marie Juelke, 7–9. Santa Barbara, Calif.: New World Arts.

Deutsch, Sarah. 1987. *No Separate Refuge: Culture, Class, and Gender on an Anglo-Hispanic Frontier in the American Southwest, 1880–1940.* New York: Oxford University Press.

Dickey, Roland F. [1949] 1970. *New Mexico Village Arts.* Reprint, Albuquerque: University of New Mexico Press.

Dockstader, Frederick J. 1977. "The Marketing of Southwestern Indian Textiles." In *Irene Emery Roundtable on Museum Textiles, 1976 Proceedings,* ed. Irene Emery and Patricia Fiske, 420–40. Washington, D.C.: Textile Museum.

Domínguez, Virginia. 1986. "The Marketing of Heritage." *American Ethnologist* (August): 546–55.

Doyle, Gene. 1968. "Candelario's Fabulous Cu-

rios." *Denver Westerner's Monthly Roundup* 24 (9): 3–13.

Dunton, Nellie. 1935. *The Spanish Colonial Ornament and the Motifs Depicted in the Textiles of the Period of the American Southwest.* Philadelphia: H. C. Perleberg.

Durán, Tobías. 1984. *We Come as Friends: The Social and Historical Context of Nineteenth-Century New Mexico.* Albuquerque: Southwest Hispanic Research Institute, University of New Mexico.

Dussenberry, W. H. 1947. "Woolen Manufacture in Sixteenth-Century New Spain." *Américas* (April): 223–34.

Edwards, Jack. 1986. "Spanish Colonial Loom." *Weaver's Journal* 11, no. 1 (summer): 16–19.

Ehly, Jean. 1973. "Truchas Becomes a Weaving Center." *Handweaver and Craftsman* 24, no. 4 (July–August): 40.

Eichstaedt, Peter. 1978. "Rio Grande Spanish Weaving." *New Mexican Weekend* (October 13): 3–6.

Elliott, Malinda. 1986. "The Tapestries of Nancy and Janusz Kozikowski." *FIBERARTS* 13 (2): 23–26.

Ellis, William. 1982. "Goal at the End of the Trail: Santa Fe." *National Geographic* (March): 322–45.

"El Sarape de Chimayó es Igual al de Saltillo." 1941. *El Nuevo Mexicano* (August 21): 9, 11.

Emery, Irene. 1966. *The Primary Structures of Fabrics: An Illustrated Classification.* Washington, D.C.: Textile Museum.

Etulain, Richard W., ed. 1994. *Contemporary New Mexico, 1940–1990.* Albuquerque: University of New Mexico Press.

Fabish, J. H. 1986. "Quechuan Rugs of Peru from the Fabish Collection." Manuscript.

Fannin, Allen. 1970. *Handspinning: Art and Technique.* New York: VanNostrand Reinhold.

Fergusson, Erna. 1928. "New Mexico's Mexicans: The Picturesque Process of Americanization." *Century Monthly Magazine* 116 (4): 437–44.

"Feria Artesana." 1981. *New Mexico Magazine* (August): 38–39.

Fisher, Nora. 1979. "Vallero Blankets." In *Spanish Textile Tradition of New Mexico and Colorado,* ed. Nora Fisher, 124–32. Santa Fe: Museum of New Mexico Press.

——1985. "Costume Equals Festive Fiesta." In *¡Vivan Las Fiestas!* 30–37. Santa Fe, Museum of New Mexico Press.

——1994. *Rio Grande Textiles.* Santa Fe: Museum of New Mexico Press. (New edition of *Spanish Textile Tradition of New Mexico and Colorado.* Santa Fe: Museum of New Mexico Press, 1979).

——ed. 1979. *Spanish Textile Tradition of New Mexico and Colorado.* Santa Fe: Museum of New Mexico Press.

Fisher, Nora and Joe Ben Wheat. 1979. "The Materials of Southwestern Weaving." In *Spanish Textile Tradition of New Mexico and Colorado,* ed. Nora Fisher, 196–200. Santa Fe: Museum of New Mexico Press.

Fleming, Jeanie Puleston. 1985. "Ganados del Valle: A Venture in Self-Sufficiency." *New Mexico Magazine* (September): 38–42.

——1989. "Cross Cultural Borrowings." *Winter Indian and Spanish Market: Official Program and Schedule of Events.* 10–11, 17.

Flores, Camille. 1991. "Tierra Amarilla." *New Mexico Magazine* (February): 26–33.

Fontana, Bernard L., Edmond J. B. Faubert, and Barney T. Burns. 1977. *The Other Southwest: Indian Arts and Crafts of Northwestern Mexico.* Phoenix: Heard Museum.

Forrest, Suzanne. 1989. *The Preservation of the Village: New Mexico's Hispanics and the New Deal.* Albuquerque: University of New Mexico Press.

Frankel, Dextra. 1979. *One Space, Three Visions.* Albuquerque: Albuquerque Museum.

Frazer, Robert W., ed. 1981. *Over the Chihuahua and Santa Fe Trails, 1847–1848: George Rutledge Gibson's Journal.* Albuquerque: University of New Mexico Press.

Gans, Herbert. 1974. *Popular Culture and High Culture.* New York: Basic Books.

216 | Gavin, Robin Farwell. 1994. *Traditional Arts of Spanish New Mexico: The Hispanic Heritage Wing at the Museum of International Folk Art.* Santa Fe: Museum of New Mexico Press.

Gibson, Arrell Morgan. 1983. *The Santa Fe and Taos Colonies: Age of the Muses, 1900–1942.* Norman: University of Oklahoma Press.

Bibliography Gibson, Charles. 1966. *Spain in America.* New York: Harper and Row.

Gjevre, John A. 1969. *Chili Line: The Narrow Trail to Santa Fe.* Española: Rio Grande Sun Press.

"Gold's Free Museum: Old Curiosity Shop" Catalog. n.d. Special Collections, Zimmerman Library, University of New Mexico, Albuquerque.

González, Nancie L. 1969. *The Spanish Americans of New Mexico: A Heritage of Pride.* Albuquerque: University of New Mexico Press.

Graburn, Nelson H. H. 1969. "Art and the Acculturative Processes." *International Social Science Journal* 21:457–68.

—1983. "Anthropology of Tourism." *Annals of Tourism Research* 10 (1): 1–189.

—1984. "The Evolution of Tourist Arts." *Annals of Tourism Research* 11:393–419.

—ed., 1976. *Ethnic and Tourist Arts: Cultural Expressions from the Fourth World.* Berkeley: University of California Press.

Gregg, Josiah. [1954] 1974. *Commerce of the Prairies,* ed. Max L. Moorhead. Reprint, Norman: University of Oklahoma Press.

Griswold, Lester. [1942] 1969. *Handicraft: Simplified Procedures and Projects.* Reprint, Colorado Springs: Out West Printing and Stationery.

Gutiérrez, Ramón A. 1991. *When Jesus Came, the Corn Mothers Went Away: Marriage, Sexuality, and Power in New Mexico, 1500–1846.* Stanford, Calif.: Stanford University Press.

Haddon, E. P., and Mary Branham. 1960. "The Weavers of Chimayo." *New Mexico Magazine* (January): 10–15.

Hafen, Leroy, and Ann Hafen. 1954. *Old Spanish Trail: Santa Fe to Los Angeles.* Glendale: A. H. Clarke.

Hall, Joanne. 1976. *Mexican Tapestry Weaving.* Helena, Mont.: J. Arvidson.

Handler, Richard, and Jocelyn Linnekin. 1984. "Tradition, Genuine or Spurious." *Journal of American Folklore* 97 (385): 273–90.

Hebras de Visión/Threads of Vision. 1982. Taos: Millicent Rogers Museum.

"The High Road." 1978. *Gulf: The Orange Disc* (summer): 10–15.

Hobsbawm, Eric, and Terence Ranger. 1983. *The Invention of Tradition.* Cambridge: Cambridge University Press.

Hoffman, Marta. 1964. *The Warp-Weighted Loom.* Oslo: Norsk Folkemuseum, Universitetsforlaget (Studia Norvegica, no. 14).

—1979. "Old European Looms." In *Looms and Their Products,* eds. Irene Emery and Patricia Fiske, 19–24. Washington, D.C.: The Textile Museum.

Horner, Alice Euretta. 1990. "The Assumption of Tradition: Creating, Collecting, and Conserving Cultural Artifacts in the Cameroon Grasslands (West Africa)." Ph.D. diss., University of California, Berkeley.

Hubbell, Lorenzo. 1930. "Fifty Years an Indian Trader," as told to J. E. Hogg. *Touring Topics* 22 (12): 24–29, 51.

Hunner, Jon. 1992. "Shooting the Dragon: Coming of Age in Los Alamos." Master's thesis, University of New Mexico.

Hunt, Marjorie, and Boris Weintraub. 1991. "Masters of Traditional Arts." *National Geographic* (January): 74–101.

Hurt, Amy Passmore. 1934. "Chimayo: The Village Time Has Blest." *New Mexico Magazine* (November): 10–12, 43, 45.

Jackson, Donald Dale. 1991. "Around Los Ojos, Sheep and Land Are Fighting Words." *Smithsonian Magazine* (April): 36–49.

"Jacobo O. Trujillo." 1990. *Spanish Market: Magazine of the Spanish Colonial Arts Society* (July): 4–5.

James, George Wharton. [1914] 1974. *Indian Blan-*

kets and Their Makers. Reprint, Toronto: Dover Publications.

Janowski, Jack. 1980. "Two-day 'Feria': A Celebration of Hispanic Art and Culture." *Albuquerque Journal* (August 17): D–2.

Jaramillo, Cleofas M. 1955. *Romance of a Little Village Girl.* San Antonio: Naylor.

——[1941] 1972. *Shadows of the Past.* Reprint, Santa Fe: Ancient City Press.

Jaramillo, Juanita. 1977. "Rio Grande Weaving, a Continuing Tradition." In *Hispanic Crafts of the Southwest,* ed. William Wroth, 9–25. Colorado Springs: Taylor Museum of the Colorado Springs Fine Arts Center.

Jenkins, Katherine Drew. 1951. "An Analysis of the Saltillo Style in Mexican Serapes." Master's thesis, University of California.

Jenkins, Myra Ellen. 1984. Introduction to *Through the Seasons at El Rancho de Las Golondrinas,* ed. Louann Jordan, George Paloheimo Jr., and Rita Paloheimo. Santa Fe: Old Cienega Village Museum.

Jenkinson, Michael. 1981. "Tapestries of Janusz and Nancy Kozikowski." *New Mexico Craft* 3 (4): 16–19.

Jeter, James, and Paula Marie Juelke. 1978. *The Saltillo Sarape.* Santa Barbara, Calif.: New World Arts.

Johnson, Richard. 1985. "Chimayo: Land of Many Weavers." *Empire Magazine, Denver Post* (May 5): 12–14.

Jules-Rossette, Bennetta. 1984. *The Messages of Tourist Art.* New York: Plenum Press.

Kagan, Samuel. 1976. "Penal Servitude in New Spain: The Colonial Textile Industry." Ph.D. diss., City College of New York.

Kapoun, Robert W., with Charles J. Lohrmann. 1992. *The Language of the Robe: American Indian Trade Blankets.* Layton, Utah: Gibbs Smith.

Kardon, Janet, ed. 1994. *Revivals! Diverse Traditions, 1920–1945: The History of Twentieth-Century American Craft.* New York: Harry N. Abrams.

Kay, Elizabeth. 1987. *Chimayó Valley Traditions.* Santa Fe: Ancient City Press.

Kent, Kate Peck. 1976. "Pueblo and Navajo Weaving Traditions and the Western World." In *Ethnic and Tourist Arts: Cultural Expressions from the Fourth World,* ed. Nelson H. H. Graburn, 85–101. Berkeley: University of California Press.

——1983a. "Spanish, Navajo, or Pueblo? A Guide to the Identification of Nineteenth-Century Southwestern Textiles." In *Hispanic Arts and Ethnohistory,* ed. Marta Weigle, 135–67. Santa Fe: Ancient City Press.

——1983b. *Prehistoric Textiles of the Southwest.* Albuquerque: University of New Mexico Press; Santa Fe: School of American Research.

——1985. *Navajo Weaving: Three Centuries of Change.* Santa Fe: School of American Research.

King, Bruce. 1994. Preface to *Victory in World War II: The New Mexico Story,* ed. Gerald W. Thomas, Monroe L. Billington, and Roger D. Walker. Las Cruces: New Mexico State University.

Kleymeyer, Charles David, ed. 1994. *Cultural Expression and Grassroots Development: Cases from Latin America and the Caribbean.* Boulder, Colo.: Lynne Rienner.

Kluckhohn, Florence, and Fred L. Strodtbeck. 1961. *Variations in Value Orientations.* Evanston: Row Peterson.

Kozikowski, Janusz. 1979. "Agueda Martinez: Weaver of Many Seasons." *New Mexico Magazine* (August): 44–46.

Kutsche, Paul. 1968. "The Anglo Side of Acculturation in Spanish-Speaking People in the United States." Proceedings, Annual Meeting of the American Ethnological Society, 178–95. Seattle: University of Washington Press.

——1979. "The Survival of Spanish American Villages." *Colorado College Studies* no. 15 (spring).

Kutsche, Paul, and John R. Van Ness. 1981. *Cañones: Values, Crisis, and Survival in a Northern New Mexico Village.* Albuquerque: University of New Mexico Press.

Lamadrid, Enrique R. 1991. "Cultural Resistance in New Mexico: A New Appraisal of a Multi-Cultural Heritage." *Spanish Market: The Magazine of the Spanish Colonial Arts Society* (July): 24–25.

Lamadrid, Enrique R., with Jack Loeffler and Miguel Gandert. 1994. *Tesoros del Espíritu: A Portrait in Sound of Hispanic New Mexico.* Albuquerque: El Norte/Academia Publications.

Lamar, Howard Roberts. 1970. *The Far Southwest: 1846–1912.* New York: W. W. Norton.

Larcombe, Samuel. 1983. "Plaza del Cerro, Chimayó, New Mexico: An Old Place Not Quite on the Highway." In *Hispanic Arts and Ethnohistory in the Southwest,* ed. Marta Weigle, 171–80. Albuquerque: University of New Mexico Press.

Lawler, John E. 1930. "Spanish-American Normal School." *New Mexico Highway Journal* 8 (10): 26–28.

Logsdon, Paul. 1986. "Reviving a Breed of Sheep—and a Village." *Albuquerque Journal North* (February 19): 8–9, 12.

"Los Tejidos Norteños." 1976. *Interweave* 1, no. 4 (summer): 15.

Lucero, Helen R. 1986. "Hispanic Weaving of North Central New Mexico: Social/Historical and Educational Dimensions of a Continuing Artistic Tradition." Ph.D. diss., University of New Mexico.

Lucero, Helen, and Suzanne Baizerman. 1993. "Agueda Salazar Martínez." In *Women's Caucus for Art: Honor Awards for Outstanding Achievement in the Visual Arts,* eds. Susan Baxter and Carmen de Novais Guerrero, 22–25. Seattle: Women's Caucus for Art.

Lummis, Charles F. [1893] 1952. *The Land of Poco Tiempo.* Albuquerque: University of New Mexico Press.

Lusk, Jennie. 1979. "Weaver's Love of Simple Things Remains Untouched by Fame." *Albuquerque Journal* (August): D-2.

——1981. "Jacobo O. Trujillo—Weaver." *Feria Artesana Newsletter* (August): 13.

MacCannell, Dean. 1976. *The Tourist: A New Theory of the Leisure Class.* New York: Schocken Books.

Mallery, Garrick. 1886. "Picture Writing of the American Indians, Preliminary Report." *Bureau of American Ethnology,* Fourth Annual Report, 1882–83.

——1893. "Picture Writing of the American Indians." *Bureau of American Ethnology Annual Report,* no. 10, 1888–89.

Manchester, Albert. 1982. "Couriers, Dudes, and Touring Cars." *New Mexico Magazine* (June): 6, 39–41, 44, 46, 48–49.

Martinez, Reyes N. 1936. "The Weaver of Talpa." Manuscript, Museum of New Mexico History Library, Santa Fe.

Mather, Christine, ed. 1983. *Colonial Frontiers: Art and Life in Spanish New Mexico.* Santa Fe: Ancient City Press.

Mauzy, Wayne. 1936. "Santa Fe's Native Market." *El Palacio* 40 (13): 14, 15, 65–73.

McCrossen, George. n.d. "The Handweaving Phenomenon in the Southwest during the Two Decades between 1930–1950: Being the History of McCrossen Handwoven Textiles, Inc." Manuscript, Collection of the Library of the Museum of International Folk Art.

McCrossen, Helen Cramp. 1931. "Native Crafts in New Mexico." *School Arts Magazine* 30 (7): 456–58.

McHugh, John. 1971. "The High Road to Taos." *New Mexico Magazine* (September–October): 6–13.

McIntyre, Kellen Kee. 1992. *Rio Grande Blankets: Late Nineteenth-Century Textiles in Transition.* Albuquerque: Adobe Gallery.

McIntyre, Kellen Kee, and Eric Lane. 1992. "Río Grande Blankets." *New Mexico Magazine* (February): 50–57.

McLuhan, T. C. 1985. *Dream Tracks: The Railroad and the American Indian, 1890–1930.* New York: Abrams.

McNeal, Lyle G. 1984. "Navajo Sheep." *Encounters* (May–June): 28–31, 37, 41.

——1985. "Churro Sheep in the Navajo Tradition." *Weaver's Journal* 10, no. 2 (fall): 31–33, 72.

McNitt, Frank. 1962. *The Indian Traders.* Norman: University of Oklahoma Press.

Meléndez, A. Gabriel. 1993. "Española." *Reflexiones del Corazón.* Lithograph portfolio with María Baca and Miguel Gandert. Albuquerque: Tamarind Institute at the University of New Mexico.

Mena, Ramon. 1925. "El Zarape." *Anales del Museo Nacional de Arqueología* 5 (1): 373–400.

Mera, Harry Percival. 1949. *The Alfred I. Barton Collection of Southwestern Textiles.* Santa Fe: San Vicente Foundation.

——1987. *Spanish-American Blanketry, Its Relationship to Aboriginal Weaving in the Southwest.* Santa Fe: School of American Research (from a 1947 manuscript).

Miller, Darlis A. 1982. "Cross-Cultural Marriages in the Southwest: The New Mexico Experience, 1846–1900." *New Mexico Historical Review* 57, no. 4 (October): 335–60.

Miller, Michael. 1986. "Churches of the Earth: A Heritage of Faith." *El Palacio* 64 (2): 26–33.

Minge, Ward Alan. 1979. "*Efectos del País:* A History of Weaving along the Rio Grande." In *Spanish Textile Tradition of New Mexico and Colorado,* ed. Nora Fisher, 8–28. Santa Fe: Museum of New Mexico Press.

Morrison, Howard. 1992. *American Encounters: A Companion to the Exhibition at the National Museum of American History.* Washington, D.C.: Smithsonian Institution.

"Museum Events: Spanish Colonial Arts." 1927. *El Palacio* 23 (12): 337–38.

Nash, June, ed. 1993. *Crafts in the World Market: The Impact of Global Exchange on Middle American Artisans.* Albany: State University of New York Press.

Nash, Gerald D. 1994. "New Mexico Since 1940: An Overview." In *Contemporary New Mexico, 1940–1990,* ed. Richard W. Etulain, 1–24. Albuquerque: University of New Mexico Press.

Neary, John. 1976. "Las Golondrinas." *Americana* 4, no. 5 (November): 36–41.

Nelson, Kathryn J. 1980. "Oral History from Eppie Archuleta—Excerpts from *Los Testamentos:* Hispanic Women Folk Artists of the San Luis Valley, Colorado." *Frontiers* 5 (3): 34–43.

Nestor, Sarah. 1978. *The Native Market of the Spanish New Mexican Craftsmen: Santa Fe, 1933–40.* Santa Fe: Colonial New Mexico Historical Foundation.

——1979. "Rio Grande Textiles—A Living Tradition." *New Mexico Magazine* (August): 20–27.

New Mexico State University. 1993. *The New Mexico Folklife Festival.* Las Cruces, N.Mex.: New Mexico Heritage Center, New Mexico State University.

Niederman, Sharon. 1994. "Los Ojos: An Almost-Forgotten Village Remembers Its Past." *Spanish Market: The Magazine of the Spanish Colonial Arts Society, Inc.* (July): 15–16.

1990 Census of Population, Social, and Economic Characteristics, New Mexico. 1993. Washington, D.C.: Bureau of the Census.

Nostrand, Richard L. 1992. *The Hispano Homeland.* Norman: University of Oklahoma Press.

O'Leary, James. 1994. "Nancy Kozikowski." In *Nancy Kozikowski: Tapestries, Paintings, and Drawings,* 5–12. Albuquerque: DSG Press.

Olson, Audrey Janet. 1990. *Trujillo Weaving at Centinela Ranch: Old Traditions, New Explorations.* Roswell, N.Mex.: Roswell Museum and Art Center.

Otero, Nina. 1936. *Old Spain in Our Southwest.* New York: Harcourt, Brace.

Owings, Nathaniel Alexander. 1970. "Las Trampas: A Past Resurrected." *New Mexico Magazine* (July–August): 30–35.

Padilla, Carmella M. 1992a. "Smithsonian Show Draws Attention to State." *New Mexico Magazine* (June): 46–53.

——1992b. "Artists Struggle to Balance Old and New." *New Mexico Magazine* (June): 50–52.

——1993. "The Next Generation: Spanish Market Kids Embrace Art of Their Elders." *New Mexico Magazine* (July): 66–75.

Panich, Paula. 1990. "Spirits in the Material World: Contemporary New Mexican Weavers Draw Inspiration from Traditional Hispanic Designs." *Spirit: The Magazine of Southwest Airlines* (July): 38–43, 54–55.

Pardue, Diana. 1992. *¡Chispas! Cultural Warriors of New Mexico.* Phoenix: Heard Museum.

Parezo, Nancy J. 1983. *Navajo Sandpainting: From Religious Act to Commercial Art.* Tucson: University of Arizona Press.

—— 1990. "A Multitude of Markets." *Journal of the Southwest* 32(4): 563–75.

Parish, William J. 1960. "The German Jew and the Commercial Revolution in Territorial New Mexico, 1850–1900." *New Mexico Historical Review* 35 (2): 1–29.

Pillsbury, Dorothy L. 1953. "Weavers of Chimayo." *Desert Magazine* (August): 12–16.

Rebolledo, Tey Diana, ed., with Erlinda Gonzales-Berry and Millie Santillanes. 1992. *Nuestras Mujeres: Hispanas of New Mexico—Their Images and Their Lives, 1582–1992.* Albuquerque: El Norte Publications/Academia.

Representative New Mexicans. 1912. Denver: C. S. Peterson.

Robbins, Catherine C. 1982. "Weavers of the Rio Grande." *New York Times,* July 18, sect. 10, p. 12.

Robinson, Sherry. 1993. "Children of Los Alamos." *Quantum: A Journal of Research and Scholarship at the University of New Mexico* 9 (2): 12–14.

Rodee, Marian E. 1977. *Southwestern Weaving.* Albuquerque: University of New Mexico Press.

—— 1987. *Weaving of the Southwest from the Maxwell Museum of Anthropology, University of New Mexico.* West Chester, Pa.: Schiffer Publishing.

Rodríguez, Sylvia. 1989. "Art, Tourism, and Race Relations in Taos: Toward a Sociology of the Art Colony." *Journal of Anthropological Research* 45 (1): 77–99.

—— 1990. "Ethnic Reconstruction in Contemporary Taos." *Journal of the Southwest* 32 (4): 541–55.

Roybal, Kay. 1991-92. "Ortega's de Chimayo." In *Guest Life/New Mexico: Culture and Cuisine.* Santa Fe: Desert Publications, 32A, 33A.

Sagel, Jim . 1981. "Que Haceres—Weaver's Way of Life Makes Art of Work." *Albuquerque Journal North* (December 5): E-6.

—— 1984. *Los Cumpleaños de Doña Agueda.* Austin: Place of Herons Press.

—— 1985. "Weaving Is Hard Work, but Wondrous." *Albuquerque Journal North* (October 19): 6–7.

—— 1987. "Being a Woman Doesn't Keep Activist from Being Involved." *Albuquerque Journal North* (February 20): 8.

Saltzman, Max, and Nora Fisher. 1979. "The Dye Analysis." In *Spanish Textile Tradition of New Mexico and Colorado,* ed. Nora Fisher, 212–16. Santa Fe: Museum of New Mexico Press.

Salvucci, Richard J. 1985. "Textiles in Spanish America: An Overview." Manuscript, University of California, Berkeley.

Schevill, Margot Blum. 1994. "The Communicative Nature of Indigenous and Mestizo Dress in Mexico and Guatemala." In *Cloth and Curing: Continuity and Change in Oaxaca,* ed. Grace Johnson and Douglas Sharon, 41–60. San Diego Museum Papers No. 32. San Diego: San Diego Museum.

Scott, Winfield Townley. 1964. "The Still Young Sunlight: Chimayo, New Mexico." In *A Vanishing America,* ed. T. C. Wheeler, 122–35. New York: Holt, Rinehart and Winston.

Scurlock, Dan. 1982. "Pastores of the Valles Caldera." *El Palacio* 88 (1): 3–11.

Sedillo-Brewster, Mela. 1935. "New Mexican Weaving and the Practical Vegetable Dyes from Spanish Colonial Times." Master's thesis, University of New Mexico.

Sewell, Brice H. 1935. "A New Type of School." *New Mexico School Review* 15, no. 2 (October): 49–50.

—— 1937. *Weaving Bulletin.* Mimeograph, State Department of Trades and Industries, Santa Fe.

Sharpe, Tom. 1992. "Chimayo Trading Post Honored as Cultural Jewel." *Albuquerque Journal North* (July 7): 1, 4.

Shils, Edward. 1981. *Tradition.* Chicago: University of Chicago Press.

Simmons, Katina, and Carol Stout. 1976. "East Meets West." *New Mexico Magazine* (February): 16–19.

——Simmons, Marc. 1991. *Coronado's Land: Essays on Daily Life in Colonial New Mexico.* Albuquerque: University of New Mexico Press.

Simmons, Virginia McConnell. 1979. *The San Luis Valley: Land of the Six-Armed Cross.* Boulder, Colo.: Pruett Publishing.

Smith, Valene, ed. 1977. *Hosts and Guests: The Anthropology of Tourism.* Philadelphia: University of Pennsylvania Press.

Smithsonian Institution. 1992. *1992 Festival of American Folklife.* Washington, D.C.: Smithsonian Institution.

Spanish Colonial Arts Society. 1995. "Recommendations for Market Artists " (Letter to artists participating in Spanish market).

Spanish Market: The Magazine of the Spanish Colonial Arts Society (July 1988–July 1995). Santa Fe: Spanish Colonial Arts Society.

Sperling, David. 1984. "Teresa Archuleta Sagel: Weaving a Link with the Past." *New Mexico Magazine* (March): 9–15.

Spillman, Trish. 1977. "New Life for an Historic Craft: Rio Grande Weaving and Dyeing Workshop." *El Palacio* 83 (1): 14–24.

—— 1979. "Bands and Stripes." In *Spanish Textile Tradition of New Mexico and Colorado,* ed. Nora Fisher, 57–73. Santa Fe: Museum of New Mexico Press.

Spooner, Brian. 1986. "Weavers and Dealers: The Authenticity of an Oriental Carpet." In *The Social Life of Things,* ed. Arjun Appadurai, 195–235. Cambridge: Cambridge University Press.

Spurlock, William Henry, II. 1974. "Federal Support for the Visual Arts in the State of New Mexico, 1933–1943." Master's thesis, University of New Mexico.

Stephen, Lynn. 1991. *Zapotec Women.* Austin: University of Texas Press.

Stoller, Irene Philip. 1981. "Our Life Is Our Work." Ph.D. diss., University of Colorado, Boulder.

Stoller, Marianne. 1974. "Hispano Arts and Crafts and the San Luis Valley." In *Determining the Feasibility of Developing a Crafts Business Enterprise for Rural Low-Income U.S. Citizens Living in the San Luis Valley.* Denver: Virginia Neal Blue Resource Centers for Colorado Women.

—— 1979a. "A Study of Nineteenth-Century Hispanic Arts and Crafts in the American Southwest: Appearances and Processes." Ph.D. diss., University of Pennsylvania.

—— 1979b. "Spanish Americans, Their Servants and Sheep: A Culture History of Weaving in Southern Colorado." In *Spanish Textile Tradition of New Mexico and Colorado,* ed. Nora Fisher, 37–52. Santa Fe: Museum of New Mexico Press.

Stoller, Marianne, Dorothy Boyd Bowen, Paula Duggan, and Kathryn Nelson. 1982. *Las Artistas del Valle de San Luis.* Arvada, Colo.: Arvada Center for the Arts and Humanities.

Stoller, Marianne, with Suzanne M. P. Martin and Kathryn J. Nelson. 1980. "Hispanic Folk Artists: Their Works—Their Worlds." *People and Policy: A Journal of Humanistic Perspectives on Colorado Issues,* 2 (2): 21–31.

Sunseri, Alvin R. 1977. "Sheep Ricos, Sheep Fortunes in the Aftermath of the American Conquest, 1846–1861." *El Palacio* 83 (1): 3–8.

"A Surging New Spirit." 1985. *Time* (July 11): 47.

Sutherland, Mason. 1949. "Adobe New Mexico." *National Geographic* (December): 783–830.

Swadesh, Frances Leon. 1974. *Los Primeros Pobladores: Hispanic Americans of the Ute Frontier.* Notre Dame: University of Notre Dame Press.

Szasz, Ferenc M. 1994. "The Cultures of Modern New Mexico, 1940–1990." In *Contemporary New Mexico, 1940–1990,* ed. Richard W. Etulain, 159–200. Albuquerque: University of New Mexico Press.

Tate, Bill, and Lisa Law. 1987. "Flashing on the '60s." *New Mexico Magazine* (September): 49–55.

Tillett, Leslie. 1979. "The Natural Dye Myth." *Interweave* 4, no. 2 (spring): 55–56.

Thieme, Otto Charles, Ruth E. Franzen, and Sally G. Kabat. 1984. *Collecting Navajo Weaving.* St. Paul: Goldstein Gallery, University of Minnesota.

Thomas, Diane H. 1978. *The Southwestern Indian Detours: The Story of the Fred Harvey Railway Experiment in Detourism.* Phoenix: Hunter Publishing.

Thomas, Gerald W., Monroe L. Billington, and Roger D. Walker, eds. 1994. *Victory in World War II: The New Mexico Story.* Las Cruces: New Mexico State University.

Tilley, Martha. 1967. *Three Textile Traditions.* Colorado Springs, Colo.: Taylor Museum of the Colorado Springs Fine Arts Center.

Towne, Charles W., and Edward N. Wentworth. 1946. *Shepherds' Empire.* Norman: University of Oklahoma Press.

Trujillo, Lisa. 1987. "Chimayo Weaving: Industry and Design." Paper presented at the annual meeting of the American Folklore Society, Albuquerque, New Mexico.

Trumbo, Theron Marcos. 1947. "The Gifts of Chimayo." *New Mexico Magazine* (February): 19, 33, 35.

Tryk, Sheila. 1977. "Reflections of a Way of Life — Spanish Colonial Arts and Crafts." *New Mexico Magazine* (January): 14–17.

Twitchell, Ralph Emerson. 1925. *Old Santa Fe: The Story of New Mexico's Ancient Capital.* Santa Fe: Santa Fe New Mexico Publishing.

Usner, Don J. 1994. "From the Heart of Chimayó." *El Palacio* 100 (1): 40–47, 52–54.

—— 1995. *Sabino's Map: Life in Chimayó's Old Plaza.* Santa Fe: Museum of New Mexico Press.

Utley, Robert M. 1961. "The Reservation Trader in Navajo History." *El Palacio* 68 (1): 5–27.

Van Ness, John R. 1979. "Hispanos in Northern New Mexico: The Development of Corporate Community and Multicommunity." Ph.D. diss., University of Pennsylvania.

Van Ness, John R., and Christine M. Van Ness, eds. 1980. *Spanish and Mexican Land Grants in New Mexico and Colorado.* Manhattan, Kans.: Sunflower University Press.

Vedder, Ann. 1983. "History of the Spanish Colonial Arts Society, Inc., 1951–1981." In *Hispanic Arts and Ethnohistory in the Southwest: New Papers Inspired by the Work of E. Boyd,* ed. Marta Weigle, with Claudia Larcombe and Samuel Larcombe, 205–17. Santa Fe: Ancient City Press.

Vergara Wilson, María. 1982. "Spanish Colonial Textile Techniques." Manuscript.

—— 1988. "New Mexican Textiles: A Contemporary Weaver Unravels Historic Threads." *Clarion* (fall): 33–40.

Wade, Edwin. 1976. "The Southwest Indian Art Market." Ph.D. diss., University of Washington.

—— 1981. "The Ethnic Art Market and the Dilemma of Innovative Indian Artists." In *Magic Images: Contemporary Native American Art,* ed. Edwin L. Wade and Rennard Strickland, 9–17. Tulsa: Philbrook Art Center.

Wall, Dennis. 1995. "Chimayó Weavers." *New Mexico Magazine* (November): 40–47.

Warren, Nancy Hunter. 1981. "Folk Art in New Mexico." *New Mexico Magazine* (November): 42–45.

Weigle, Marta. 1978. *Brothers of Light, Brothers of Blood: The Penitents of the Southwest.* Albuquerque: University of New Mexico Press.

—— 1983. "The First Twenty-Five Years of the Spanish Colonial Arts Society." In *Hispanic Arts and Ethnohistory in the Southwest,* ed. Marta Weigle, with Claudia Larcombe and Samuel Larcombe, 181–203. Albuquerque: University of New Mexico Press.

—— ed. 1975. *Hispanic Villages of Northern New Mexico.* (A reprint of vol. 2 of the 1935 Tewa Basin Study with supplementary materials.) Santa Fe: Lightning Tree.

Weigle, Marta, ed., with Claudia Larcombe and Samuel Larcombe. 1983. *Hispanic Arts and Ethno-*

history in the Southwest: New Papers Inspired by the Work of E. Boyd. Santa Fe, Ancient City Press; Albuquerque: University of New Mexico Press.

Weigle, Marta, and Peter White. 1988. *The Lore of New Mexico.* Albuquerque: University of New Mexico Press.

Welsh, Michael. 1994. "A Land of Extremes: The Economy of Modern New Mexico, 1940–1990." In *Contemporary New Mexico, 1940–1990,* ed. Richard W. Etulain, 61–89. Albuquerque: University of New Mexico Press.

Wentworth, Edward Norris. 1948. *America's Sheep Trails.* Ames: Iowa State College Press.

Wheat, Joe Ben. 1976. "Spanish-American and Navajo Weaving, 1600 to Now." *Collected Papers in Honor of Margery Ferguson Lambert.* Papers of the Archeological Society of New Mexico. 3, 199–226.

——1977. "Documentary Basis for Material Changes and Design Styles in Navajo Blanket Weaving." In *Ethnographic Textiles of the Western Hemisphere,* 420–44. Proceedings of the Irene Emery Roundtable on Museum Textiles. Washington, D.C.: Textile Museum.

——1979a. "Rio Grande, Pueblo, and Navajo Weavers: Cross-Cultural Influence." In *Spanish Textile Tradition of New Mexico and Colorado,* ed. Nora Fisher, 29–36. Santa Fe: Museum of New Mexico Press.

——1979b. "Saltillo Sarapes of Mexico." In *Spanish Textile Tradition of New Mexico and Colorado,* ed. Nora Fisher, 74–82. Santa Fe: Museum of New Mexico Press.

——1984. *The Gift of Spiderwoman: Southwestern Textiles.* Philadelphia: University of Pennsylvania Museum.

——1988. "Spanish Colonial Weaving." In *The North American Indian Collection of the Lowe Art Museum.* Coral Gables: Lowe Art Museum, University of Miami.

——1994. "Yarns to the Navajo: The Materials of Weaving." In *A Burst of Brilliance: Germantown, Pennsylvania, and Navajo Weaving.* Philadelphia: Arthur Ross Gallery, University of Pennsylvania.

Williams, Jerry L. 1986. *New Mexico in Maps.* 2d edition. Albuquerque: University of New Mexico Press.

Wilson, Kax. 1985. "Jerga: A Twill in Harmony with Its Heritage." *New Mexico Magazine* (November–December): 60–63.

Wroth, William. 1980. "Hispanic Southwestern Craft Traditions and the Taylor Museum Collection." In *Spanish and Mexican Land Grants in New Mexico and Colorado,* ed. John R. Van Ness and Christine M. Van Ness, Manhattan, Kans.: Sunflower University Press.

——1983. "New Hope in Hard Times: Hispanic Crafts Are Revived during Troubled Years." *El Palacio* 89 (2): 22–31.

——1994. "The Hispanic Craft Revival in New Mexico." In *Revivals! Diverse Traditions, 1920–1945: The History of Twentieth-Century American Craft,* ed. Janet Kardon, 84–93. New York: Harry N. Abrams.

——ed. 1977. *Hispanic Crafts of the Southwest.* Colorado Springs: Taylor Museum of the Colorado Springs Fine Arts Center.

——1985. *Weaving and Colcha from the Hispanic Southwest.* Santa Fe: Ancient City Press.

Zimmerman, Felice. 1956. "Chimayo Blanket Traced." *Española Valley News* (December): 12, 16.

Zoretich, Frank. 1995. "Weaving as a Fine Reputation." *Albuquerque Journal* (February 26): D1–2.

Index

Library of Congress

Cataloging-in-Publication Data

Lucero, Helen R.,

Chimayó weaving: the transformation of a tradition

Helen R. Lucero, Suzanne Baizerman.

p. cm.

Includes bibliographical references and index.

ISBN 0–8263–1975–0 (cloth) ISBN 0–8263–1976–9 (pbk)

1. Hispanic Americans — New Mexico — Social life and customs.

2. Hispanic Americans — Rio Grande Valley — Social life and customs.

3. Weaving — New Mexico — History.

4. Weaving — Rio Grande Valley — History.

5. New Mexico — Social life and customs.

6. Rio Grande Valley — Social life and customs.

7. Weavers — New Mexico — Biography.

8. Weavers — Rio Grande Valley — Biography.

9. Hispanic American arts — New Mexico — History.

10. Hispanic American arts — Rio Grande Valley — History.

I. Baizerman, Suzanne.

II. Title.

F805.S75L83 1998

746.1′4′097895 — dc21 98–23210

CIP

Typeset in Monotype Garamond

Color separations, printing, and binding by MilanoStampa SPA, Italy

Designed and composed by Sue Niewiarowski